W9-CJW-517

MARLENE DIETRICH

MARLENE DIETRICH
Photographs and Memories

From the Marlene Dietrich Collection of the FilmMuseum Berlin

COMPILED BY JEAN-JACQUES NAUDET

CAPTIONS BY MARIA RIVA

with Werner Sudendorf

Alfred A. Knopf *New York* 2001

This Is a Borzoi Book
Published by Alfred A. Knopf

Copyright © 2001 by Die Marlene Dietrich Collection GmbH

www.aaknopf.com

Knopf, Borzoi Books, and the colophon are registered trademarks of Random House, Inc.

ISBN: 0-375-40534-8
LCCN: 2001094890

Manufactured in Spain
First Edition

Grateful acknowledgment is made to the following for permission to reprint previously
published and unpublished material:

Yul Brynner Enterprises, Inc.: Letters from Yul Brynner. Courtesy of Yul Brynner
Enterprises, Inc.

Leatrice G. "Tinker" Fountain: Notes from John Gilbert. Courtesy of Leatrice G.
"Tinker" Fountain.

The Hemingway Foundation and John F. Kennedy Library: Excerpt from "A Tribute
to Mamma from Papa Hemingway" by Ernest Hemingway (*Life* Magazine, August 18,
1952). Reprinted courtesy of The Hemingway Foundation and John F. Kennedy Library.

Erich Maria Remarque Peace Center: Letter from Erich Maria Remarque. Courtesy
of Erich Maria Remarque Peace Center, Germany.

Meri and Nicholas von Sternberg: Excerpts from letters and from *Fun in a Chinese
Laundry* by Joseph von Sternberg (Macmillan, New York, 1965). Reprinted courtesy of
Meri and Nicholas von Sternberg.

Kurt Weill Foundation for Music: Letters from Kurt Weill. Reprinted with the
permission of the Kurt Weill Foundation for Music, New York. All rights reserved.

Contents

Memories of Dietrich

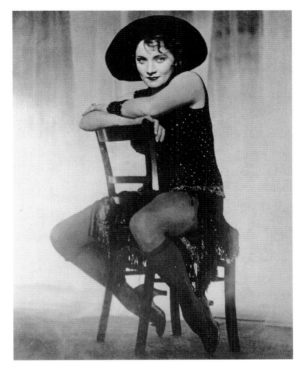

JOSEF VON STERNBERG

A ship now sails the seas, registered as the *Marlene;* numberless children grow up with a name unknown to the world not long ago. "Marlene" is a contraction of "Maria Magdalene," two names not often found in one person. Before becoming reconciled to being known as Marlene Dietrich, she pleaded with me to change her name, as no non-German could pronounce it correctly. The plea was ignored and she was told, correctly pronounced or not, the name would become quite well known. She attached no value to it when I met her, nor did she attach value to anything else so far as I could ascertain, with the exception of her baby daughter, a musical saw, and some recordings by a singer called Whispering Jack Smith.

 As I came to know more about her I also became familiar with the conditions that had produced her, her family, and the circle around her. Her energy to survive and to rise above her environment must have been fantastic. She was subject to severe depressions, though these were balanced by periods of unbelievable vigor. To exhaust her was not possible; it was she who exhausted others, and with enthusiasms few were able to share. At times provoking because of her peculiar superstitions, she balanced this with uncommon good sense, which approached scholarship. The theatre was in her blood, and she was familiar with every parasite in it. Her reading consisted of Hamsun, Lägerlof, Hofmannsthal, and Hölderlin. She worshipped Rilke and knew by heart the writings of Erich Kästner. She gave me a book of the last-mentioned poet in which she strongly underlined one particular poem. Were it in English, the sense of it would be this:

Gloom comes and goes without a cause
And one is full of only emptiness.

One isn't sick, nor is one well.
It is as if the soul were indisposed.

One wants to be alone, but then again with others
One's disposition may be out of joint.
The stars appear to be mere freckles.
One isn't sick, one only suffers.

One wants to run, but finds no place to hide.
It is as if retreat led to the grave.
The distant glance shows but dark spots.
One likes to die—or take a fortnight's leave.

Despite her melancholy, she was well dressed and believed herself to be beautiful, though until this was radically altered by me, she had been photographed to look like a female impersonator. There are many unflattering photographs of her pre–*Blue Angel* period in existence, portraying an inhibited subject almost anxious to hide. Nevertheless she distributed them to all and sundry with the air of bestowing a priceless gift.

Berlin in the fall of 1929. The war that had ended eleven years before had left the capital of a once proud Germany physically intact. Other things had happened that proved as destructive and more so than if the city had been turned into rubble—something the next war was to accomplish. When I arrived, Berlin had barely recovered from upheavals that its people should have remembered. Following in the wake of the defeat of the German Empire, the fleet had revolted, what was left of the army had scurried to hide, officers had had their epaulettes ripped off by the mobs, and the emperor had fled; all this was a prelude to political confusion, chaos, starvation, and a currency inflation that bordered on insanity. Paper money that was worth a fortune the day before would not buy a loaf of bread the following morning. A people once strong and arrogant had been leveled to animals foraging for food. All normal values had become obsolete.

Berlin demanded distraction, and those who supplied it demanded their share. Cabarets, theatres, and night clubs teemed with actors and actresses. No companion of theirs was twice the same; they were surcharged and stimulated night and day; they slipped in and out of their haunts like eels. It would be wrong to suppose that all of the city was in hectic pursuit of questionable values, but enough was in sight to give that impression. The public display included girls in boots with whips in hand, waiting to beat up their patrons; and another group, flaunting pigtails and schoolbooks, paraded to appeal to those who hurried to meet them with set jaw and clenched fists. Outwardly Berlin in 1929 was an evocation by Goya, Beardsley, Marquis de Bayros, Zille, Baudelaire, and Huysmans.

The Berlin of 1929 was the background of "the woman who was to charm the world." Heinrich Mann's book contained a brilliant chart of an amoral woman whose flesh brought about the downfall of a high school professor. My associates had told me that the portrait of the seductive harlot was anchored in the personal history of the author. Be that as it may, one stately and dignified elderly German lady, thought to be the original, had already been presented to me as a prospect for the part of the alluring female. And as I proceeded to dictate the scenario,

everyone's inamorata was ushered into the office to unveil charms that had they been gathered in one individual might have been more than desirable. One had the necessary eyes, another a graceful posture, one legs that weren't knock-kneed, and still another a voice that promised deviltry, but I could not see how half a dozen different women could be made to play one part.

All the other members of the cast had been chosen. An able staff was at my beck and call. Missing was Lola, so named by me and inspired by Wedekind's Lulu. In planning the work I had decided on an elephantine cast of supporting players, in order to have its collective bulk reduce the visible fat of my leading man, who was adding to his bulges day by day on the assumption that he had to fortify his body for the strenuous task ahead.

As the deadline for starting the film approached, an uneasiness made itself felt. A rumor began to circulate that the woman I sought was not on earth. In turning over the pages of a trade catalogue that contained a photograph of every actress in Germany I had paused at a flat and uninteresting portrait of a Fräulein Dietrich, and, asking my assistant about her as I had asked about many others, saw him shrug his shoulders while saying, "*Der Popo ist nicht schlecht, aber brauchen wir nicht auch ein Gesicht?*" ("Not at all bad from the rear, but do we not also need a face?"). So she was promptly relegated to the others and forgotten until, by accident, I attended a play by Georg Kaiser, *Zwei Krawatten,* in which members of my cast already chosen were performing.

It was in that play that I saw Fräulein Dietrich in the flesh, if that it can be called, for she had wrapped herself up as if to conceal every part of her body. What little she had to do on that stage was not easily apparent; I remember only one line of dialogue. Here was the face I had sought, and, so far as I could tell, a figure that did justice to it. Moreover, there was something else I had not sought, something that told me my search was over. She leaned against the wings with a cold disdain for the buffoonery, in sharp contrast to the effervescence of the others, who had been informed that I was to be treated to a sample of the greatness of the German stage. She had heard that I was in the audience, but as she did not consider herself involved, she was indifferent to my presence.

There was an impressive poise about her (not natural, as it turned out, for she was an exuberant bubbler when not restrained) that made me certain that she would lend a classic stature to the turmoil the woman of my film would have to create. Here was not only a model who had been designed by Rops, but Toulouse-Lautrec would have turned a couple of handsprings had he laid eyes on her. Her appearance was ideal; what she did with it was something else again.

As Fräulein Dietrich sat in the office one late afternoon she made not the slightest effort to intensify my interest. She was seated in a corner of a sofa facing my desk, her eyes downcast, a study in apathy. Across from me was a bundle of womanhood who was vital to my film, attempting to blot herself out. Clad in a heliotrope winter suit, with hat and gloves to match, and furs, she appeared to have come to visit me in order to take a much-needed rest. To draw her out of her lethargy I inquired why her reputation as an actress seemed to be a doubtful one. For a moment she looked at her gloved hands, and then, as if she had exposed too much, hid them quickly in back of her.

This shrouded lady in front of me was not going to make the task of converting her into a tiger an easy one.

As I was trying to fuse her actual image with what was in my mind, Erich Pommer, flanked by jovial Jannings, entered and with admirable directness asked her to take off her bonnet and walk up and down. This was the usual ceremonial of interviewing an actress to determine at once whether she was bald or had a limp. She complied by strolling through the small room with bovine listlessness, not seeming to look where she was going, and giving me the impression that any moment she might bump into the furniture. Her eyes were completely veiled. The two experts exchanged telling glances and, one clearing his throat while the other delicately scratched his ear, left the room after a couple of limp handshakes that were meant to give me their opinion. Afterward Jannings informed me that a cow veils her eyes only when giving birth to a calf. This was not the only disparaging remark I was to hear, for that night several of my alarmed helpers rushed to the theatre to check my judgment and returned to tell me that they had seen nothing that was worth looking at, and a friendly suggestion was made that I should have my eyesight checked.

Miss Dietrich remained standing after the producer and the star had delivered their unspoken verdict. No doubt she had expected nothing else, but she looked at the door which had closed behind them with a deep look of contempt which she then transferred to me as if I had been responsible for the unnecessary humiliation. I asked her to please be seated again and studied her. Obviously she had a great deal of vitality, though not knowing what to do with it she concealed it completely. I then proceeded to give her a rough idea of what was

in store for her, and she became alerted enough to respond in a childish voice that she had been under the impression that she might be wanted for a minor part, not for the leading role. I told her that this was not so, and that she was perfect for what I had in mind. This apparently only made her indignant, as if I had slighted her. She came out of her shell long enough to inform me that she could not act, that it was impossible for anyone to photograph her to look like herself, that she had been treated badly by the press and, to my surprise, she also revealed that she had been featured in three films in which she had not been good. This was a novel experience for me, for no one to whom I had ever offered a part had volunteered to apprise me of failures.

Actually I found out later that she had not only been ineffective in three films but in nine, and had been in musicals, not only in the chorus of hits such as *Broadway* but had been featured by many talented men. Apparently everyone in Berlin had "discovered" her long before I came along.

The next day proved to be an ordeal. If I had first seen her films before seeing her on stage, my reaction would have been the same as everyone else's. In them she was an awkward, unattractive woman, left to her own devices, and presented in an embarrassing exhibition of drivel. Ice cold water was poured on me. In any event I dreaded tests. I had made only two of them before.

I put her into the crucible of my conception, blended her image to correspond with mine, and, pouring lights on her until the alchemy was complete, proceeded with the test. She came to life and responded to my instructions with an ease that I had never before encountered. She seemed pleased at

the trouble I took with her, but she never saw the test, nor ever asked to see it.

The two tests were screened the following morning in a crowded projection room. A unanimous opinion ruled out the woman of my choice in favor of Lucie Mannheim. Erich Pommer quietly settled the matter by stating that the choice of the cast was my responsibility and that it was his responsibility to support me. This of course was the final word, except for one more small voice that came from Emil Jannings, who muttered in a hollow voice that would have brought credit to Cassandra that I would rue the day.

The cast of players was now complete, and the filming began. My leading lady had been engaged for a relatively small sum, though the five thousand dollars her contract called for was almost a hundred times as much as the pittance she earned at the theatre, where she had to appear nightly throughout the entire filming. She had to be at the studio at seven in the morning and work late until she barely had time to reach her theatre for the night performance; after which, so I was told, she went to a midnight dinner with her friends to regale them with a vivid and explicit account of what she was forced to endure on my stages.

During the filming she complained that what I was instructing her to do would make it impossible for her to ever show her face again, repeating this even after she saw the completed film. At the time she told others that her torture was not only intensified by the twists and turns her body was subjected to but that each sound from her came under directorial censure. This foreigner, who ruled the stage with an iron hand, not only made her speak in English that had vowels and conso-

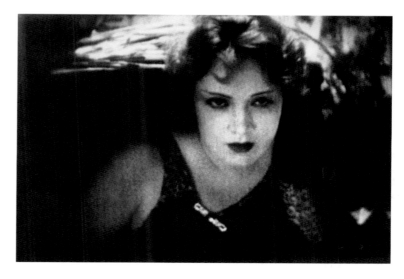

The "tart" face that—with a garter belt—launched a career. *The Blue Angel*, Berlin, 1930.

nants that were beyond belief but he even had the temerity to assume jurisdiction over her native language. It was punishing enough to work with Jannings, who, though the prime consideration of the director, was notorious for his tantrums, but, worst of all, she could do nothing to please this other exacting person, and if that was the way to make a living she would have none of it.

On the eve of April Fool's Day, 1930, *The Blue Angel* was unrolled before the Berlin public for the first time. Erich Pommer, with a discretion rare among producers in the annals of our profession, had let my work speak for itself, not tampering with a single frame. By coincidence or not, that very evening was the time for Frau Dietrich to leave for Hollywood, since she had decided to accept the Paramount contract. The railroad station was close to the Gloria-Palast, where the film opened, and as the boat train was not scheduled to leave until midnight, she had been persuaded to take a bow at the finish of the performance that she thought would bring her ruin and oblivion. It is pleasant to record that she was not attired as if she might have to sneak out of the stage door and run for the waiting train, but was festooned and garlanded in the flouncy tradition of a film star. She received a thunderous ovation. The beginning of the journey into the stratosphere had been nicely timed.

Cables from my associates notified me how the film had been received by public and critics. But not so the cable that came from a ship. It merely read: "Who is to play opposite me?" I replied that Gary Cooper had been chosen, though it was not what I was tempted to reply. Added to the ordinary difficulties of my work, an actress had been launched in a few hasty weeks who would now play a part that had not been written for her.

A stranger she was, for no one had seen *The Blue Angel* outside Germany, and it was not shown in the United States until she had once more revealed herself as a stellar attraction in the second film made under my "tormenting" tutelage. This post-graduation piece was to be named *Morocco.* Miss Dietrich had much more to do with the choice of this second vehicle than merely conforming to the instructions of her teacher, for when I had left Berlin, before I knew that she would follow, she had sent a *bon voyage* basket to the ship, and in it was a novel by Benno Vigny. Its title was *Amy Jolly,* and it dealt with the Foreign Legion. As I read it in an idle moment, it occurred to me that there was a foreign legion of women, so to speak, who also chose to hide their wounds behind an incognito.

Upon being informed that this book was to be the basis for the next film, she had cabled that it would be better to choose a more suitable story for her, protesting that *Amy Jolly* was "*schwache Limonade*" ("weak lemonade"). Her judgment was correct so far as the subject matter of the novel was concerned, for she could not possibly know the reason for its choice. I had deliberately selected a theme that was visual and owed no allegiance to a cascade of words.

I had shuddered at the idea of the sounds that would emerge from the mouth of my Aphrodite when the time came to engage in mortal combat with an unfamiliar language. Her German and French were impeccable, but her knowledge of English was then poor, and unless carefully handled, difficult to reconcile with the charm of her looks. Weber and Fields and their many successors had made audiences howl with their imitations of English slaughtered by the German novice. An

image that had no accent, German or otherwise, could not be subjected to a guttural pronunciation with a rolling *r* sound, *v* substituted for *w, ch* for *j, b* for *p,* and *z* for *s.* My fears were not based on any fantasy, for in filming the English version of *The Blue Angel* simultaneously with the German, I had witnessed the facial contortions and the wrestling match with the tongue that went with the most elemental sounds that came from her lips. Plainly she would need to be kept out of sight until this handicap was overcome, though there was no way of concealing her in a film which was to feature her.

I had seen the "modest little German Hausfrau," whom all these preparations were to frame, wearing the full-dress regalia of a man, high hat and all, at a Berlin shindy, and so outfitted her, planning to have her dress like a man in one of the café sequences when she would sing in French and, circulating among the audience, favor another woman with a kiss. The formal male finery fitted her with much charm, and I not only wished to touch lightly on a Lesbian accent (no scene of mine having any sexual connotation has ever been censored) but also to demonstrate that her sensual appeal was not entirely due to the classic formation of her legs.

Asked to make a trailer to acquaint the sales force with a potential star, she appeared in a short scene wearing white tie and tails. At once I ran into a storm of opposition. The studio officials swore by all that was sacred that their wives wore nothing but skirts, one of them even going so far as to claim that a pair of trousers could not be lifted. Hours of debate ensued, draining my energies and theirs. While they could recuperate, I would be making the film, and their opinion seemed to be that a director needed not energy to do his work.

When I stood my ground on the question of what my performers were going to wear, the choice of the players became a bone of contention. Gary Cooper was considered to be harmless enough not to injure the film, but Adolphe Menjou was turned down as a liability until it was pointed out that all this was of no importance as the film had to sink or swim solely on the merits of an unknown personality. In passing, it should be mentioned that less than a year later Adolph Zukor confided to me that the company had been saved from bankruptcy by the success of this film.

It was finally conceded that the debonair Menjou could join the cast, and so this gentleman became privileged to share in the opening scenes of *Morocco,* with which I hoped to repeat what had been done once before—the transformation of my protegée into a star.

We had bad luck at the beginning. The scenario describes the opening scene as taking place on the forward deck of a small steamer approaching the shore of North Africa. Leaning on the rail, peering into the foggy night that shrouds her destination, is a mysterious woman, her forlorn countenance made luminous by a beam of light aimed at her by one of my electricians. Normally the men who manipulate the lights recline on the scaffolding, reading comics or dozing, fairly indifferent to what transpires below them. But not this time. Their eyes were pinned on someone unknown to them who had aroused their curiosity, for the director seemed to be taking excessive pains, gauzing and making light rays to toy with her skin texture, even asking for a "cucaracha" (a transparent plastic contraption with broken surface) in order to bounce a few highlights here and there. And whereas most featured players had substitutes

standing in for light adjustments, this lady waited without a sign of impatience for the director to signal the beginning of the scene.

The director then took his place behind the camera and assistant called, "Scene one, take one." Jauntily, Mr. Menjou, playing a citizen of the world, strolled by an assortment of Arabs and Levantines sprawling on the deck to accost the inscrutable female gazing intently into the dark, her eyes riveted on a board on which had been chalked "North Africa." Raising his hat, he stated politely that he knew the country ahead and asked whether he could be of any help. So far, so good—everything was going along well. The scene required that the woman being photographed as an alluring enigma look him up and down in sober appraisal while the muffled foghorn moaned. She was to reject his kind offer by saying that she needed no help, but she was to voice this in a way to indicate that her immediate destiny was a dubious one.

The words were "I don't need any help." That was what was put in, but it was not what came out. The star of my film, on the first sounds designed to enrapture an audience, had taken one of the words of that simple sentence into her mouth and garbled it. Everyone was startled, even Mr. Menjou, whose poise was proverbial; but more than startled was the man at the sound controls, who threw me a despairing look like a trout about to expire. The word "help" had been mutilated to sound like "hellubh."

Unaffected, I approached from behind the camera and explained to the lady, who had failed to take note of the commotion her linguistics had aroused, that there was nothing unusual about a first take being unsatisfactory, that the scene would be more effective were excess syllables eliminated. I carefully called attention to the fact that "help" contained only four letters and needed no additional sounds to make it intelligible. She listened carefully, as she always did, and mentioned that she might never be able to discard an accent. With this I agreed, but I stated that the accent would have to be acceptable to me.

After a few more attempts on her part to embellish a simple word with sounds that would have made a laughing stock of both of us, I suggested that she substitute the word for "assistance" for the word that gave her so much trouble. This, after a few preliminary trial runs through the teeth, she declined to consider, saying that the other word was preferable. By this time the stage was in a dither. Various bystanders were melting away, and couriers had been dispatched to every department in the studio to inform them that all was not as it should be.

We tried it a few more times, the result being the same and aggravated by additional stumbles due to the tension. Her sharp ears had taken note of an alien sound that preceded the letter *l,* and she reproduced the sound formed by the movement of the tongue to expel that letter to the best of her ability. Suggestions were made by my solicitous staff members. Why not approve the scene as good enough and, on a later day, when the word could be properly pronounced, record it and then insert it into the sound track? His procedure would have been quite normal, but was out of the question in this case, for if this portion of the film were to be seen the following morning by the studio executives, who inspected each day's work as if it were representative of the entire film, the German charmer

would promptly be eliminated from the project. No, this was the acid test!

I persisted in the attempt to teach her how to pronounce the fatal word. Though a pallor had now spread over the faces of those who had remained on the stage, she was unperturbed. She knew that there was something wrong, and she had seen this sort of thing during the making of her first film with me, participating with others in having pronunciation and tone corrected, and in the German language as well as in English. Concluding that perhaps my enunciation was at fault, Menjou was asked to pronounce the word for her several times, and when that failed, others were told to drop the fateful word into her ear. Each time, in went the word "help," out came vowels, consonants, and an occasional diphthong that failed to meet any known standard of charm. My patience with actors is not limited except by their endurance, and hour after hour fled. The fact that I had to speak German to her made matters worse, for nobody had the slightest idea of what was being done to improve matters. Menjou, who had a smattering of German, had retired, pleading a headache.

Suddenly I had an inspiration. I instructed the young lady who had endured all this without a whimper to pronounce the letters *h-e-l-p* in German and to forget that it was an English word. Out came the word, this time faultlessly. The scene was recorded without further incident, and the launching of the good ship Marlene was under way.

From *Fun in a Chinese Laundry* (Macmillan and Company, New York, 1965)

JOE PASTERNAK

In January 1929 the Germans made their first feature film in sound. It was called *I Kiss Your Hand, Madame.* The song it featured was not long in crossing the Atlantic to become as popular in America as it was in Europe. *I Kiss Your Hand, Madame* starred the singer Harry Liedtke and a Berlin nightclub artist named Marlene Dietrich. The picture itself was a misbegotten creature. Most of the time it was nothing more than a silent film, but every now and then a few feet of sound photography was inserted. Harry Liedtke sang the famous tune.

The picture established Marlene Dietrich as a great personality in Germany. Pommer sent to Hollywood for the director Josef von Sternberg, who had brilliantly directed Emil Jannings in *The Last Command* and had made a violent story of gangsters and killings, *Underworld.* Sternberg was a former cameraman, a specialist in moody shots, visual symbolism, and many such things which appealed to the Germans.

The picture Sternberg was to do was *The Blue Angel,* with Dietrich and Emil Jannings.

Later, I was doing an historical epic out at the Ufa studio at Neubabelsberg. It starred and was directed by William Dieterle.

I dropped by the set one day and found almost half the crew gone. "Where's everybody?" I asked the assistant director.

"They're over on the next stage."

"What's on the next stage?"

"Haven't you been there yet?" He looked at me as though I was a man from another world. "You've never seen such legs."

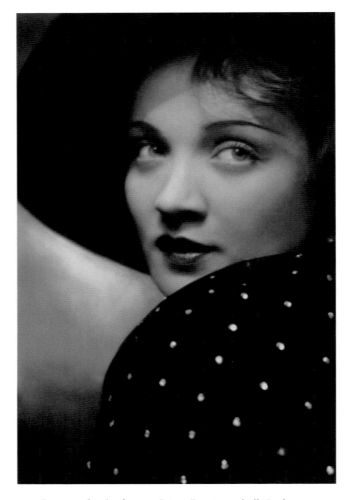

Another pose for the famous "pirate" costume ball, Berlin.

It was obvious he was far more intrigued with what was happening there than he was with King Ludwig II, the hero of my epic.

I wasted no time going to the next stage. Joe Sternberg was there doing the "Falling in Love Again" number from *The Blue Angel* with this Marlene Dietrich who was beginning to be so talked about. Beginning, I say. When I saw how Joe was handling the number and got a look at those lovely legs, I could see that what was attracting my crew would soon be doing the same for cash-paying customers.

What magnetism! How she moved! And that voice: I was convinced she could be seductive merely asking the time of day. I wanted to meet her, but the problem was how? Joe Sternberg was keeping her under lock and key on the set.

Finally it occurred to me that here I was, a Universal Pictures executive. Oughtn't I to begin negotiations, to investigate whether the possessor of those beautiful legs would be interested in a Hollywood contract? I broached the subject to Sternberg and asked him if I might send Marlene my card and visit with her between shots. He said it would be all right.

In a few minutes her maid came up to me. "The *gnädige Fräulein* will see you now."

It was a blistering hot day, I remember. I had been carrying my coat over my arm, so I put it on again, followed the maid and waited discreetly at the door.

"Come in," a silken voice beckoned.

I walked in. Marlene, wreathed coolly in a sheer peignoir and nothing else, shimmering like the moon on a cloudy night, outstretched a long bare arm. I felt the thermometer rise. I tugged at my collar. "Hot, isn't it?" I offered.

"Do you think so?"

In her gossamer chiffon she may have wondered why I kept mopping my brow, but if so she gave no sign.

She said she would be quite willing to entertain an offer from Universal. I said I would wire them.

That was my first meeting with Marlene. I have often thought of our first meeting as pure Dietrich: daring, unforgettable, touched with her unique personal magic.

In 1938 a group of motion picture exhibitors, theatre owners, and the like pooled contributions and took space in the motion picture trade papers to enlighten those of us who made films on the facts of life.

They told us that we, sitting in our expensive offices, knew little of the realities of the motion picture business. There were a number of so-called stars, they said, who literally kept people away from their theatres. We producers thought many of these people important but they were, we were told, "box-office poison." Among the stars they named as "Poisonalities" were Joan Crawford, Katharine Hepburn, and Marlene Dietrich.

The years have, of course, proved how absurd these gentlemen were. But it is apparently a lesson that many people have to learn time and time again. Joan Crawford went on to greater artistic and financial successes than she had ever known; Katharine Hepburn has proved one of our most formidable box-office attractions; and Marlene—well, let us talk about Marlene.

Even while I had the Deanna Durbin pictures under way, I wanted to do something different. Universal being a studio with a pronounced partiality for the Western picture, or "hoss-opry," I began playing with the idea of making such a picture

myself. Naturally I wished to avoid the conventional Western entirely. In mood, story, and casting. I ran across an old Western starring Tom Mix, *Destry,* which seemed to fill the bill perfectly. Destry was a quiet man, not your typical Western hero hankerin' for a fight, quick on the draw. When my writers Bruce Manning and Felix Jackson got through with him, Destry not only wasn't hankerin', he just *wouldn't* fight.

Then it came to me that Marlene Dietrich ought to be the heroine. I had followed her career with mounting dismay. Not entirely through her fault, she had become so stylized and rigid that she had achieved a curious lifelessness on the screen. In *The Scarlet Empress* there were so many angles, so many trick shots, so many doodads, ribbons, and rosettes around her that she scarcely seemed human at all. A mannequin in a shop window might have posed for this static film.

I knew this wasn't Marlene Dietrich. I said to myself, here is a hero like Destry. His girl won't be the typical simpering Western heroine, suffering silently, entreating her man to take care of himself. First place, she ought to be a girl working in a saloon. Sure of herself. Able to handle rough characters. And, beneath it all, as unpredictable as a cat. And our hero, far from being tender with her, at one point, would empty a water bucket in her face.

I told the powers that be that for the hero I wanted Jimmy Stewart and that the role of the heroine had been written for Marlene Dietrich.

There ensued the usual protestations. A Western hero had to be strong, powerful, with dynamite in his fists, and Jimmy was shy, likable, and apparently soft. And as for Dietrich, hadn't I heard? Did I want to see the grosses on the last picture she had made in England? Didn't I know she was finished, washed up, through? Had I not read the exhibitors' advertisements in the trade papers?

In those years when Hitler was riding high, Marlene, whose contacts in the chancelleries of the world were magnificent, never ceased to help countless people, great and small, talented or not. This story has never been told, and perhaps may never be, for she alone knows all the details; but I knew that Marlene worked ceaselessly to help many people escape to freedom. She did this quietly, without ever calling attention to her actions or herself.

I have always believed Marlene has a quality that makes her unique in all the world. I was determined that she play in *Destry Rides Again.* Luckily, the success of the Durbin pictures proved the strongest argument I need and I was given permission to sign her.

She was on the Riviera when I located her. I put in a transatlantic call to her at once.

"I've got a picture for you, Marlene," I said.

"Why?"

I wasn't sure I'd heard right. "What'd you say?"

"I said, 'Why?' "

"For the simple reason, darling, that I've seen the wonderful work you've done and I know you are great. I'd love to have you in my picture."

"What do you want me to do?"

This was going to be it, I realized. Gone the soft-focus lenses and the aphrodisiacal sets. I coughed slightly. "A Western picture, Marlene."

She laughed delightedly. "You must be crazy."

"Marlene, darling, will you please trust me? I've got a picture that will be wonderful for you. It's a marvelous part, believe me. You'll be great in it."

"Haven't you heard, Joe?" she teased. "I'm box-office poison."

"Don't you believe it. The American public will line up to see you."

"All right," she said finally, and not too enthusiastically, "I'll come back."

I met her at the Pasadena station when she arrived. The studio sent over one of its publicity people, but there was no one else—no photographers, no reporters. No newspaper knew she was coming, or if they did, they paid no attention.

Marlene threw her head back and laughed when she saw me. "Joe, you're making the biggest mistake of your life. I don't know why I listen to you."

I had come to the station in a big black studio limousine. I opened the rear door for her and got in beside her. We started for the studio. She was telling me about her trip and chiding me for being a foolish man who'd risk a failure out of pure sentimentality. I didn't reply. I took out a sack of Bull Durham and some cigarette papers, blew at one until I had a single paper. Then with one hand, using my teeth to open the neck of the sack, I dropped tobacco onto the paper, wet the length of it, closed the sack and held out the makings to her. "Cigarette?"

"What're you doing?" she asked.

"Showing you the first thing I want you to learn. I want you to be able to take the fixin's and make a smoke for yourself with one hand."

Her smile was like a sunny morning. "You know, this pic-

ture might be fun at that." Then her face clouded suddenly. "But I haven't seen the script. If I still don't think it's right for me, may I back out?"

"You may indeed," I assured her.

I got her favorite composer, Frederick Hollander, who had written "Falling in Love Again," which she had sung in *The Blue Angel,* to write another song for her in this picture. With Frank Loesser's lyrics, Marlene made "See What the Boys in the Back Room Will Have" almost as famous as her first song.

Jimmy Stewart, in his quiet, competent way, set the pattern for a new kind of Western hero. And Marlene, brawling, exerting her charms among the rough men of the frontier, made you feel for once that not all the saloon girls had kid brothers in Harvard.

When we were finished I took Marlene out to dinner. I felt pretty good, but she was blue. I ordered a bottle of Mercier '28. I held my glass up to her.

"For the first time," she said, "I did a picture without knowing what it was all about. I'm not sure it was the right thing to do."

"It was exactly the right thing, Marlene."

"If anything comes of this," she said, sipping, "then I owe everything to you."

"You owe me nothing. You are the one. The artist has it in him. I'm just the window—that's all the producer ever is."

"No," she insisted. "I'll owe you a part of my life. Joe . . . I want to give you something you'll remember," she added quickly, impulsively. "What do you want? Ask anything and it's yours if I can possibly do it."

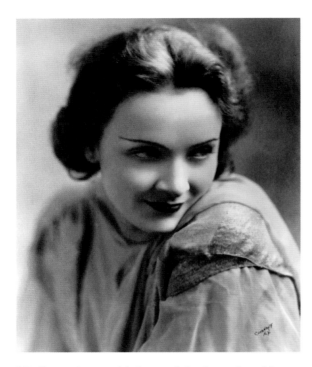

"Coy" never became Marlene and she, being the sublime self-critic, knew it.

I had a fork in my hand and I put it against the table and broke it in two. I gave her half of it. "All right," I said. "When I want to take you up on it, I'll send you my half."

"What do you want?"

"I don't know. I need some time to think about it."

The next day I went to a jeweler and had the broken fork copied in something more seemly than restaurant silver plate. When I brought it to Marlene I told her I'd decided what I wanted of her. "You can give me twenty-four hours of your life to do with as I please," I told her.

She put her hand out, smiling. "It's a deal."

Some weeks later I took her to one of Los Angeles' suburbs to see the preview of *Destry Rides Again*. It was the wrong crowd; an audience which had come to see a "woman's picture," a soap-opera kind of thing, found itself looking at our sophisticated—we hoped—Western. All the nuances, the shading that George Marshall, our director, had gotten so well on the film, I thought, were completely lost on the audience. I sat with Marlene and directly behind us two ladies were loud in their comments. "Did you ever see anything so ridiculous?" Or: "Imagine spending good money on something like this."

Marlene left before the final fadeout. I waited to confer with our executives. They didn't know whether it was good, bad, or indifferent. It wasn't played according to the rules and they didn't know how to react. I went to see Marlene.

"I think you've got a flop, Joe," she said.

"Does our bet still go?"

"Of course," she said. "A bet's a bet, isn't it?"

"That's all I want to know."

Marlene and I made three pictures together. As with everything this woman touches, the experience of each was unforgettable. She is the most self-conscious of women and yet, like many artists who know their craft absolutely and are aware every moment of what they are doing, she never tries to give the impression of effortlessness. She knows just how she should be lit and it is not from vanity or know-it-all. Every cameraman who has ever worked with her has had to agree she was quite right. She is always precisely studied; on the stage she always had a full-length mirror or two nearby so she could see just what she was doing and whether or not it was effective. But, believe me, she is not vain. Marlene is studied where it counts.

Two or three years ago she was asked by the officers of the Academy to present one of the technical awards at the annual Oscar presentations. Every young star who preceded her came out floating on gossamer tulles and net. Their shoulders were bare and the colors of their gowns were delicate pastels, pink and rose and soft peach. When it came Marlene's turn to walk out, the audience gasped. Marlene wore a long black dress, cut very tight, with a high neckline and sleeves to the wrists. A slash in the skirt permitted her to walk and permitted a glimpse of her magnificent legs. Believe me, she knew what she was doing. And the younger girls couldn't even compete with her.

I think this indicates Marlene's secret. Whatever she does, she does very well. Friends claim she "persecutes with kindness." One of my assistant directors, sent home from the set one morning with a high fever, was astonished that evening to wake from his febrile sleeping to find a lady on hands and knees scrubbing his kitchen floor. It was the star of the picture he was working on, Marlene Dietrich, who heard he lived alone, had brought over some clear chicken soup and, finding his kitchen floor could stand a washing, did the job herself.

The last picture we made together was, in many ways, our most interesting. It was called *The Flame of New Orleans* and it remains the only American film to have been directed by René Clair. It will be recalled how much we who worked in Germany in the first days of the talking pictures owed to this great French director. When Marlene and I learned that Clair was a refugee from the Vichy government and that he was actually in America, we hardly had to exchange a word on the subject.

"What do you say?" I asked Marlene.

"I think it'd be wonderful."

The Flame of New Orleans was not an unqualified success. I do not think it made the bookkeepers at Universal very happy. The critics were, I thought, unfair to René. It is my firm conviction that if Clair had made this same picture in France and it had come over here with a French soundtrack and the usual subtitles, the critical ladies and gentlemen would have been talking about "Gallic wit," "the deft French touch," and "Latin sauciness."

And Marlene? The critics were most cruel to her, chiding her for being mannered again and all the rest of it. She thought she was spoofing her old self, but apparently the gentle satire was lost. Marlene didn't mind. It was the spring of 1941. France, the Low Countries, most of Europe, had been overrun,

and Marlene's heart was not entirely centered on making motion pictures. She was thinking about the war and her adopted country's imminent part in it.

Marlene spent three solid years during the war entertaining our troops. She was with them in the winter frosts and under the hot sun. She never asked a favor, was willing to do anything that amused the boys. She played a musical saw for them, put on a jeweled sheath over long GI underwear; she bathed out of a helmet like an infantryman, slept on the ground, refused to be evacuated when there was artillery fire around her. During these three years she did not make one picture, and she did not care. It was entirely fitting, I think, for the War Department to give her a Medal of Freedom.

Some years later, Marlene opened in a night club act in Las Vegas. She was breathlessly beautiful, magnificent—pure Dietrich. When I went to her dressing room, she held out her hand to me. "When are you going to collect your bet, Joe?" she greeted me. "I'm not getting any younger, you know."

From *Easy the Hard Way* as told to David Chandler
(G. P. Putnam's Sons, New York, 1956)

JEAN COCTEAU

Marlene Dietrich! . . . Your name, at first the sound of a caress, becomes the crack of a whip. When you wear feathers, and furs, and plumes, you wear them as the birds and animals wear them, as though they belong to your body.

In your voice we hear the voice of the Lorelei; in your look, the Lorelei turns to us. But the Lorelei was a danger, to be feared. You are not; because the secret of your beauty lies in the care of your loving kindness of the heart. This care of heart is what holds you higher than elegance, fashion or style: higher even than your fame, your courage, your bearing, your films, and your songs.

Your beauty is its own poet, its own praise. There is no need for us to speak of it, and so I salute not your beauty but your goodness. It shines in you, as light shines in the moving wave of the sea; a transparent wave coming out of the far distance, and carrying like a gift its light, its voice, and the plumes of foam, to the shore where we stand.

From the sequins of *The Blue Angel* to the dinner jacket of *Morocco*; from the shabby black dress of *Dishonored* to the cock feathers of *Shanghai Express*; from the diamonds of *Desire* to the American uniform; from port to port, from reef to reef, from crest to crest, from breakwater to breakwater, there comes to us (all sails flying) a frigate, a figurehead, a Chinese fish, a lyrebird, a legend, a wonder: Marlene Dietrich!

Written as an introduction for Miss Dietrich's appearance at the French
Polio Benefit in Monte Carlo (translated by Christopher Fry)

JOHN ENGSTEAD

Marlene had made a half dozen German movies plus von Sternberg's *The Blue Angel* with Emil Jannings before she was signed, so she wasn't exactly a pig in a poke. Paramount had sense enough to realize that it was on to a good thing and threw an elaborate cocktail party at the Coconut Grove at the Ambassador Hotel in Los Angeles to introduce Marlene to the press. She was sexy and sultry if you like big women—there was at least 160 pounds of her. And obviously, nobody had checked her wardrobe in advance, because this fleshy lady arrived in a light, multicolored chiffon dress with little furbelows hanging around which put every one of her pounds on view. On top she wore a big horsehair hat. For her first Hollywood movie, Travis Banton camouflaged the extra pounds by dressing her mostly in dark colors.

One thing that Marlene brought to Hollywood was a good set of brains that she put to constant use. It didn't take her long to lose weight and learn how to dress.

Marlene also has great self-discipline and determination. Once, when von Sternberg let drop some caustic remark that Marlene was putting on a little weight, for the next week nothing went into her stomach but tomato juice and crackers. For the first five years of her Hollywood career, von Sternberg took complete control of her portrait sittings. I'd stick around to watch and learn because, added to his directing ability, he was one of the great cameramen in films. He used a high spot to bring out the shadows under her cheekbones. He would ask Marlene to move in various positions—leaning over a chair, in backbreaking contortions with nothing to support

her. She would hold these positions for minutes on end while he studied the situation and spoke to her only in German. When the pose was suitable, he began to work on her face. At his command her head would rise and fall; the lids would lower; the mouth would open and sex appeal would pour from her face. When all was to von Sternberg's satisfaction, he would poke photographer Richee in the back and the shutter would click. At one point when Marlene's mind wasn't working as he thought it should, he lapsed into English, "Think of something! Think of anything! Count the bricks on the wall!"

Nothing was too difficult for Miss Dietrich to endure for her career. For a scene in *The Scarlet Empress*, she ran down an elaborate staircase in her many-petticoated costume forty-five times before von Sternberg approved the scene. It took all of one morning. And, for her last Paramount film with von Sternberg, *The Devil Is a Woman*, Travis Banton and Dietrich found an enormous Spanish comb for her to wear. To anchor this to Marlene's head, hairdresser Nellie Manley made little braids of Marlene's own hair and wired the comb to these. And if this weren't enough, a large mantilla was draped on the comb. God knows the agony she went through each day with no time to remove it at noon. I was there in her dressing room one night and watched Nellie with wire cutters and loud crunches snip the bands and release the comb. Marlene fell forward, arms and head resting on her dressing table, exhausted from pain. When she came up, tears were running down her face.

From *Star Shots: Fifty Years of Pictures and Stories by One of Hollywood's Greatest Photographers* (E. P. Dutton, New York, 1978)

The first time I ever clapped eyes on her was at a tea party. When Travis Banton caught sight of her I thought he'd faint dead away. Her gown of black satin was skintight over rather lumpy hips, with a train besides. And the bottom of the dress writhed with black ostrich feathers. Travis took her in hand and together they made fashion history.

Marlene loved feathers—paradise, ostrich, egrets, even stuffed birds. Banton once made her an evening gown trimmed with four thousand dollars' worth of black paradise feathers. It was a knockout. Every star in town wanted to duplicate it, but they couldn't buy the feathers.

When an agent of the federal government swooped down on the studio and snatched away all the paradise feathers, I wondered if a certain star's jealousy hadn't got the better of her discretion. The agent said it was against the law to import or even buy paradise. Heaven forbid! These had been bought years before, but thereafter Marlene had to be content with the plumage of lesser and drabber birds.

Marlene was all women rolled into one—mother, daughter, siren, sweetheart, actress, slitch, homemaker, companion, and friend. And her introduction of slacks into our town is still on her conscience. Following her style, some of the funniest female shapes since Eve ate the apple laid themselves open to ridicule by squeezing all too solid flesh, and too much of it, into a pair of pants. No one ever wore them with Dietrich's distinction.

She set a style in kindness too. When a new star came to Paramount, Marlene was right there with a welcome. I was in Gladys Swarthout's dressing room when Dietrich, whose room was across the walk, came over, introduced herself, and held out a cake topped with white icing, gardenias, and a huge bow of white satin ribbon. She'd baked it for Gladys the night before.

Marlene was the only star at Paramount who had a special kitchen built onto her dressing-room suite. I've seen her turn out an omelet while wearing a court dress and a white wig when she was playing *The Scarlet Empress* and never get a spot on her gown or a drop of perspiration on her pretty forehead.

From *From Under My Hat* (Doubleday & Company, Garden City, N.Y., 1952)

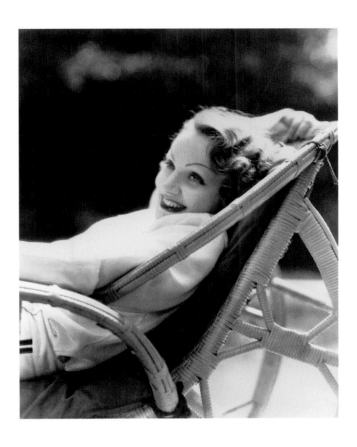

CLARA BIANCHI
(ladies' room attendant at New York's Colony Restaurant)

In twenty years I've never seen her replenish her makeup—not even her lipstick.

SIR ALEXANDER FLEMING
(the discoverer of penicillin, who met Dietrich only once, but who corresponded with her and had her picture hanging in his outer office in London)

I don't know what people mean by glamour. But Miss Dietrich is incredibly intelligent and brilliantly witty.

MERCEDES McCAMBRIDGE
(actress)

You should really hear her tell the story of her funeral.

KENNETH TYNAN

From the flat screen Dietrich stormed the senses, looking always tangible, and at the same time untouchable. Her eyes were a pair of mournful rebukes, twin appeals to us not to lose our heads by becoming "emotionally involved": but the milk-soft skin (which still shows no sign of curdling) gave the lie to them. And how cynically witty were her lips! This was not the fatal woman panting for fulfillment, like Theda Bara and the rest: it was the fatal woman fulfilled, gorged and sleek with triumph. The aftermath, as Ovid noted, is sadness, and it was sadness which Dietrich communicated, even in her first youth. "There is a gloom in deep love," said Landor, "as in deep waters." But Dietrich had not alone the earth-melancholy of Lilith: she could awake and sing, brandishing her hips like Eve defying the Fall. "Beware the *amazing* blonde women!" she cried in one of her early songs: and there was in her voice that note of almost military harshness, which you find in so many Germanic heroines. The order rings out riotously, and men come cringing to heel: the rule is instant obedience, the sheep must beg to be slaughtered. That, at least, was the Dietrich myth, and it has its echoes in fictional women as disparate as Wedekind's Lulu and La Mort in Cocteau's *Orphée.* Most women, according to an old joke, have gender but no sex. With Dietrich the opposite is very close to the truth. She has sex, but no particular gender. Her ways are mannish: the characters she plays love power and wear slacks, and they never have headaches or hysterics. They are also quite undomesticated. Dietrich's masculinity appeals to women and her sexuality to men.

From *The Face of the World* by Cecil Beaton
(Weidenfeld & Nicolson, London, 1957)

MITCHELL LEISEN

Marlene came back from the war very much changed. She's never gotten over the horrors she saw there. She slept for months in jeeps, on floors, even bare dirt, and I tried to tell her she should write a humorous book about her experiences, but it was no laughing matter. She told me that she was walking through a little French village one afternoon after VE day. All around her was rubble and she couldn't understand why because all the buildings along the street were still standing, with curtains blowing in their windows. Then she looked through one of the windows and she saw that there was nothing behind. The fronts of the buildings were still standing but everything behind them had been destroyed and there was not a single person there.

I went out to the airport to meet her, and the first thing she did when she got off the plane was say, "I must call the General in Paris." I said, "But you've just come from Paris!" She said, "I know, but he made me promise I would call; he was worried about me." She told me she had been participating in a ceremony, in Paris, and as she walked off the stage, a GI came up to her and said, "The General expects you at his apartment." Marlene said, "But I don't know the General." "He expects you," said the GI. "So," said Marlene, "I went over there and stayed two weeks. He wants me to marry him, but I can't be an army wife. What would I say to the other army wives?"

The studio didn't want Marlene at first [for *Golden Earrings*], but I insisted. The whole point of the story was that this Gypsy woman was so seductive underneath all her filthy clothes

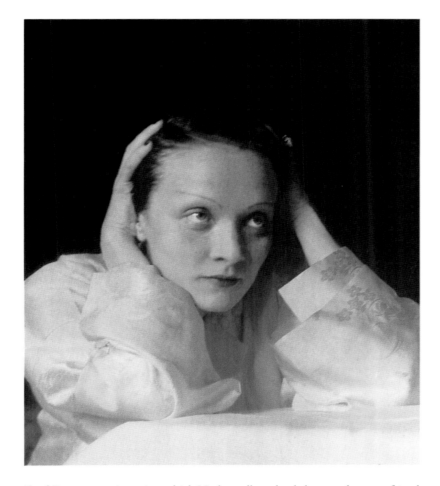

Cecil Beaton experimenting, which Marlene allowed only because he was a friend.

and greasy hair and the stuffy Englishman couldn't help falling in love with her. I said, "There's only one woman who can be glamorous under all that and it's Marlene." After she accepted the role, Marlene decided to do some research. She visited all the Gypsy camps around Paris and even stayed in one of them for several days.

Ray Milland didn't want to make the picture. He didn't like Marlene; he thought she was too young to do it, so he was a real bastard at first. He calmed down a little by the end, but he and Marlene fought the whole time. When we were shooting the scene where he first meets her as she's eating the stew, over and over, Marlene would stick a fish head into her mouth, suck the eye out, and then pull out the rest of the head. Then, after I yelled cut, she would stick her finger down her throat to make herself throw it up. This whole performance made Ray violently ill.

From *Mitchell Leisen, Hollywood Director* by David Chierichetti
(Photoventures Press, Los Angeles, 1995)

EDWARD G. ROBINSON

My first impression of Miss Dietrich made me nervous, because, to carp, she appeared to have such arrogant self-assurance and security. I had never met her before, though I had seen all her pictures and was aware that she was sexy, temperamental, demanding, beautiful, and perhaps the synthetic creation of Joseph von Sternberg.

Playing with her, I learned that we shared a common passion: work. More than that: Be on time, know the lines, toe the marks, say the words, be ready for anything. God, she was beautiful—and still is—but I don't think it interested her very much. Beauty, that obsessive sexual thing she had, and her superficial self-confidence were simply instruments to help her bank account and her art.

One of the things about her that astonished me most was her knowledge of the technical side of motion pictures. She seemed to know everything. She constantly watched the camera and the light, and she would politely superintend, make suggestions to the cameraman and gaffers so subtly and so sexily that no one was offended, and she got precisely what she wanted. (I didn't mind: what possible difference could it make which side of my face was photographed? Both sides were equally homely.)

She came to my house often, loved the pictures, understood them, knew many of the artists personally, and wearing some of the most breathtaking gowns on record, would come off as an intellectual, which, indeed, she was.

My view of her as an actress? I am not sure I would call it talent; it is something beyond that—mystery, unavailability, distance, feminine mystique. She is the quintessential sex goddess; she is also the quintessential German hausfrau. She is mother as sex: sex as it was intended.

From *All My Yesterdays,* written with Leonard Spigelgass
(Hawthorn Books, New York, 1973)

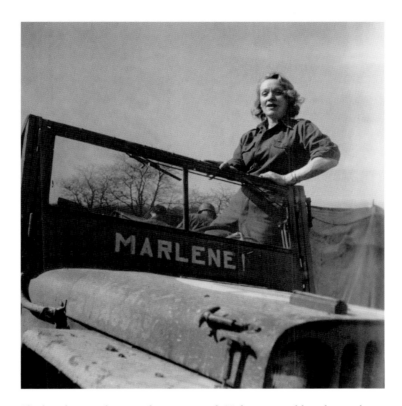

She loved jeeps: they—and an entranced GI driver—could get her to the front. Italy, 1944.

PB: I've never seen Dietrich as she was in *Touch of Evil*—she transcends everything and becomes almost a mythical figure.

OW: The whole character, you know, was written after the picture started. We were well along before I even thought it up. Then I phoned Marlene and said I had a couple of days' work for her and she'd have to have dark hair because, I told her, "I liked you as a brunette in *Golden Earrings*." She didn't ask to read the script. She just said, "Well, I'll go over to Paramount—I think that wig is still there—and then I'll go to Metro for a dress. . . ." The front office didn't even know she was in the picture. You should have seen them in the projection room during the first rushes: "Hey! Isn't that Dietrich?" And I said, "Yes." They said, "We haven't got *her* in the budget." And I said, "No. Won't cost you anything as long as you don't give her billing." They decided they wanted to and paid her to be in it. But it was up to them.

PB: Well, it was actually a digression as far as the plot is concerned.

OW: Yeah, but it helped it enormously. Look what that does for the film—that scene when those two suddenly encounter each other. And when she sees him floating in the bay—it *makes* the picture, you know.

PB: That's what I think. Where did the pianola come from? It seems like a remembrance of *The Blue Angel* [1930].

OW: Honestly, I wasn't thinking of that. I've never seen *The Blue Angel*. I just think we found a pianola among the props. I think all that Dietrich part of it is as good as anything I've ever done in movies. When I think of that opening in New York without even a press showing . . . Really, Marlene was extraordinary in that. She really was the Super-Marlene. Everything she has ever been was in that little house for about four minutes there.

PB: My favorite moment is the look between the two of you. You both just stand there looking at each other, and it's as though you knew each other for years.

OW: Yes, an enormous mutual trust. We've been all these years—sawing each other in half eight times a day and being everywhere. She was never late by a minute. You can't *know* how close we are.

From *This Is Orson Welles* by Orson Welles and Peter Bogdanovich
(Da Capo Press, 1998)

KARL LAGERFELD

Dear Marlene,
I hope you do not mind that I address you this way.
 Our telephone conversation was very [difficult(?)] . . . yesterday. In the evening, my telephone was out of order. In Paris this happens all the time. You had trouble understanding me as I also had trouble hearing.
 I wanted to tell you again at what point your records have given me pleasure.

There are so many songs that I do not know and your way of interpreting them is really music. I cannot leave them to anyone else to sing after you.

"Nach meine Beene ist gans Berlin verruckl" is my favorite song. All the songs ring with nostalgia for our country's spirit, gone forever. The Germany that you sing of has nothing to do with the Germany that subsists today. I truly regret to not have known the other that is nevertheless familiar to me and that I miss in one sense.

I really understand that you no longer wish to sing in Germany today even if the events of ten years ago are no longer today's.

My mother, who knew well the Berlin that you sing about, also was very touched and very moved listening to you. If I can do something for you, don't hesitate to call me.

I will take care of your clothes.

(a Sunday, sometime in the eighties)

ERNEST HEMINGWAY

If she had nothing more than her voice she could break your heart with it. But she has that beautiful body and the timeless loveliness of her face. It makes no difference how she breaks your heart if she is there to mend it.

She cannot be cruel nor unjust but she can be angry and fools bore her and she shows it unless the fool is in bad trouble. Anyone who is in serious enough trouble has her sympathy.

If this makes her sound too perfect, you should know that she can destroy any competing woman without even noticing her. She does it sometimes for fun and then tosses the man back where he belongs. She has a strange, for these times, code that will not let her take a man away from another woman if the woman wants him.

We know each other very well and are very fond of each other. When we meet we tell each other everything that has happened in between times and I don't think we ever lie to each other unless it is very necessary on a temporary basis.

All the wonderful stories I could tell you about Marlene. She would not mind and I would not mind. But many people would. Marlene makes her own rules in this life but the standards of conduct and of decency in human relationships that she imposes on herself are no less strict than the original ten.

That is probably what makes her mysterious: that anyone so beautiful and talented and able to do what she wants should only do what she believes to be absolutely right and to have had the intelligence and the courage to make the rules she follows.

She loves writing and is an intelligent and scrupulous critic and the happiest time I have is when I have written something that I am sure is good and she reads it and likes it. Since she knows about the things I write about, which are people, country, life and death and problems of honor and of conduct, I value her opinion more than that of many critics. Since she knows about love, and knows that it is a thing which exists or does not exist, I value her opinion there more than that of the professors. For I think she knows more about love than anyone.

From "A Tribute to Mamma from Papa Hemingway"
(*Life* magazine, August 18, 1952)

KATHARINE HOUGHTON HEPBURN

Marlene—
Isn't it fascinating.
When we say *Marlene*—
It conjures up a picture:
Beautiful beautiful legs—
Attached to a gorgeous torso—
Draped—dressed—decorated with
　　material or dresses or pants or coats or furs—
And one looks—
And—
OH!
There's that lovely head commanding
　　this great show—

With its soft and suggestive message
　　of all the joys life offers us—
And she is fun and sweet and true—
Thank you—
Dear *Marlene*—
　　　　　Affectionately
　　　　　Kate

MARLENE DIETRICH

I'm not much: nothing spectacular. A director once said to me
when I was making a picture, "Come now, give me Marlene."
What is Marlene? I asked. I don't know. . . .

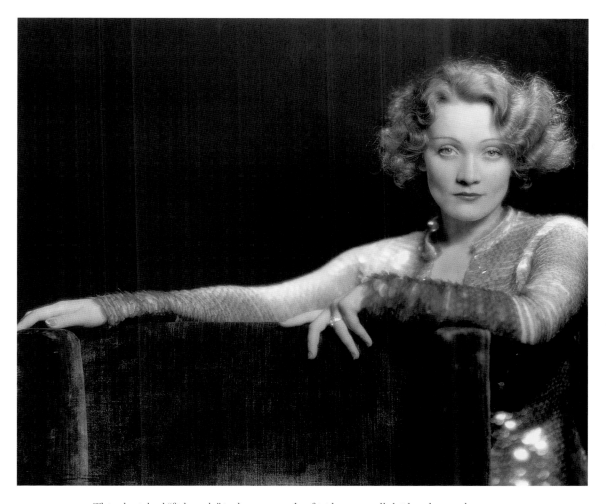

This cherished "fish scale" jacket was made of iridescent celluloid scales, each sewn by hand onto a silk chiffon base; their sea-green shimmer was never duplicated. The jacket was made in Berlin in 1929, and Marlene kept it until it was lost during the war.

Portraits

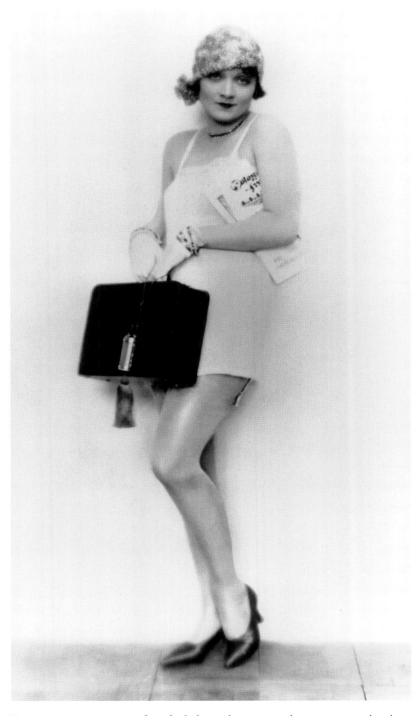

Young aspiring actresses often find themselves in tasteless situations that later haunt and may even embarrass, though in the Berlin of 1926, this pose for a magazine would not have been considered risqué. (Martin Badekow, Berlin, 1926)

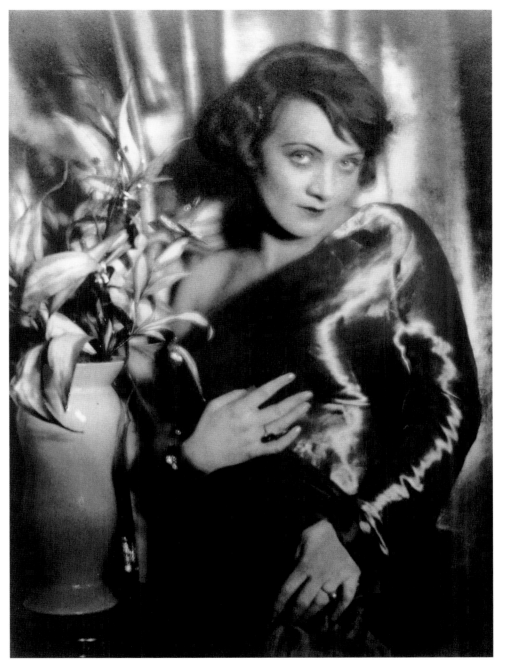

Away from her husband's professional eye, when asked by the photographer for the pose of an American vamp, Marlene obliged. (Photographer unknown, Vienna, 1927)

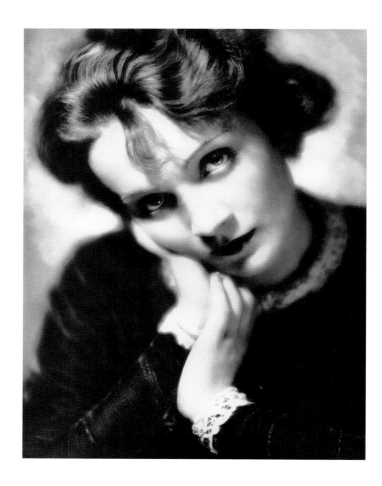

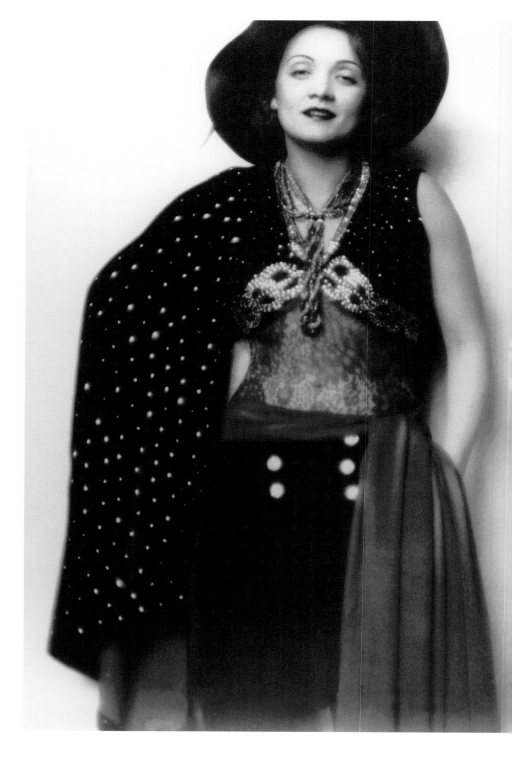

ABOVE: Berlin, 1930, during the filming of *The Blue Angel*. This "Madonna" pose was von Sternberg's favorite before he created his signature "back halo" lighting. Marlene is wearing her favorite "lady" dress of sapphire velvet and Venetian lace. (Photographer unknown)

RIGHT: Berlin, 1930: These were the years of costume balls. Everyone tried to outdo one another. Marlene arrived in her own creation of sexy pirate—assembled from odd pieces of her soon-to-be-famous *Blue Angel* costume. (Mario von Bucovich, Berlin, 1930)

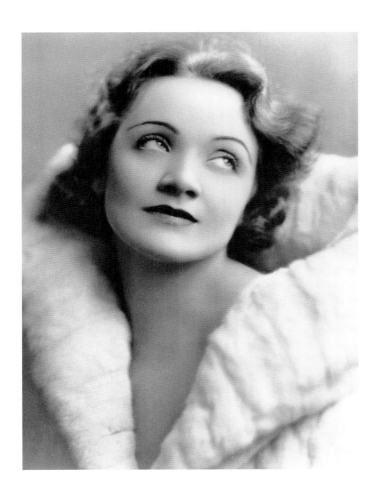

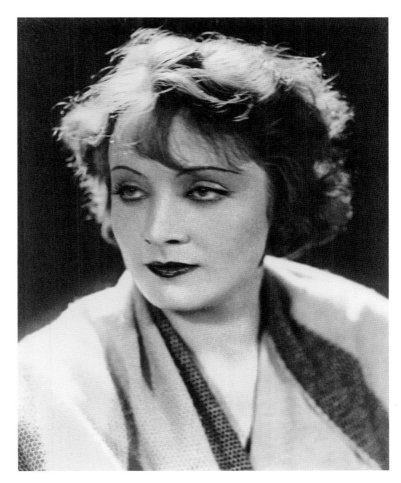

LEFT: Alone on her arrival in America in 1930, Marlene had no choice but to comply with her new studio's order for immediate publicity portraits. When von Sternberg saw them, he destroyed most of the negatives. (Irving Chidoff, New York, 1930)

ABOVE: Taken at the time of her first lead role, in *The Ship of Lost Souls* (directed by Maurice Tourneur). She would later describe this as "an actressy portrait before America." (Elli Marcus, Berlin, 1928)

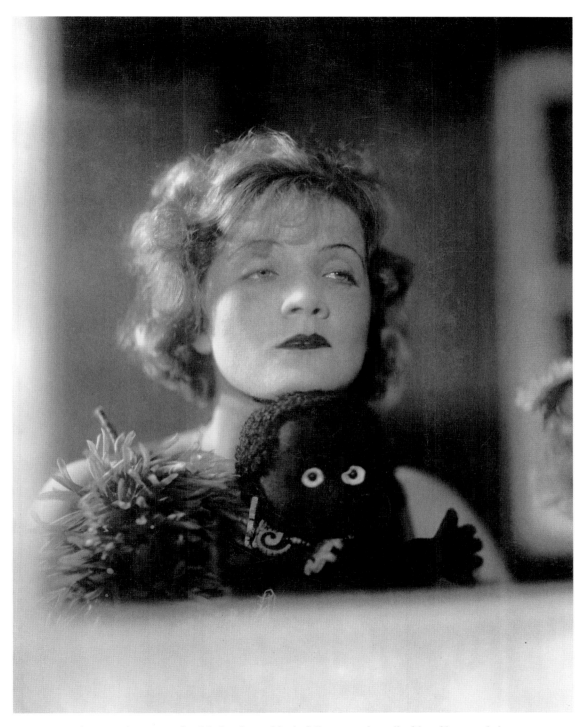

A star in his own right, Marlene's good-luck doll appeared in all of her films until the 1940s. When setting up a studio dressing room, her good-luck doll was the first to be unpacked and placed upon the dressing table. (Elli Marcus, Berlin)

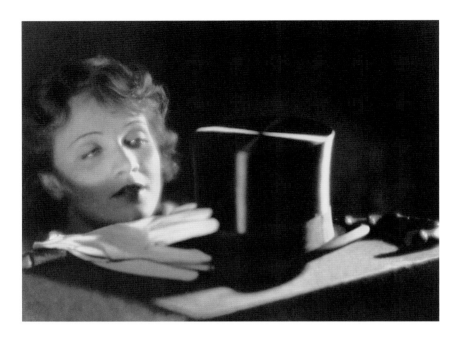

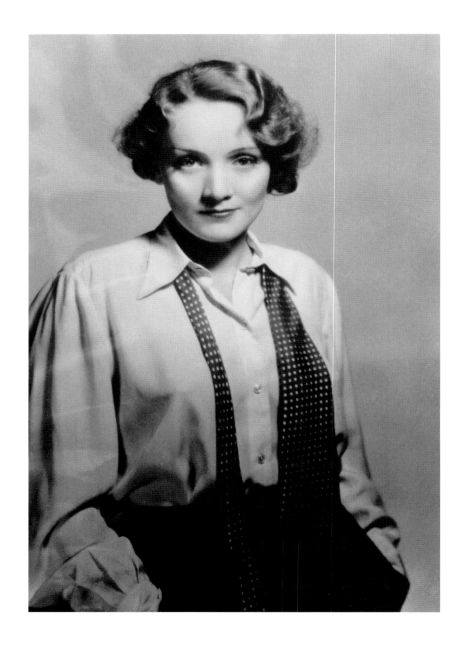

ABOVE: A woman longing for a rich lover in his top hat, or a woman longing to be the one who wears it? (Photographer unknown, Berlin, 1930)

RIGHT: A man's shirt, a man's tie, a masculine pose, and a man's speculative gaze that even Cary Grant might envy. In 1930, already the true emancipated woman, Marlene was ahead of her time, her century. (Photographer unknown, believed to be von Sternberg, 1930)

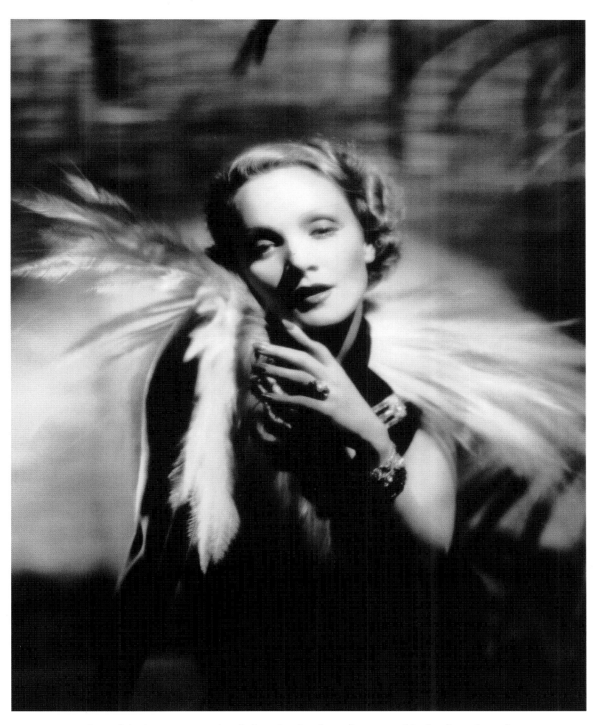

One of the last portraits taken before the slaughter of egrets and birds-of-paradise—for their magnificent plumage as universal adornment—was finally outlawed. Marlene, who never threw away a feather or a fur, used her egrets here as a reflective collar to bounce light from the key light on her face. (William Walling, Los Angeles, circa 1937)

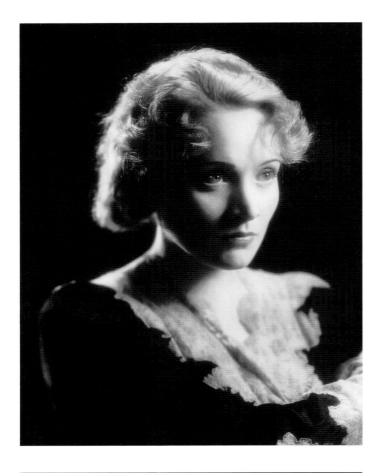

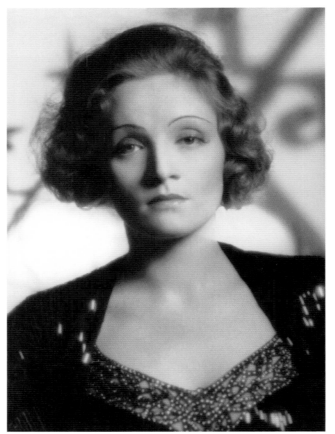

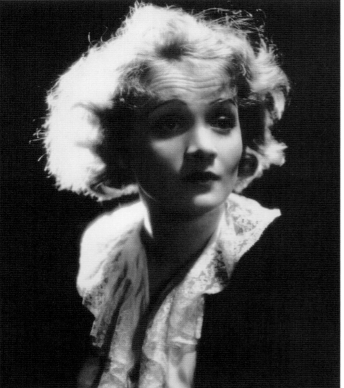

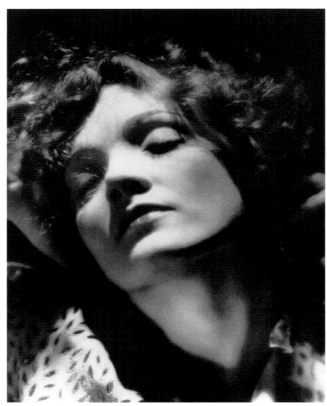

TOP LEFT: Looking feminine and fragile in early 1930, almost unsure of what Hollywood will do to her. She was still heavy, but von Sternberg made sure that her proportions were hidden by a black dress, a black background, and shadows. Only her hair, her face, and the lace reflect the light. All Eugene Richee had to do was release the shutter. (Von Sternberg)

TOP RIGHT: A rare portrait where the face is almost fully visible. The eyebrow is still building up to a half circle, which means she is still at the beginning of her Hollywood career. The ornament in the background helps to conceal the fact that she seems to be a bit absentminded. (Eugene Richee)

BOTTOM LEFT: The hair, the face, and the lace again, but more shadows on the face than before. Taken in 1930, but surely after she won recognition for *Morocco*. She could pose like that for minutes on end and yet still give the impression that it was a "natural" shot. The only natural thing were the wrinkles on her forehead. (Eugene Richee)

BOTTOM RIGHT: Another "natural," almost intimate portrait, from 1931. The camera loved her, and so did von Sternberg. One can see that she loved to be devoted to both of them. (Von Sternberg)

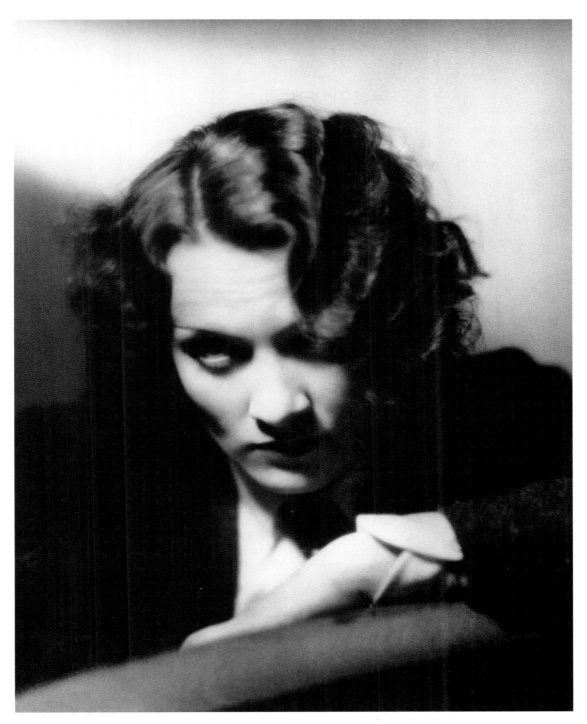

Still very "Berlin" in look and concept: The marcelled hair, the man's cuff without jeweler's cuff links that would become such a Marlene trademark, the nose lit flat without its famous center line and shading, the hair without its halo lighting appearing dark, and the "look," so contrived, so lacking in Marlene's unique air of command, all scream "just arrived in Hollywood, trying very hard to look like a star on a fan magazine cover." (Von Sternberg)

Oh Love Face!
I'm so happy today and it's such a nice feeling.
Let's try and remain this way always.
I love you.
G. D. F. S. O. B.

Miss Dietrich

All kidding aside, Good afternoon

Marlene Dietrich
Beverly Hills

Hatchener's Flowers
6327 Yucca Street
Hollywood

Good luck and happiness - Jool Face. And work like hell!! I you know

Marlene -
I too think you are very young - thank God - but for a very different reason.
Love - Jack.

Oh - I love you so!

Just because you are so sweet and beautiful and generous and fine. How nice a world it all people were like you.
Jack Gilbert.

A relatively long note (LEFT) from John Gilbert, who usually sent bouquets and expressed his love on flower cards (RIGHT). Marlene, who loved him, was present the night of his death. Their secret code at the end of the letter was a joke between them: "God Damn Fucking Son Of a Bitch."

Mercedes de Acosta, on the other hand, was a handful. "I have missed you so much lately, I have missed the closeness I had with you and the nights, when in the dark, I have been able to hold you in my arms." Marlene would read these letters aloud to her husband and add the usual "Oh, please, she really is too much."

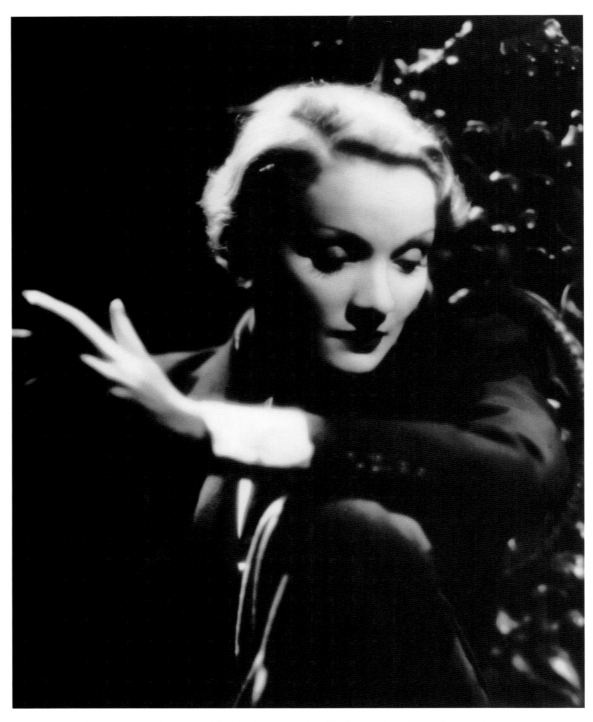

Costume by and conceived by Marlene, posed and lit by von Sternberg, shutter released by Eugene Richee: the cuff links, the halo, the nose, the pose. Elegant, assured, impeccable, a creature in full command—the sublime Marlene achieved! (Von Sternberg)

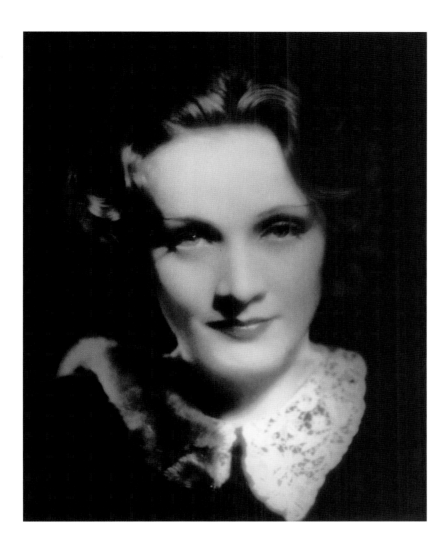

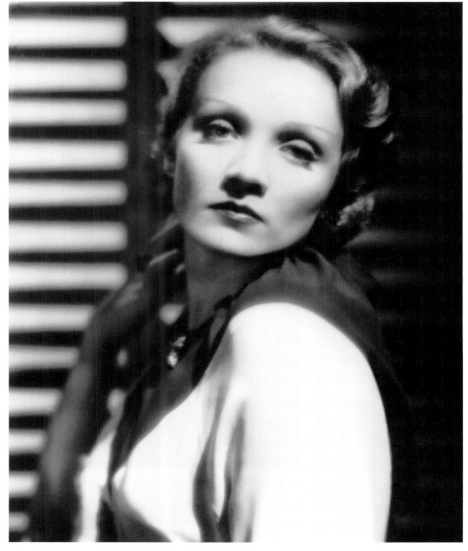

ABOVE: The "Madonna" look repeated. The exaggerated sheen on the lips belied the intent, so it was rarely used for release to the press. (Von Sternberg)

RIGHT: The off-center bustline and exaggerated arm surface, as well as the undefined hair and Cupid's bow upper lip, identify this photograph as not having been taken under the guardianship of von Sternberg. (William Walling)

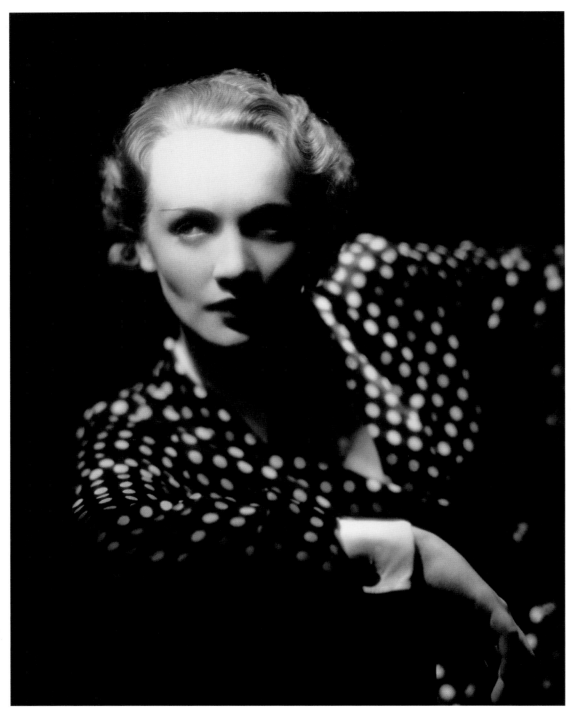

More and more, von Sternberg's muse became his collaborator. Here, having chosen to wear one of her husband's silk dressing gowns, she gives her mentor not only a patterned surface to challenge his photographic genius but also that bisexual look they both enjoyed. (Von Sternberg)

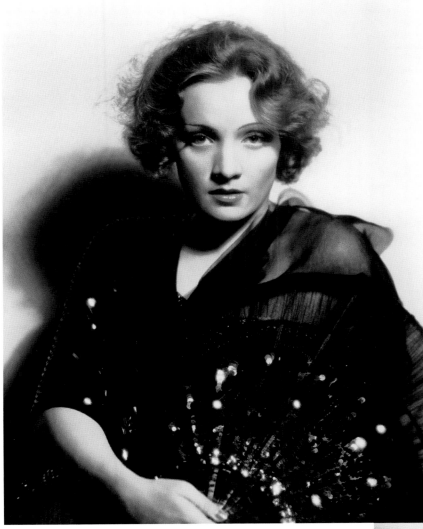

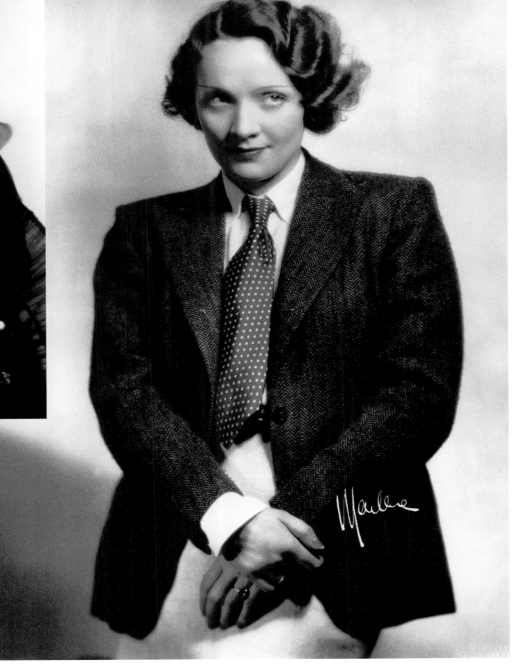

ABOVE: 1932, in a *Shanghai Express* outfit. The tousled hair, the unusual white background, the slightly surprised look, suggest a candid shot. It may have taken von Sternberg and Dietrich a while to arrange this. (Von Sternberg)

RIGHT: This three-quarter photograph, its male attire considered too shocking for American fans, was adored by Europeans. (Von Sternberg)

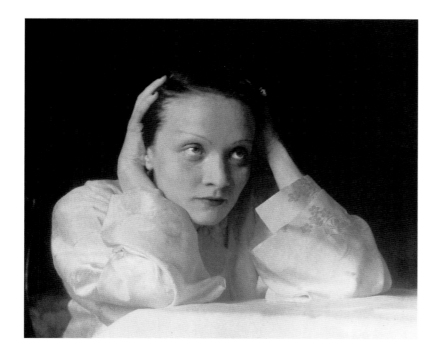

ABOVE: Cecil Beaton took this photograph in Salzburg, obviously a sitting between friends. Not for release, nor to be taken too seriously. (Cecil Beaton)

RIGHT: The expression in both of these portraits gives proof that Marlene's beauty did not depend entirely on makeup, though her hair and those spectacular cheekbones yearned for von Sternberg's lighting. (Von Sternberg)

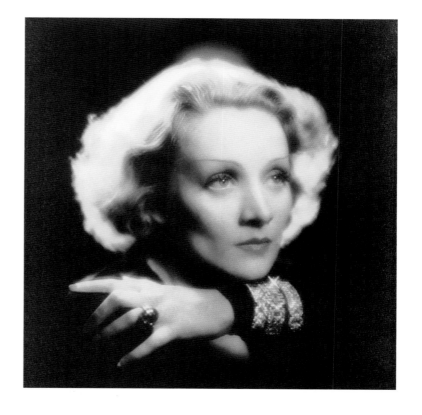

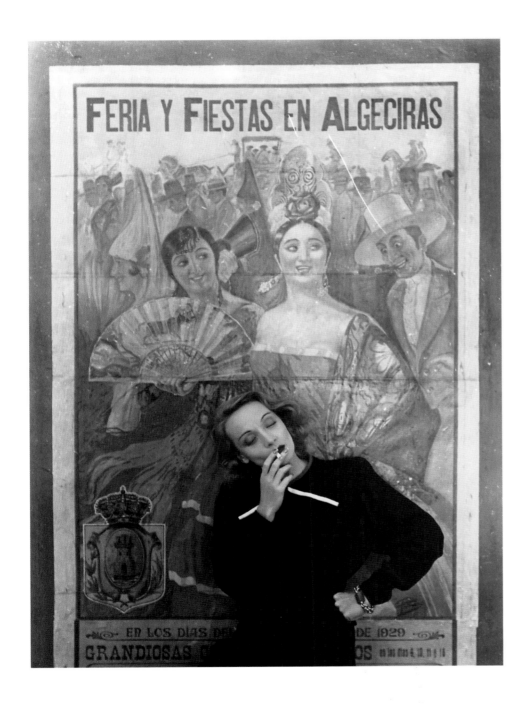

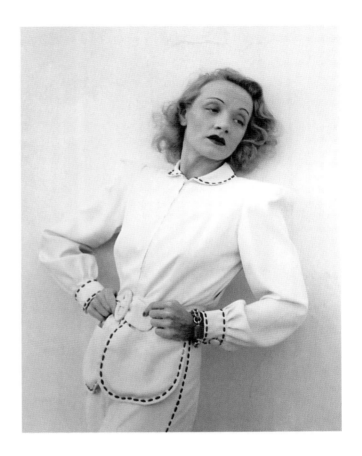

Photographed by Louise Dahl-Wolfe for a Spanish magazine as publicity for *Desire*. Marlene is wearing her own clothes. Marlene's credo following von Sternberg's talented photography is evident: "When you are forced to pose for someone you have no professional confidence in, grit your teeth and try at least to appear Dietrich."

On the rebound from Garbo, Mercedes de Acosta, Marlene's lover, waxed poetic to her newest passion: "This is just to tell you that I have not forgotten you today, I am glad I am not seeing you because I am again an old man—only you, for the few hours that I am with you, bring me to life."

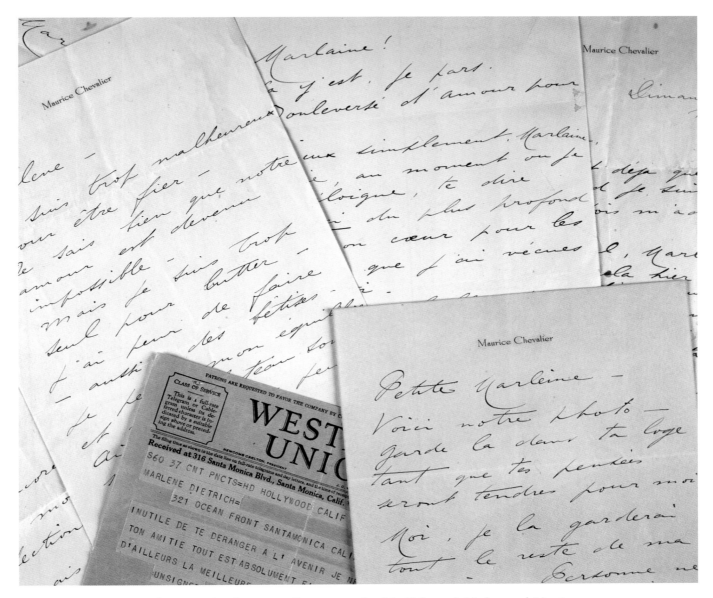

In between other lovers, two Europeans isolated in Hollywood, Marlene and Maurice Chevalier, found each other and their favorite language. In his letters he always seemed to be in turmoil: "I am too miserable to be proud—I know well that our love has become impossible—but I am too alone to fight. . . . I can't stand it anymore." As with all of her lovers, eventually he could stand it no longer: "That's it, I'm leaving."

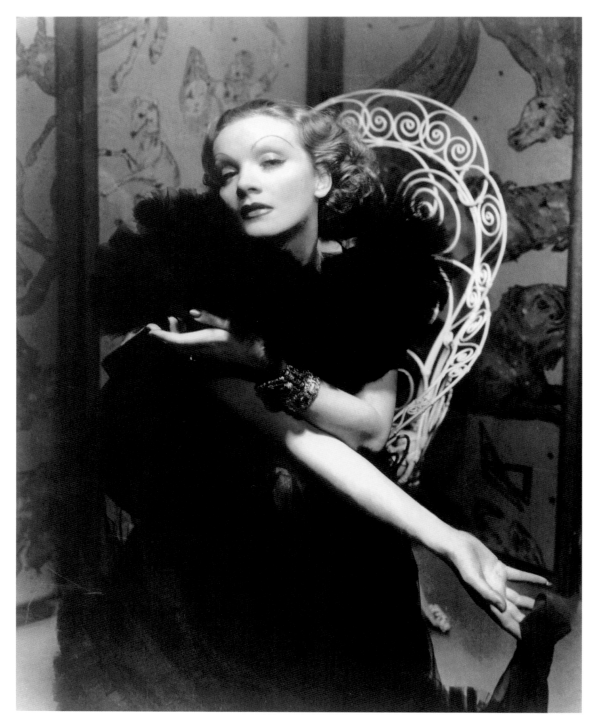

ABOVE AND OPPOSITE: When renowned photographers were contracted to photograph Dietrich, they invariably shied away from any resemblance to von Sternberg's technique. Usually this resulted in either overposed (right) or underposed examples of their laudable art. Edward Steichen had taken a superb portrait of Marlene and her husband in the early thirties, and she, expecting the same perfection from this 1935 sitting, was disappointed.
(Edward Steichen, 1935)

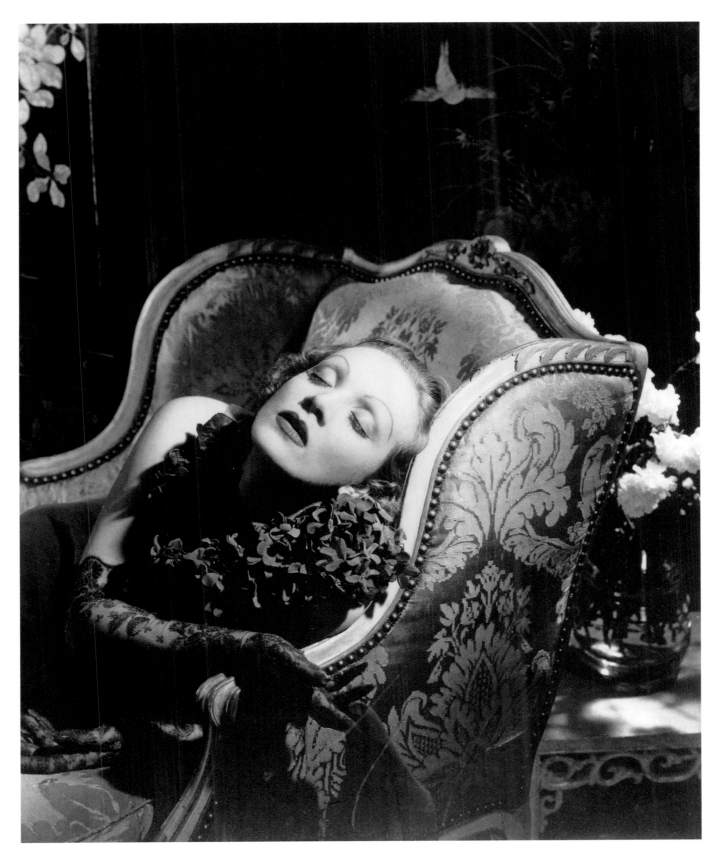

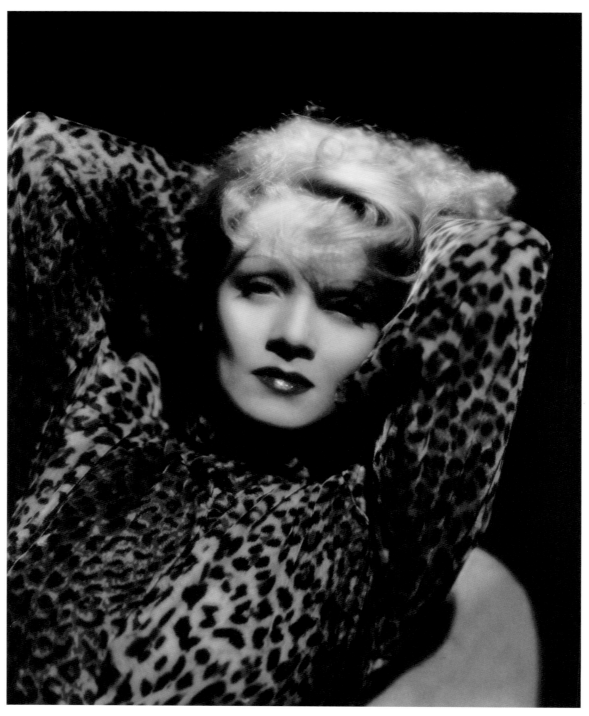

A fan portrait taken during the film *Seven Sinners*, in which she starred with John Wayne, their first picture together. (Whitey Schaefer)

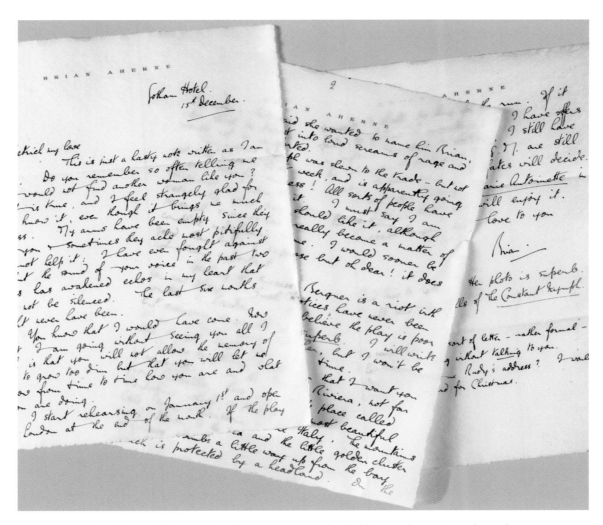

Brian Aherne: "My arms have been empty since they held you and sometimes they ache most pitifully. I cannot help it." A sweet and tender man, he fell hopelessly in love with Marlene and always stood by her as a friend. Over the years he wrote many letters of devotion and advice, and finally one of gentle parting.

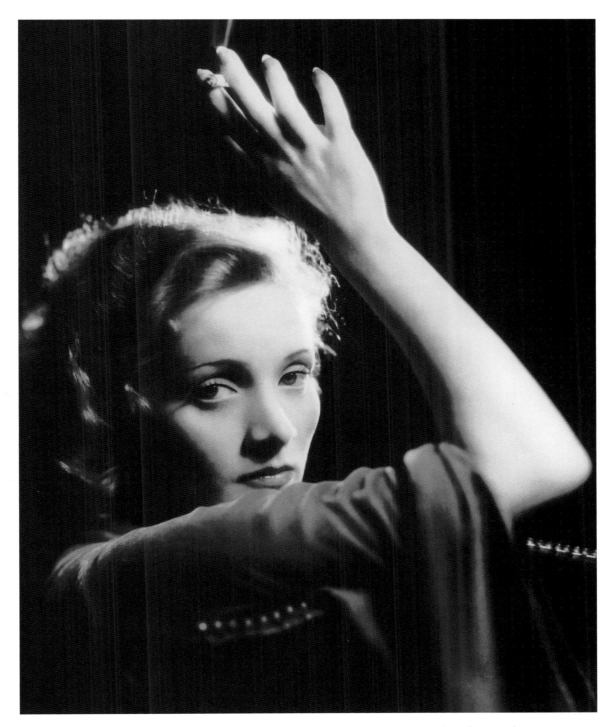

A private test portrait taken by von Sternberg, one of their favorites: hers, because he retouched her arm and fingers, making them appear slimmer; his, because of the way her gaze penetrates through the lens to him behind the camera. Circa 1931–32.

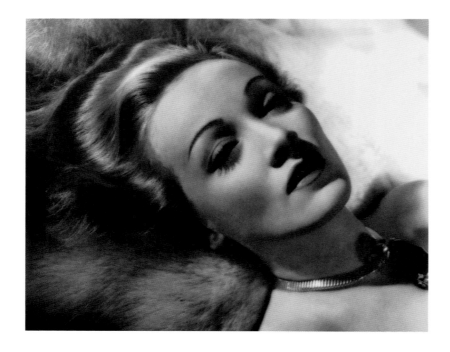

Publicity portraits taken for and during the time of films with John Wayne: *Pittsburgh* and *The Spoilers*. In the years after the magic of von Sternberg disappeared, the time and place of some portraits are identifiable only by her hair, clothes, jewelry, and such. Here she is wearing her private collection of overly large gold topazes, which were fashionable in the early forties. (Whitey Schaefer)

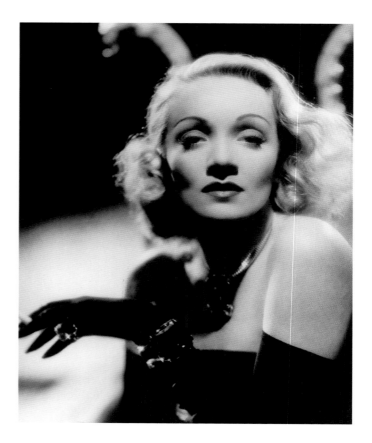

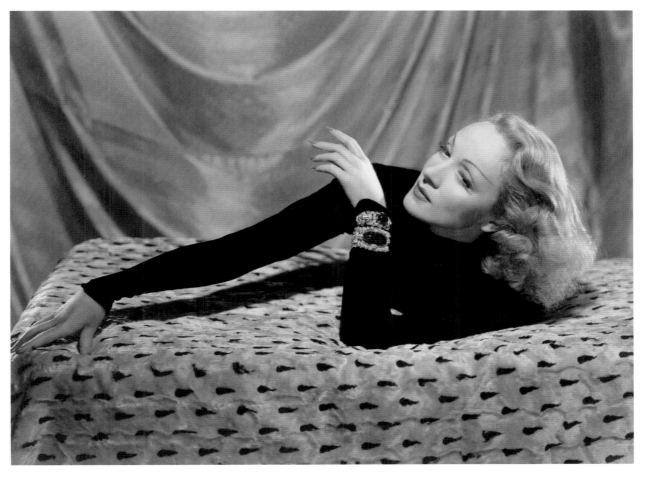

Her collection of Cabochon emeralds places this photograph in the thirties, before they were confiscated by the U.S. government to pay back taxes. It is interesting to note that the face in all of these diverse pictures does not change. (Photographer unknown)

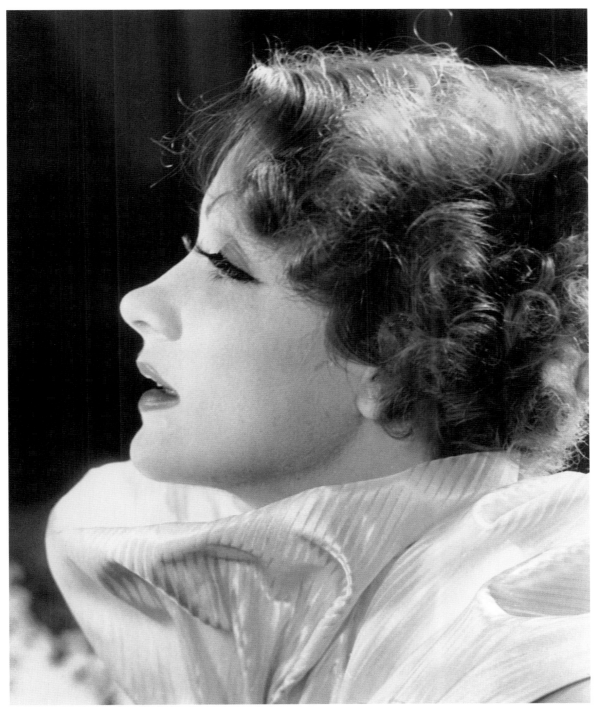

A favorite photo of hers and of her daughter's, she considered it her "American face," possibly because of the extended tips of the saucy false eyelashes and the Barbie-type nose. (Photographer unknown)

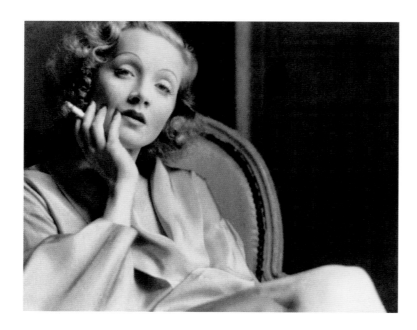

These images were taken by one of the few great photographers whom she trusted: the first expected, the second offbeat. Respecting his craft, she followed his will. The bottom right pose reminds one of the superb moment in *Touch of Evil* years later, in 1958. (Richard Avedon, 1950s)

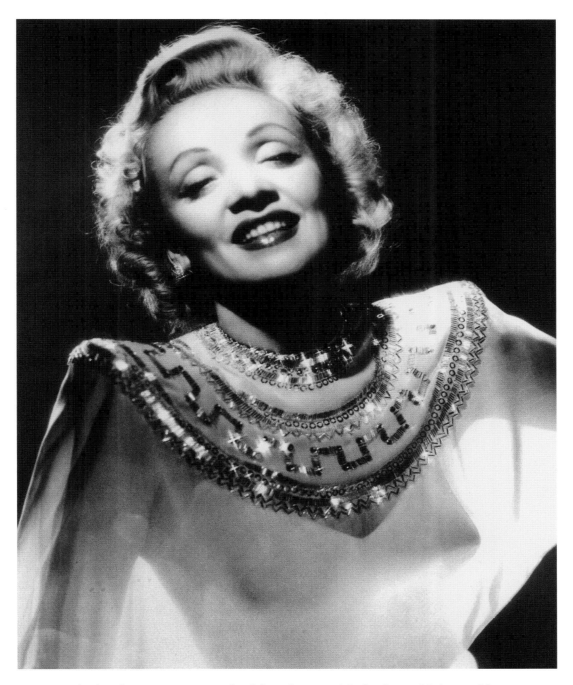

The foundation garment now refined from the original Berlin design. Marlene and her favorite American designer, Irene, together concocted this white chiffon to show the brassiereless perfection underneath. (Whitey Schaefer, 1940s)

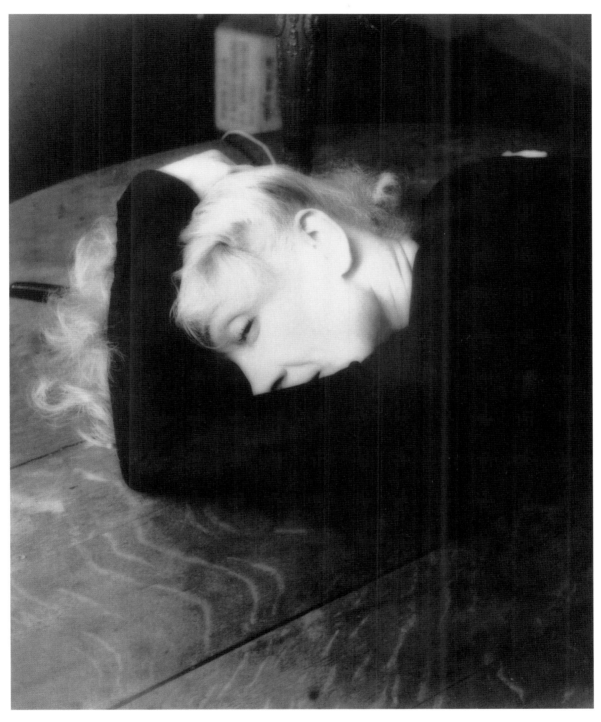

One of the many beautiful portraits taken during a sitting for a *Life* magazine cover. Late in the shoot, Marlene was told to pose as she wished, and the photographer was enchanted. (Milton Greene, New York City, 1950s)

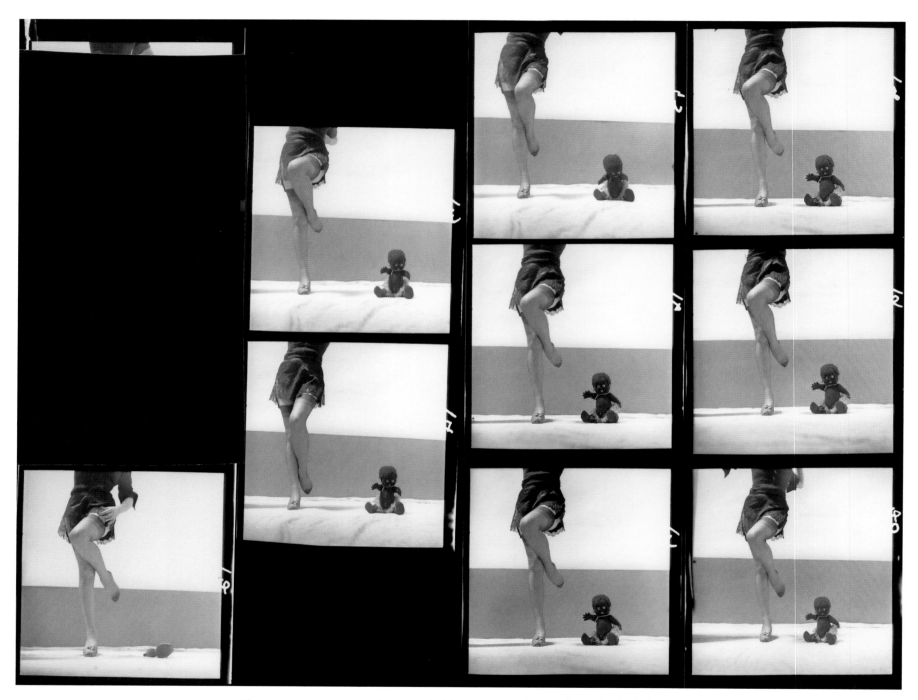

The commercial reason for these wonderful pictures is unknown. Certainly she had the black lace panties, garter belt, sexy mules, and, of course, those fabulous legs. What is interesting is the sheer fun that radiates from these images. Probably for the first time in her life as a star, she didn't have to worry about her face and could let herself go. (Photographer unknown, 1960s)

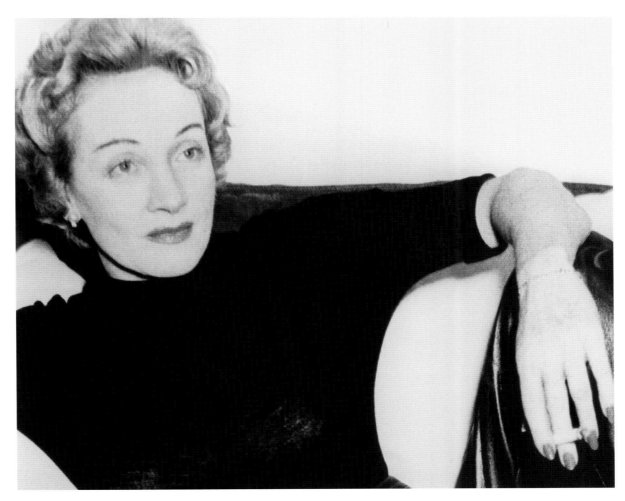

Marlene the grandmother, in the black calfskin pants that she appropriated from the shooting scene in *The Monte Carlo Story*. (Alex Liberman, 1957)

Beads, Furs, and Feathers

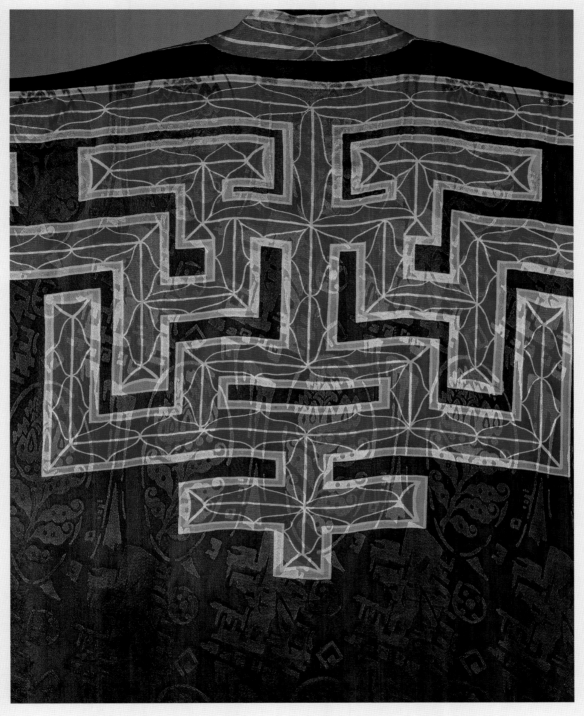

Detail of a kimono jacket worn in the 1928 German silent film *Princess Olala*. The amazing condition of its heavy silk crepe attests to the sentimental value it must have had for Marlene.

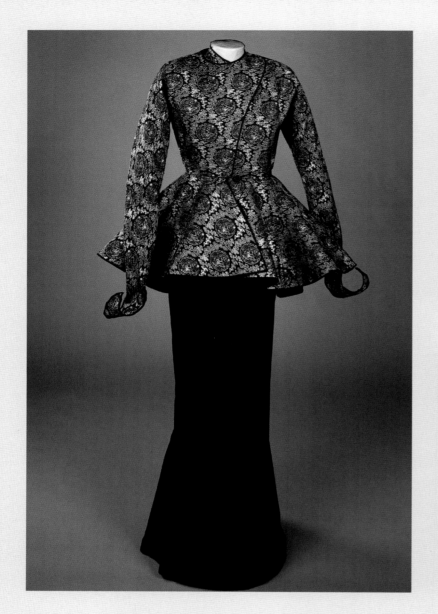

ABOVE AND TOP RIGHT: 1930s. Designed by the great French designer Alix, this two-piece masterpiece of Chinese brocade and navy blue double silk jersey was created exclusively for Dietrich. Though the peplum is lined in jersey and stiffened, its circumference is left fluid to allow the lower body to move beneath it. The closure traversing upward at an angle ensures that the bust is not flattened by the weight of the brocade. To elongate the figure, the neck is high and the sleeves slim and overly long, extending all the way to the fingers with a stiffened reverse-leaf curl—reminiscent of the attire of ancient temple dancers. The shoes made by Perugia for this outfit (MIDDLE RIGHT) were considered too "clumpy" and were never worn. This dress was to appear in *Angel* and was thought to be a creation of Travis Banton, the film's costume designer.

BOTTOM RIGHT: 1930s. The doe-suede handbag with its malachite-encrusted initials was created in the United States. Marlene hated small handbags: she thought them a sign of affectation.

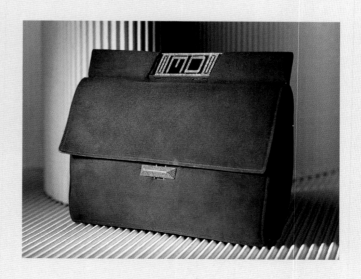

TOP LEFT: The skimpy leopard coat worn in 1930 in *The Blue Angel*, shown here over Irene's halter top and tailored skirt of the 1940s.

TOP RIGHT: Her favorite look. Perhaps only Fred Astaire and Cary Grant could match Marlene when in her tails. This is one of many made by Eddie Schmidt (Hollywood), the only tailor besides Knize she trusted.

BOTTOM LEFT: Samples of the numerous stockings made to order, first for *Desire* and then used again for the naughty one in *The Flame of New Orleans*.

BOTTOM RIGHT: Dressing-room mules, their basket-weave pattern of satin ribbon bearing her name, a gift from her American cobbler Edouard.

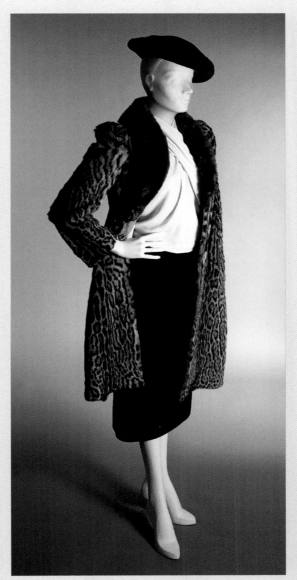

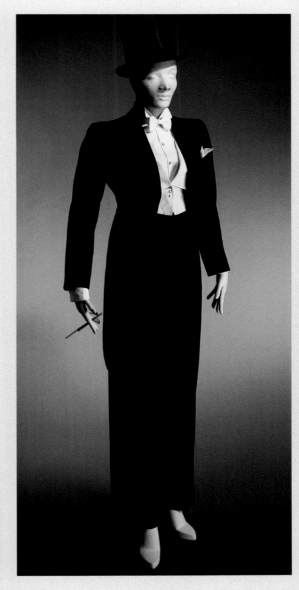

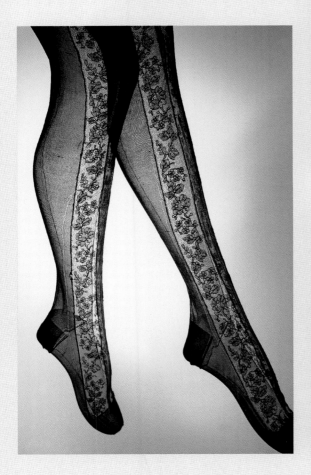

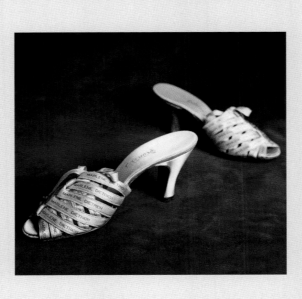

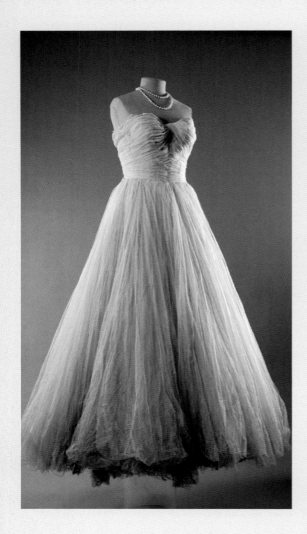

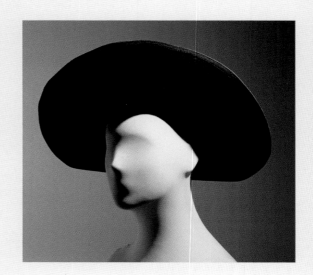

TOP LEFT: Silk net evening gown first designed by Travis Banton in 1937 for *Angel*. Copied innumerable times for both work and private use, over the years it was attributed to a string of designers, including even Dior.

TOP RIGHT: The show-off carpenter's hat Marlene wore in *The Blue Angel* while singing "Falling in Love Again," which is not a direct translation of the original German song.

BOTTOM LEFT: This silk net hat is another example of a desperate effort to come up with ever new looks for an exceedingly famous face.

BOTTOM RIGHT: Marlene's favorite private dress of black double silk jersey. First designed by Balenciaga. She wore it and all her dress medals in a receiving line on the tenth anniversary of the end of World War II, bowing to President Charles de Gaulle. She later wore it with superb dignity as a costume in *Judgment at Nuremberg* in 1961.

MIDDLE: 1930s. One-of-a-kind hat designed by the French milliner Agnès, and worn mostly in Paris for luncheons.

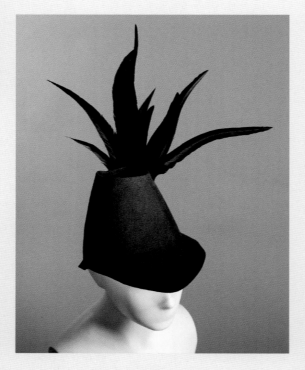

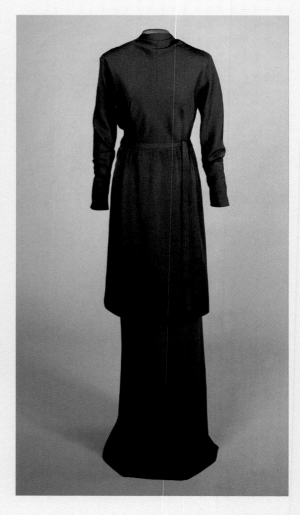

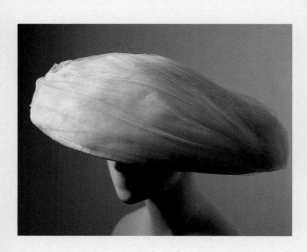

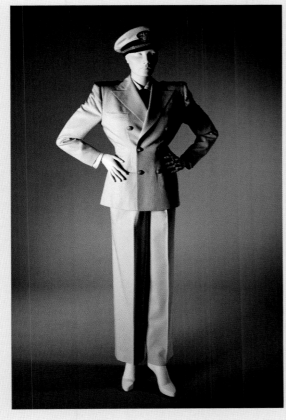

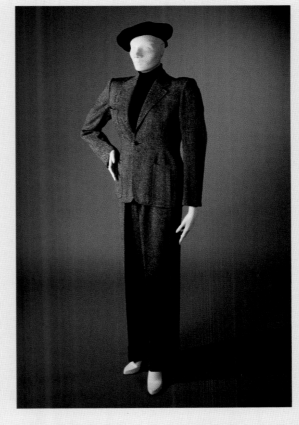

TOP LEFT: 1940. Naval officer's uniform from *Seven Sinners*.

TOP RIGHT: 1932. Travel suit made for train arrivals.

BOTTOM LEFT: A raw linen suit made by her favorite tailor, Knize of Austria, worn to go to work in.

BOTTOM RIGHT: 1954. Ringmaster for a star-studded charity gala of the Ringling Bros. and Barnum & Bailey Circus at Madison Square Garden, New York City. Later photographed for *Vogue*. Her own design worn with Edwardian-style high-heeled boots and circus whip. Before the era of "hot pants," these minimal black velvet shorts caused a sensation.

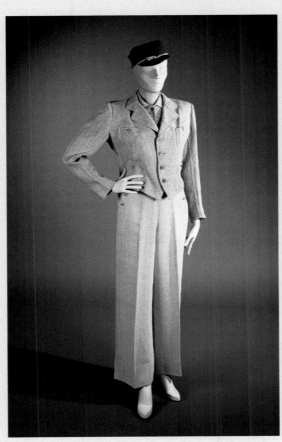

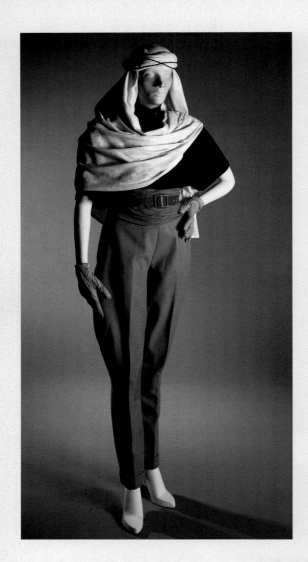

LEFT: 1936. The oasis riding costume from *The Garden of Allah,* worn with made-to-measure jodhpur boots. Two costumes were made, one for Marlene, the other for her double, who actually rode the horse.

RIGHT AND MIDDLE: 1930s. Black wool with red suede insets. This Tyrolean outfit made by Lanz of Salzburg was worn with shoes to match of a black suede and red leather design.

BOTTOM: In the days of train travel, ship holds, and frenzied porters, elegant luggage always had its obligatory protective covers. These pieces of dyed burgundy cowhide by Hermès (before the design house was known as such) sported khaki canvas covers with a band-enhanced monogram the color of their interior.

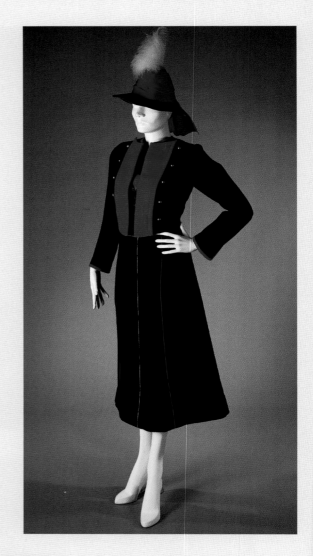

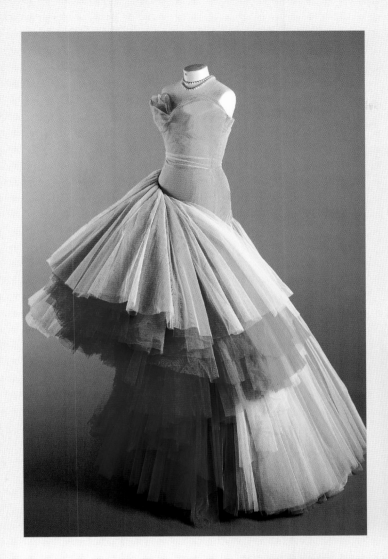

LEFT: Christened "the Lobster," this ball gown of salmon-to-pink net by Elizabeth Arden was worn only once, for a forced personal appearance to publicize the worst Hollywood picture of her career, *Rancho Notorious*.

RIGHT: The famous arrival costume for *Seven Sinners*, by Irene. Its stunning effect was heightened by its accompanying black-and-white-striped and -tipped ostrich-feather boa, saucy hat, and black net gloves.

MIDDLE: The froufrou handbag for the white honky-tonk costume in *Seven Sinners*, 1940.

BOTTOM LEFT: Late 1930s suede handbag made for summer suits.

BOTTOM RIGHT: The ultimate Dietrich stage shoe, hand-made by the Italian artisan cobbler Massaro in beige silk crepe, with his signature rhinestone bauble on the heel.

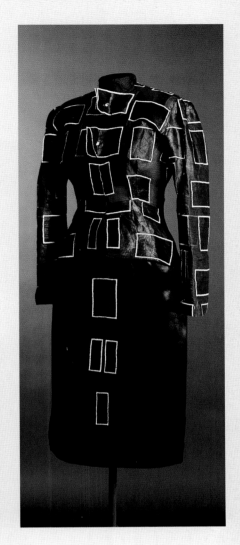

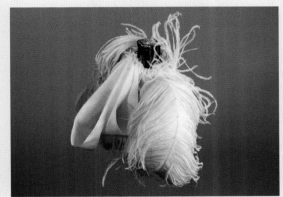

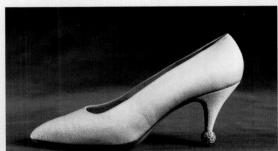

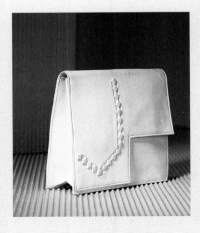

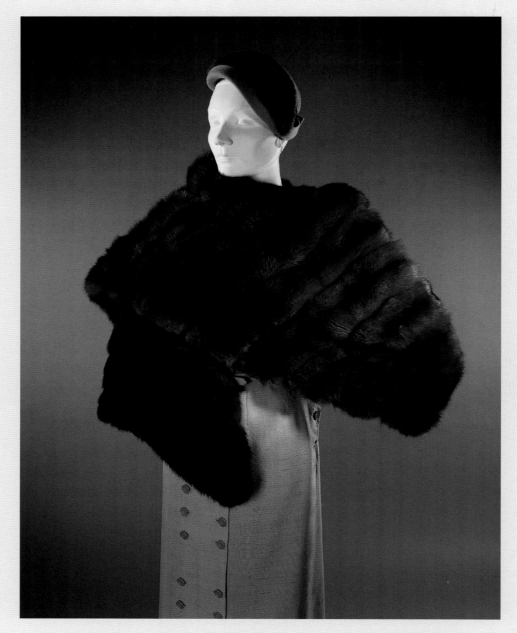

Russian sable stole worn in *No Highway;* known as "the Animal" Indian blanket; highly insured. When broke, Marlene would try to lose it, but it was always returned. Hat by Lilly Dache.

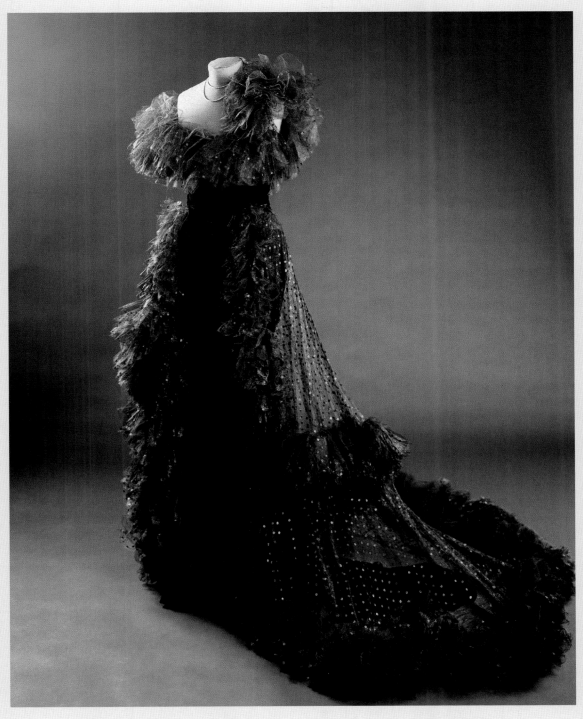

Dress designed by Vera West for *Pittsburgh,* 1942, Marlene's last film with John Wayne and her last for Universal, the studio that resurrected her film career in 1939.

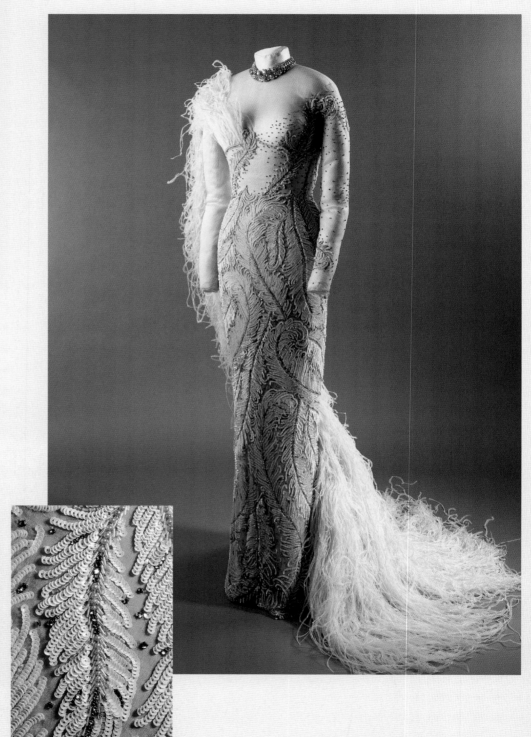

ABOVE: Throughout the world, wherever Marlene appeared, the management would affix a brass plate on her dressing-room door to honor her appearance. Afterward she would always take it with her. Most were later stolen by souvenir hunters; some she gave to her grandsons. The ones shown here were found in her Paris apartment.

RIGHT: One of the earlier Vegas dresses, from 1955. Thousands of dull-finish sequins were each positioned many times until one pattern was acceptable, then individually sewn into place by hand. The dyed-to-match ostrich feathers were each knotted to achieve the necessary length of swag and then blown by giant wind machines as she made her first entrance onto the stage. A sensation like all of her Vegas dresses, this too was never worn again after she perfected her one-woman concert appearances.

INSET: A detailed close-up of the Vegas dress.

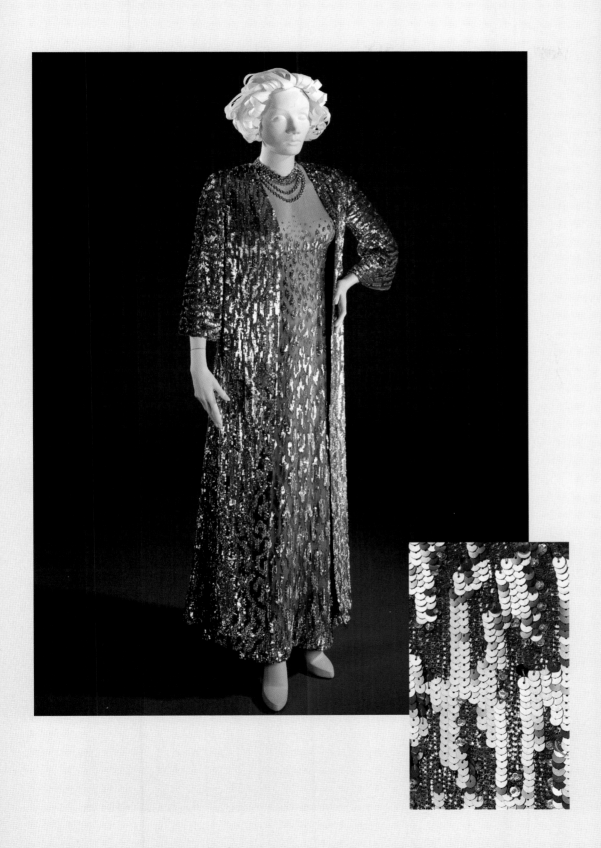

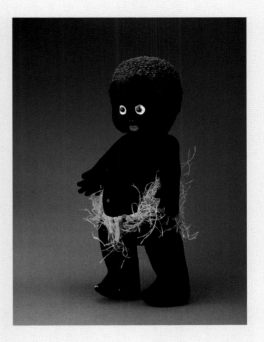

LEFT: One of the costumes created especially for stage appearances. Built upon the basic foundation, as were all of them, this was done in individually hand-stitched golden sequins (INSET), with a matching mandarin-cut coat. Later the gold ensemble embroidered with beads set among hundreds of small mirrors would take the place of this less spectacular design.

ABOVE: Käthe Kruse doll, 1930. Marlene's mascot and good-luck charm, he stuck by her through thick and thin. Only during the war years did he not accompany her to the front. A film star in his own right, he can be seen in *The Blue Angel, Morocco, Dishonored,* and more. Always the first to be unpacked in any dressing room—and always the last to be repacked.

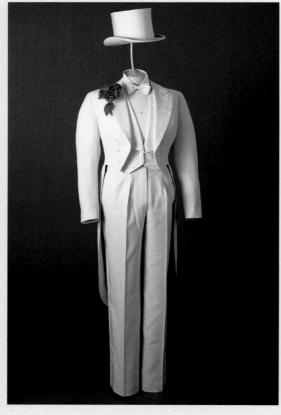

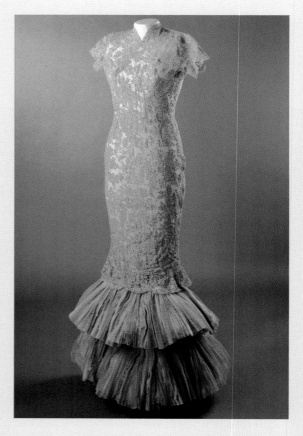

TOP LEFT: Complete dress suit, one of many tailored by Knize for those Vegas dates and concert tours when Marlene switched from her favorite black tails to white to give a different look. Though the cut was copied from that of the white perfection she wore in *Blonde Venus,* she never felt comfortable in white tails onstage; they reminded her of Liberace.

TOP RIGHT: 1950s. A favorite dress by Dior. Above the high stiffened tulle, the dress tapers so tightly it is difficult to walk in—but worth the discomfort.

BOTTOM LEFT: This attempt at an Adrian design—so beloved of MGM stars—was rejected.

BOTTOM RIGHT: Schiaparelli's overstuffed, overly heavy duvet-like morning robe intended to be worn for breakfasts in luxury hotel suites—never worn as such, but just perfect for looking a little glamorous while keeping warm in the terrible winter of 1944 at the front.

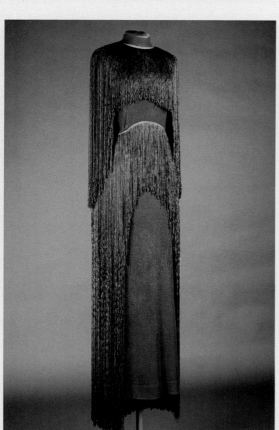

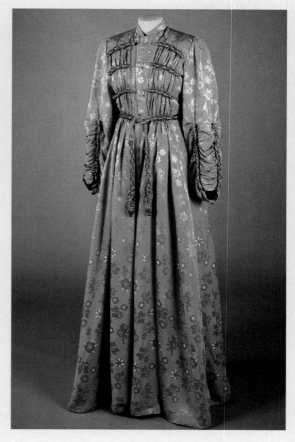

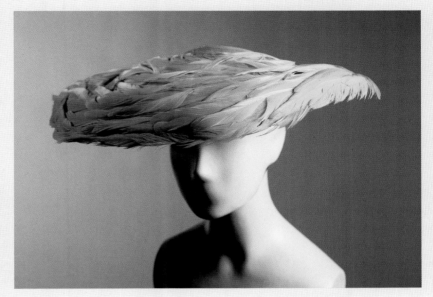

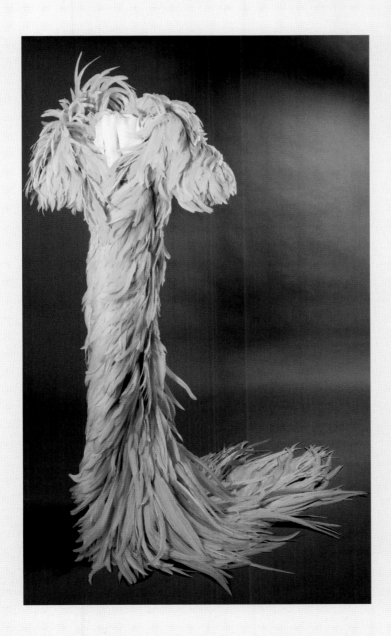

ABOVE: 1930s. Dyed feather hat by the French milliner LeGroux. Because its exaggerated width threw too much shadow onto the face, it was never used in studio photo sessions.

LEFT: 1950s. The problem with appearing in Las Vegas year after year was having to come up with ever new, sensational costumes. The Vegas public expected it, especially from such a glamorous star. Though this opulent feather dress caused a media flurry because of the way she manipulated it (using its high side slit to show lots of leg), she never wore it again after the engagement; yellow wasn't a good color for her anyway.

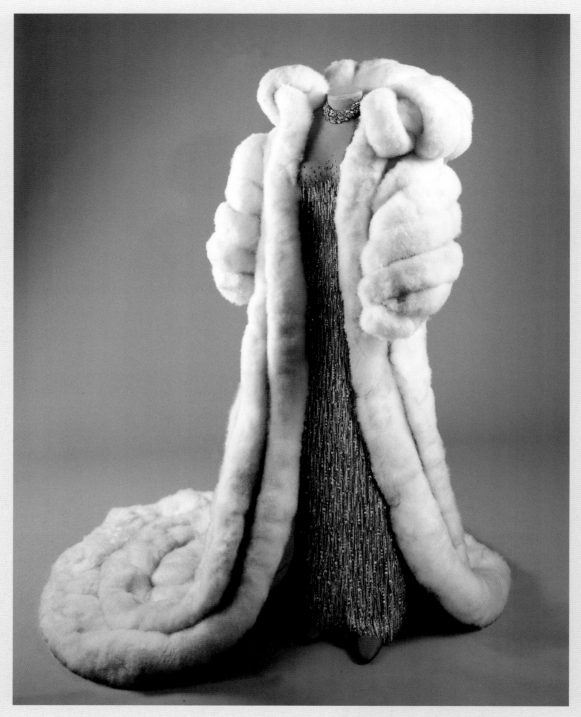

The world-famous swan's coat with one of its crystal bugle-bead gowns, this one fringed and tasseled. The coat, often described as being fox, ermine, or some material from outer space, is made by Bianchini of a silk chiffon known as soufflé, upon which is sewn, in a seemingly endless undulating design, the underbelly down of male swans. Marlene traveled with two such coats. As they could not be hung, each had its own long table to lie upon while waiting to be chosen, then was shaken to fluff for at least five minutes before being allowed to add its perfection to that of its mistress.

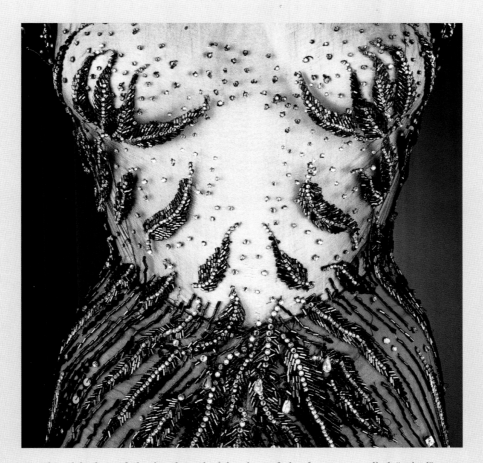

Detail and bodice of the hand-stitched beading of the famous so-called "naked" stage dress—she was never naked but completely covered, first by its bust- and body-shaping foundation, then by the dress itself, both ending up at the very base of the neck and fastened by two overly long, specially manufactured zippers, one positioned on top of the other at the back. The impression of nakedness was an illusion created by the suggestive placement of beads, rhinestones, sequins, and such on the gossamer Bianchini soufflé chiffon.

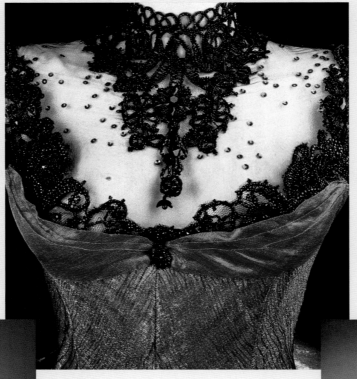

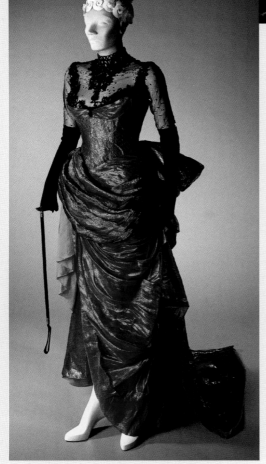

1956. The famous cameo costume for *Around the World in 80 Days*, designed by Miles White and adapted from the one worn in *Rancho Notorious*. Dietrich, given a free hand by her friend, the producer Michael Todd, took the basic cut of the costume worn in the mediocre Fritz Lang film and reworked it into this perfection. Shown here with its riding crop but without the obligatory high-heeled boots, it must be seen on film to do it—and her—justice. Note the beading on the Bianchini soufflé above the breast-mounting of her famous Vegas and concert gowns, later credited to Jean Louis's genius.

Snapshots

ABOVE LEFT: The Dietrichs, Berlin, circa 1906. Left to right: Marie Magdalene, Josefine Wilhelmine Elisabeth (née Felsing), Louis Erich Otto, and the eldest daughter, Elisabeth Ottilie Josephine. On seeing this obvious elegance, one can understand Marlene's lifelong devotion to her aristocratic heritage.

ABOVE RIGHT: Josephine and her daughters at the North Sea. In the early 1900s European children did not wear bathing attire—sun and sea air were considered medicinal, and therefore naked-ness essential for children's health. This photograph was taken by either a nursemaid or a female servant, with an early Voigt-länder camera.

LEFT: The Dietrich sisters, in their special daytime play smocks of blue-black velvet Victorian alpaca. The sharp focus in this 1905 photograph attests to the little girls' discipline—had they moved, the image would have been blurred.

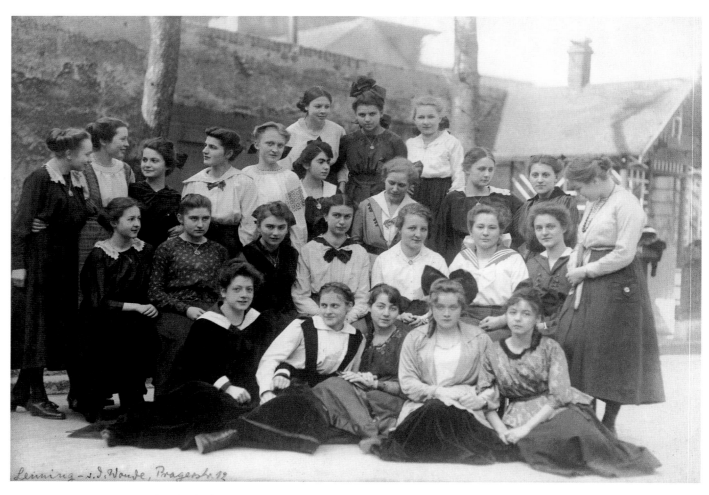

Lenning- v.d.Woude, Pragerstr. 18

High school class photograph. The First World War, in its second year, has already claimed more than 150,000 lives—many of Maria Magdalene's classmates are in mourning attire. She, as she claimed in her diary at this time, was very proud to be now old enough to wear her hair up—allowing the corkscrew curl seen here to drape down along the right side of her neck. Her eye-catching, overly large hair bow, setting her apart from everyone else in the group, makes one wonder how such a show of individualism was permitted in the strict disciplinary structure of a Prussian school in 1916.

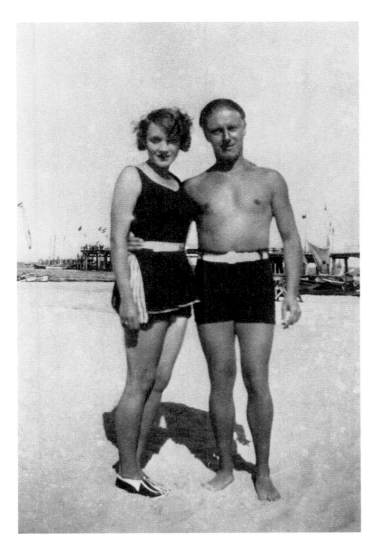

LEFT: Mr. and Mrs. Rudolf Emilian Sieber at Swinemunde. Even in 1927, Marlene's bathing costume would have been considered shocking in its skimpiness.

RIGHT: Here, in 1928 with her three-year-old daughter, Maria (known as Heidede), her costume is far more acceptable in style. Of course, being Marlene, she adds a stiff lacquered Japanese parasol to create a difference.

At home in her first Beverly Hills house, 1930. Taken by von Sternberg with her "Brownie." One of the many snapshots sent daily by post to her husband and daughter, still in Berlin.

Marlene's private diary, age sixteen, with the First World War raging:

Berlin
9 November 1918

Why must I experience these terrible times? I did so want a golden youth and now it turned out like this! I am sorry about the Kaiser and all the others. They say bad things will happen tonight. The mob was after people with carriages. We had some ladies invited for tea but none of them could get through to our house. Only Countess Gersdor did. On Kurfürstendamm, her husband got his epaulets torn off by armed soldiers, and everywhere one looks, there are red flags. What does the nation want? They have what they wanted, haven't they? Oh, if I were a little bit happy, things wouldn't be so difficult to bear. Maybe soon a time will come when I will be able to tell about happiness again—only happiness.

If only Richard were here again. He is in the Ukraine. I am scared for him, I love someone completely different, but he is an actor and he has a very short memory about some short, wonderful moments and his promise never to forget. I knew right away then it would be like this and was so upset that it would be so. It certainly would be a wonder if I could ever be happy in love. I have too little pride. I should say, if you don't want me anymore, fine, I won't run after you. But I can't—and after all we are so far away from each other, so far. . . . The day before yesterday I saw Henny [Henny Porten, the silent-film star]. She was very sweet; she said she would definitely come to the Mozart Hall (auditorium) while the play was on. So that meant it could only be Thursday evening. I went there with flowers and beautiful Henny didn't keep her promise. I took the flowers for her again at ten o'clock; now one couldn't risk that anymore. . . . I brought my pillow to the studio. She was sweet, but left right away. Just proves one shouldn't trust women. . . . This evening was supposed to be Dassau's second concert. It was canceled. Mutti wouldn't have let me out anyway. Oh, if I just could be a little happy, then everything would become so much easier. Maybe there will come a time when this book speaks of happiness, only happiness.

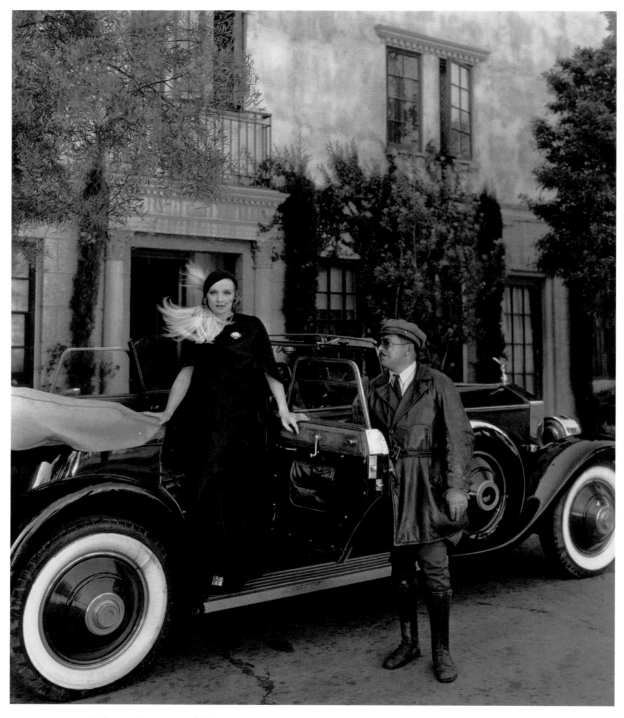

In front of Paramount's "dressing room row," 1931. The famous forest green and gold-speckled Rolls-Royce was her Hollywood arrival gift from von Sternberg. (Photographer unknown)

Beverly Hills, 1931, mother and daughter (age five and a half). Taken by von Sternberg, to be sent to Berlin to show the father how happy his child was in sunny California soon after her arrival. Marlene rarely wore bathing suits and hated swimming.

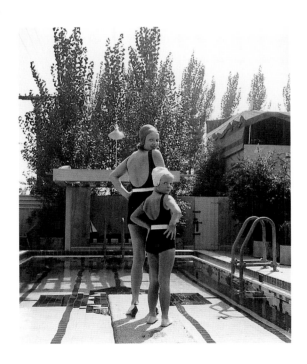 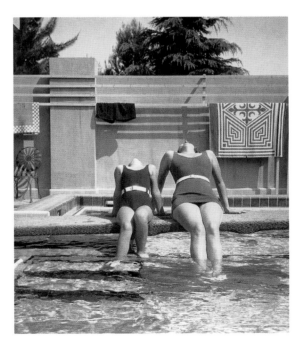 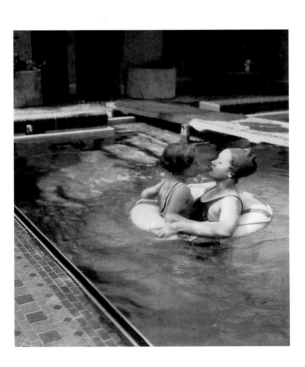

In the early thirties, women relaxed in sensuous negligees—Marlene in her usual made-to-measure trousers and a man's silk shirt. (Von Sternberg)

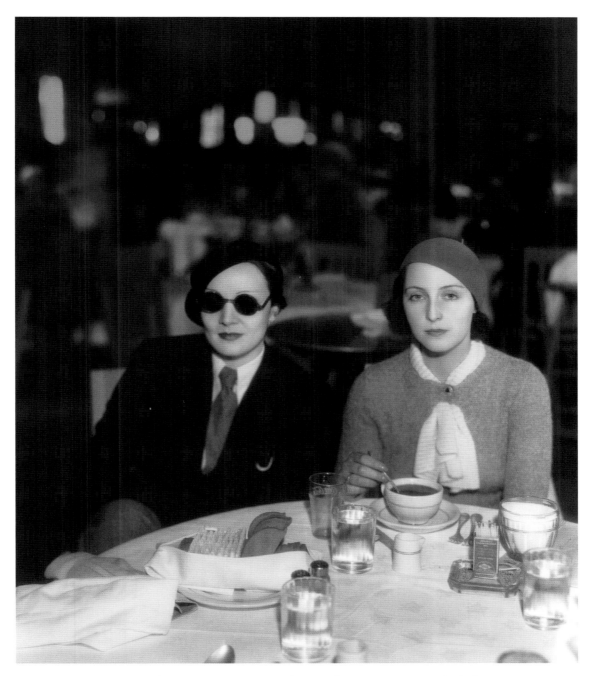

Paramount Studio commissary, 1933. Dorothea Wieck, a German actress who had a great success in *Mädchen in Uniform,* was brought to Hollywood to see what could be done with her. Marlene, knowing the uproar this film had caused in America because of its lesbian theme, decided to have fun and dress the part for the publicity-department-organized moment. Fräulein Wieck soon returned to her homeland. (Photographer unknown)

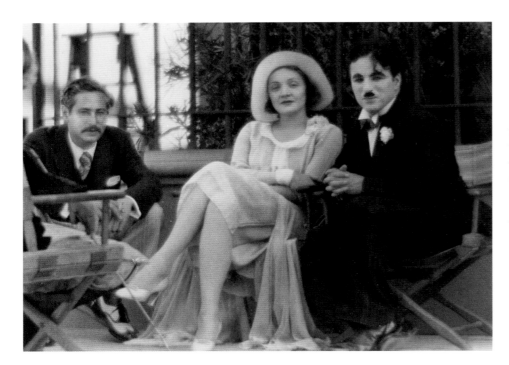

LEFT: Newly arrived in Hollywood, von Sternberg took his protégée star to meet the great Chaplin on the set of *City Lights.* Although she tried to look nonchalant, one can detect her self-consciousness both in her attire and in the amateurish way she positioned her legs. (Hyman Fink)

BELOW: The Coconut Grove, Hollywood, 1935. Rudolf Sieber with Maria and his wife and their mutual friend, the German director of *Metropolis* and *M,* Fritz Lang. (Photographer unknown)

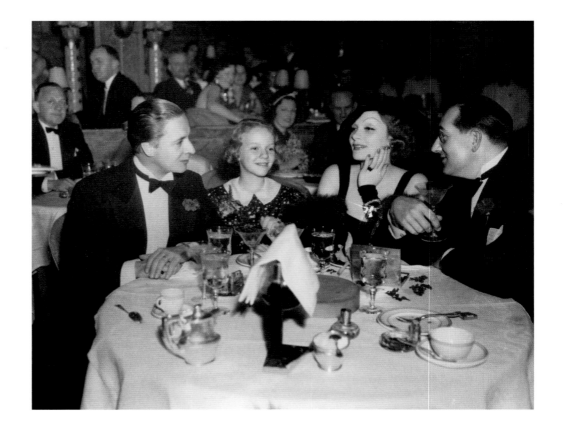

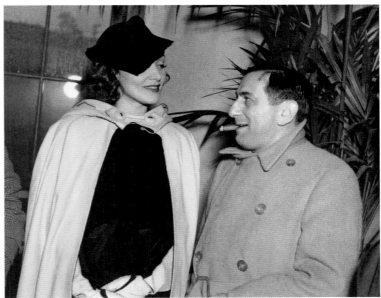

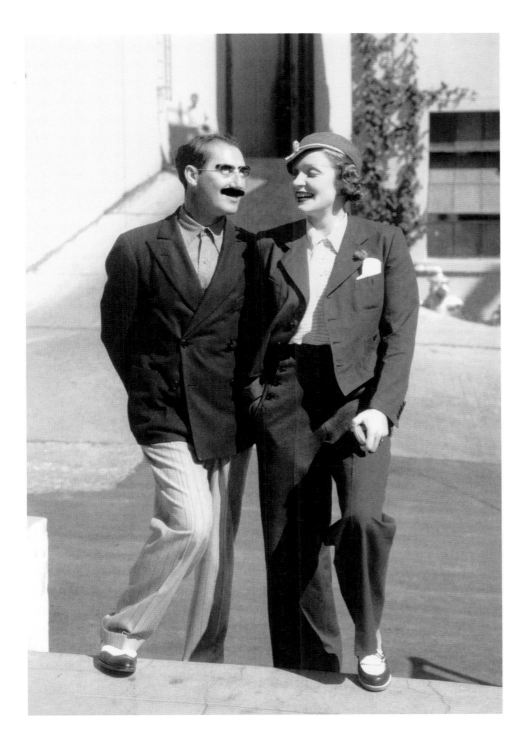

Photographs by Hyman Fink, the only "home lot" candid photographer Marlene ever trusted. Fink never submitted his pictures of her to his bosses without first showing them to Marlene. Here, with the director Ernst Lubitsch (ABOVE), whom she did not like, and with fellow Paramount contract player Groucho Marx (LEFT). Although she didn't know who he was, she consented to have this candid taken because von Sternberg told her Groucho Marx was a brilliant performer. (Hyman Fink)

Von Sternberg writes to Marlene on a trip to
Mexico, July 12, 1933:

Sublime Woman . . . Beloved
wonderment, the sigh I have
sighed for you would suffice for
the breathing of Methuselah.
Doesn't it bore you to hear over
and over again the lament of my
longing and my love for you? The
beauty of your voice, the scent
of your hair, the magic of your
movement, the play of your eyes,
your silken skin, the touch of
your hands, your awesome brow,
if only you knew what it would
mean to me if I could just reach
out to touch you—and soon—
this seems such an endless time
away—I will stand before you—
and my dumb eyes will look at
you, gently and truly, and no sign
will be allowed to show you the
passion of my adoration for you
nor the witches' cauldron of my
feelings—so you won't be scared
away. . . . I have once again said
too much. Only a supernatural
being can take so much adula-
tion and you are so beautifully
human. . . .

China Meer
Herbst 1936

ich danke dir fuer deine suesse kabel - ich habe versucht
dich von tokyo aus telefonish zu erreichen aber mir wurde
gesagt dass du. dich irgendwo in oesterreich erholst - ich
war ein bischen beunruhigt dass du auf mein kabel vor meiner
abreise von hollywood nicht antworteste - du sagst dass ich m
mich aussprechen soll - hiermit geschieht es - ich bin muede
und habe wenig freude gehabt - und dachte ich schaue mir die
kleine erde an - nun sehe ich sie - und es macht mich glueck-
lich - ich war ueberall in japan korea manchurei und china
wo ich noch immer mich befinde - morgen gehe ich nach canton
und makau - die menschen waren ueberall xuxxxn ruehrend
und oft weinten fremde vor freude oder weil ich nach einigen
stunden wieder wegfuhr - ich sehe eine welt von der ich
eine vorstellung hatte genau so wie sie ist - nichs bis jetzt
ueberrascht und alles ist wie von mir inseniert (wenn ich
ungestoert denke) - du kannst dir woll vorstellen dass ich
oft an dich dachte - abgesehen davon dass dich die menschen
hier alle sehr lieben - namm ich auch den shanghai express
von peking nach shanghai - und oft sass shanghai lily neben
mir - hoffentlich geht es dir gut - ich weiss dass du dich
oft leer fuehlst - kenne auch deine gedanken und denke oft
mit wenn du am meisten glaubst dass ich dich ausschalte -
mir tut dass herz sehr weh - ich wollte dir ja helfen -
xxuxx, aber du warst dagegen - trotzdem helfe ich noch
immer - wenn dieser brief zu dumm ist dann lese die worte
mit meiner stimme-wenn sie ganz sanft ist und es wird nicht
so ganz dumm klingen - ich habe mich gestern mit vollmoeller
in shanghai getroffen und ich glaube dass unsere wege nach
einer woche sich wieder scheiden - er geht weiter mit einem
deutschen shiff und ich bleibe ein wenig laenger - ich
will mir siam und cambodien burma und java anschauen dann
gehe ich durch indien und durch persien und egyptien nach
london - ich glaube wenn die vielen goetter die ich hier
persoenlich treffe es erlauben dann bin ich in london
ungefaehr sechs wochen nachdem du diese zeilen liesst -
von singapore nach london sind es nur fuenf tage mit flugzeug
also sehr weit weg bin ich doch nicht - hie und da werde ich
dir sagen wo ich mich aufhalte damit du mir hie und da ein
telegram schicken kannst - du schreibst ja immer noch schoene
worte - leider nicht nur mir allein - ob ich je wieder arbeit
finde die mir freude macht weiss ich nicht - trotzdem habe
ich in diesen wenigen wochen mindestens drei schoene stoffe
mir ausgedacht - aber zwischen denken und film giebt es eine
grosse dunkle welt - arbeite du schoen und mache mir freude -
und wenn du oft an mich denkst dann weiss ich es und die
stelle im herz wo ich dich versteckt habe glueht

Jo

From von Sternberg, traveling on the South China Seas:

I am tired and had little joy—and thought I would go take a look at the little world—now that I have seen her it has made me happy—I was everywhere in japan, korea, manchuria, and china, where I am still—tomorrow I am going to canton and macao—everywhere the people were touching—often complete strangers cried out of joy because I was leaving after only a few hours— I am seeing a world exactly as I imagined it would be—nothing as yet has been surprising—as though it is all my creation (when thinking uninterrupted)—you can surely imagine how often I thought of you—which has nothing to do with the fact that here everyone loves you—I took the shanghai express from peking to shanghai— and often shanghai lily sat next to me—hopefully you are well—I know you often feel drained— know also your thoughts—those times when you believe I am ignoring you the most—my heart suffers—I wanted to help you but you were against that—despite that I still do . . . so—as far away I am really not—here and there I will let you know where I stop so that you can here or there send me a telegram—you do still write such lovely words—sadly not to me alone—work beautifully and bring me joy and if you think of me I shall know and in the place where I hid you will glow.

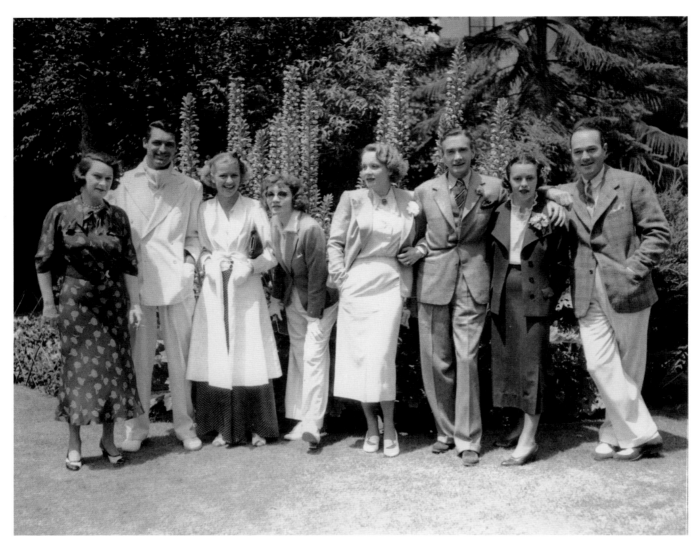

A Hollywood Sunday brunch amid giant larkspur, 1935. Left to right: the hostess, a rich American with a title due to wedlock, the countess Dorothy diFrasso; Cary Grant; unknown; Claudette Colbert; Marlene in her favorite blue linen blazer outfit from *Desire;* Clifton Webb and friends. (Photographer unknown)

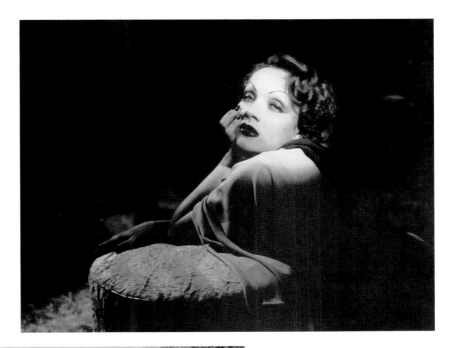

1935. Having rented the opulent house of the Countess diFrasso, Marlene agreed to do a fan magazine layout for *How the Stars Live*. Without the guiding hands of von Sternberg, she took on the persona of a glamorous movie star, dropping the European mystique he had cultivated. These and the photographs on the following pages were all taken in one day. They mark the first time Dietrich agreed to sit for "leg art" since becoming a star. (Eugene Richee)

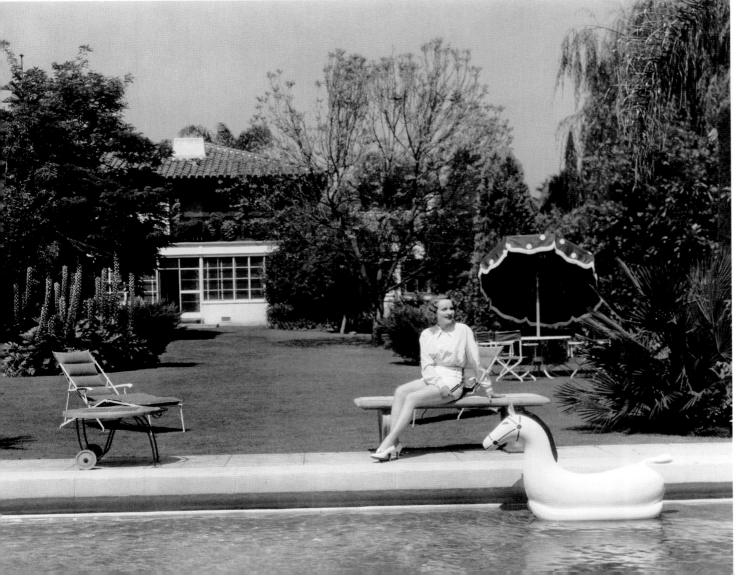

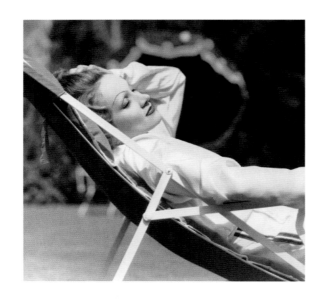
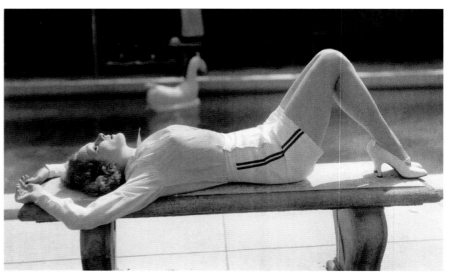
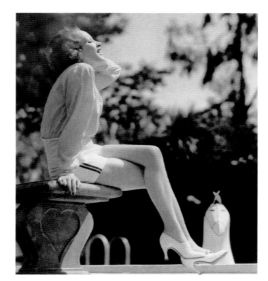

RIGHT: On location in the Arizona desert for *The Garden of Allah*, 1936. Marlene acquired her first home-movie camera and loved recording moments of what she considered "a disaster in the making."

BELOW: A staged publicity photo of costar Charles Boyer having his picture taken. The Bedouin tent in the background gives the desert outside Yuma that Sahara look.

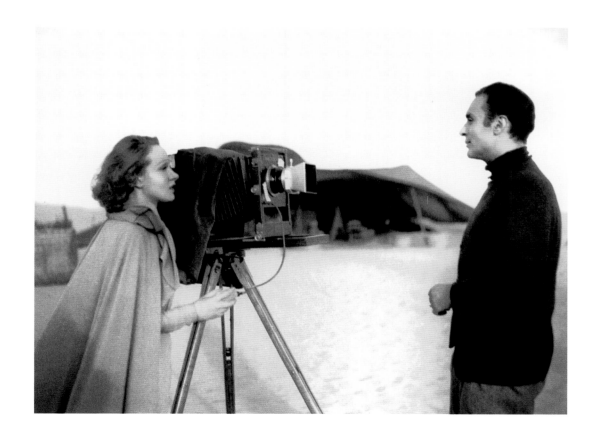

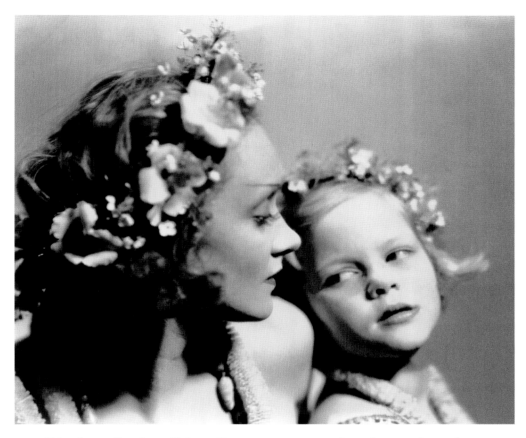

Taken by von Sternberg. All things Hawaiian were very popular in the 1930s. In matching grass skirts, paper flowers, and real shell necklaces after performing "Little Grass Shack." Hula movements and all, von Sternberg did a mother-daughter sitting at home in Beverly Hills. The many different poses of this session were developed and printed at Paramount and attributed to the faithful Richee.

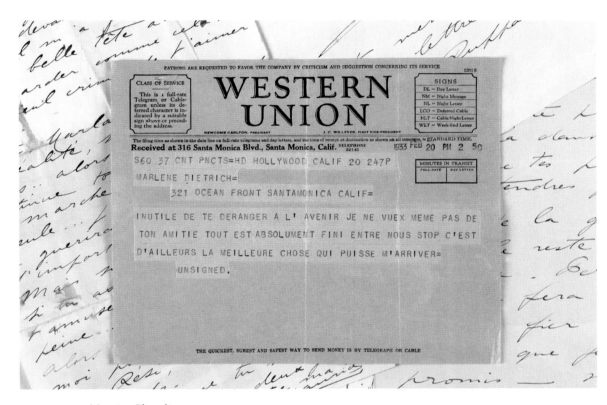

Maurice Chevalier:

USELESS TO DISTURB YOURSELF IN THE FUTURE I DO NOT EVEN WANT
YOUR FRIENDSHIP EVERYTHING IS ABSOLUTELY FINISHED BETWEEN US
STOP NONETHELESS IT IS THE BEST THING THAT COULD HAPPEN TO ME
 UNSIGNED

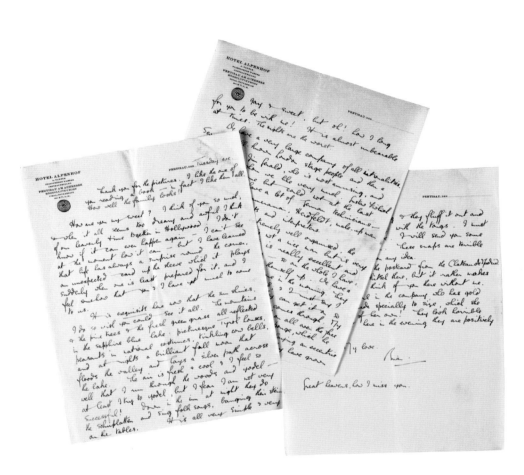

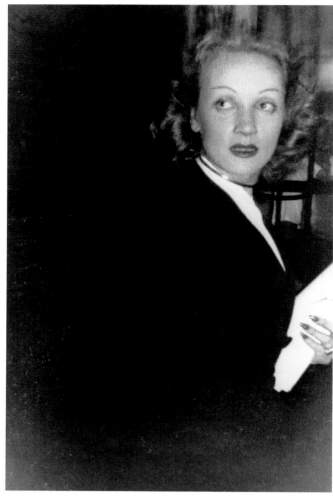

LEFT: Away shooting in the Alps, Brian Aherne sent long love letters to Marlene:

> Down in the inn at night they do the schwinplatten and sing folk songs,
> banging their steins on the tables. It is all very simple and very gay & sweet,
> but oh! how I long for you to be with me! It is almost unbearable at times.
> The nights are the worst.

RIGHT: Early 1940s. Taken as she exited a long evening of dancing, serving, and working the kitchen detail at the Hollywood Canteen for the troops of World War II. (Photographer unknown)

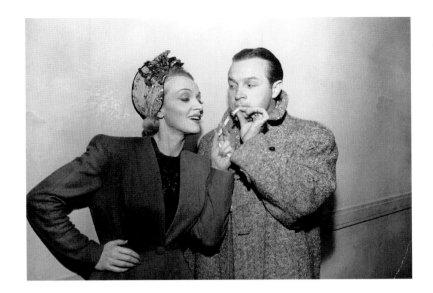

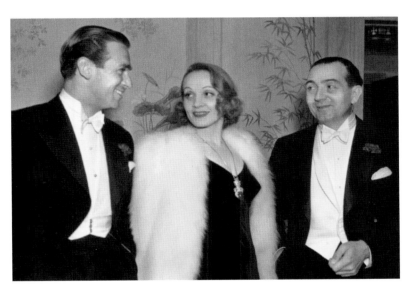

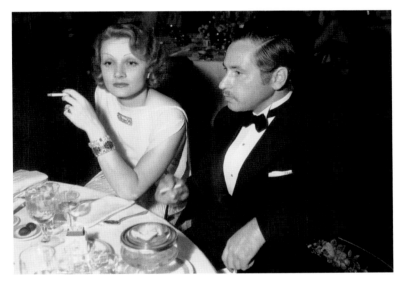

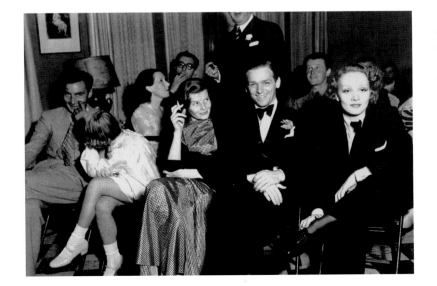

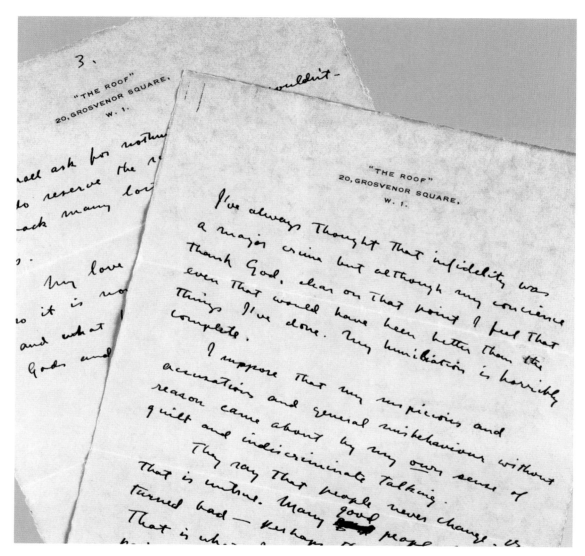

All too soon, Douglas was suffering as well:

I've always thought that infidelity was a major crime but although my con-
science is, thank God, clear on that point I feel that even that would have
been better than the things I've done. My humiliation is horribly complete.

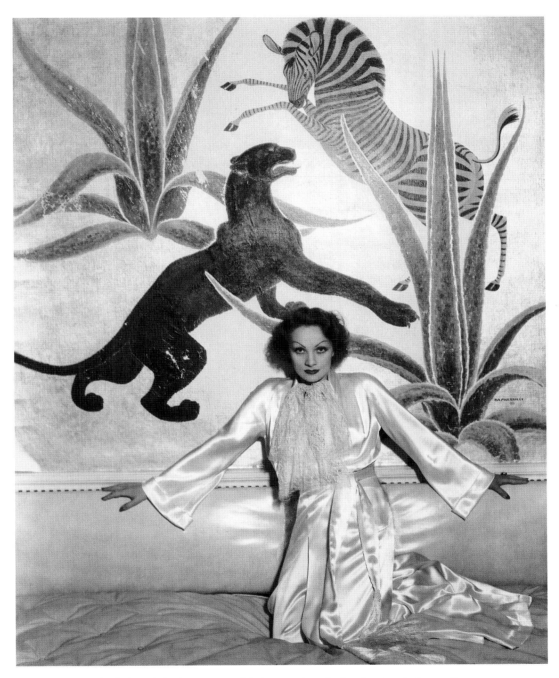

Dorothy diFrasso's bedroom, 1935. Marlene against the hand-painted silver wallpaper—a movie-star pose to make the fans drool. (Photographer unknown)

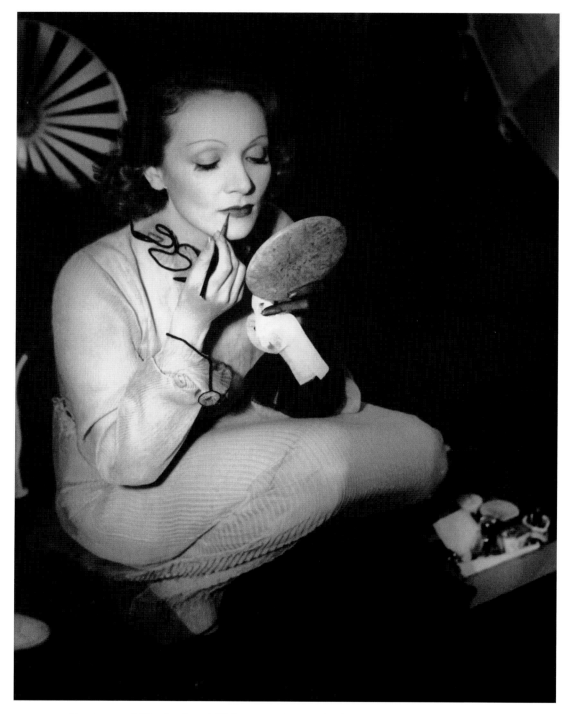

On the set of *The Garden of Allah,* 1936. This was the first Technicolor picture location shoot: in the desert, with dressing tents for the stars instead of the comfort of the Paramount home lot. Marlene, always the trouper, had a ball. (Photographer unknown)

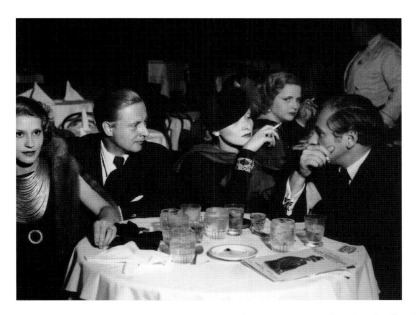

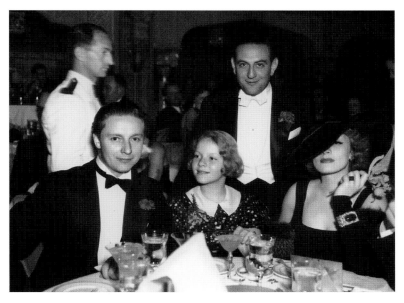

TOP LEFT: An evening out in Los Angeles for the family lovers: Dietrich's husband, Rudi, with his mistress, Tamara, and Marlene with von Sternberg. Although not at all shocking in Europe, in America it was—very. (Hyman Fink)

TOP RIGHT: A dinner with Rudi, Maria, and Fritz Lang, who was cropped out because Guy Lombardo was more recognizable. (Charles Rhodes)

BOTTOM LEFT: Mother and daughter in fur, on the SS *Bremen,* April 1931. (Photographer unknown)

BOTTOM RIGHT: A sensation on board the SS *Europa,* a German luxury liner that stopped first in Cherbourg, France, where she disembarked. It was 1933; Hitler had just come to power, and her instinctive decision not to travel to Germany was interesting. (Paul Cwojdzinski)

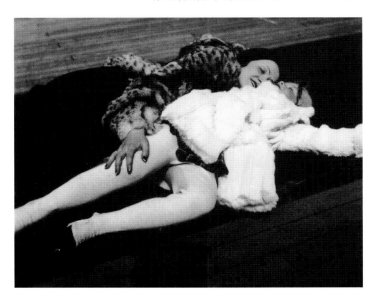

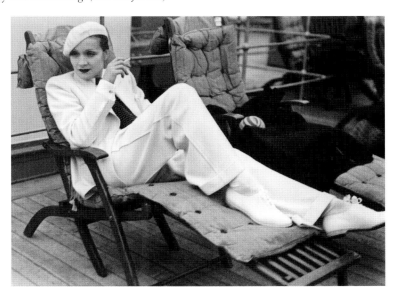

ABOVE: 1930s. Once again a family photo, but when it was published, both her husband, Rudi, and the unknown lady on his right were cropped out, leaving only the famous Wimbledon champion Fred Perry next to his latest conquest. (Hyman Fink)

BELOW: A Hollywood party gathering in 1937. Marlene, in a flowered silk Irene specially designed to show off her first-ever tan (acquired in the south of France), flanked by (left to right) Jack Warner, Tyrone Power (practically obscured), and Douglas Fairbanks Jr. (in the foreground). (Photographer unknown)

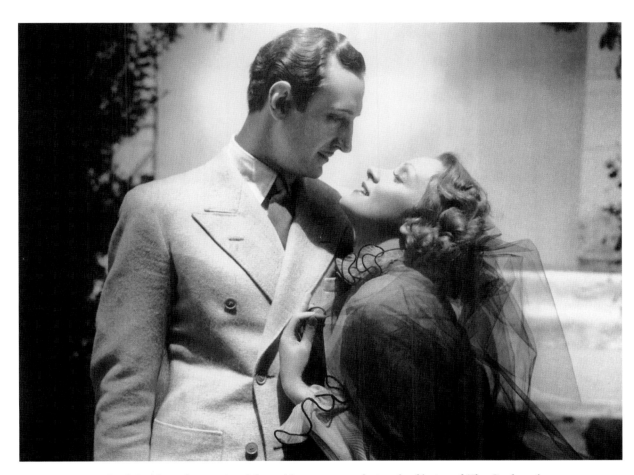

Basil Rathbone being adored for publicity reasons during the filming of *The Garden of Allah* in 1936. (Photographer unknown)

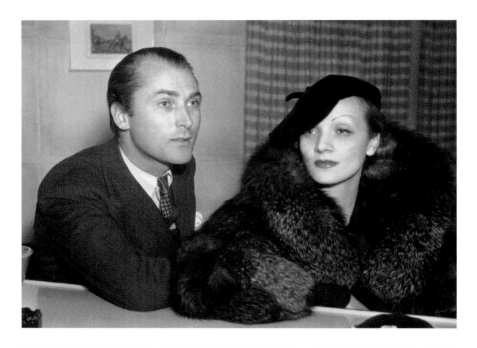

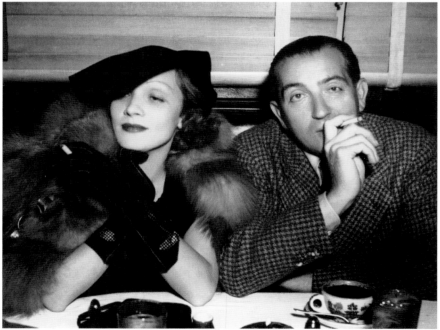

TOP: With Brian Aherne in 1933. Her leading man in *Song of Songs*, he became a lover as well as a lasting friend. (Hyman Fink)

BOTTOM: With Fritz Lang—their bored expressions say it all. Once the two were German buddies, but by the time Lang directed her in *Rancho Notorious* (1952), Marlene had begun referring to him as "Hitler." (Photographer unknown)

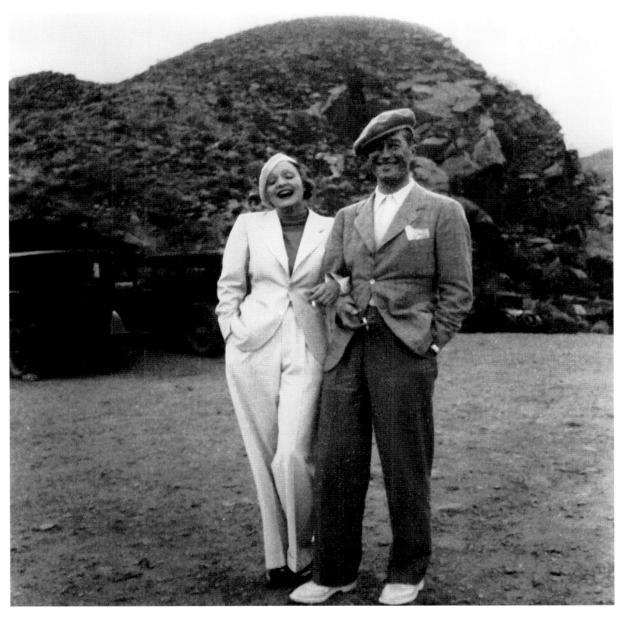

French pals Marlene and Maurice Chevalier on a day off in the mid-1930s, enjoying a trip to the California desert. Who took this? Makes for interesting speculation.

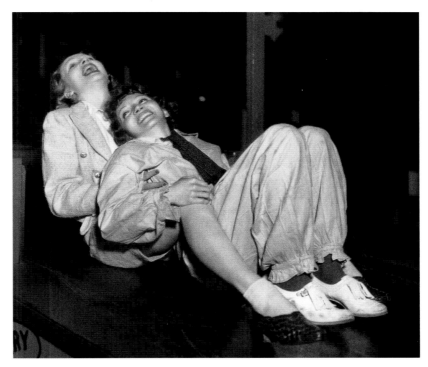

In 1935 Carole Lombard rented the Venice Pier Fun House and threw herself a star-studded birthday party. Among her guests, Marlene and Claudette Colbert and the Paramount publicity department. (Photographer unknown)

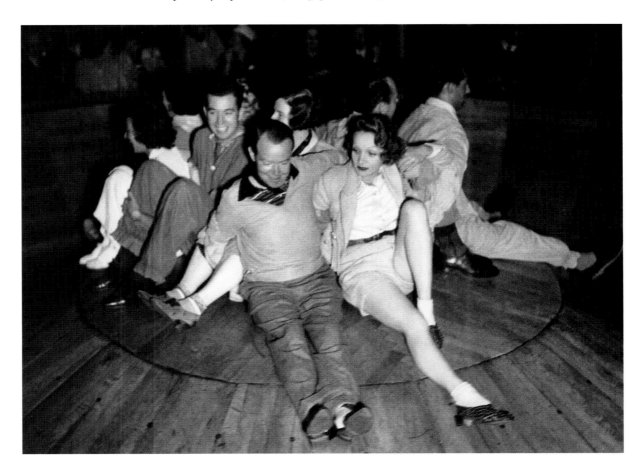

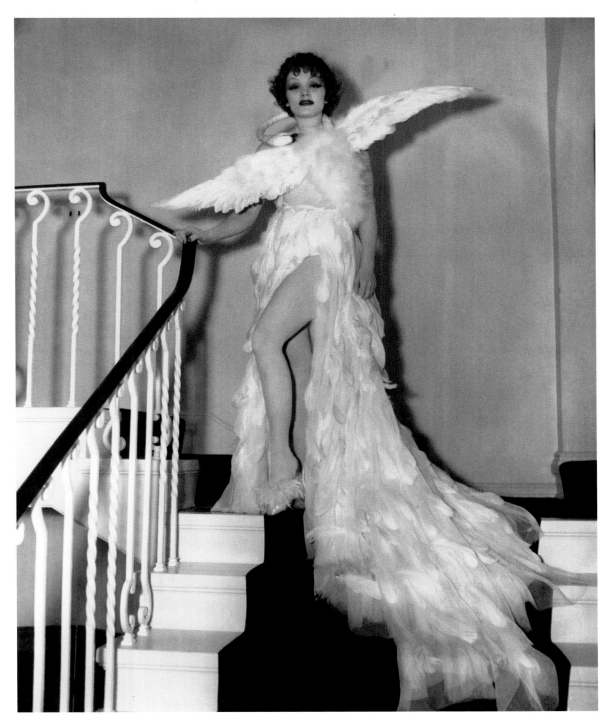

For a Rathbone costume party labeled "Come as one you most admire," 1935. Marlene and Paramount designer Travis Banton re-created the mythical legend of Leda and the swan. In gossamer chiffon and swan feathers, she triumphed. More than twenty years later she would remember it when designing her famous swan coat for the stage.

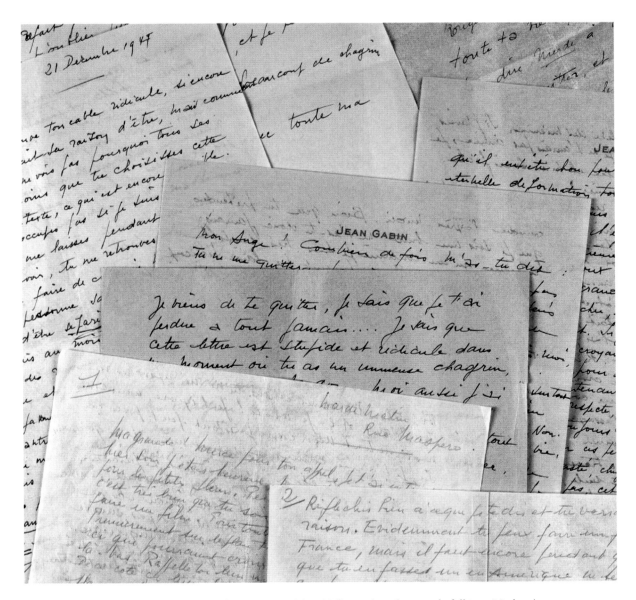

Jean Gabin left occupied France, arrived in Hollywood, and promptly fell into Marlene's arms. Except for the last, all his letters reveal their love affair to have been one of the most enduring, most passionate, and most painful of both their lives—and, of course, Gabin suffered most. "I thought I saw in people's faces that they knew it wasn't only the flu that made me ill. I am in your bed. I am without you. I am dying of sadness." When their affair was over, however, he was the only Dietrich suitor to say good-bye once and mean it.

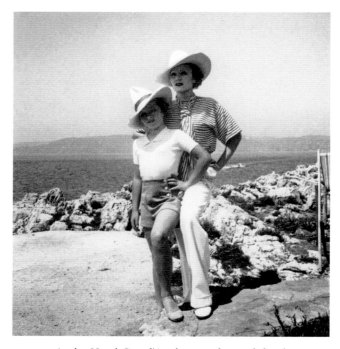

ABOVE: At the Hôtel Cap d'Antibes, mother and daughter pose for Erich Maria Remarque, then Marlene's lover. (Photographer unknown)

BELOW: Cap d'Antibes in the south of France, summer of 1938. Taken there by the owner of this magnificent twin-masted schooner, the Standard Oil heiress Marion (known as Jo) Carstairs. (Photographer unknown)

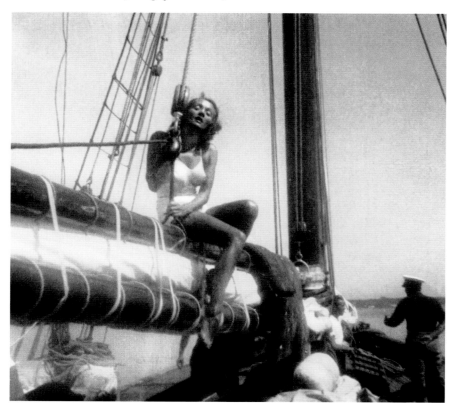

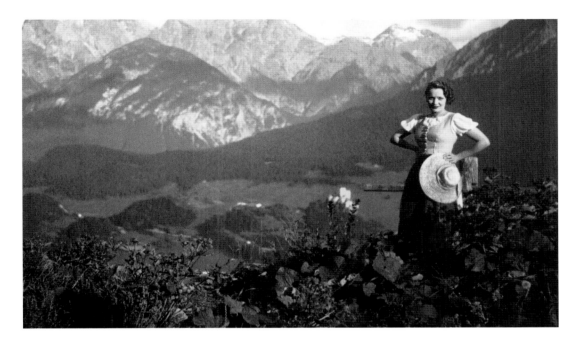

LEFT: In a Lanz dirndl on a meadow above St. Galgen, Austria, 1933. (Photographer unknown)

BOTTOM LEFT: The Lido in Venice, with Elsa Maxwell and the Earl of Warwick—just a summer pal in 1937. (Giacomelli)

BOTTOM RIGHT: Paris, 1937. Husband and wife lunching at their favorite daytime restaurant, Little Hungary. After daughter and husband's lover were cropped out of the picture, Dietrich's handwritten comments became interesting. (Lucien Aigner)

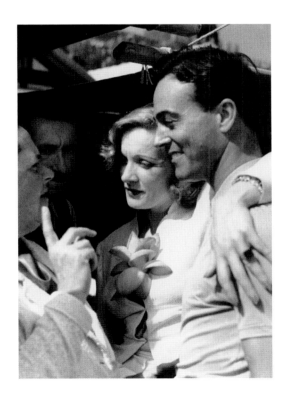

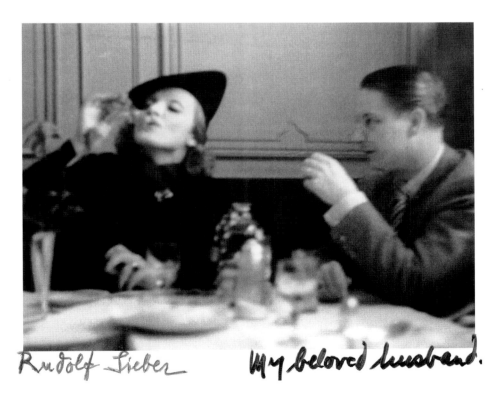

Rudolf Sieber My beloved husband.

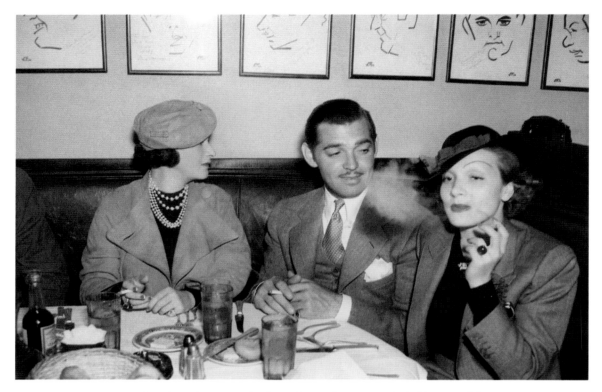

ABOVE: Lunch at the Brown Derby with an admiring Clark Gable . . . and his mistress. (Photographer unknown)

BELOW LEFT: Anne Warner, Noël Coward on a rare Hollywood visit, and Marlene in her favorite crossover halter top instead of a blouse—created by Irene (long before Donna Karan thought of it). (Hyman Fink)

BELOW RIGHT: Jean Gabin, Marlene, and the French painter Bernard Lamotte on his bistro-like terrace in New York. (K. W. Hermann)

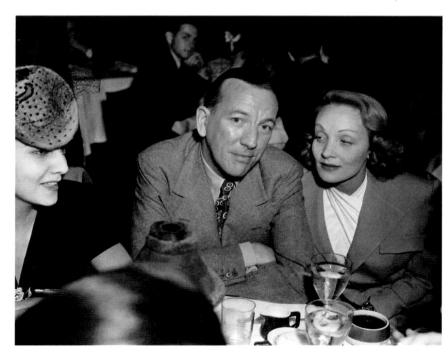

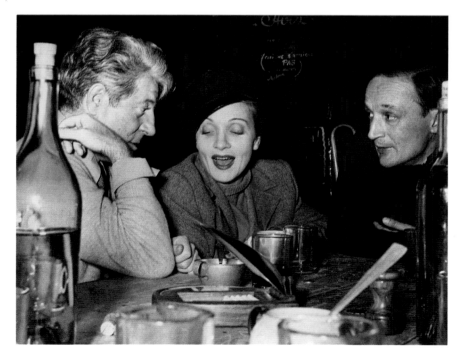

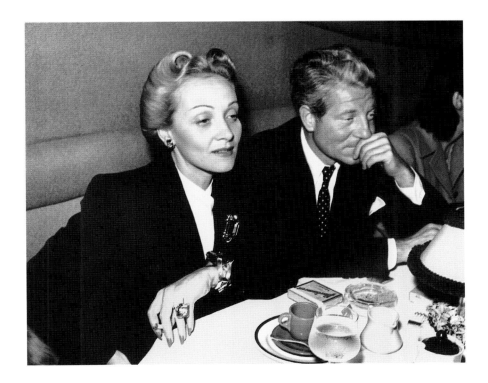

ABOVE: The hair, the Irene halter top, and the topaz ring identify this as having been taken in the 1940s on one of their last evenings out before Jean Gabin left America to join up with the Free French fighting force under Charles de Gaulle. (Hyman Fink)

BELOW: With Raoul Walsh, her director on *Manpower*. (Hyman Fink)

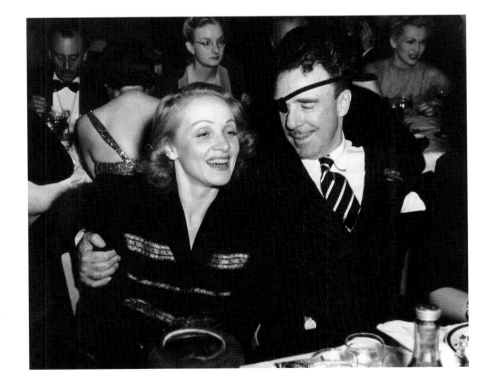

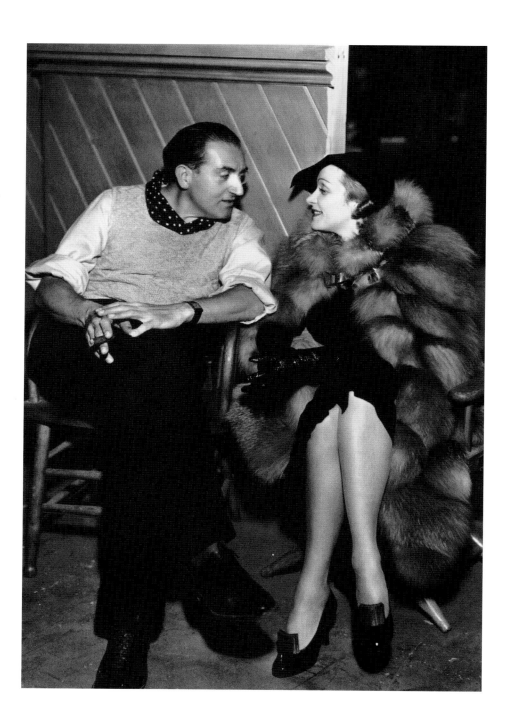

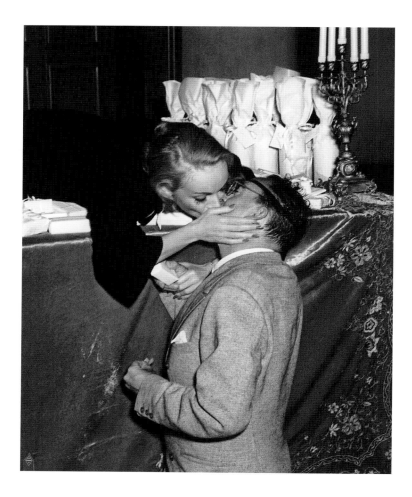

LEFT: Dietrich visiting a Fritz Lang set in one of her Paris purchases of the 1930s—a three-quarter red fox cape, its skins worked in the round. (Photographer unknown)

ABOVE: In 1941, at the wrap party for *Manpower*. Marlene, handing out her farewell presents to the crew of the film, adds a special kiss for her director, Raoul Walsh. (Photographer unknown)

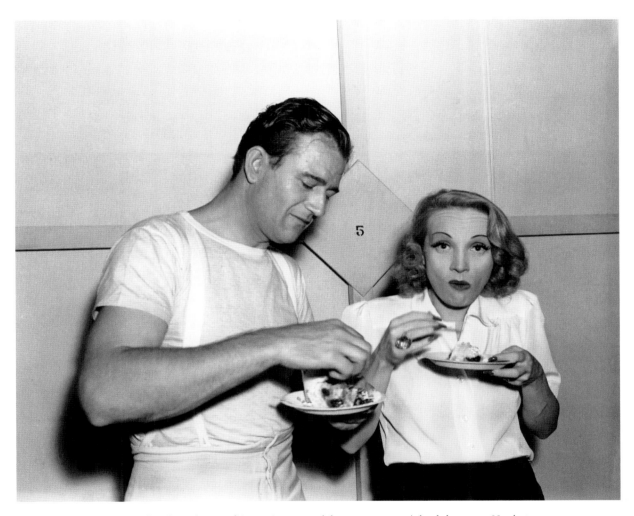

During a break on the set of *Seven Sinners*, celebrating someone's birthday, 1940. Her hair, makeup, jewelry, and casual dress indicate that on this day she was not working; only Wayne was. (Photographer unknown)

OFFICE OF
WILLIAM RANDOLPH HEARST
WYNTOON
McCLOUD, CALIFORNIA

December 31, 1941

Miss Louella O. Parsons,

619 No. Maple Ave.,

Beverly Hills, Calif.

My dear Louella :

I am very sorry if the article in the American Weekly distressed Miss Dietrich, although I do not see anything very distressing in the article.

I have just read it and it seems harmless enough.

Miss Dietrich probably does create a good deal of disturbance.

Most beautiful women do.

They possibly do not mean to, although I have a suspicion that they secretly enjoy the commotion they create.

However, let me repeat, if there was anything in the article which distressed Miss Dietrich, I am sorry.

Please make my apologies.

Sincerely yours,

W R Hearst

After an unfavorable news piece about Miss Dietrich's being difficult during filming, William Randolph Hearst tried to calm the star down via Louella Parsons, who was no doubt happily stirring things up for her column.

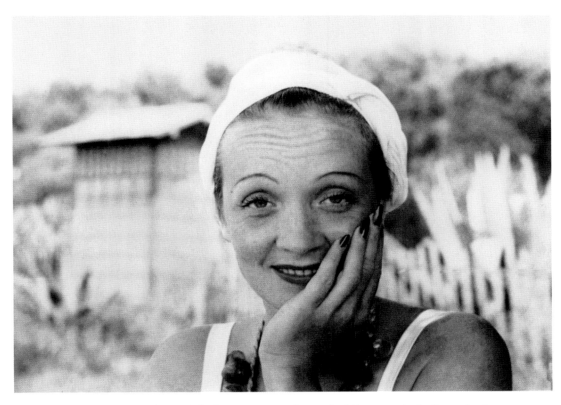

Cap d'Antibes, July 1939. The last summer in the south of France with the Kennedy clan before the outbreak of war. Snapshot taken by her daughter.

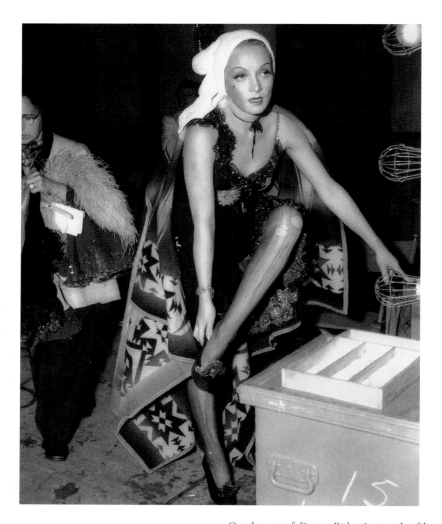
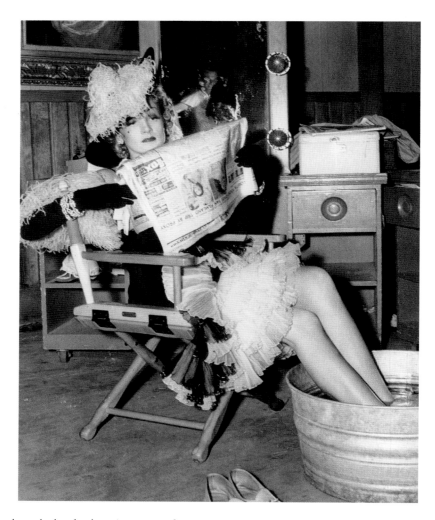

On the set of *Destry Rides Again*, the film that brought her back to America and resurrected her career, September 1939. See Joe Pasternak's memories of Dietrich, pages xvii–xxiv. (Photographer unknown)

From a letter by Erich Maria Remarque, [early 1940s]:

If you were but an actress, then it would be simpler, since the roots of actors lie shallow under the earth,—sometimes even on its surface. But your roots are much more ramified and deeper, they come from somewhere else. That's why the impact you create is so different . . . you shock, you capture. . . . Beauty and personality, fascination and character. . . . Only a very good or a very bad director could manage things properly. Jo understood that once, managed to hit the mark, but even then to a limited extent: he showed only one side, but that he saw thoroughly. The rest was supplied by you: the ambiguity, the gleam of tragedy, in the Platonic sense, not in the Aristotelian sense. Naughty Lola . . . with you the character became broken, fragile humanity, and nobody was able to say when or where. That was your secret. . . . Surely you are not only an actress, just as I am not only a writer. This rare, ambiguous species is in great danger. . . . You must jump higher. Or tear the ground from under those who watch.

BELOW: With Erich Maria Remarque at the exclusive Zebra Room in Manhattan in 1951, a decade after his love letters to Marlene. She is wearing her favorite beige silk chiffon gown, designed by Dior for *Stage Fright*. (Photographer unknown)

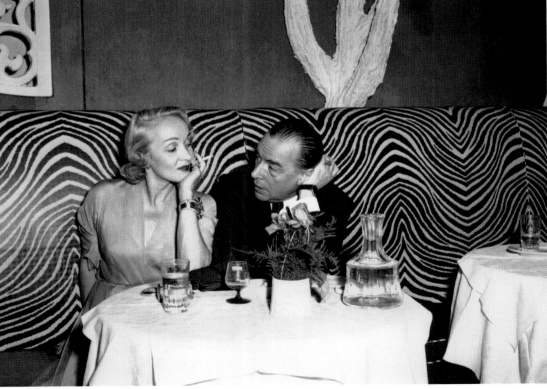

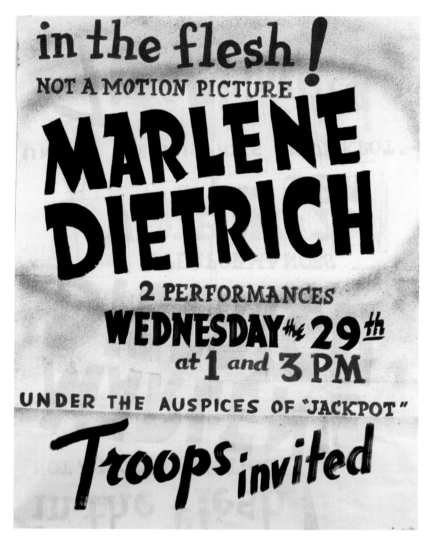

World War II: As the Allies pushed into Germany, Marlene sang for the troops on the front lines. They needed protection by Jackpot, a code name for missions against enemy airfields by the U.S. Air Force.

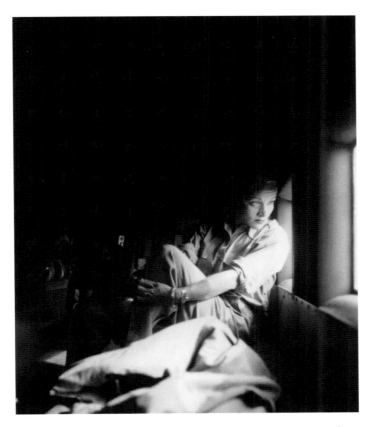

On a military cargo transport as it leaves Algiers en route to somewhere in Italy, summer of 1944.

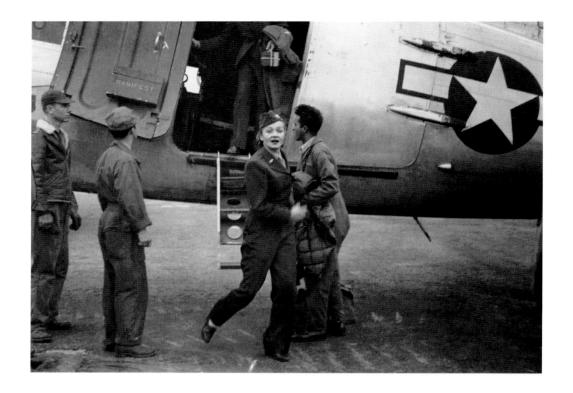

ABOVE: In her official USO entertainer's uniform, Italy, 1944.

BELOW: The back of an army truck, a safe field, a makeshift stage—anything would do to interrupt, if only for a few precious moments, the reality of war.

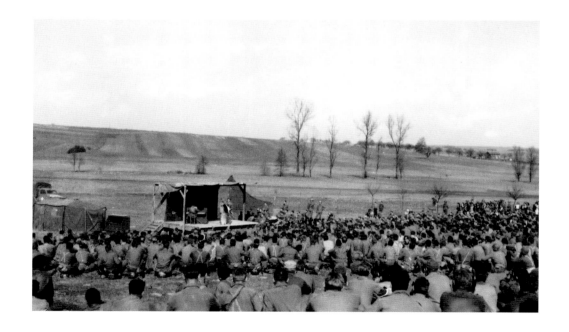

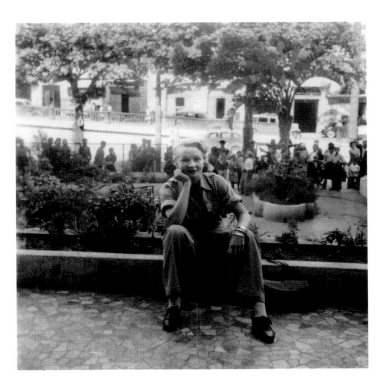

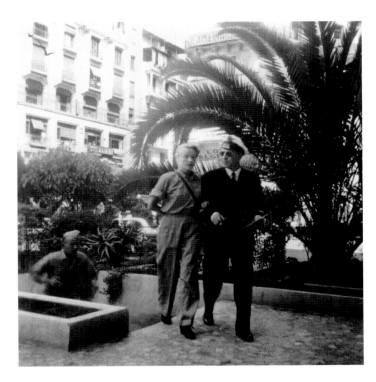

Algiers, 1944. Even in war, lovers can find each other if one of them has Dietrich's determination. RIGHT: Marlene with Gabin.

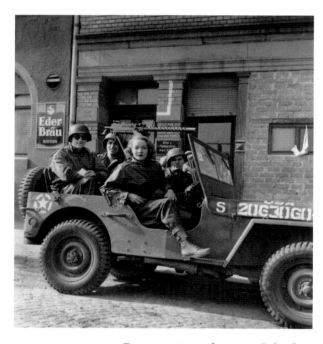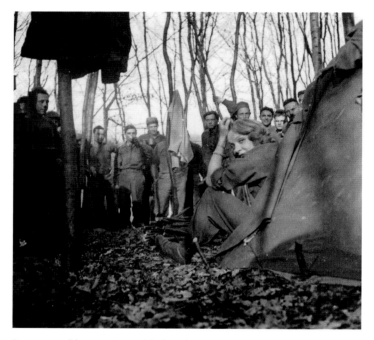

Germany, winter of 1944–45. Behind enemy lines. By now an old campaigner, Marlene has shed her USO uniform for that of a true GI.

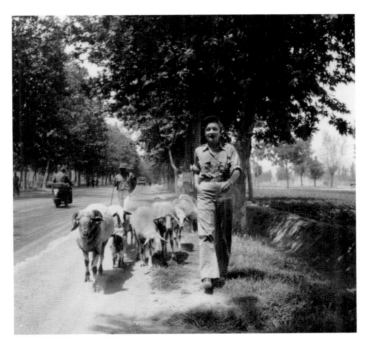

North Africa, 1944. Waiting for travel orders that would eventually take her into Italy.

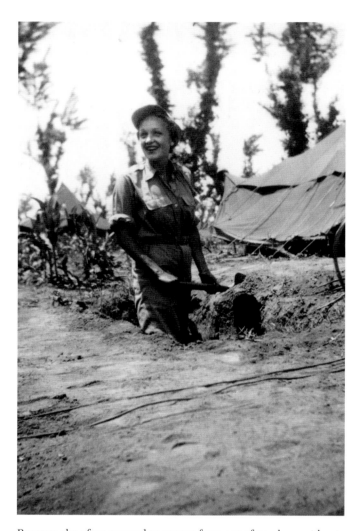

Because she often seemed to appear from out of nowhere without the usual movie-star hoopla, GIs would adopt her and regard her as one of their own. Here given a shovel, Marlene was taught how to dig herself a foxhole.

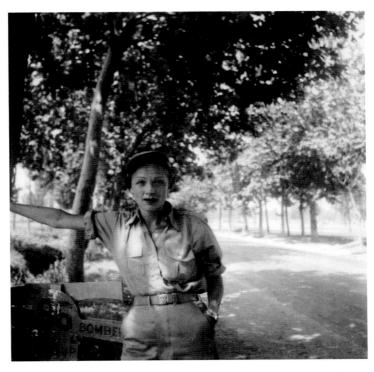

Jean Gabin had this snapshot taken on their last afternoon together in Algiers.

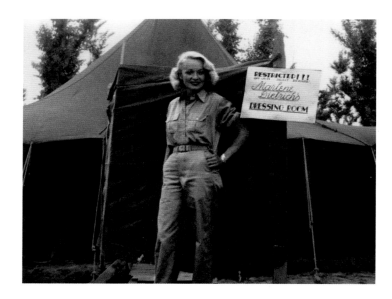

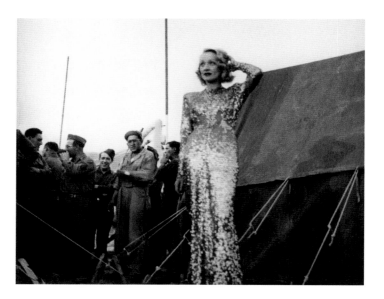

ABOVE: Italy, 1944. A tent proudly designated as her dressing room.

BELOW: A beautiful woman in no-man's-land. The shimmer of a real movie star playing her musical saw clamped between her knees while she stroked it with her bow was always a hit!

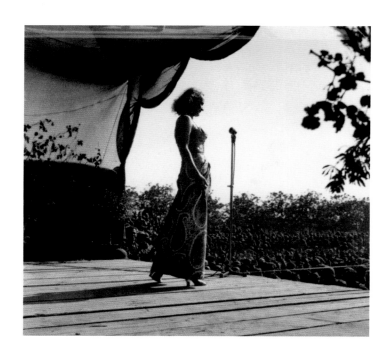

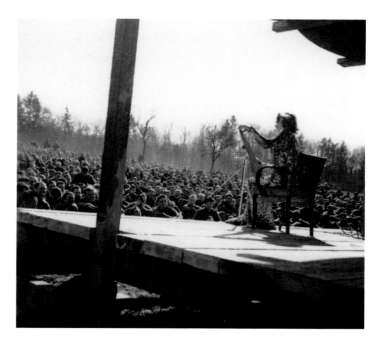

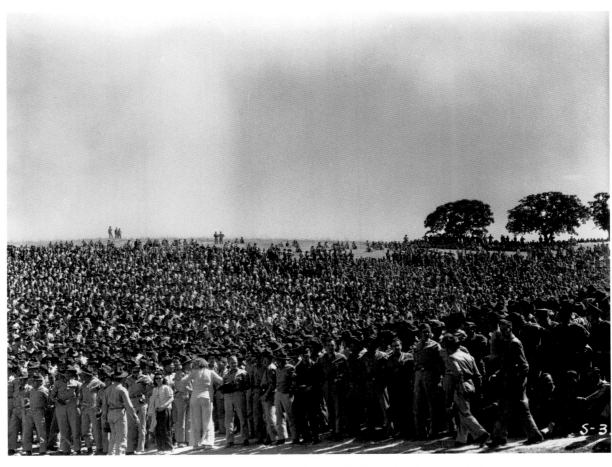

With General Mark Clark's Fifth Army, Italy, 1944. To be such a famous and glamorous star and still be approachable made Marlene very special to whatever unit she was assigned to—or, later in the war, managed to reach on her own (against army rules).

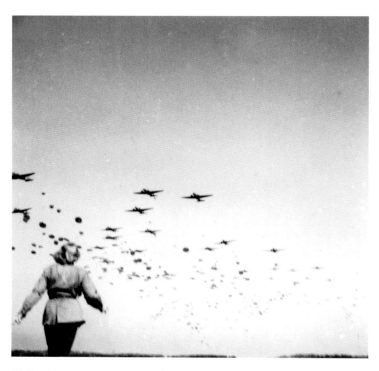

Holland, 1945. Having acquired General Gavin's own jump jacket as a personal gift from the general, Marlene watched as his 82nd Airborne Division showed off their skill.

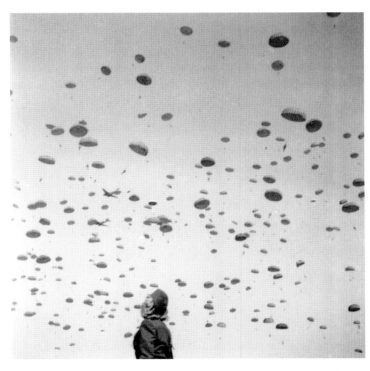

Of all the units that adopted Marlene and considered her one of their own, only the gallant 82nd Airborne Division captured part of her heart.

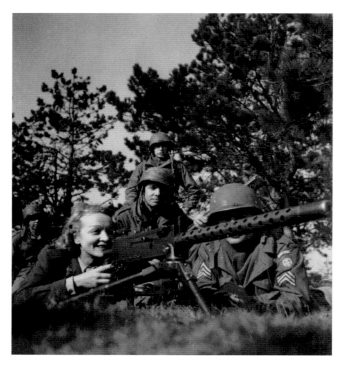

Holland. Getting ready for a big push, the 82nd thought they might take Marlene with them.

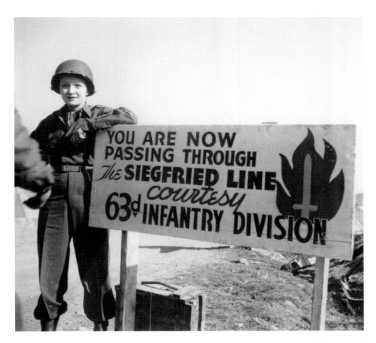

1945. With what was known as the "Blood and Fire" Division of General Patton's Third Army. Marlene, now a full-fledged GI, got her wish to enter Germany with the American troops.

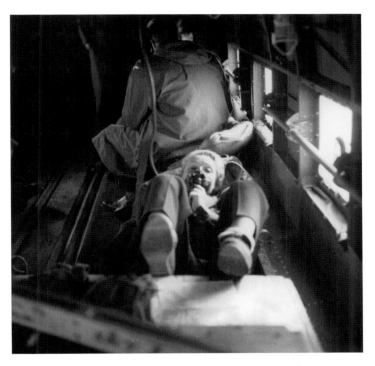

Once again as military cargo being transported from somewhere to somewhere in Germany, in the winter of 1945.

Both on leave, Gabin and Dietrich meet again. It was cold in liberated Paris in the winter of 1945. Note her white silk jump scarf, a mark of her devotion to the 82nd Airborne Division.

A British transport is greeted by "Lili Marlene," Rome, 1944.

ABOVE: Marlene obliged whenever soldiers asked to have their picture taken with her to send back home to prove they had actually met her. Here in Germany, with the 6th Armored Division, atop a Pershing tank, she grants its crewmen and some eager brass their wish.

BELOW: Taken in Czechoslovakia, 1945. Marlene, in her own handwriting, identifies the group among which she stands and thereby makes a moral statement.

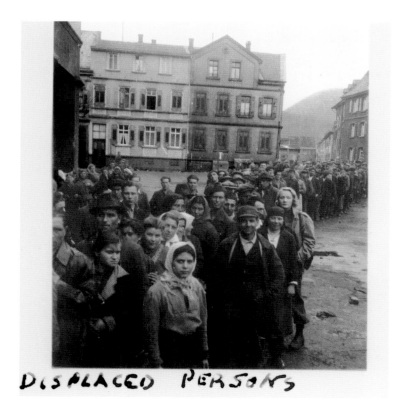

DISPLACED PERSONS

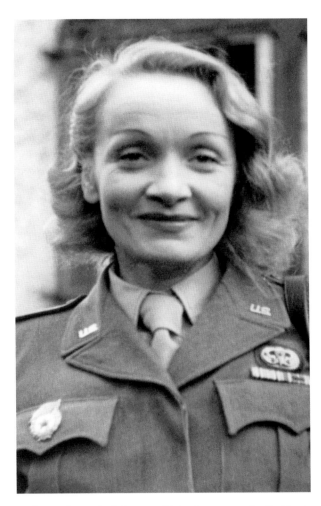

Berlin at the end of the war. This picture says it all. She is wearing her Eisenhower battle jacket. On the right pocket flap is the badge of the Soviet Elite Guards, given to her when a group of Russian soldiers met up with her escort of a group of American GIs. On the left breast is a Jump Master pin presented to her by the 82nd Airborne Division, beneath which are campaign ribbons with battle stars . . . And then her face: the softness of her expression proves that this picture must have been taken by someone she loved—an American soldier.

Special Service, ASCZ,
presents
A USO Camp Show
with

MARLENE DIETRICH
IN PERSON

Place : Renaissance Theatre, Namur **Time :** 1930 HRS

Date : 24. Nov.

No Civilians Admitted

Placard kept for two reasons: first, because any souvenir of her war work was precious to her, and second, because she loved the last sentence on it. Marlene always referred to "normal" people as civilians and now had it in print.

ABOVE: General James Gavin always admired Marlene and her work for the troops. Leaving her in Paris when he returned stateside, he sent cables to cheer her up.

BELOW: Marlene wrote to her mother after the war ended:

> Up to 1939 Hitler sent messages to me that I should come back and when I refused they said that they had means to make me very unhappy. I knew that they meant you and I nearly went crazy with fear they would take it out on you.—
>
> You must have had great courage—all through those years. Liesel told me that you had Jewish friends in your apartment.
>
> Considering the fact that you were constantly watched—that was wonderful of you.—I only hope that I can make good someday all the hardship you had to suffer on my account.—Should anything come up where you need help please tell it to whoever brings this letter—or Miss Craven at the radio station. She can let me know right away.

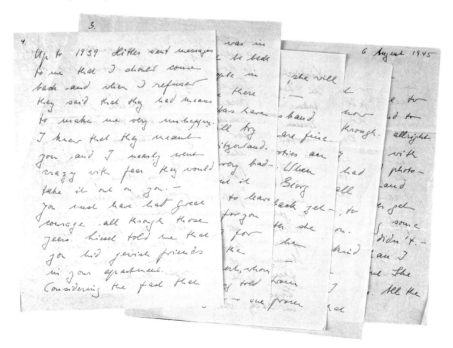

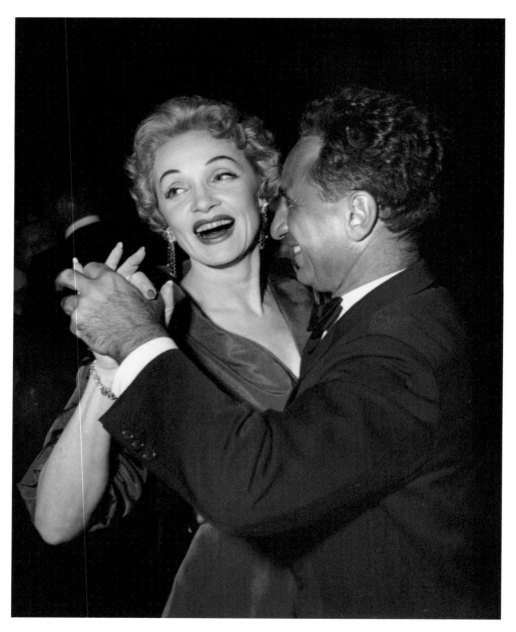

Elia Kazan, a bit too short but obviously enjoying himself, during the period of his *Streetcar Named Desire*. (Photographer unknown)

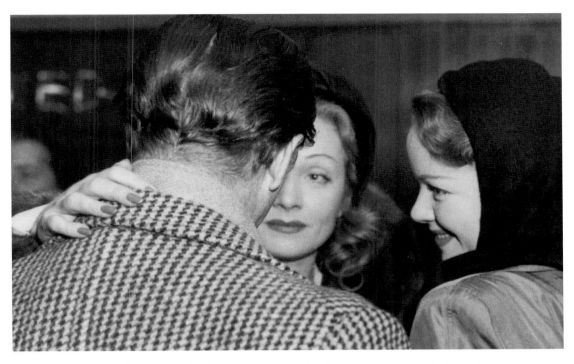

A good-bye between husband and wife in 1946, with daughter looking on. (Bordfotograf)

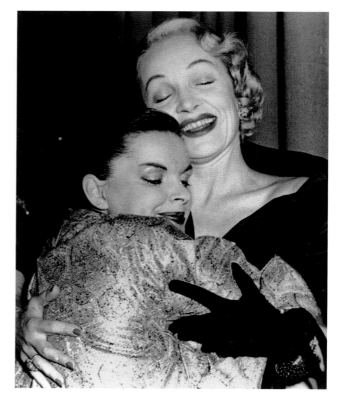

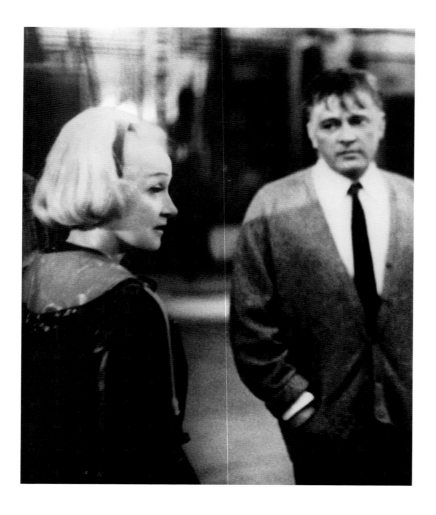

ABOVE: The congratulatory hug was recorded backstage after Judy Garland's opening night at the Palace, October 1960. (Photographer unknown)

LEFT: Meeting Richard Burton for the first time on the set of *Who's Afraid of Virginia Woolf?* (Photographer unknown)

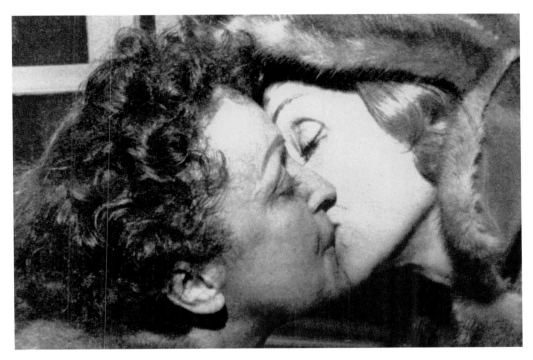

Another opening, another enchanted member of the audience—this time with a kiss of appreciation for her girlfriend Edith Piaf. (Photographer unknown)

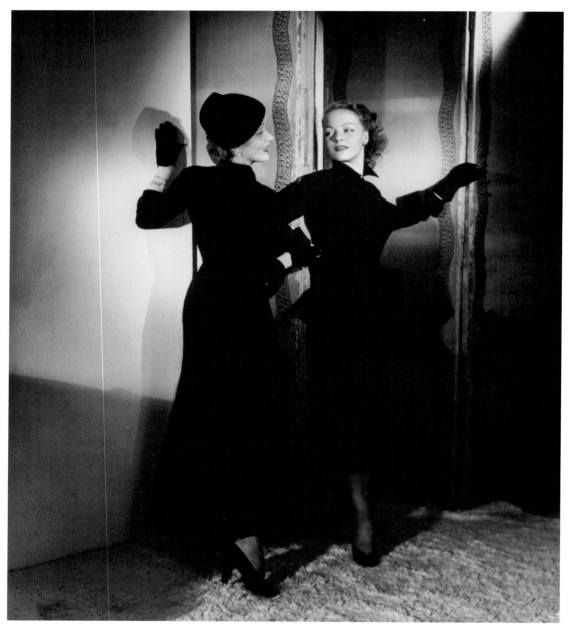

Posing with her daughter, both in Dior's "New Look" splendor, for the photographer Horst
P. Horst and *Vogue*, 1950s.

Her first year as a grandmother, taken in Alexander Liberman's kitchen by his wife, Tatiana. New York City, 1948.

Possessions

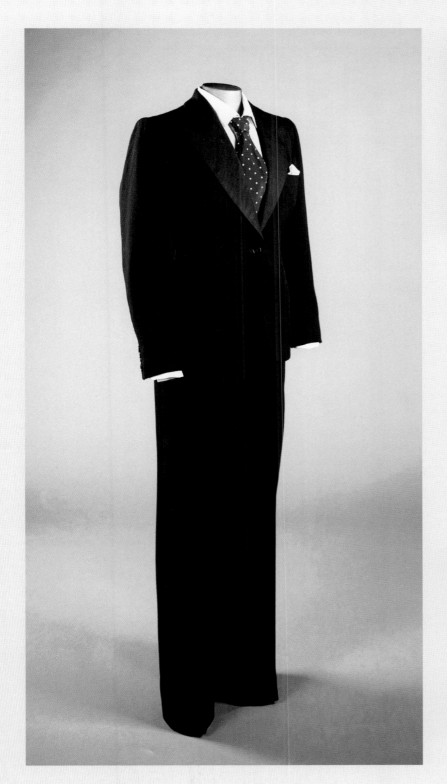

LEFT: This evening suit, made by Watson & Son—known in Germany as a "smoking" mostly from the Roaring Twenties Prohibition movies—was one of many made by a legion of men's tailors that Marlene kept in stock.

ABOVE: These starched cuffs were made for her many dress suits. Their buttoned fastening was hidden inside the sleeve, which not only aided the fast costume change from woman to man but also ensured the smooth fit of the tailcoat by eliminating shirtsleeves. Though costume jewelry was always worn with stage costumes, for Marlene's favorite white tie and tails, the cuff links were always her own—from Cartier, Van Cleef & Arpels, or Trabert & Hoeffer—and, therefore, real.

BELOW: 1930s. Handmade of calf and alligator in Paris by Pinet to be worn with Knize suits. In the thirties no men's shoes were ever made in women's sizes unless to order.

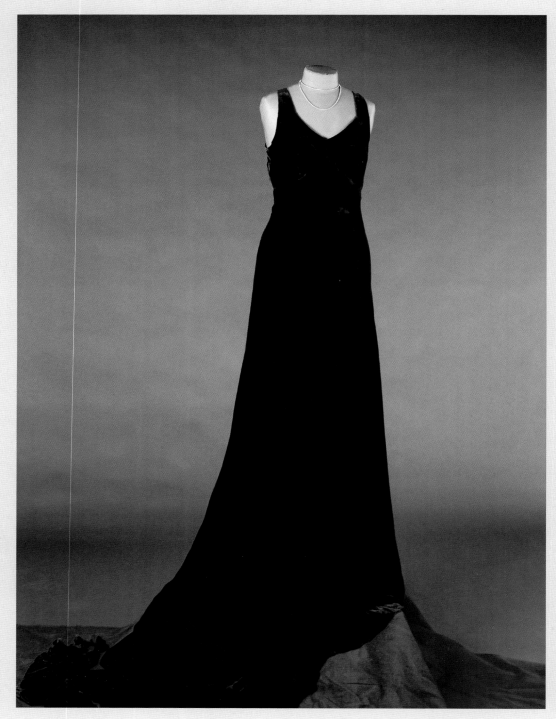

1930s. This may be a classic example of the couturier Madeline Vionnet: of silk velvet, its train tapered, descending from a waistless bodice reminiscent of Edwardian style. Labels were often removed to avoid having to pay duty when returning to America.

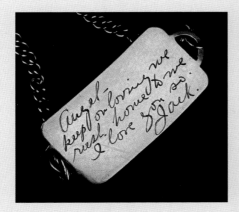

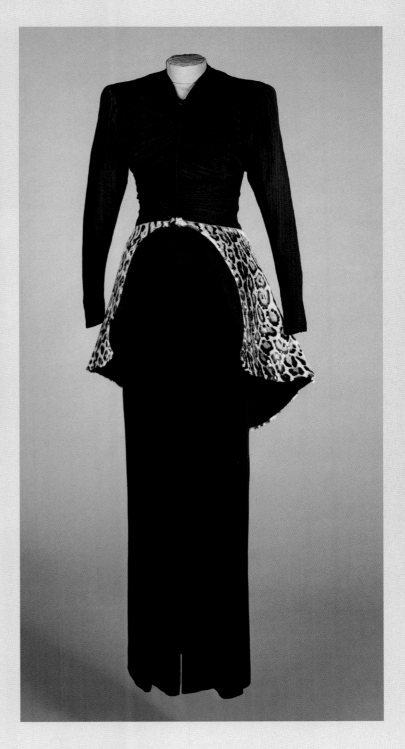

TOP LEFT: When anklets were very new, this one, with its endearing message, "Angel—keep on loving me, rush home to me, I love you so. Jack," was given to Marlene by John Gilbert.

TOP RIGHT: A solid gold Flato cigarette case probably given as an end-of-filming gift, as its monogram would not have been Marlene's choice.

ABOVE LEFT: Many believed Marlene should have become a director. Maybe if she had lived in another era she would have. This replica of a director's chair, its front engraved with her name, on its back "The Directors Guild of America," was presented to her by Joe Pasternak, the producer of *Seven Sinners*. Note the female symbol of a handbag hanging on the chair.

ABOVE RIGHT: Massive golden brooch adorned with brilliants, believed to have belonged to Sarah Bernhardt. Bought for Marlene at auction by the president of Condé Nast, it was a gift she treasured.

RIGHT: 1930s. For a star identified as foreign and therefore excitingly mysterious to American audiences, shopping in Paris was an essential activity. As Garbo was the only other foreign star of note and no one ever wrote about what she wore, Marlene had a clear field. The dress is by Molyneux.

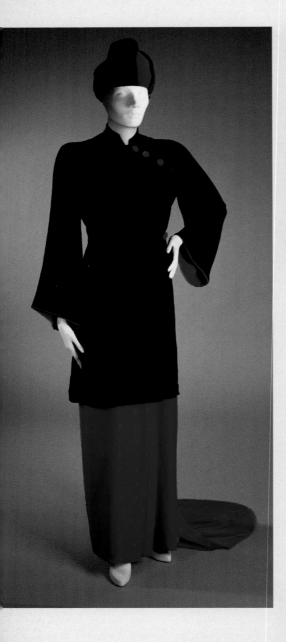

LEFT AND ABOVE: The black silk velvet and matte jersey oriental-motif lounging ensemble with pompom closure suggests Patou.

RIGHT: This silk chiffon negligee imported from Paris was to be used in *Desire*. After it was condemned by the censor as too risqué, Marlene kept it for herself.

BELOW: In the days of daily couturier fittings, women wore undergarments such as these. The monogram in palest pink-beige satin stitched upon the gossamer silk crepe panties, their side closure of tiny hooks and eyes slightly offset from the all-important hipline—these were rarely worn: they were considered necessary for "on show" stardom but too "froufrou" for one who preferred trousers in everyday life.

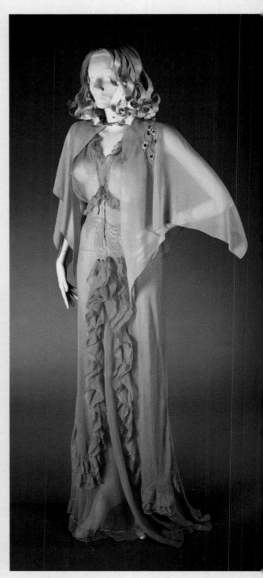

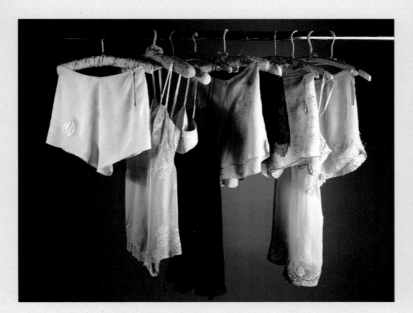

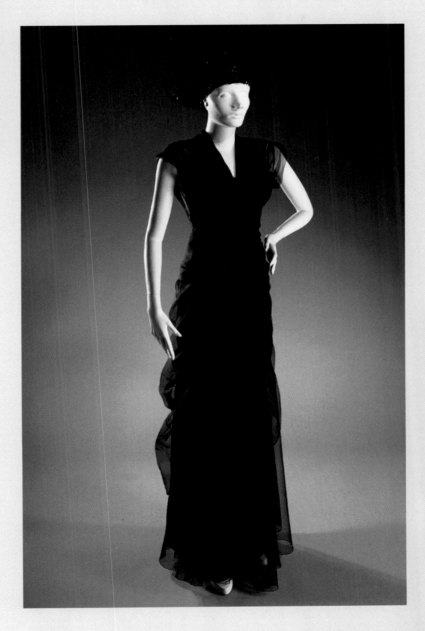

LEFT: 1940s. A favorite evening dress of slightly stiffened silk chiffon from Italy. The fabric was no longer available at the time because of the war in Europe; Irene made this from the last bolt found in the workshop of Bullocks Wilshire.

TOP LEFT: Detail of its ruffled front closure indicates how very thin Marlene was at the time.

BELOW: Front and back view of brooch with castanets motif made for Marlene in 1935 by the crew of *The Devil Is a Woman*. On the back the dedication refers to the film's shooting title, *Caprice Español*.

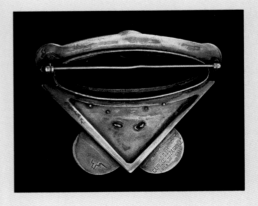

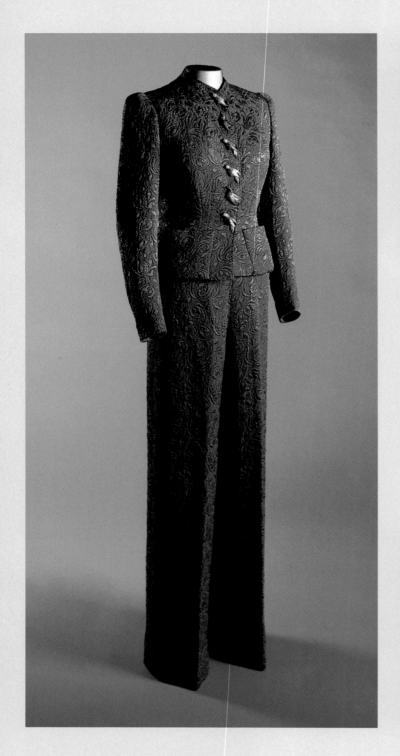

LEFT: A lounge suit of bouclé silk made expressly for publicity interviews. The unique parrot buttons (ABOVE) mark this as one of Elsa Schiaparelli's designs.

BELOW: This early 1900s lapis-lazuli-enameled gold cigarette case was von Sternberg's gift at the completion of *The Blue Angel.* Its exterior is embellished by diamond hinges; its two halves open like doors, displaying cigarettes and an inscription that reads: "Woman, Mother, and Actress, as never before."

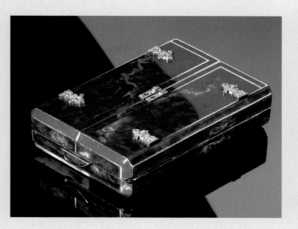

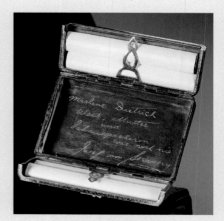

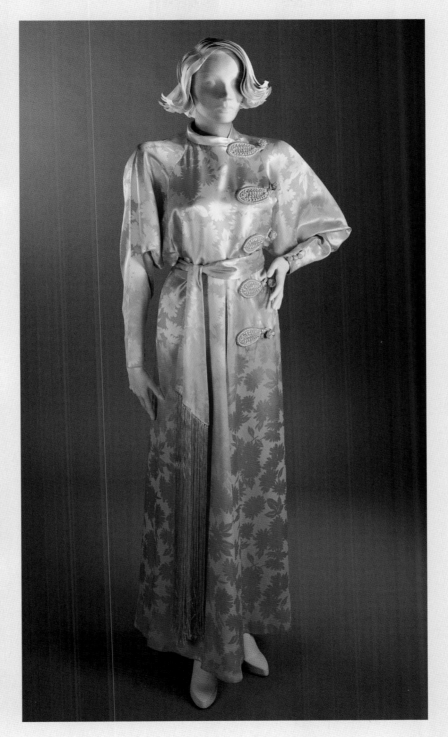

FAR UPPER LEFT AND LEFT: 1938. Dressing gown of satin velvet. The Asian-style toggle closures suggest it was designed by Alix.

FAR LOWER LEFT: Acquired after she arrived in Paris wearing trousers (which were banned) and worn only with Irene suits, this René Boivin cuff bracelet of Indian sandalwood and gold studs retains its haunting perfume to this day. Inscription on the inside: "À Marlene Dietrich, la Police de Paris reconnaissante, le Préfet Jean Chiappe, 13/6/33."

FAR BOTTOM LEFT: Cartier. Small matchboxes with decorative covers were placed alongside small ashtrays at each place setting at fancy dinner parties in the 1940s. This one, of 14 karat gold, was a treasured gift.

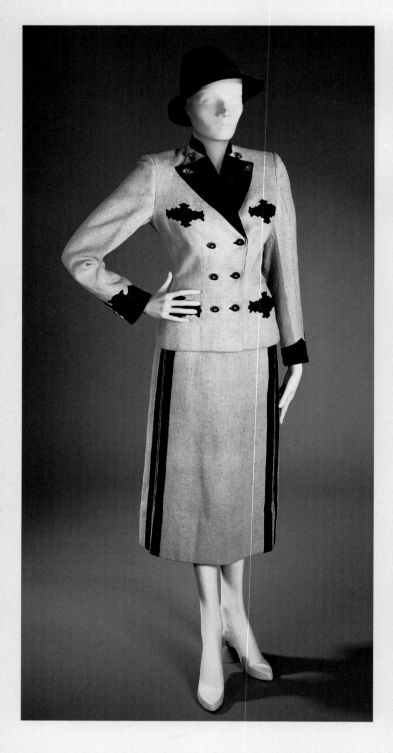

ABOVE LEFT: Gold pocket frame. Both images are imprinted onto the gold surface. Whether Douglas Fairbanks Jr. gave this to Marlene or she gave it to him only to have it returned when their romance ended is unknown.

ABOVE RIGHT: Solid gold compact and matching cigarette case, gifts from Douglas Fairbanks Jr., with jeweled emblems commemorating special occasions during their love affair. His nickname for her, "Dushka," is written in his handwriting on the lid.

LEFT AND BELOW: Tyrolean costume of raw beige linen, decorated with forest green felt appliqué and genuine stag buttons. Austria, 1930s.

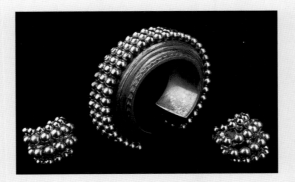

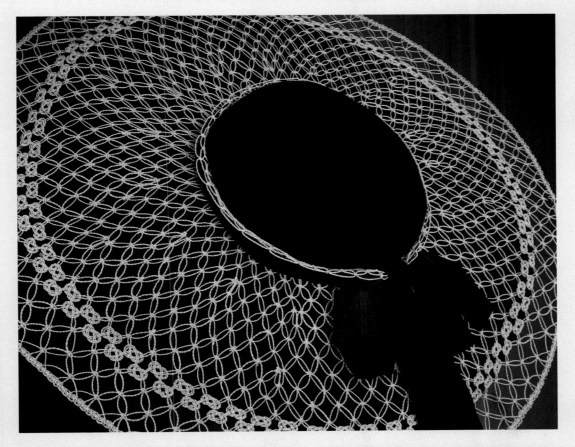

TOP: 1940s. Cartier. Silver cuff bracelet and matching ear clips worn for the Irene suit and large Panama hat portrait taken by Horst for *Vogue* magazine.

MIDDLE: Made by the French milliner LeGroux for *Martin Roumagnac*. Much too ostentatious for a "woman of the people" in a French provincial town, it was never worn in the film.

BOTTOM: Wartime ID bracelet given by "the brute" (Gabin) to his angel (Marlene)—by Cartier, of course.

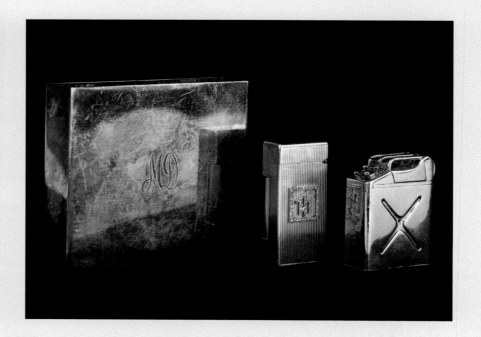

TOP LEFT: 1940s. Given to Ernest Hemingway at the beginning of the war. (Whether it was returned to her after the war ended or after his death in 1962 is unknown.)

TOP RIGHT: Left to right: The gilded box and the gold and rhinestone Dunhill lighter are easily identified as given gifts for they bear the inevitable monograms Marlene disliked. But the cigarette lighter on the far right was her very own and very special. Made for her by the 1940s jeweler Flato to her own specifications in the shape of a military gas can (known by both the British and the American armed forces as a "Jerry can"), it was the only cigarette lighter she carried from then until she stopped smoking in the 1960s.

BOTTOM: Marlene always told her daughter: "Most children inherit medals from their father; you will inherit them from your mother." Top row, left to right: Ordre pour le Mérite (France), Ordre Nationale de la Légion d'Honneur: Commandeur (France), Operation Entertainment medal (United States), Ordre des Arts et des Lettres (France), Medallion of Honor of the State of Israel. Bottom row, left to right: Ordre Nationale de la Légion d'Honneur: Officier (France), Medal of Freedom (United States), Fashion Foundation of America award, Chevalier de l'Ordre de Léopold (Belgium), Operation Entertainment Medal (U.S. Armed Forces).

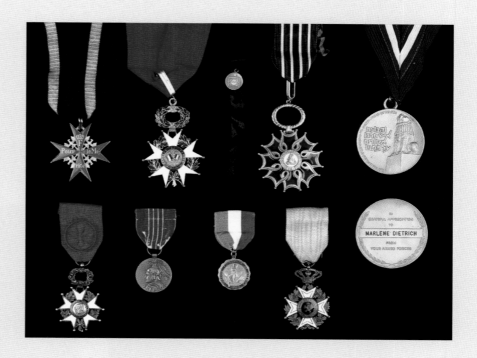

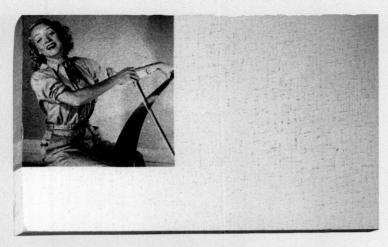

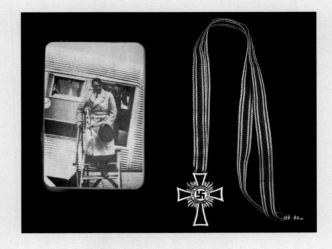

TOP LEFT: One of thousands of such autograph blocks depicting Marlene in military khaki playing her musical saw, used during the war years to sign and hand out to eager GIs.

TOP RIGHT: The photo handed to her by a Nazi in Spain and the Order of Glorious Aryan Motherhood she said was presented to her by an envoy of Hitler's in 1938. Found among her stored papers. Her comment? "The unbelievable chutzpah of those bastards!" (Inscribed "16 December 1938 A. Hitler.")

MIDDLE: War souvenirs were forbidden to be brought back home to America, yet these pistols—the pair probably from General Patton—were found among Marlene's treasured war mementos.

BOTTOM LEFT: Having learned to play the musical saw in Vienna in the 1920s, she got this one (engraved with "Now Suidy is gone the sun don't shine . . . Vienna 1927") from her lover Igo Sym (who acted with her in *Café Electric*), and carried it with her to America. Years later, in its patent leather carrying case, it accompanied Marlene back to Europe to entertain the Allied troops.

BOTTOM RIGHT: Marlene's first set of U.S. dog tags for overseas duty. "Marie M Sieber, U.S.O. T44, A.P."

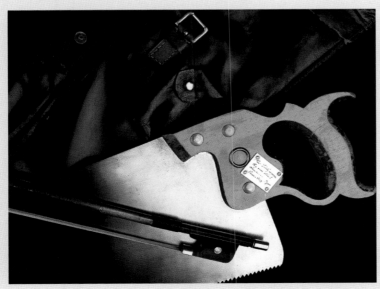

TOP LEFT: This unique bracelet made in the 1930s was a family joke. As European men insisted on kissing Marlene's hand in homage even when she was wearing gloves, the idea was to give such cavaliers something better to kiss than leather. Of course she rarely wore it, but secretly wished she could whenever she was in Austria.

TOP RIGHT: Bakelite poker chips bracelet given to her by Frank Sinatra during one of their Las Vegas rendezvous.

BOTTOM LEFT: In 1942, while filming *The Lady Is Willing,* Marlene tripped and fell during a scene in which she was carrying a baby. Twisting her body to protect the child, she broke her right ankle. Determined not to hold up production, she returned within days of the accident, and finished the rest of the film wearing what was standard in those days—an overlong heavy plaster walking cast, which she managed to manipulate. It was visually camouflaged so well when the film was edited that no one noticed it. This gold pin, specially made in Hollywood to commemorate her heroic professionalism, was presented to her by cast and crew. She especially loved that they had thought to place real rubies on her toes to simulate red nail polish.

BOTTOM RIGHT: The "coolie" doll given to Marlene by von Sternberg to bring her luck. It joined her favorite "savage" doll in numerous films.

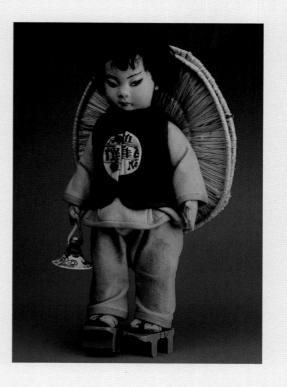

TOP LEFT: One of several portable typewriters, a gift from Noël Coward, that Marlene traveled with over the years.

TOP RIGHT: A sample collection of the many diaries given to Marlene as gifts. Rarely used, as she preferred the uniform simplicity of the Letts one-page-a-day diaries, sometimes switching to those made by Smythson of Bond Street.

BOTTOM LEFT: Gold disk that once hung on a key ring, engraved in her own writing "1118 Child Street," which in 1948 referred to 1118 Lexington Avenue, her married daughter's address.

BOTTOM RIGHT: This heavy French rotary set sat on the bed beside one of her many Moroccan red leather telephone books, into which she would stuff odd scraps of paper bearing numbers that she could then never retrieve—or if she did, she would struggle to figure out to whom they might belong.

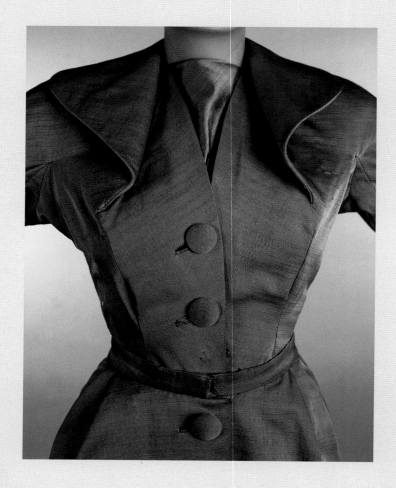

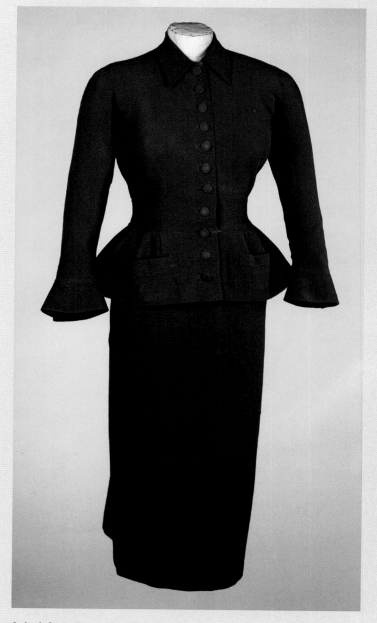

LEFT: 1950. Christian Dior. Although it's a rather dowdy look from the creator of the "New Look" explosion, she, being a new grandmother, bought it.

RIGHT: An example of Dior's "New Look" of the late 1940s, this wool crepe was worn in the portrait sitting of mother and daughter for Horst and *Vogue*.

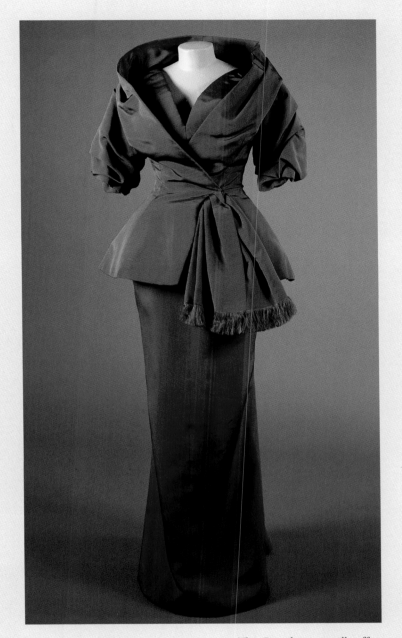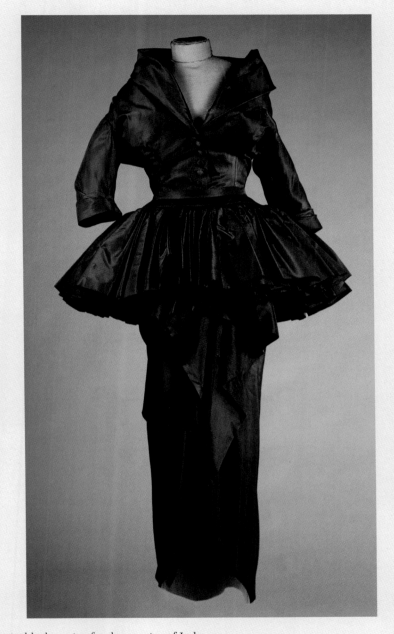

LEFT: This Dior design in silk taffeta was worn in its black version for the opening of Judy Garland's return to the Palace in 1952.

RIGHT: Private two-piece silk taffeta evening dress from the "New Look" era, worn for Broadway theater openings—when people still dressed for such occasions.

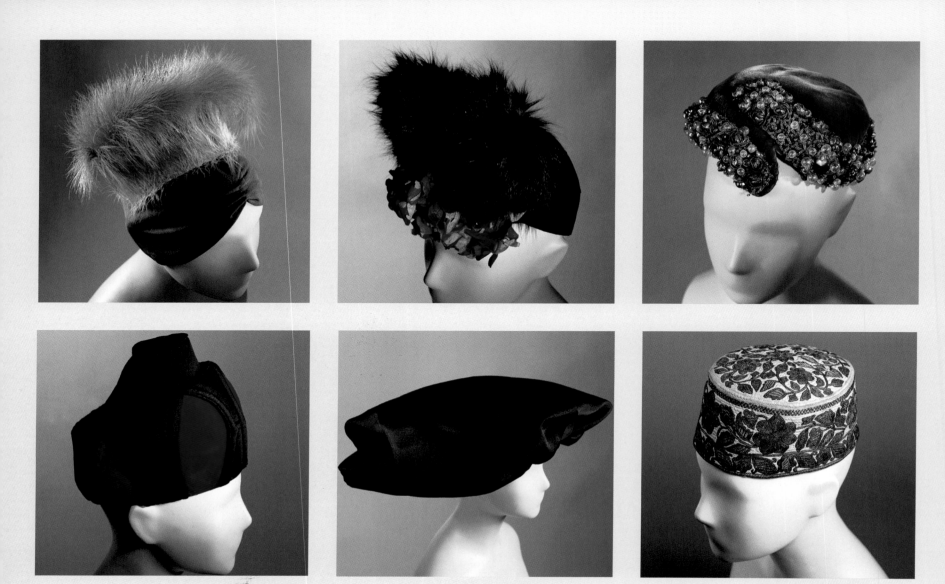

As ladies wore hats with everything, even evening wear, fittings were a daily duty at the millinery salons of Agnès, Lilly Daché, John Frederics, Caroline Reboux, Suzanne Talbot, and others.

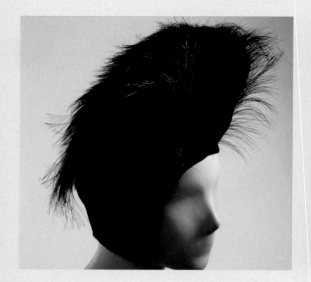
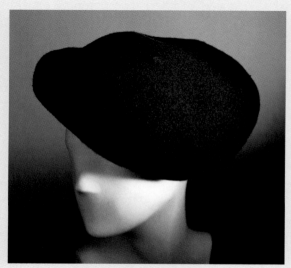
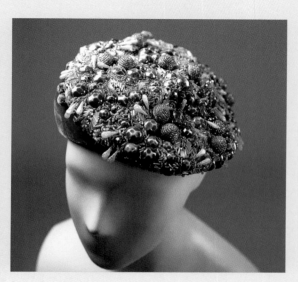

At Work

BELOW: *Café Electric* (*When a Woman Loses Her Way*), Austria, 1927, silent. By 1927 the identification of Dietrich and legs had become universal and would last throughout her lifetime.

RIGHT: *Prinzessin Olala* (*Princess Olala*), Germany, 1928, silent. By now a seasoned motion picture performer—she was allowed to wear her own negligee in the role.

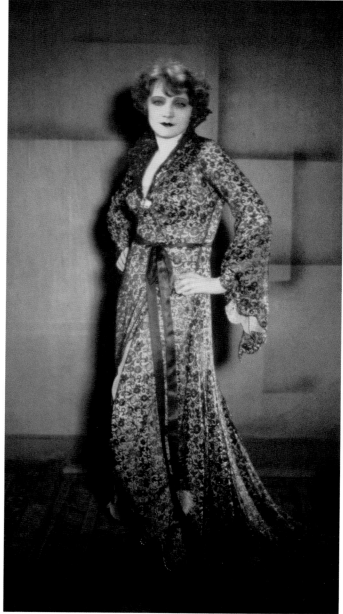

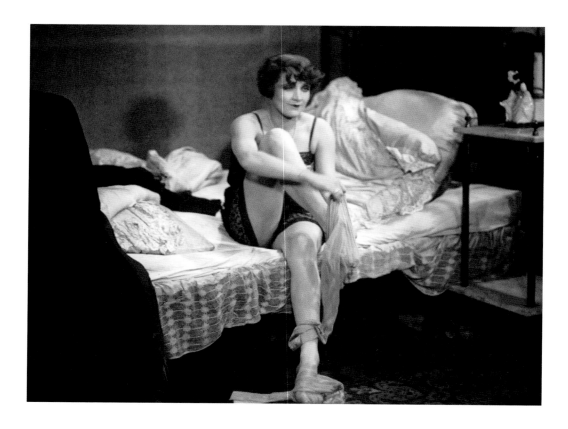

TOP LEFT: *Tragödie der Liebe* (*Tragedy of Love*), Germany, 1923, silent. Emil Jannings was the star; she, in a small part, played mistress. In later years she insisted she had never met the great actor—her role was so insignificant. She did meet her future husband, Rudolf Sieber, who was a production assistant for the film.

TOP RIGHT: *Der Sprung ins Leben* (*The Leap into Life*), Germany, 1924, silent. Newly married and pregnant, she played a small part—a girl on the beach. It was the only professional role Marlene ever appeared in wearing a bathing suit.

RIGHT: *Das Schiff der verlorenen Menschen* (*The Ship of Lost Souls*), Germany, 1929, silent. A German-French coproduction (French title, *Le Navire des hommes perdus,* released in England as *The Ship of Lost Men*). Here she shared billing with the star—although still below the title of the film.

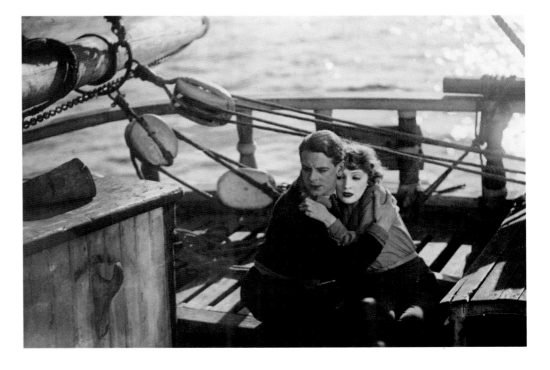

RIGHT: *Café Electric,* Austria, 1927, silent. A portrait taken on the set. Later, when she became known, reprinted as a postcard that her husband stopped the sale of.

BOTTOM LEFT: *Gefahren der Brautzeit (Dangers of the Engagement Period),* also known as *Aus dem Tagebuch eines Verfuehrers (From the Diary of a Seducer), Eine Nacht der Liebe (One Night of Love), Liebesnächte (Nights of Love), Liebesbriefe (Love Letters);* Germany, 1929, silent. As in American films, if a duo clicks, cast them together again. Willi Forst and Marlene, this time in lead instead of supporting roles. The silk flowers on her shoulder strap facing the camera were pinned there by her in the hope that they would shadow her fat upper arm.

BOTTOM RIGHT: *Ich kuesse Ihre Hand, Madame,* Germany, 1929, silent, released in the United States in 1932 as *I Kiss Your Hand, Madame.* Although a silent film, the famous tenor Richard Tauber's renditions of the popular song of the same title was used as incorporated sound. Through this, Marlene's infatuation with, and later enduring love for, Tauber began. This was to be Marlene's last silent film and her last as a member of the supporting cast. Soon her name would always appear above a film's title, the true position of a star.

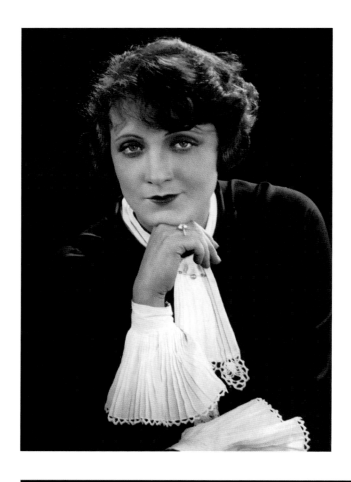

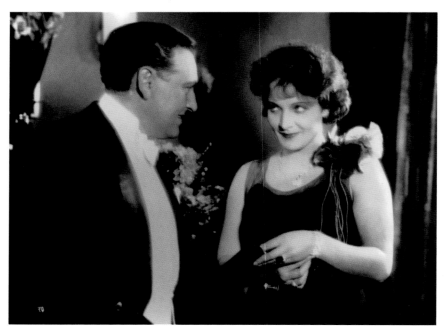

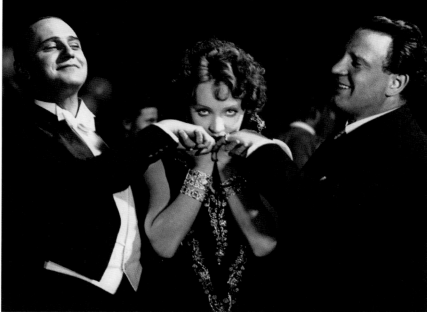

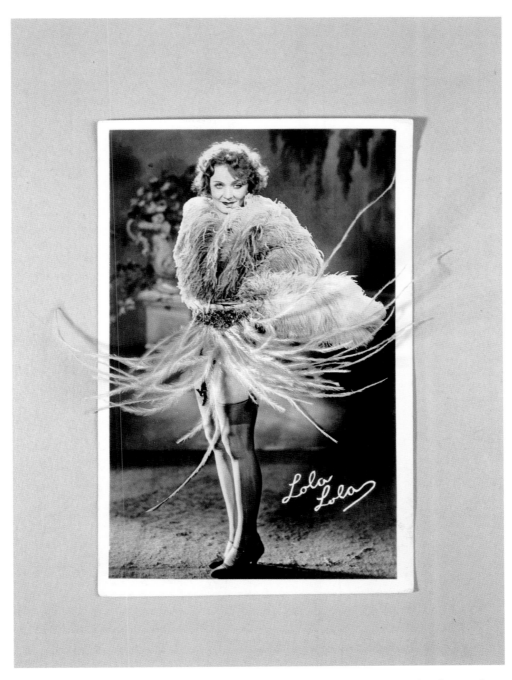

The actual postcard with its pasted-on feathers used in that famous moment in *The Blue Angel*.

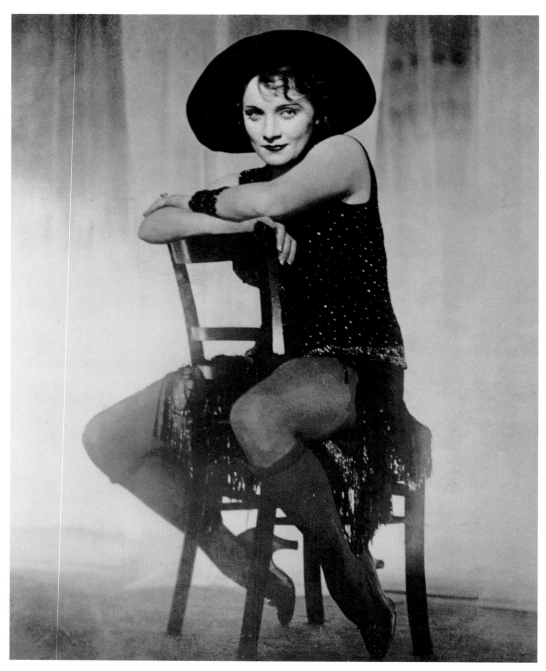

Der blaue Engel (*The Blue Angel*), Germany, 1930, an Erich Pommer-Production and Ufa-Sound-Film. The first German sound film—a landmark production even without the introduction of Marlene Dietrich in the role that would make her a world star—it was directed, constructed, and artistically conceived by an American hired by Ufa, Josef von Sternberg. Its German star, Emil Jannings, had just received the first Academy Award for his superb work in *The Last Command,* also directed by von Sternberg. With both principal men being familiar with and respecting each other's talents and temperaments, Jannings could concentrate on his unequaled performance, von Sternberg on his courageous choice of casting a young German actress to play his creation of Lola Lola.

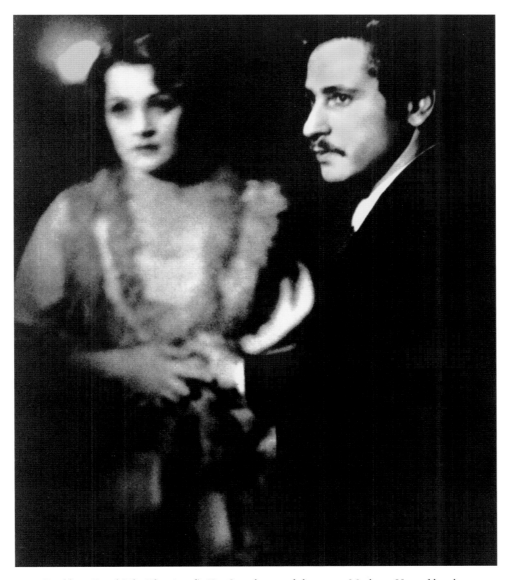

Der blaue Engel (*The Blue Angel*). Von Sternberg and the young Marlene. He and he alone insisted on hiring her for the role, then fell in love with her. This acknowledged master-piece of the art of film demonstrates the use of everyday sound as a contributing factor to a narrative's reality and, when needed, impact. Nowadays it is remembered mostly for the overwhelming presence of Marlene Dietrich, but it is important to note, as she herself maintained, that although without her the film might not be famous, its perfection would still remain intact.

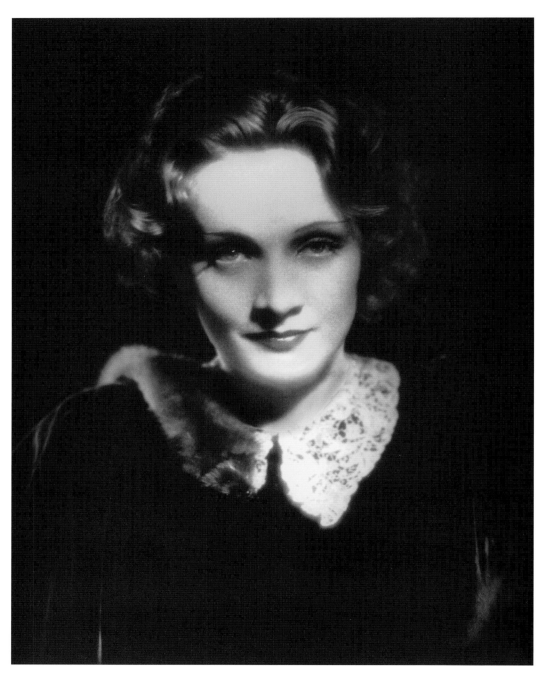

ABOVE AND OPPOSITE: Both of these stills were taken in one sitting at the time of *Morocco* in 1930. On the left, the soft uncertainty of a new arrival in a foreign land remains; on the right, by highlighting the hair, shadowing the eye sockets, elongating the nose, and instructing his star to think of all she has left behind, von Sternberg achieves the intriguing face of a mystifying woman. (Von Sternberg)

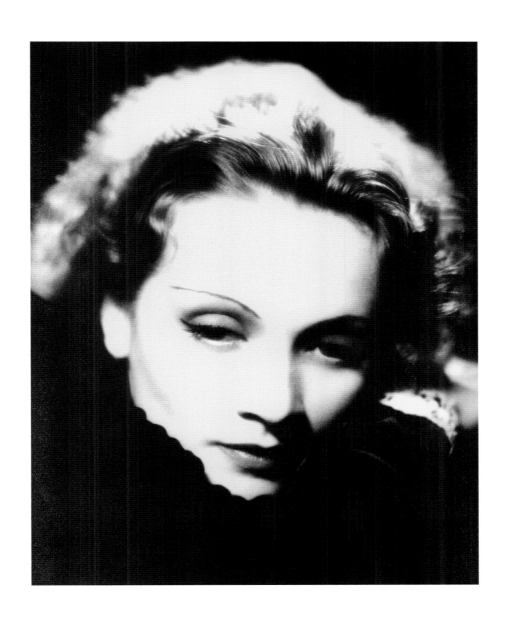

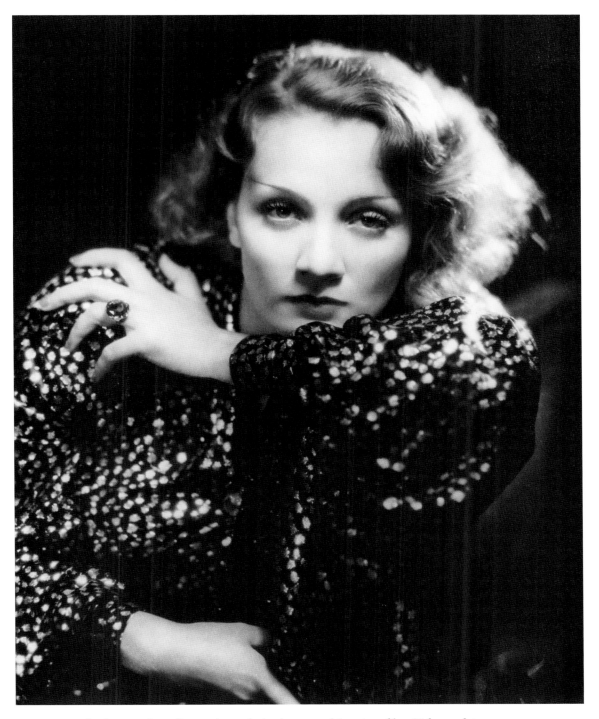

By the time this still was taken—during her second American film, *Dishonored,* in 1931—she had the "look" down pat. She is wearing the large sapphire given to her by von Sternberg after the completion of *Morocco.*

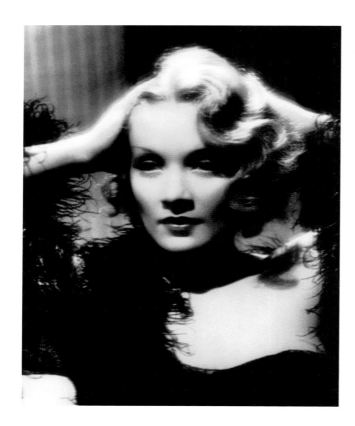

LEFT AND RIGHT: Two of the hundreds of portraits taken during the shooting of *Shanghai Express* in 1932, featuring perhaps her favorite look in the film—she in the feathered black chiffon negligee.

BELOW: This now modern pose was then thought too stark, the lips, eyes, and finger wave too defined.

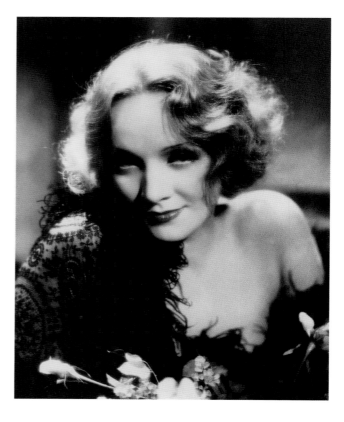

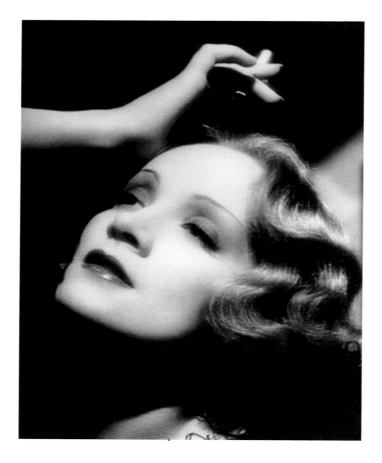

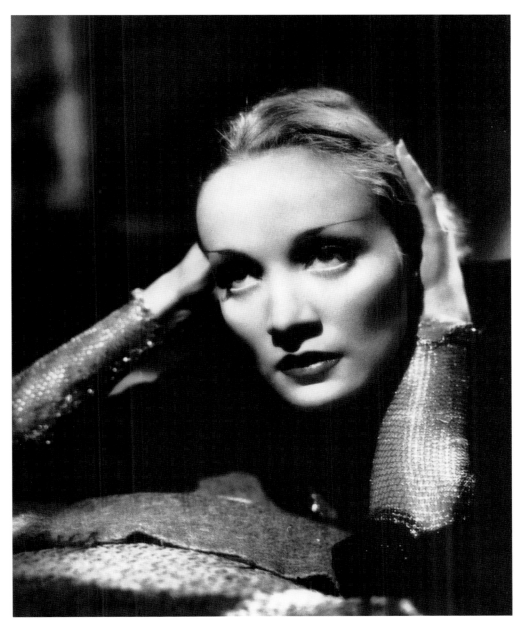

The staggering demand for ever new and ever more stills, needed for publicity and clamoring fans, often led von Sternberg and Marlene to try for something really new. She liked this pose, but objected to the highlights on the chin; von Sternberg thought the white grease-paint line on the inside of her eye this time too obvious, but released the photo anyway.

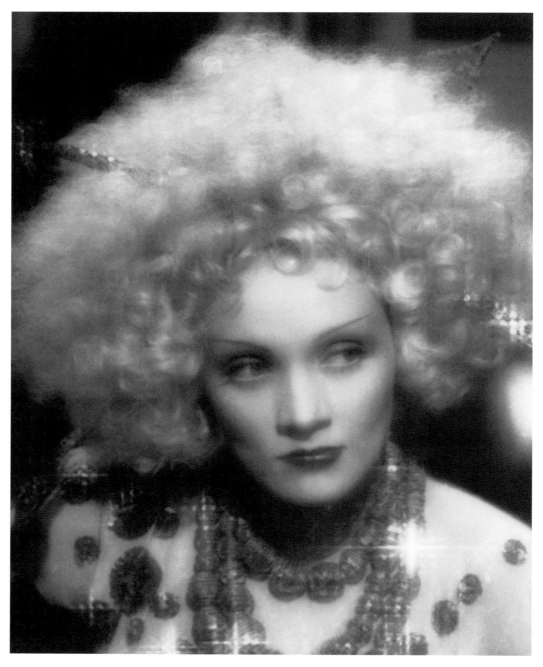

Blonde Venus, 1932. She put on this fuzzy-wuzzy wig in the voodoo scene, after removing the full head of a gorilla and before pulling off the body suit—emerging from it in a revealing, sparkling costume. This metamorphosis of swaying gorilla into spectacular woman was first thought too erotic to pass the censors, yet after much discussion within the studio and censorship office it was allowed. This image and that of her first white tails are two images most remembered from this film, although her favorite was the whore outfit with the torn lace blouse and cherry-trimmed hat.

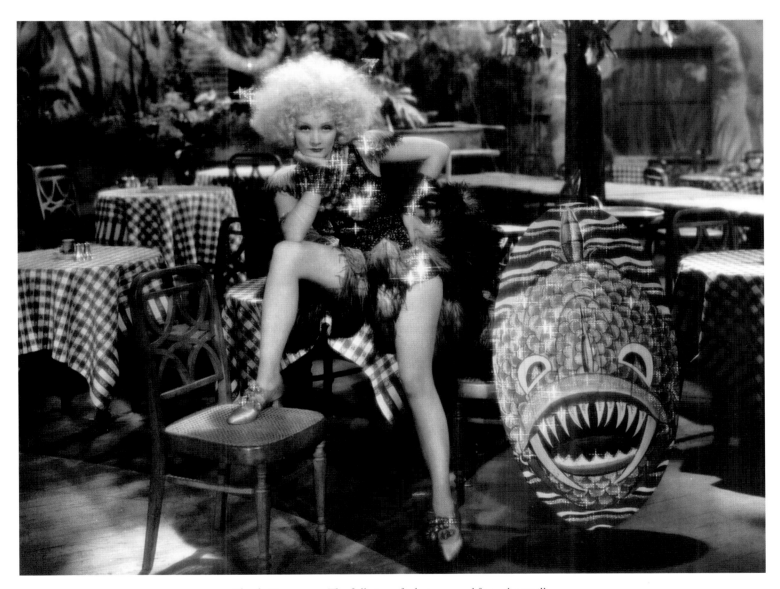

Blonde Venus, 1932. The full view of what emerged from the gorilla.

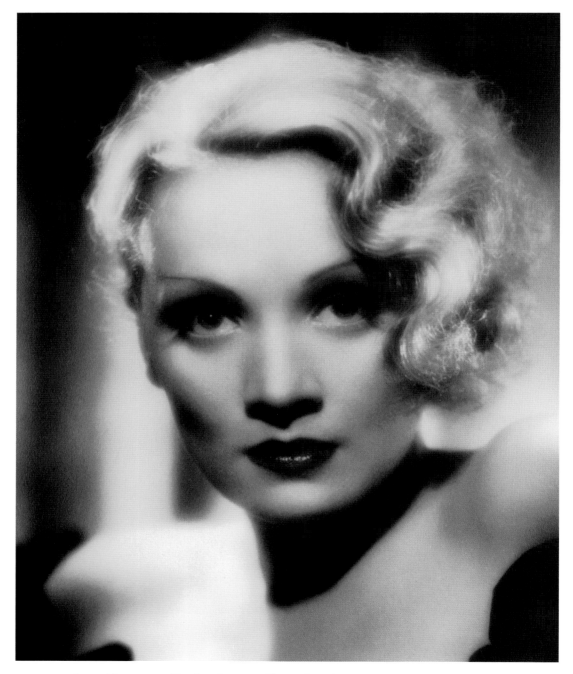

Song of Songs, 1933. The first American film made without von Sternberg; each day was a struggle. Although she rather enjoyed the "Miss Strict" atmosphere on the set, she knew the film was a disaster from the start.

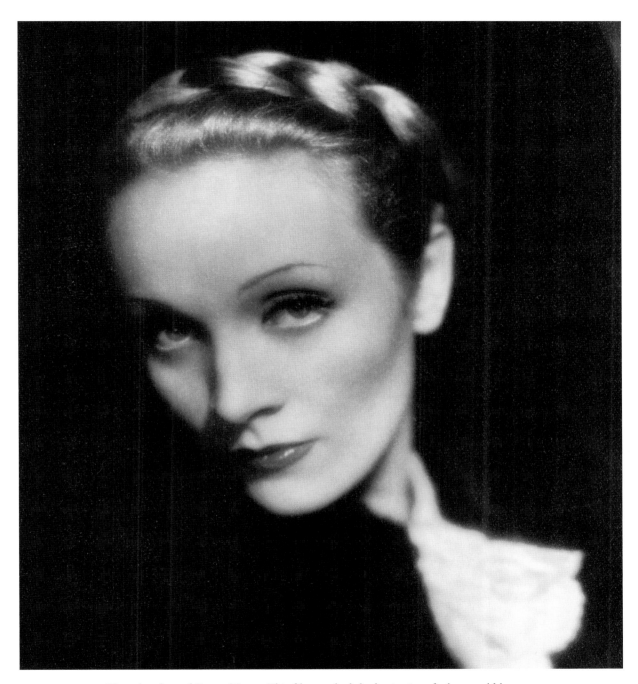

The other face of *Song of Songs*. This film marked the beginning of what would become her lifelong dedication to protecting and perfecting what von Sternberg had created. The lighting in both of these portraits shows what a great pupil she was, what she had learned from the master.

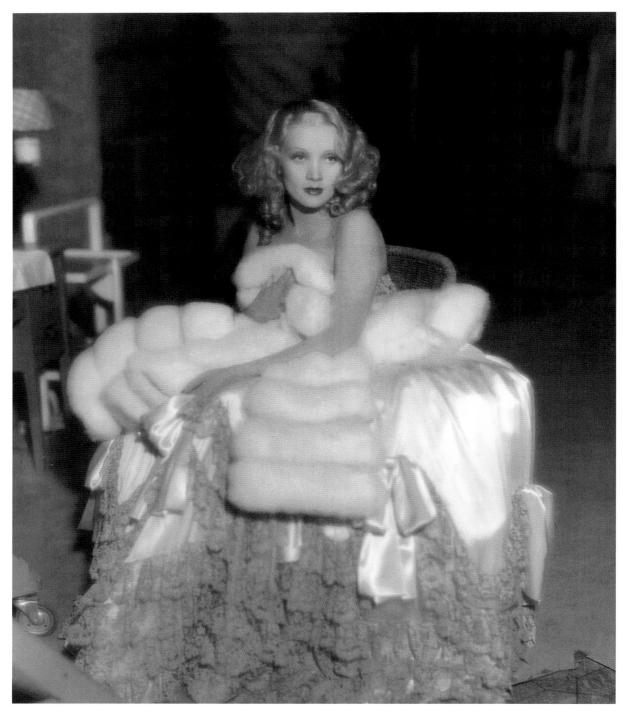

One of her favorite films was *The Scarlet Empress,* which reunited von Sternberg and his star in 1934. Every costume was superb, every camera angle sublime, and overall it was visual perfection. In some scenes she was even allowed to act a little.

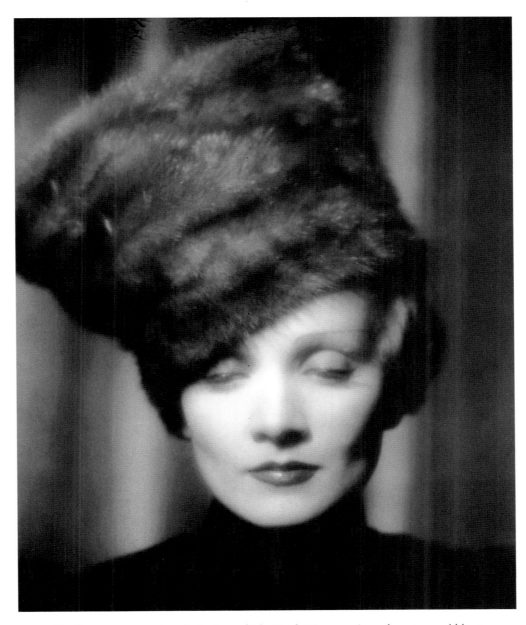

The face most remembered: the icon of *The Scarlet Empress*. Any other star would have worn that fabulous mink with feminine curls—not Dietrich!

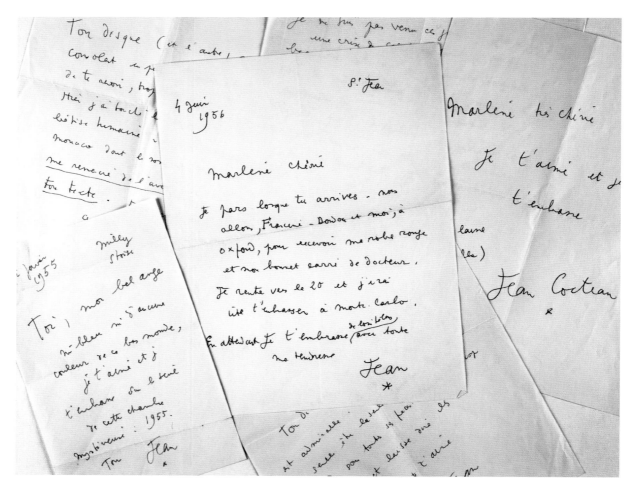

Jean Cocteau and Marlene were always great chums, sharing tastes and an admiration for men, art, and fashion. Over the years they wrote to each other, and usually Cocteau told her where he could be reached, if she would just call:

> My dear Marlene, I think of you without end, so noble in this ignoble epoch. . . . I am living at 36 rue de Mont Pensier . . .

> Here I am immortal, that is to say I will die shortly—and I would like to hold you before I die. Awaiting this sweet moment, I am playing and replaying your record, I know it by heart in the proper sense of the term. . . . This week I am at Santo Sospir, St. Jean Cap Ferrat. . . .

Kurt Weill, the famous German writer and lyricist, wrote
from Louveciennes in France:

1st December 1933
Dear Marlene Dietrich

 I am sending you as a small New Year's gift the manuscript of the song that I wrote for you in the fall. If you have it played for you, tell the pianist he should look it over a little before. I do not know if the key is correct, in any case you have to sing it one octave lower than it is written.

 I want to thank you again for your telegram and to tell you how happy it makes me to think of working with you and Sternberg. . . . Unfortunately, I haven't heard a word for one and a half weeks. In my last telegram, I begged Sternberg to have Paramount make me an offer. . . . I know the price I can get here (in Berlin a year ago I had command of a contract for the film *Little Man, What Now?* for 20,000 marks), but I do not know how that compares with what is paid in Hollywood. Perhaps you could give me some advice, as for over there you are better informed. . . .

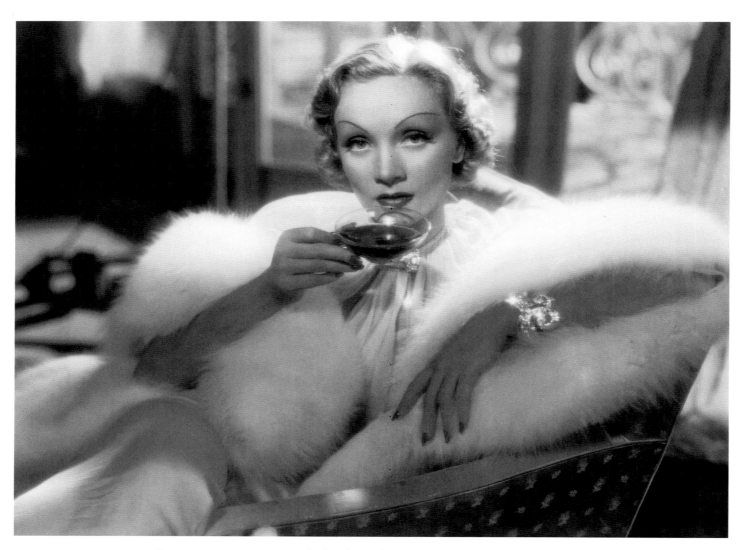

Desire, 1936, a romantic comedy that demanded little and could just as well have been played by Carole Lombard with a foreign accent. The film marked the year Dietrich took over "Dietrich" as her personal duty. Marlene and Travis Banton concentrated on creating a series of breathtaking looks that only Dietrich could do justice to and in which she triumphed every time. Each costume designed for this film has stood the test of time and fashion's quirks.

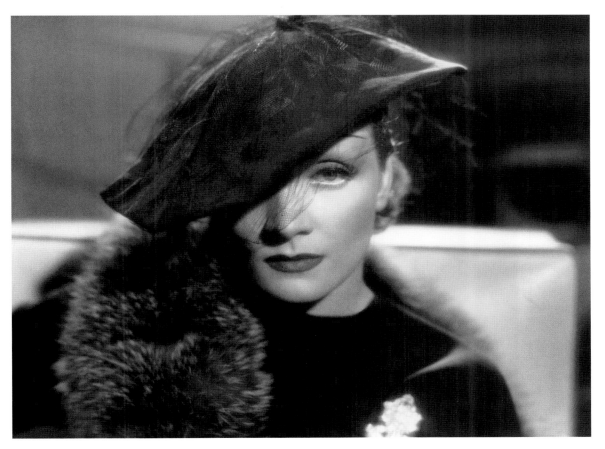

The face of *Desire* created by Marlene, who remembered the lessons learned from her mentor very, very well—except that he would have retouched the side of her neck to bring out the beauty of her jawline. In the film, Marlene wore her own collection of Cabochon emeralds and diamonds.

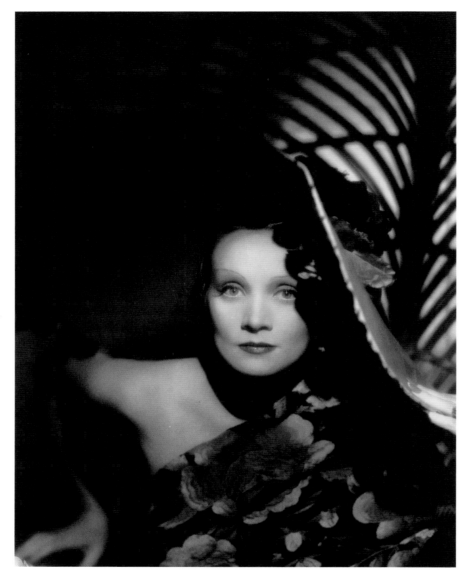

The Devil Is a Woman, 1935, her last film with von Sternberg. This still was made before the film began shooting and before the now famous look for the film had been perfected. In contrast to what was finally so gloriously achieved, this image is interesting.

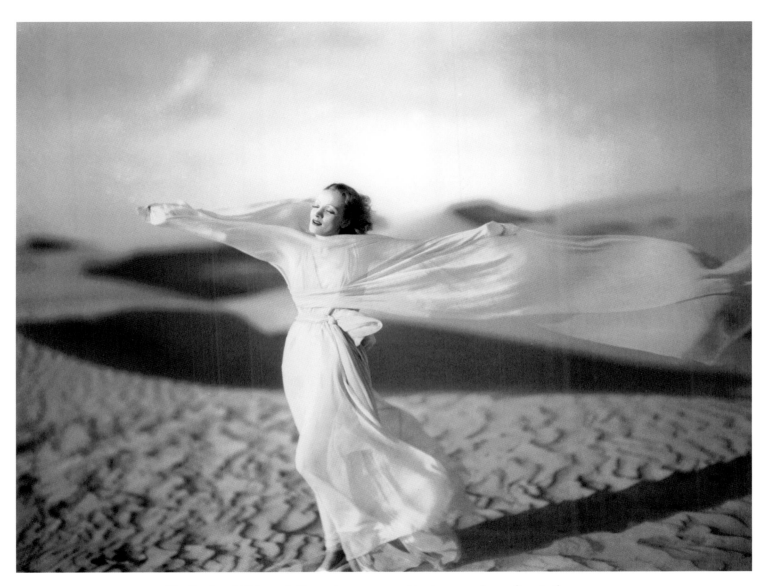

The Garden of Allah, 1936. The excitement created by the new color medium in the 1930s was such that everyone and everything on film appeared in glaring color, no subtleties allowed: fire-engine reds, sapphire blues, Beverly Hills lawn greens, egg-yolk yellows. Dietrich, on leave from her studio, contracted for her first color film, David O. Selznick's *Garden of Allah;* knowing that this was to be a film set mostly in the Sahara Desert, she decided—against all the expert opinions—to wear floating chiffon in the pastel shade of faintest desert beige, and thereby made Technicolor history. If this film is remembered (which is seldom), it is for its astounding use of muted color. Unfortunately, she was fighting so hard for the clothes, she never got around to creating a pastel palette for her makeup and hair.

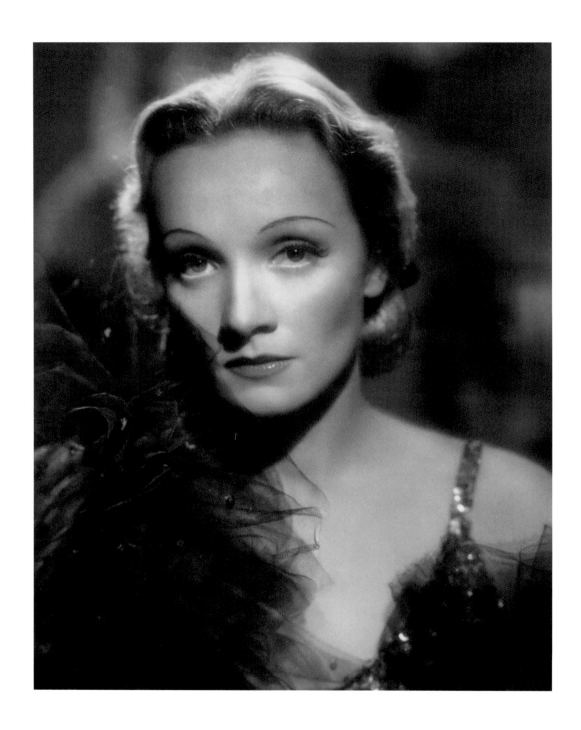

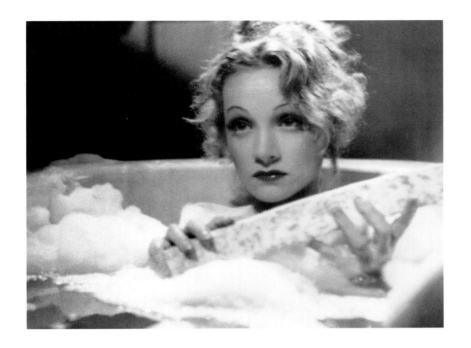

THIS PAGE AND OPPOSITE: *Knight Without Armour,* 1937. Her first British film (and her first bath scene), a disappointing experience. But she did her duty, collected the huge salary, during the filming tried to talk Edward VIII out of giving up the throne for nothing more important than a conniving woman, and left for Paris.

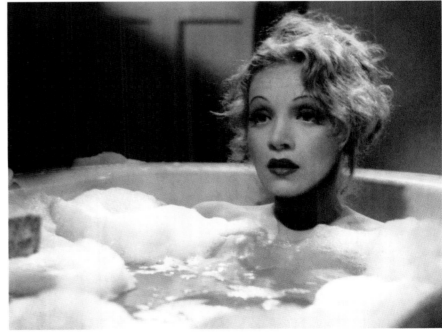

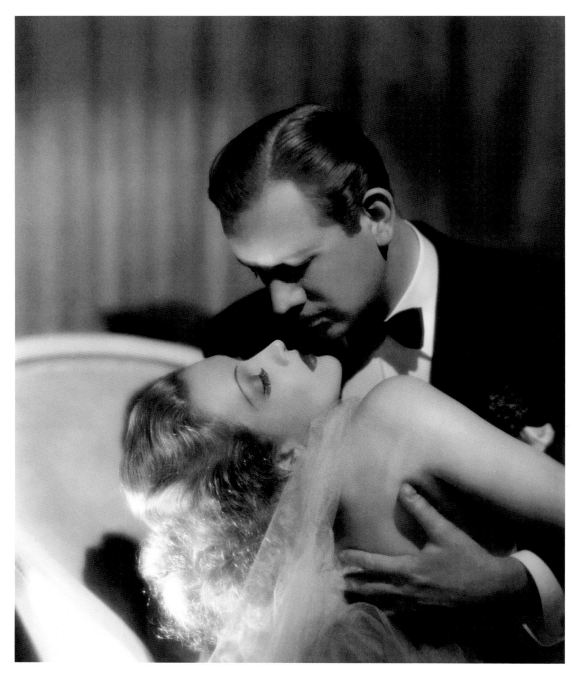

Angel, 1937, with Melvyn Douglas. Her last film as a Paramount contract star of the 1930s, by Ernst Lubitsch. Being called "box-office poison" and the release of this film complemented each other. Unfortunately, it is memorable only for its visual elements: a magnificent black velvet suit with its cascade of white silk ruffle at neck and wrists, a formfitting jewel-encrusted evening dress with matching mink-trimmed stole, a gray tulle strapless ball gown, and not much else.

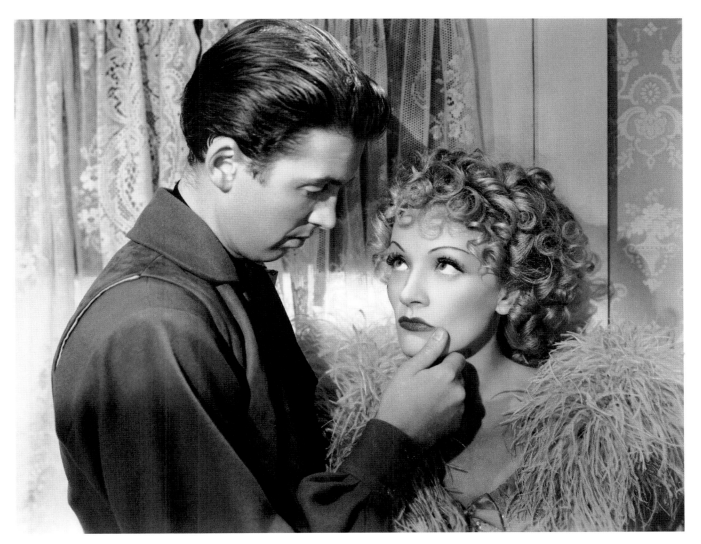

Destry Rides Again, 1939. With war imminent in Europe, in the summer of 1939 Marlene accepted an offer from a Berlin acquaintance, Joe Pasternak, to appear in *Destry Rides Again,* an American Western to be filmed at Universal Studios. Jimmy Stewart was to be the star, and the daunting task of "carrying" the film would be his, not hers. A good script, a very talented costar, and the veteran director George Marshall to show her the so-American ropes—she enjoyed herself tremendously. The film and her becoming an American citizen resurrected her career, and reestablished her stardom. She did what she always did—created costumes—and that is what gave the film the special look one remembers.

ARTISTS

They are a race completely apart from all other human beings.

Their emotions, all their feelings, their reactions are opposed to so-called "normal" people's sentiments. They are vulnerable and deeply sensitive people, due to their talents, their super-imagination, their knowledge of hidden influences of which we ordinary human beings are not. They are not easy to live with - if you choose to live with them at all, if you have the luck to meet them at all.

Writers, composers, painters - also artists like directors, and actors fall into the same category. They have to be handled with kid-gloves, mentally and physically. All their reactions go to extremes, compared to non-artistic human beings.
As I was lucky enough to meet and love and work for many, many artists, I learned, not without heartbreak and pain, to become a better, more intelligent, respectful and devoted person. No tears were wasted in the process. My tears - not theirs!

MD on artists—her typewriter, her rough draft.

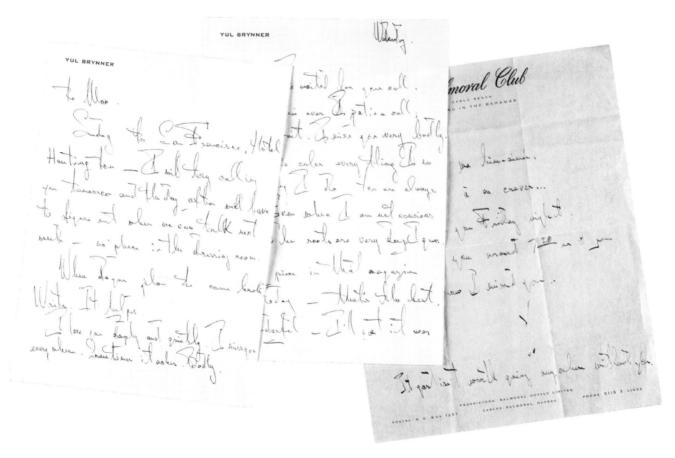

During their long love affair in the 1950s, Yul Brynner and Marlene had a secret code and pet names. Their love notes were exchanged via dressers (his) or maids (hers). Here he calls her Max:

> To Max
> Sunday to San Francisco, Hotel
> Hunting You—I will try calling tomorrow and the day after will have to figure
> out when we can talk next week—no phone in the dressing room.
> When do you plan to come back? Write It helps
> I love you deeply and quietly. I miss you everywhere. Sometimes it aches. Badly.

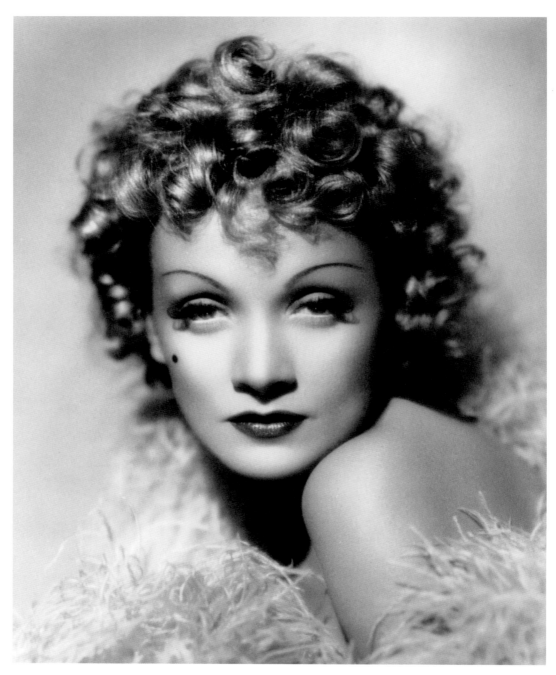

The Shirley Temple ringlets of *Destry Rides Again* (so reminiscent of her Leda and the swan ones), the borderline pout, the once mysterious look now slightly "come-hither," bedroom eyes under newly curved eyebrows—the Americanization of Marlene.

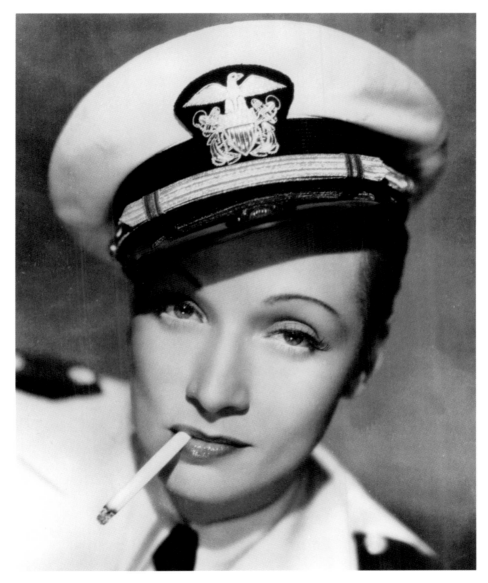

It took only the success of one film before Marlene once more took charge. This, for her favorite sequence in the 1940 *Seven Sinners,* is her naval officer's look. Her leading man, John Wayne, stood his ground in the picture, but never topped Stewart.

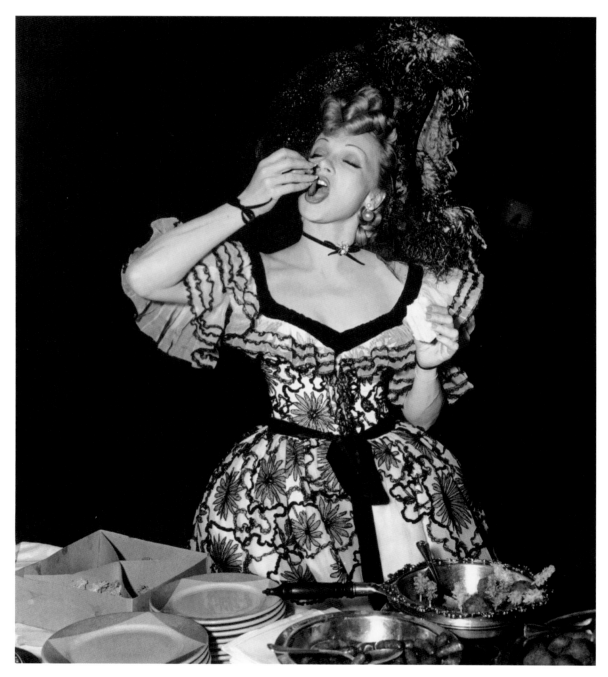

ABOVE AND OPPOSITE: *The Flame of New Orleans,* 1941. Playing a dual role—one a gorgeous lady of the evening, the other an equally gorgeous true lady—Marlene had the time of her life creating their distinctive period costumes and wigs. Bangs of course for the whore, upswept curls for the lady. With the French refugee director René Clair completely out of his depth and no costar to speak of (Bruce Cabot), nothing worked—but the costumes and Dietrich looked divine.

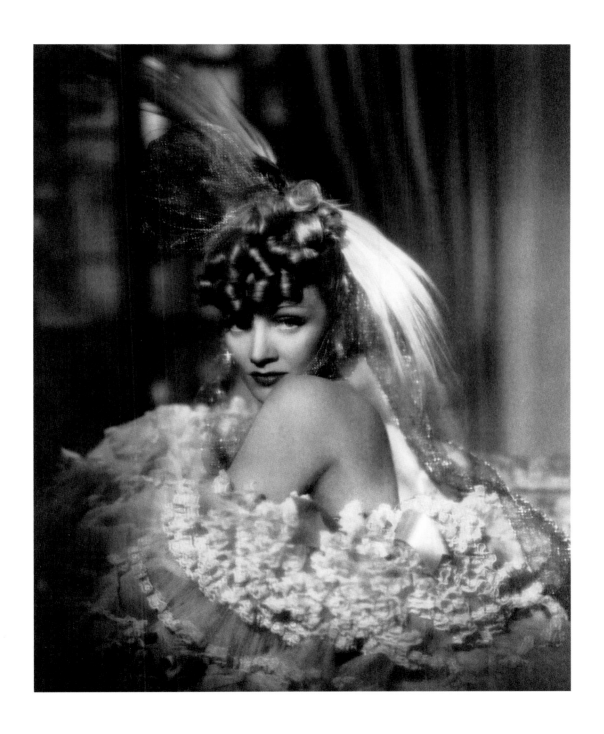

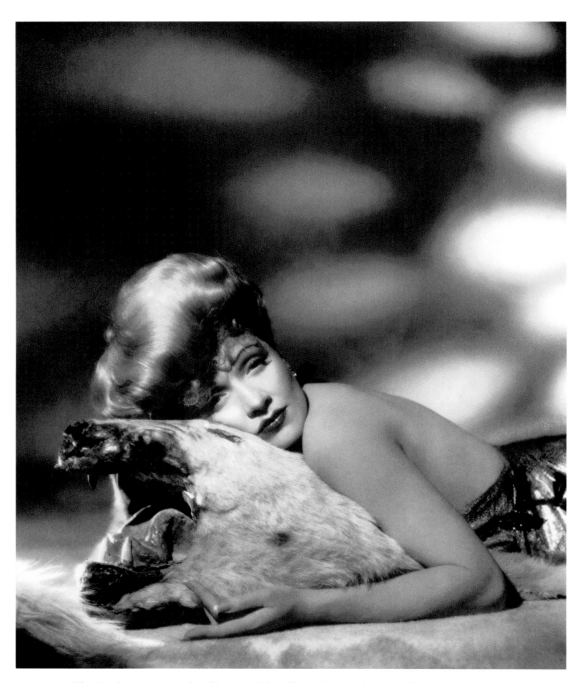

The Spoilers, 1942. Another film with John Wayne. By now bored with routine roles that required only a different hairdo to distinguish one from another, Marlene did her star duty, but without her usual inventiveness.

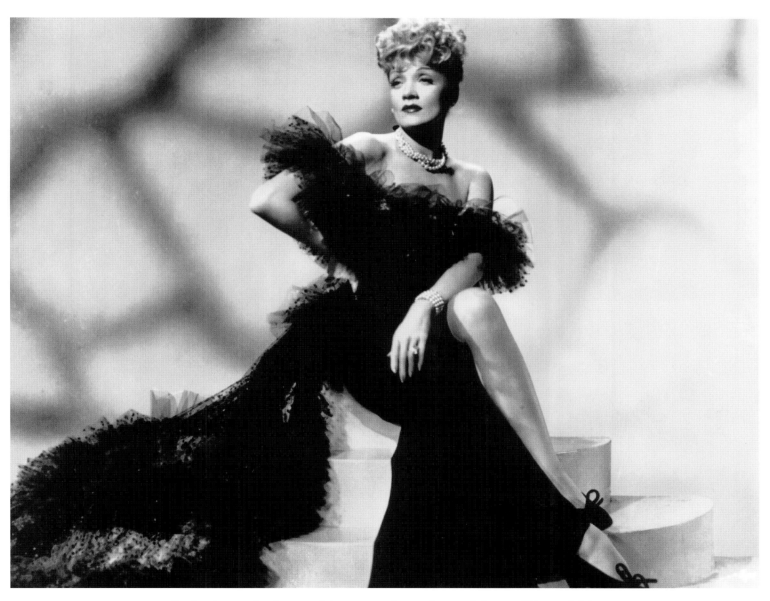

Pittsburgh, 1942. Another one of those required poses for one of the trio of films with John Wayne—which, except for their first picture together, never seemed to click.

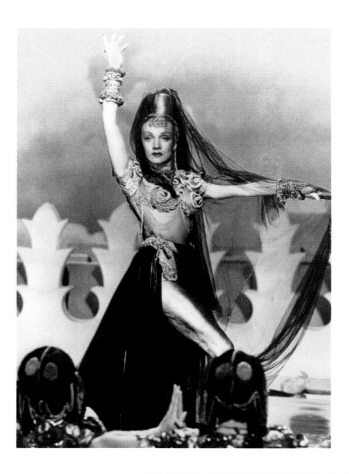

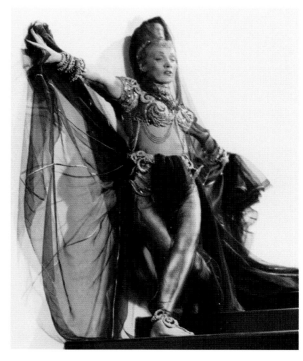

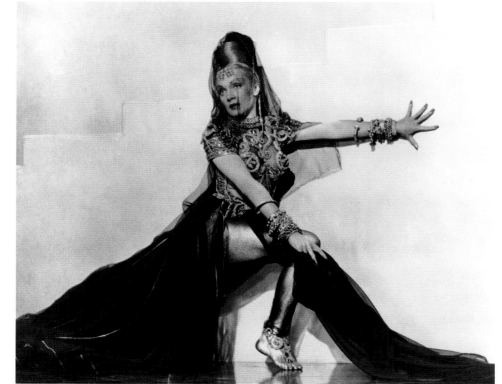

Kismet, 1944. Finally having made it to the mighty MGM (Garbo's studio), to appear in what she knew beforehand would be a dismal flop, she tried everything to make visual impact in the film (her last before going overseas to entertain the troops): she gave the great Sydney Guilaroff free rein to design incredible wigs; she refused the chain-link pants made for her dance number and instead painted her legs gold. And she accomplished what she had set out to do: mention *Kismet* and all anyone remembers is hairdos and those incredible gold legs.

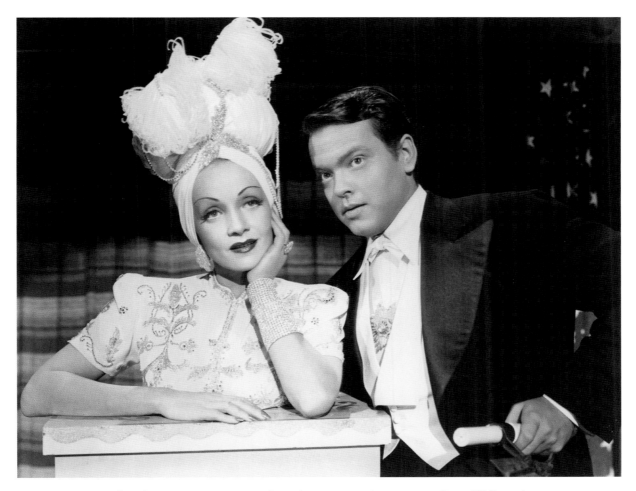

Follow the Boys, 1944. Having performed as a magician's assistant to Orson Welles in his magic act at many army training camps, she repeated the act with him in one of the many cameo appearances made by Hollywood stars in this morale-building propaganda film. He sawed her in half. She never did reveal how he did it.

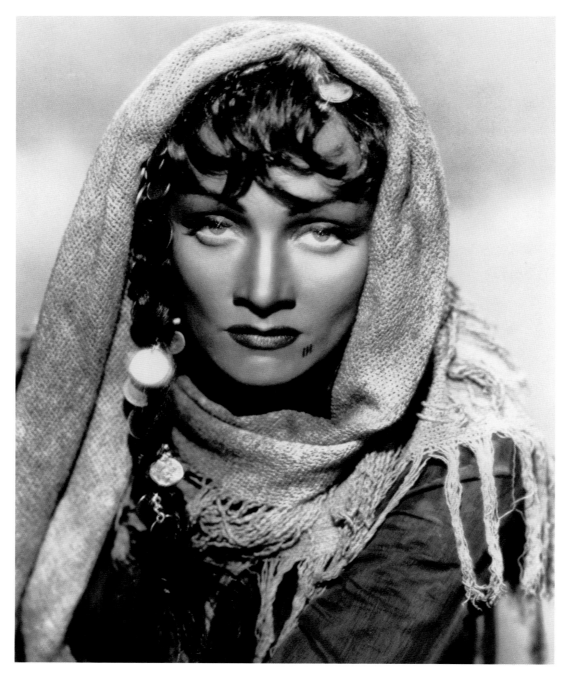

Golden Earrings, 1947. Having found no work except in a disastrous French film shot in postwar Europe, Marlene accepted an offer from her friend Mitchell Leisen to return to her home studio, Paramount, and become a Gypsy. One of her favorite roles, because for once she had the fun of being in disguise. With a lackluster costar (Ray Milland) and an equally unexciting script, she found herself right back where she had been with *Kismet*. Though her war work had changed her, her duty to "Dietrich" was intact. So instead of displaying gold legs at forty-six, she transformed herself into the sexiest Gypsy that ever existed, the only exciting image in this film.

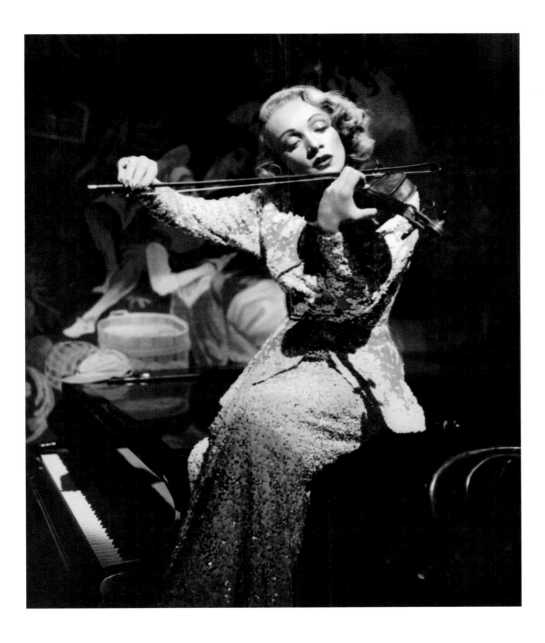

LEFT: Billy Wilder, so amazingly intuitive when casting his films, came up with the idea in 1948 of casting Marlene in his film *A Foreign Affair*. She was hesitant to portray any German of the Nazi era, even if only a cabaret singer in bombed-out Berlin, but still she trusted Wilder and, with an excellent script and equally fine direction, brought to the part an admirable mix of pathos and weltschmertz, portraying a woman victimized both by men and by war, yet still a survivor. This film once again resurrected her career as glamorous star, though now she was a grandmother, carrying with it the added bonus of—Actress.

BELOW: *Martin Roumagnac, 1946.* Marlene remained in Paris after the war to be with Jean Gabin while entertaining the American occupation forces, and agreed to costar with him in this French-language film to help its financing. Her perfect French was not the problem, only the lack of any igniting fire between the stars, as their private affair was already on the rocks.

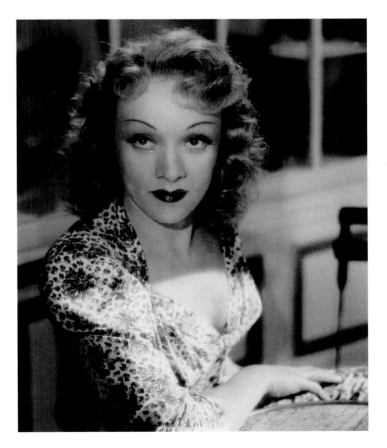

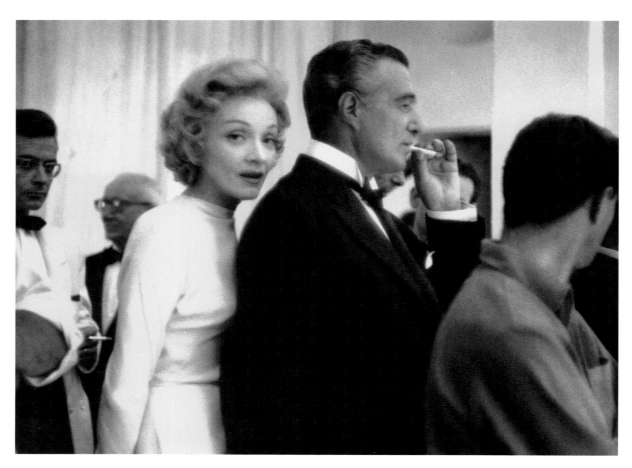

The Monte Carlo Story, 1957. Filmed in Europe, directed by Samuel Taylor, and costarring Vittorio de Sica. Neither the film nor the chemistry between the stars worked, but the costumes credited to Jean Louis—mostly designed by Balenciaga and Dietrich, from her own Irenes—were breathtaking in their perfected simplicity and classic beauty.

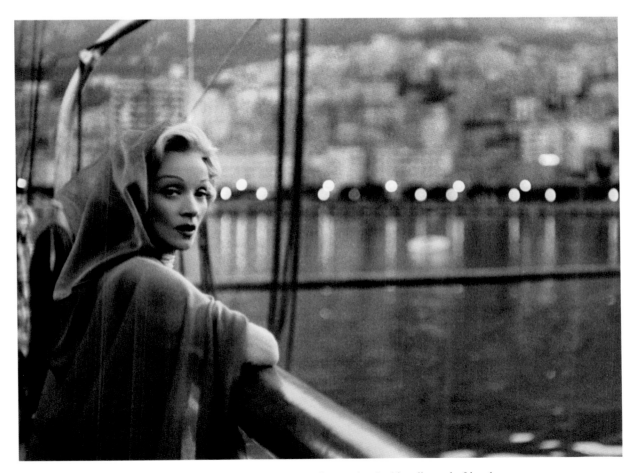

The Monte Carlo Story, 1957. Face with its frame, the double silk cowl of her burnoose, copied from the one worn many years before in *The Garden of Allah.* When Marlene knew something worked, be it hair, makeup, pose, costume, attitude, gesture, or whatever, she locked it into her brain to be called forth whenever needed to rescue a show, a portrait sitting, or a film, such as this one.

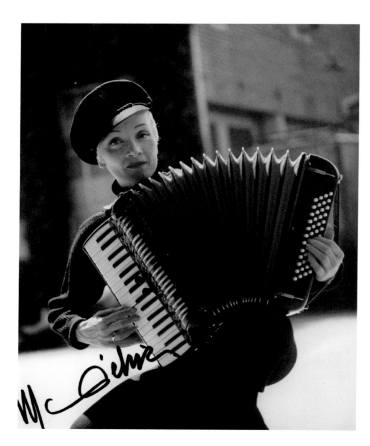

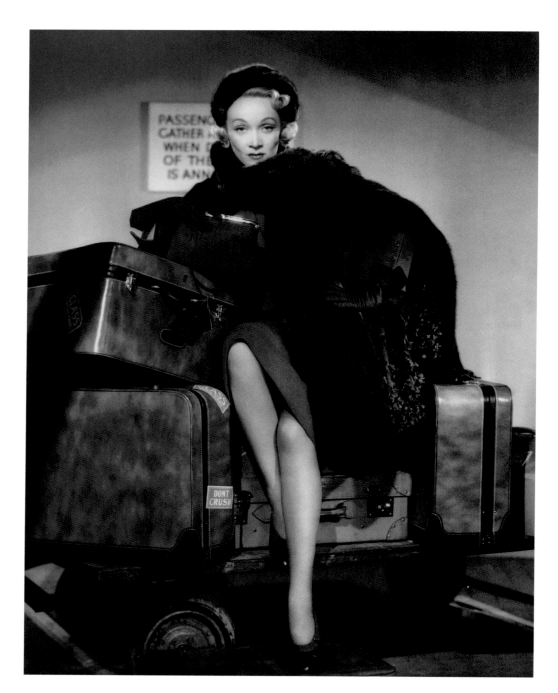

ABOVE: A 1958 candid taken on the lot, in the entertainer costume for the Billy Wilder film *Witness for the Prosecution*.

RIGHT: The famous poster portrait of 1951 for *No Highway*, the film in which she not only wore her own clothes but also posed for this photo perched on her own Mark Cross gunmetal gray cowhide luggage. (Cornel Lucas)

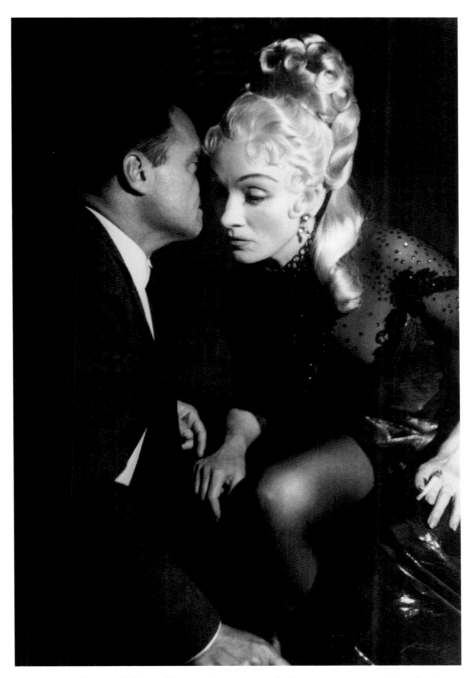

On the set of *Around the World in 80 Days,* waiting for her cameo turn and that familiar phrase "We are ready for you now, Miss Dietrich," while her pal and producer Michael Todd whispers, "What?"

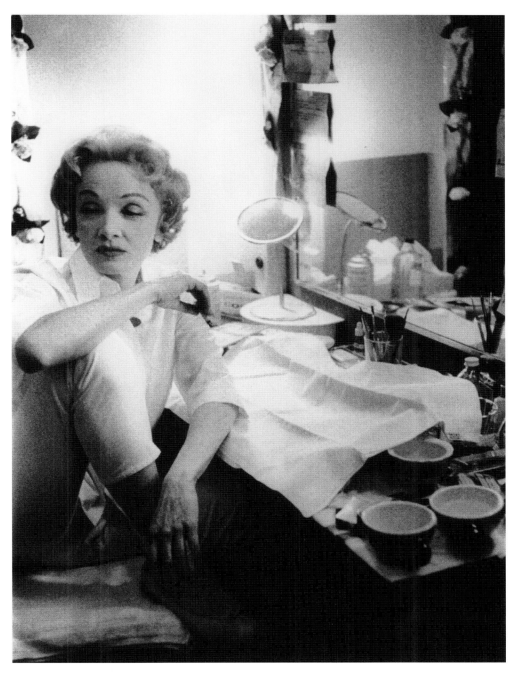

Tired, in her dressing room after a rehearsal run-through. Her hairstyle and Capri pants date this as the first year at the Sahara in Las Vegas, 1953. (William Claxton)

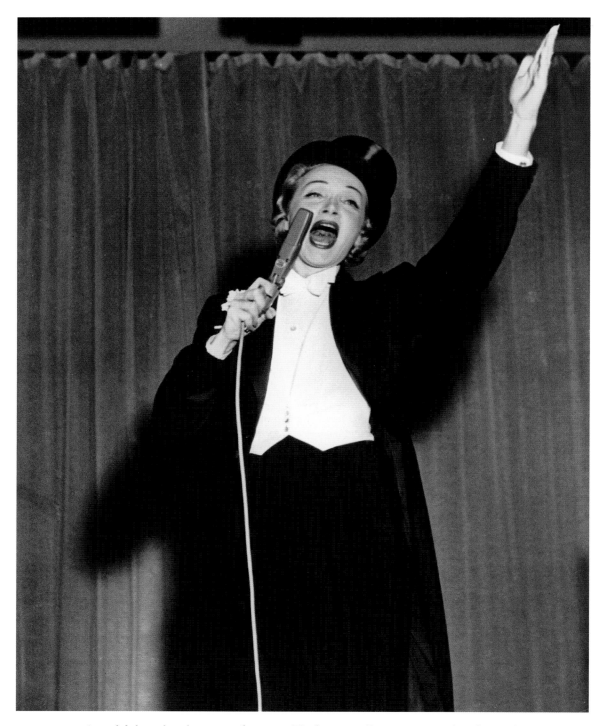

A candid shot taken during a performance. The first part of her one-woman show featured glamour, romance, and sentimentality in glittering dress; the second half featured humor, longing, and love in white tie and tails.

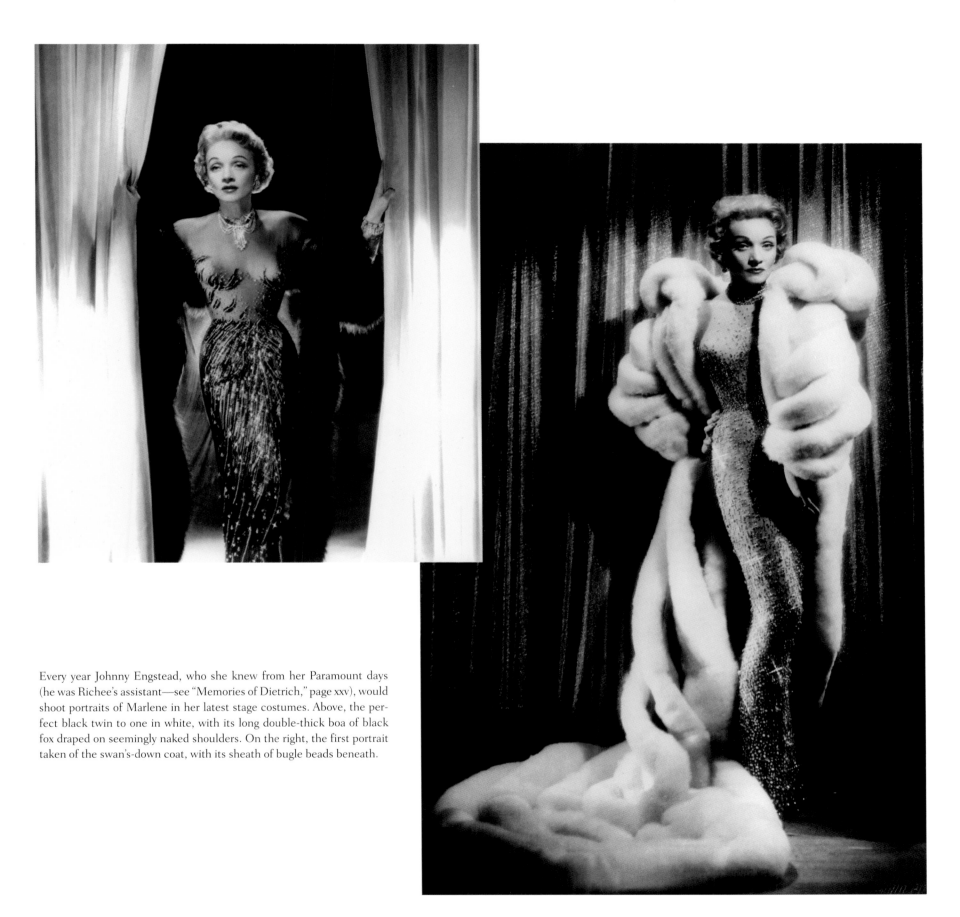

Every year Johnny Engstead, who she knew from her Paramount days (he was Richee's assistant—see "Memories of Dietrich," page xxv), would shoot portraits of Marlene in her latest stage costumes. Above, the perfect black twin to one in white, with its long double-thick boa of black fox draped on seemingly naked shoulders. On the right, the first portrait taken of the swan's-down coat, with its sheath of bugle beads beneath.

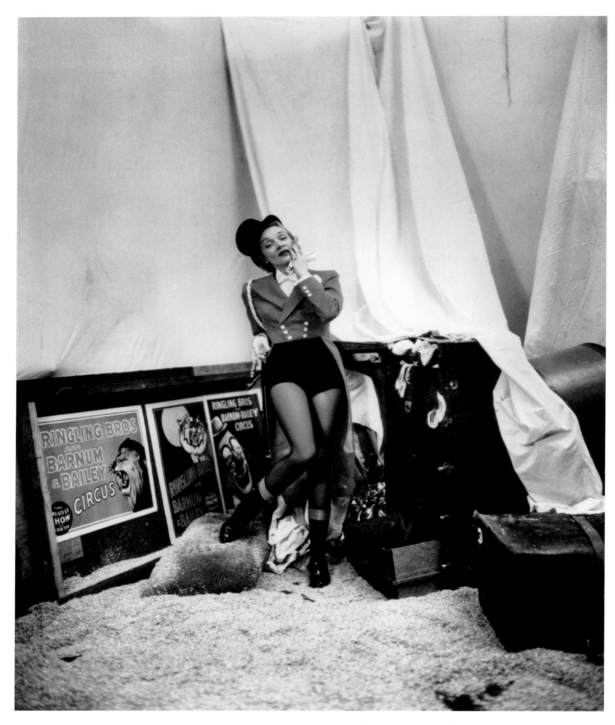

1954. Having caused a sensation as the ringmaster for Ringling Bros. and Barnum & Bailey Circus at Madison Square Garden, Marlene posed for this full-page portrait commissioned by *Vogue*. (Nick de Morgoli)

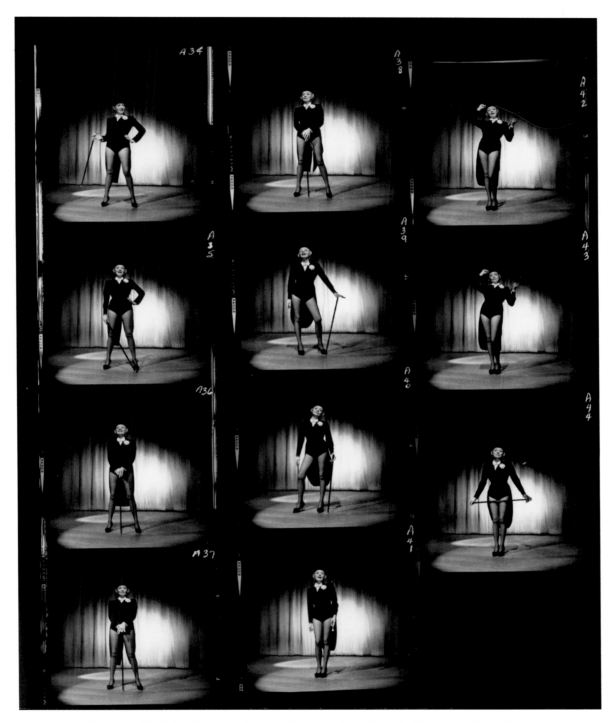

Las Vegas finale in tailcoat, top hat, and "hot pants." She danced with her own chorus line.

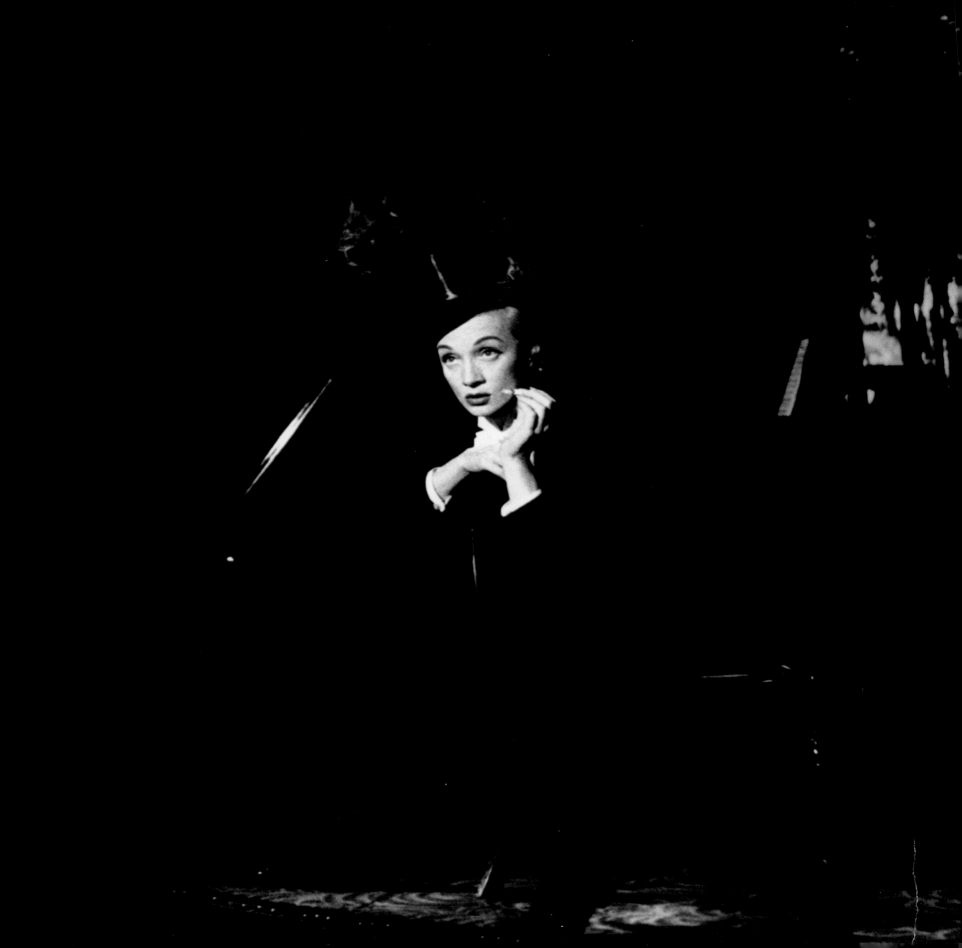

Isn't it strange:
The legs
That made
My rise to glory
Easy, NO?
Because
My Downfall!
Into misery!
Queasy, NO?

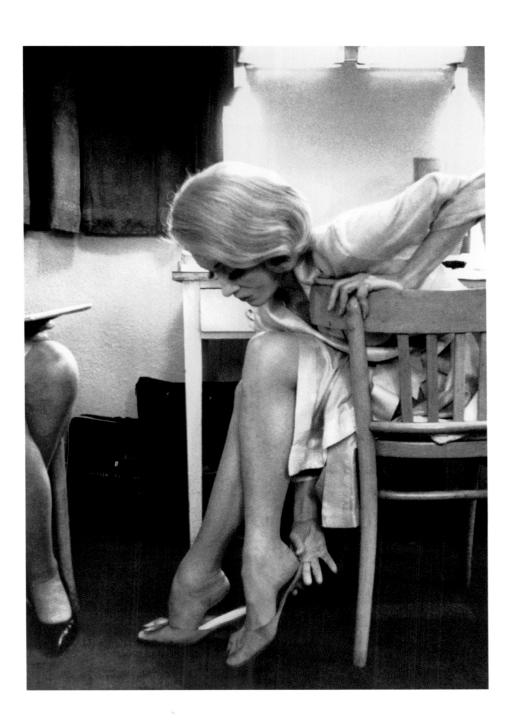

OPPOSITE: Café de Paris, London, 1955. This was her first semi-concert appearance without the brashness of Vegas: while she was singing "One for My Baby," a young photographer captured a series of moments that would become not only her favorite but also some of the most acclaimed photographs of Dietrich ever taken. (Antony Armstrong-Jones, now Lord Snowdon)

RIGHT: Taken in her dressing room during her second appearance at the Edinburgh Festival. Judging from her expression, this must have been before a performance: she has that look of a soldier about to go into battle.

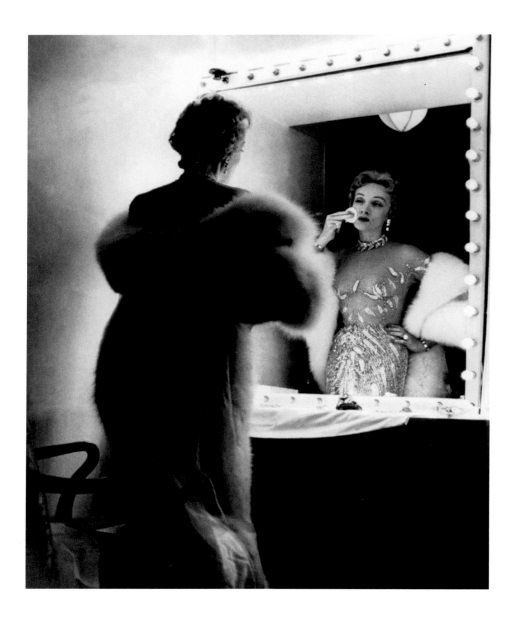

LEFT: The Olympia, Paris. Ready to go to work.

BELOW: Marlon Brando had called to complain that Marlene shouldn't perform in South Africa. She didn't agree, preferring to teach tolerance while she was there: she gave preferential interviews to black journalists and offered work, where possible, to black musicians.

> *When I went to South Africa Brando called me in Paris to tell me to cancel because of APARTHEID. I told him that I just gave a concert in TEXAS where no black people were allowed in the concert hall — told him he should work on this first

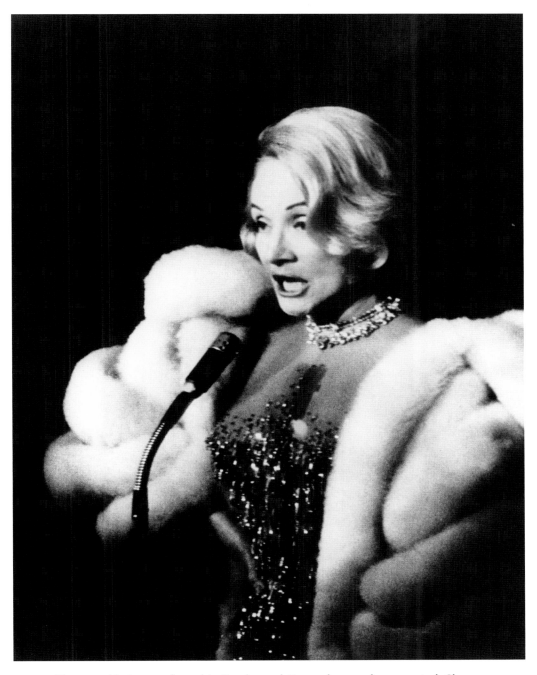

The years Marlene performed in Sweden and Denmark were always magical. She was wonderful, the audiences were wonderful, everything worked. Even her wig—often in the earlier years appearing too contrived—was now chic and modern. (J. Sen Carlen)

Her famous swan-enveloped straight-legged bow; photograph taken by her grandson Peter at the Queen's Theatre, London.

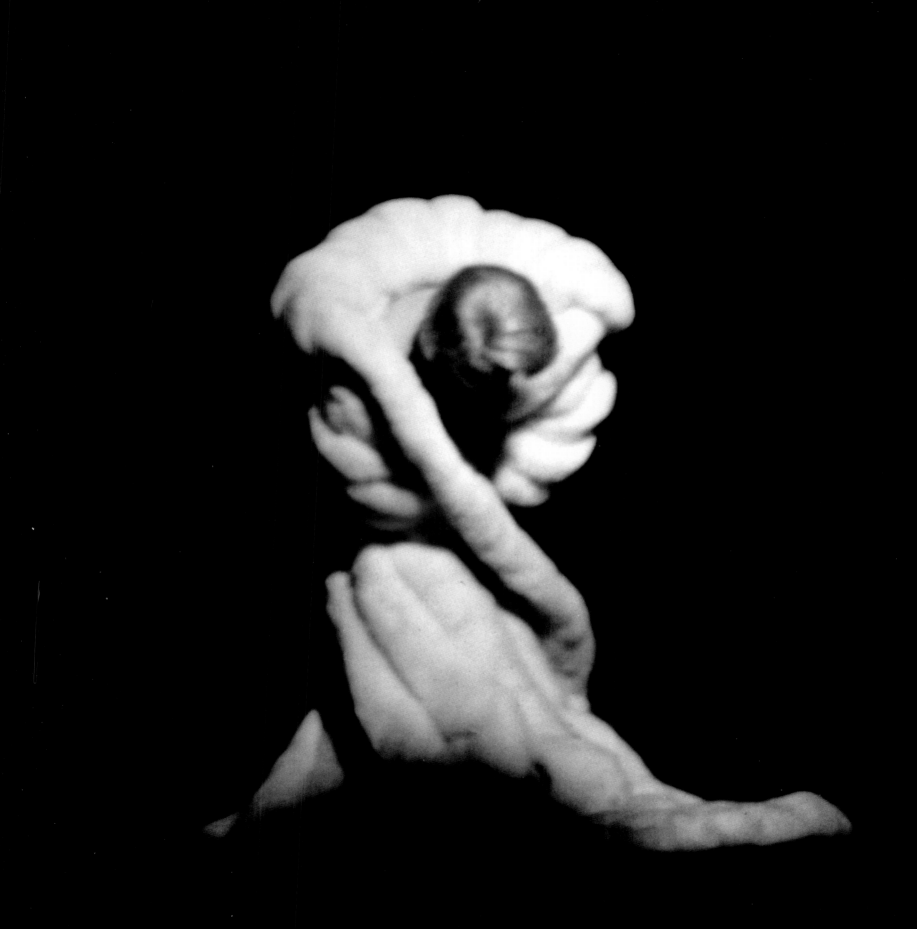

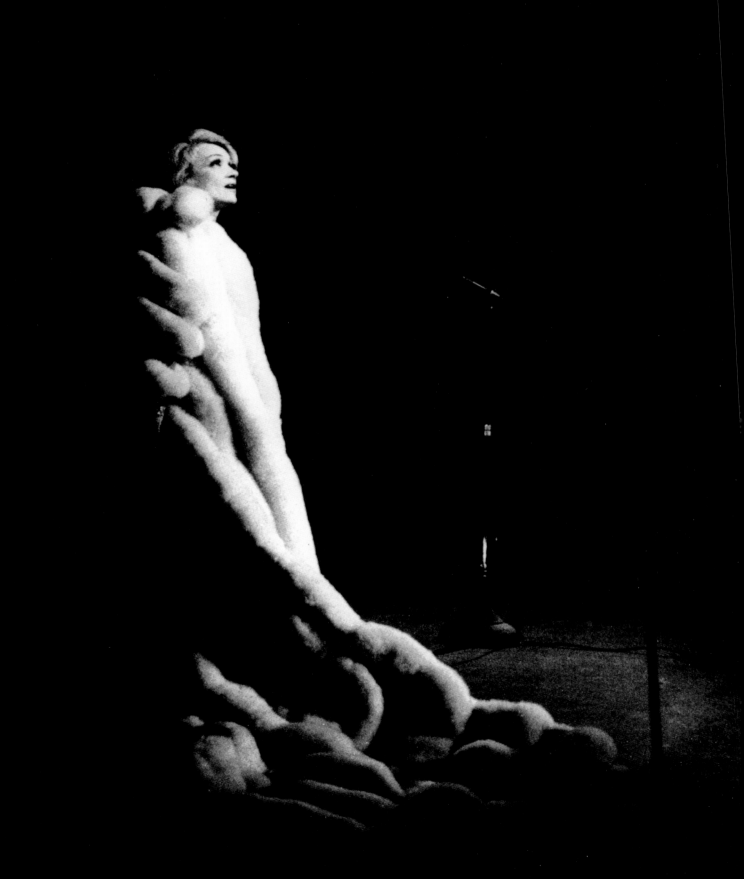

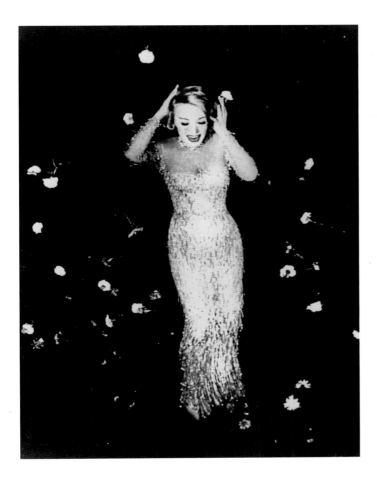

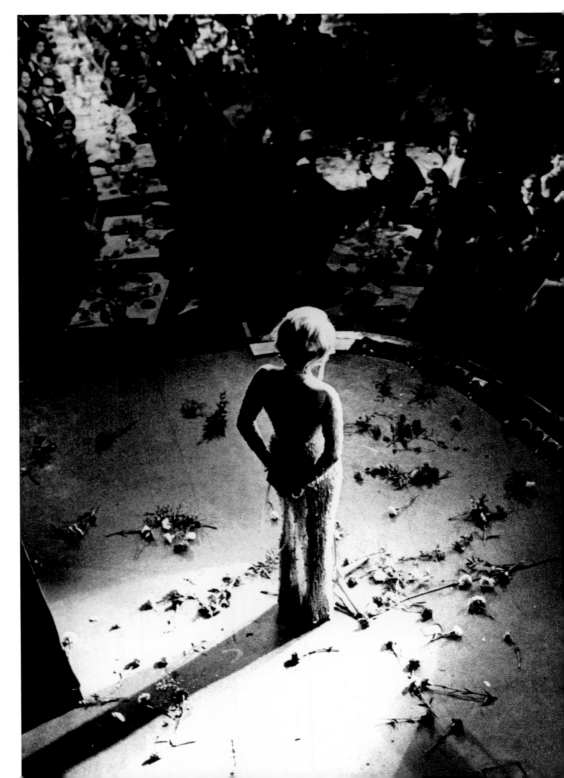

OPPOSITE: Edinburgh. A beautiful light-and-shadow version of the whipped-cream look of the fabulous swan's-down coat, which depended on the stillness of its wearer to make it sublime. (Peter Basch)

ABOVE: Stockholm. As she was about to take her final bow, the exuberant audience pelted her with flowers, taking her completely by surprise. She loved this picture. (Bengt H. Malmquist)

RIGHT: Fresh carnations at her feet, showing her appreciation for this lovely gesture, she stands in her standard pose singing an encore of "Where Have All the Flowers Gone." Notice her extreme thinness, the startling fragility. She had beaten cancer, but it left its mark. (Bengt H. Malmquist)

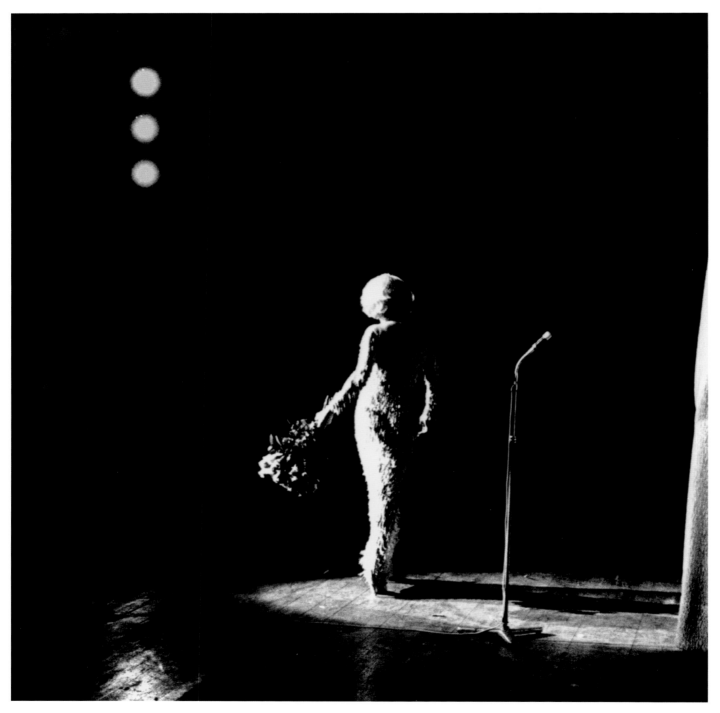

The loose hanging crystals sway; the gliding walk accentuates the elegant, elongated line of thigh and leg beneath a gossamer sheath. Few know the courage it takes to be alone in a circle of light before a darkness filled with utter strangers. (J. Sen Carlen)

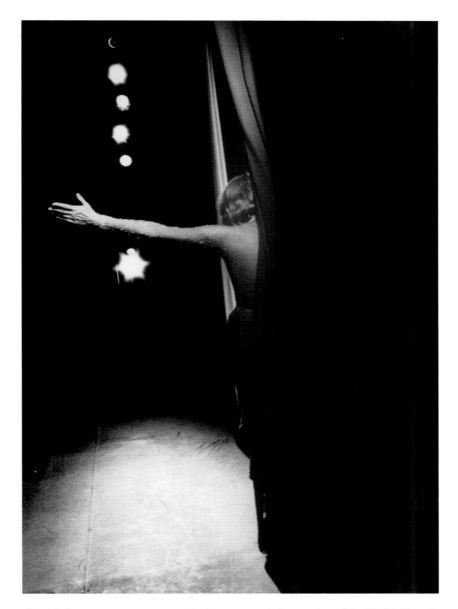

One of those great moments caught by a true artist's eye: that of Roddy McDowall, who, because he was a trusted friend, was allowed to photograph from the wings during a performance on Broadway. A rare gift that he repaid by producing a series of unique images. This was her final gesture of farewell when the exhaustion of too many curtain calls forced it.

Filmography

Theatography and Concertography

Discography

Collection Inventory and Exhibitions

Acknowledgments

Index

Filmography

1923 · DER MENSCH AM WEGE

English title: *Man by the Wayside*

Germany, 1923
An Osmania-Film Production
Black-and-white

CAST:
ALEXANDER GRANACH (Cobbler); EMILIE UNDA (his wife); WILHELM DIETERLE (Michael, the "human angel"); HEINRICH GEORGE (Squire); WILHELM VÖLCKER (Coachman); SOPHIE PAGAY (Shopkeeper's wife); MARLENE DIETRICH (Shopkeeper's daughter); WILHELM DIEGELMANN (Landlord); LIESELOTTE ROLLE (Cobbler's daughter); DR. MAX POHL (Senior clerk); LUDWIG REX (Watchman); ERNST GRONAU (Doctor); FRITZ RASP (Farmhand); WERNER PLEDATH (Young farmhand); DOLLY LORENZ, SEEBERG (Maids); with Gerhard Bienert, Georg Hilbert, Fritz Kampers, Max Nemetz, Hermine Körner, Lotte Stein, Bäk, Gerlach-Jacobi, Hagewald, Härting, Herbst, Matt, Rausch, Zeiselmaier, Brockmann.

CREDITS: WILHELM DIETERLE (director and scenarist; based on a short story by LEO TOLSTOY); WILLY HAMEISTER (photographer); WILLY HABANTZ (production manager); HERBERT RICHTER-LUCKIAN (art director).

LENGTH: 1,646 meters.

PRODUCTION DATES: end of April to mid-May 1923.

PRESS RELEASE: June 12, 1923, Alhambra, Berlin.

1923 · TRAGÖDIE DER LIEBE

English title: *Tragedy of Love*

Germany, 1923
A Joe May-Film Production
Released through Ufa-Film AG
Black-and-white

CAST:
MIA MAY (Countess Manon de Moreau); RUDOLF FORSTER (Count François de Moreau); HEDWIG PAULY-WINTERSTEIN (Adrienne de Moreau, his mother); EMIL JANNINGS (Ombrade, a pimp); ERIKA GLÄSSNER (Musette, his mistress); GUIDO HERZFELD (Marcel Géraud); WLADIMIR GAIDAROW (André Rabatin); IDA WÜST (Madame de la Roquère); IRMGARD BERN (Yvonne); HERMANN VALLENTIN (Police superintendent); ARNOLD KORFF (Henry Beaufort, Detective); KURT VESPERMANN (Deputy district attorney); KURT GÖTZ (District attorney); MARLENE DIETRICH (Lucie, his mistress); EUGEN REX (Jean, valet of Count de Moreau); with Lena Amsel, Charlotte Ander, Paul Biensfeldt, Paul Graetz, Karl Gerhardt, Ernst Gronau, Albert Patry, Hans Kuhnert, Fritz Richard, Rudolf Lettinger, Ferry Sikla, Hans Wassmann, Loni Nest.

CREDITS: JOE MAY (director); LEO BIRINSKI, ADOLF LANTZ (scenarists); SOPHUS WANGOE, KARL PUTH (photographers); PAUL LENI (set decorator); ALI HUBERT (costumer); RUDOLF SIEBER (production manager); ROBERT WÜLLNER (assistant director); HANS LECHNER (stills photographer).

LENGTH: Part I: 1,939 meters; Part II: 1,790 meters; Part III: 1,719 meters, Part IV: 1,984 meters; 3,468 meters (new assembled version by Joe May).

PREMIERE: Part I and Part II: October 8, 1923, Ufa Palast am Zoo, Berlin; Part III and Part IV: November 7, 1923, Ufa Palast am Zoo, Berlin.

1923 · DER KLEINE NAPOLEON

English title: *The Little Napoleon*

A.k.a. *So sind die Männer* (*Men Are Like This*; *That's How the Men Are*); *Napoleons kleiner Bruder* (*Napoleon's Little Brother*).

Germany, 1923
An Europäische Film-Allianz (Efa) Production
Released through Ufa-Film AG
Black-and-white

CAST:
EGON VON HAGEN (Napoleon Bonaparte); PAUL HEIDEMANN (Jérôme Bonaparte); HARRY LIEDTKE (Georg von Melsungen); JACOB TIEDTKE (Jeremias von Katzenellenbogen); ANTONIA DIETRICH (Charlotte, his niece), LONI NEST (Lieselotte, his niece); ALICE HECHY (Annemarie); KURT VESPERMANN (Florian Wunderlich); PAUL BIENSFELDT (Field marshal); KURT FUSS (Director of the Royal Ballet); MARQUISETTE BOSKY (Prima ballerina); MARLENE DIETRICH (Kathrin, Charlotte's maid); WILHELM BENDOW (Jérôme's valet).

CREDITS: GEORG JACOBY (director); ROBERT LIEBMANN, GEORG JACOBY (scenarists); MAX SCHNEIDER, EMIL SCHÜNEMANN (photographers); MARTIN JACOBY-BOY (set decorator).

LENGTH: 2,713 meters.

PRODUCTION DATES: June to November 1922, Schloss Wilhelmshoehe near Kassel and Efa-Studios Berlin.

PREMIERE: November 29, 1923, Marmorhaus, Berlin.

1924 · DER SPRUNG INS LEBEN

English title: *The Leap into Life*

Germany, 1924
A Messter-Film Production (Ufa)
Released through Ufa-Film, AG; European distribution by Pan-Film, AG Black-and-white

CAST:

XENIA DESNI (Idea, a circus acrobat); WALTER RILLA (Frank, her partner); PAUL HEIDEMANN (Dr. Rudolf Borris, a young scholar); FRIDA RICHARD (his aunt); KÄTHE HAACK (Dr. Borris's secretary); LEONHARD HASKEL (Ringmaster); LYDIA POTECHINA (Ringmaster's wife); DR. GEBBING (Trainer); HANS BRAUSEWETTER (Borris's friend); MARLENE DIETRICH (Girl on the beach); HANS HEINRICH VON TWARDOWSKI (Violinist); with Max Gülstorff, Erling Hanson, Max Valentin, Ernst Pröckl, Hermann Thimig.
CREDITS: DR. JOHANNES GUTER (director); ERICH POMMER (producer); FRANZ SCHULZ (scenarist); FRITZ ARNO WAGNER (photographer); RUDI FELD (set decorator).
LENGTH: 2,075 meters.
PRODUCTION DATES: end of July to early in August 1923, Jofa-Studio among others.
PREMIERE: February 4, 1924, Tauentzienpalast, Berlin.

1926 · MANON LESCAUT

Germany, 1926
An Ufa-Film Production
Released through Universum-Film-Verleih GmbH
Released in the United States in December 1926
Black-and-white

CAST:

LYA DE PUTTI (Manon Lescaut); WLADIMIR GAIDAROV (Des Grieux); EDUARD ROTHAUSER (Marshal des Grieux); FRITZ GREINER (Marquis de Bli); HUBERT VON MEYERINCK (Son of Marquis de Bli); FRIDA RICHARD, EMILIE KURZ (Manon's aunts); LYDIA POTECHINA (Susanne); THEODOR LOOS (Tiberge); SIEGFRIED ARNO (Lescaut); TRUDE HESTERBERG (Claire); MARLENE DIETRICH (Micheline); with Olga Engl, Karl Harbacher, Hans Junkermann, Hermann Picha.

CREDITS: ARTHUR ROBISON (director); HANS KYSER, ARTHUR ROBISON (scenarists); THEODOR SPARKUHL (photographer); PAUL LENI (set decorator and costumer); based on L 'Histoire de Manon Lescaut by ABBÉ PRÉVOST.
LENGTH: 2,645 meters.
PRODUCTION DATES: June to September 1925, Ufa-Studios Berlin-Tempelhof; September to October 1925, Neubabelsberg.
PREMIERE: February 15, 1926, Ufa-Palast am Zoo, Berlin.

1926 · MADAME WÜNSCHT KEINE KINDER

English title: *Madame Doesn't Want Children*

Germany, 1926
A Deutsche Vereins-Film AG (Deutsche Fox-Defa/Fox Europa) Production
Released through Deutsche Vereins-Film AG
Released in the United States in 1927 as *Madame Wants No Children*
Black-and-white

CAST:

MARÍA CORDA (Elyane Parizot); HARRY LIEDTKE (Paul Le Barroy); MARIA PAUDLER (Louise Bonvin); TRUDE HESTERBERG (Elyane's mother); DINA GRALLA (Lulu, Elyane's sister); HERMANN VALLENTIN (Paul's uncle); CAMILLA VON HOLLAY (Louise's maid); OLGA MANNEL (Louise's cook); ELLEN MÜLLER (Elyane's maid); with Marlene Dietrich, John Loder.
CREDITS: ALEXANDER KORDA (director); KARL FREUND (producer); THEODOR SPARKUHL, ROBERT BABERSKE (photographers); ADOLF LANTZ, BÉLA BALÁZS (scenarists); OTTO FRIEDRICH WERNDORFF (set decorator); KARL HARTL (associate producer); RUDOLF SIEBER (production manager); MAISON DEUILLET (costumer); LICHTENSTEIN (stills photographer); based on the novel *Madame ne veut pas d'enfants* by CLÉMENT VAUTEL.
LENGTH: 2,166 meters.
PRODUCTION DATES: October to November 1926, Ufa-Studios Berlin-Tempelhof.
PREMIERE: December 14, 1926, Capitol, Berlin.

1927 · EINE DUBARRY VON HEUTE

English title: *A Modern Dubarry*

Germany 1927
A Fellner & Somlo Production (for Ufa)
Released through Ufa-Film AG
Released in the United States in 1928
Black-and-white

CAST:

MARÍA CORDA (Toinette, a modern Dubarry); ALFRED ABEL (Pascal, artist); FRIEDRICH KAYSSLER (Cornelius Corbett); JULIUS VON SZÖREGHY (General Padilla); JEAN BRADIN (Alfons); HANS ALBERS (Paul Arnaud); ALFRED GERASCH (Count Rabbatz); ALBERT PAULIG (Clairet); HANS WASSMANN (Jules Paton, theater manager); KARL PLATEN (Count Alfons's valet); EUGEN BURG (Levasseur); MARLAINE [sic] DIETRICH (a coquette); HILDA RADNEY (Juliette Duflos); JULIA SERDA (Aunt Julie); HEDWIG WANGEL (Rosalie); LOTTE LORRING (a mannequin); HIDIGEIGA (the cat).
CREDITS: ALEXANDER KORDA (director); ROBERT LIEBMANN, ALEXANDER KORDA, PAUL REBOUX (scenarists); FRITZ ARNO WAGNER (photographer); OTTO FRIEDRICH WERNDORFF (set decorator); based on the story "Eine Dubarry von Heute" by LUDWIG (LAJOS) BIRO.
LENGTH: 3,004 meters.
PRODUCTION DATES: April to August 1926, Ufa-Studios Berlin-Tempelhof and Neubabelsberg.
PREMIERE: January 24, 1927, Ufa-Palast am Zoo, Berlin.

1927 · DER JUXBARON

English titles: *The Imaginary Baron; The Bogus Baron*

Germany 1927
An Ellen Richter-Film Production
Released through Ufa-Film AG
Black-and-white

CAST:

REINHOLD SCHÜNZEL (Blaukehlchen, the "imaginary baron"); HENRY BENDER (Hugo Windisch); JULIE SERDA (Zerline Windisch); MARLENE DIETRICH (Sophie, her daughter); TEDDY BILL (Hans von Grabow); COLETTE BRETTL (Hilde von Grabow); ALBERT PAULIG (Baron von Kimmel); TRUDE HESTERBERG (Fränze); KARL HARBACHER (Stotterwilhelm); HERMANN PICHA (Tramp); FRITZ KAMPERS (Policeman); HEINRICH GOTHO (Guest in Grabow's house); KARL BECKMANN (Landlord).
CREDITS: DR. WILLI WOLFF (director); ROBERT LIEBMANN, DR. WILLI WOLFF (scenarists); AXEL GRAATKJAR (photographer); ERNST STERN (set decorator); based on the operetta by PORDES-MILO, HERMANN HALLER, and WALTER KOLLO.
LENGTH: 2,179 meters.
PRODUCTION DATES: October to November 1926, Ufa-Studios Berlin-Tempelhof.
PREMIERE: March 4, 1927, Mozartsaal, Berlin.

1927 · KOPF HOCH, CHARLY

English titles: *Heads Up, Charly; Chin Up, Charly*

Germany, 1927
An Ellen Richter-Film Production
Released through Ufa-Film AG
Black-and-white

CAST:

ANTON POINTNER (Frank Ditmar); ELLEN RICHTER (Charlotte "Charly" Ditmar); MICHAEL BOHNEN (John Jacob Bunjes); MAX GÜLSTORFF (Harry Moshenheim); MARGERIE QUIMBY (Margie Quinn); GEORGE DE CARLTON (Rufus Quinn); ANGELO FERRARI (Marquis d'Ormesson); ROBERT SCHOLZ (Duke of Sanzedilla); NIKOLAI MALIKOFF (Prince Platonoff); TONY TETZLAFF (Madame Zangenberg); MARLENE DIETRICH (Edmée Marchand); BLANDINE EBINGER (Seamstress); ALBERT PAULIG (Bunjes's valet).
CREDITS: DR. WILLI WOLFF (director); ROBERT LIEBMANN, DR. WILLI WOLFF (scenarists); AXEL GRAATKJAER, GEORG KRAUSE (photographers); ERNST STERN (set decorator); based on the novel by LUDWIG WOLFF.
LENGTH: 2,512 meters.
PRODUCTION DATES: 1926, Efa-Studios; outdoor shootings in Paris, Hamburg, and New York.
PREMIERE: March 18, 1927, Ufa-Theater Kurfürstendamm, Berlin.

1927 · SEIN GRÖSSTER BLUFF

English title: *His Greatest Bluff*

Germany, 1927
A Nero Film Production
Released through Südfilm AG (Emelka)
Black-and-white

CAST:
HARRY PIEL (Henry Devall and Harry Devall, twin brothers); TONY TETZLAFF (Madame Andersson); LOTTE LORRING (Tilly, her daughter); ALBERT PAULIG (Mimikry); FRITZ GREINER (Hennessy); CHARLY BERGER ("Count" Koks); BORIS MICHAILOW (Sherry); MARLENE DIETRICH (Yvette); PAUL WALKER ("Goliath," a dwarf); KURT GERRON (the Rajah of Johore); EUGEN BURG (Police superintendent); OSSIP DARMATOW ("Count" Apollinaris); VICKY WERCKMEISTER (Suzanne); PAUL MOLESKA, OSWALD SCHEFFEL, CURT BULLERJAHN, CHARLES FRANÇOIS, WOLFGANG VON SCHWIND (Gangsters); with Hans Breitensträter.
CREDITS: HARRY PIEL (director); HENRIK GALEEN (scenarist); GEORG MUSCHNER, GOTTHARDT WOLF (photographers); WALTER ZEISKE, LEONHARD (production managers); W. A. HERRMANN (set decorator); EDMUND HEUBERGER (assistant director); DR. HERBERT NOSSEN (titles).
LENGTH: 2,984 meters.
PRODUCTION DATES: January 24 to end of February 1927, Studio Berlin-Grunewald.
PREMIERE: May 12, 1927, Alhambra-Palast, Berlin.

1927 · CAFÉ ELECTRIC

English title: *When a Woman Loses Her Way*

Austria, 1927
A Sascha-Film Production
Released through Sascha Filmindustrie AG
Released in Germany as *Wenn ein Weib den Weg verliert* through Südfilm AG
Black-and-white

CAST:
WILLI FORST (Ferdl); MARLENE DIETRICH (Erni Göttlinger); FRITZ ALBERTI (Kommerzialrat Göttlinger, her father); ANNY COTY (his mistress); IGO SYM (Max Stöger, architect); VERA SALVOTTI (Paula); NINA VANNA (Hansi); WILHELM VÖLCKER (Dr.

Lehner); ALBERT E. KERSTEN (Mr. Zerner); with Dolly Davis.
CREDITS: GUSTAV UCICKY (director); JACQUES BACHRACH (scenarist); HANS ANDROSCHIN (photographer); ARTUR BERGER (set decorator); KARL HARTL (assistant director); based on the play *Die Liebesbörse* by FELIX FISCHER.
LENGTH: 2,400 meters.
PRODUCTION DATES: summer 1927, Vienna.
PREMIERE: November 25, 1927, in Vienna; release in Germany: March 22, 1928, Emelka-Palast, Berlin.

1928 · PRINZESSIN OLALA

English title: *Princess Olala*

Germany, 1928
A Super-Film Production
Released through Deutsches Lichtspiel-Syndikat AG
Black-and-white

CAST:
HERMANN BÖTTCHER (the Prince); WALTER RILLA (Prince Boris, his son); GEORG ALEXANDER (Chamberlain); CARMEN BONI (Princess Xenia); ILA MEERY (Hedy, her friend); MARLENE DIETRICH (Chichotte de Gastoné); HANS ALBERS (René, Chichotte's friend); CARL GOETZ (an old cavalier); JULIUS VON SZÖREGHY (Strong man); LYA CHRISTY (Lady Jackson); ARIBERT WÄSCHER (Police superintendent); with Alfred Abel.
CREDITS: ROBERT LAND (director); FRANZ SCHULZ (scenarist); WILLI GOLDBERGER (photographer); FRITZ BRUNN (production manager); ROBERT NEPPACH (set decorator); based on the operetta by JEAN GILBERT (music); RUDOLF BERNAUER, RUDOLF SCHANZER (libretto).
LENGTH: 2,922 meters.
PRODUCTION DATES: 1928, Ufa-Studios Berlin-Tempelhof.
PREMIERE: September 5, 1928, Ufa-Theater Kurfürstendamm, Berlin.

1929 · ICH KEUSSE IHRE HAND, MADAME

English title: *I Kiss Your Hand, Madame*

Germany, 1928
A Super-Film Production

Released through Deutsches Lichtspiel-Syndikat AG
Released in the United States in 1932 through Stanley Distributing Co.
Black-and-white

CAST:
HARRY LIEDTKE (Jacques, the headwaiter); MARLENE DIETRICH (Laurence Gérard); PIERRE DE GUIGNAND (Adolphe Gérard, her ex-husband); KARL HUSZAR-PUFFY (Talandier, her lawyer); HANS HEINRICH VON TWARDOWSKI (Waiter).
CREDITS: ROBERT LAND (director and scenarist); FRIEDEL BUCKOW (assistant director); CARL DREWS, GOTTHARDT WOLF (photographers); FRED ZINNEMANN (assistant photographer); ROBERT NEPPACH (set decorator); FRITZ BRUNN (production manager); based on an original story by ROBERT LAND and ROLF E. VANLOO; English titles for the American release by HELENE TURNER.
SONGS: Title song by RALPH ERWIN (music); FRITZ ROTTER (lyrics); sung on soundtrack by Richard Tauber.
LENGTH: 2,002 meters.
PRODUCTION DATES: December 1928 to January 1929, Efa-Studios, Berlin, and Ufa-Studios Berlin-Tempelhof.
PREMIERE: January 17, 1929, Tauentzien-Palast, Berlin.
RESTORED MATERIAL by Filmmuseum Berlin—Deutsche Kinemathek and Deutsches Bundesarchiv, 1995; length: 1,893 meters; premiere: November 11, 1995, Kunst- und Ausstellungshalle der Bundesrepublik Deutschland, Bonn.

1929 · DIE FRAU, NACH DER MAN SICH SEHNT

English title: *The Woman One Longs For*

Germany, 1929
A Terra-Film Production
Released in the United States as *Three Loves* (silent) through Moviegraphs, Inc., in 1929 and with a synchronized score through Associated Cinemas in 1931
Black-and-white

CAST:
MARLENE DIETRICH (Stascha); FRITZ KORTNER (Dr. Karoff); FRIDA RICHARD (Mrs. Leblanc); OSKAR SIMA (Charles Leblanc, her son); UNO HENNING (Henry Leblanc, her son); BRUNO ZIENER (Philipp, Leblanc's

valet); KARL ETLINGER (Old Poitrier); EDITH EDWARDS (Angela Poitrier, his daughter).
CREDITS: KURT BERNHARDT (director); LADISLAUS VAJDA (scenarist); KURT COURANT, HANS SCHEIB (photographers); ROBERT NEPPACH (set decorator); HERMANN GRUND (head of production); OTTO LEHMANN (production manager); based on the novel by MAX BROD; synchronized score for the American release in 1931 by EDWARD KILENYI, WALTHER BRANSEN.
LENGTH: 2,360 meters.
PRODUCTION DATES: January to February 1929, Terra Glashaus, Berlin-Marienfelde, and Ufa-Studios Neubabelsberg.
PREMIERE: April 29, 1929, Mozartsaal, Berlin.

1929 · DAS SCHIFF DER VERLORENEN MENSCHEN

English title: *The Ship of Lost Souls*
French title: *Le Navire des hommes perdus*

Germany, 1929
A Max Glass-Film Production
Released through Orplidmetro AG
Released in England in 1930 as *The Ship of Lost Men*
Black-and-white

CAST:
FRITZ KORTNER (Captain Fernando Vela); MARLENE DIETRICH (Ethel Marley); ROBIN IRVINE (T. W. Cheyne, a young American doctor); VLADIMIR SOKOLOFF (Grischa, the cook); GASTON MODOT (Morain, the escaped convict); BORIS DE FAS (Tatooed sailor); FEDOR SCHALJAPIN JR. (Nick); MAX MAXIMILIAN (Tom Butley); FRIEDRICH GNASS (Matrose); FRITZ ALBERTI (Captain of luxury liner), ROBERT GARRISON (Landlord), HEINRICH GOTHO (Sailor); with Harry Grunwald, Emil Heyse, Fred Immler, Alfred Loretto, Gerhard Ritterband, Arthur Wartan, Heinz Wemper.
CREDITS: MAURICE TOURNEUR (director and scenarist); MAX GLASS (producer); NIKOLAUS FARKAS (photographer); FRANZ SCHROEDTER (set decorator); JACQUES TOURNEUR (assistant director); RUDOLF STROBL (production manager); based on the novel by FRANZOS KEREMEN.
LENGTH: 2,593 meters.

PRODUCTION DATES: April to June 1929, Staaken-Studios, Berlin, the harbor of Rostock, and the river Trave.
PREMIERE: September 17, 1929, Ufa-Pavillon am Nollendorfplatz, Berlin.

1929 · GEFAHREN DER BRAUTZEIT

English title: *Dangers of the Engagement Period*
A.k.a. *Aus dem Tagebuch eines Verfuehrers* (*From the Diary of a Seducer*) (working title); *Eine Nacht der Liebe* (*One Night of Love*); *Liebesnächte* (*Nights of Love*); *Liebesbriefe* (*Love Letters*).

Germany, 1929
A Strauss-Film Production
Released through Hegewald-Film AG
Black-and-white

CAST:

WILLI FORST (Baron van Geldern); MARLENE DIETRICH (Evelyne); LOTTE LORRING (Yvette); ELZA TEMARY (Florence); ERNST STAHL-NACHBAUR (McClure); BRUNO ZIENER (Miller); with Albert Hörrmann, Otto Kronburger, Hans Wallner.
CREDITS: FRED SAUER (director); ARTHUR STRAUSS (producer); WALTER WASSERMANN, WALTER SCHLEE (scenarists); LÁSZLÓ SCHÄFFER (photographer); MAX HEILBRONNER (set decorator); ROBERT LEISTENSCHNEIDER (production manager).
LENGTH: 2,232 meters.
PRODUCTION DATES: September to October 1929, Staaken Studios, Berlin; outdoor shootings in Scheveningen.
PREMIERE: February 21, 1930, Roxy-Palast, Berlin.
RESTORED MATERIAL by Filmmuseum Berlin—Deutsche Kinemathek, 1998; length: 2,047 meters; premiere: July 2, 1998, Weimar.

1929 · SCREEN TEST FOR DER BLAUE ENGEL

An Erich Pommer-Production for Universum Film AG (Ufa)

CAST:

MARLENE DIETRICH; a piano player (probably Peter Kreuder)

CREDITS: JOSEF VON STERNBERG (director); GÜNTHER RITTAU (photography); Klangfilm (sound system).
SONGS: "You're the Cream in My Coffee" by BUDDY DE SYLVA, LEW BROWN, RAY HENDERSON (music and lyrics); "Wer wird denn weinen, wenn man auseinandergeht" by HUGO HIRSCH (music) and ARTHUR REBNER (lyrics).
LENGTH: 104 meters.
PRODUCTION DATES: October 1929.

1930 · DER BLAUE ENGEL

English version: *The Blue Angel*

Germany, 1930
An Erich Pommer-Production
An Ufa-Sound-Film
Released through Ufa-Film AG
Released in the United States in 1931 through Paramount Pictures
Black-and-white

CAST:

EMIL JANNINGS (Professor Immanuel Rath); MARLENE DIETRICH (Rosa Fröhlich, a.k.a. Lola Lola); KURT GERRON (Kiepert, the magician); ROSA VALETTI (Guste, his wife); HANS ALBERS (Mazeppa); REINHOLD BERNT (Clown); EDUARD VON WINTERSTEIN (School director); HANS ROTH (Beadle); Students: ROLF MÜLLER (Angst), ROLANT VARNO (Lohmann), CARL BALHAUS (Ertzum), ROBERT KLEIN-LÖRCK (Goldstaub); KARL HUSZAR-PUFFY (Landlord); WILHELM DIEGELMANN (Captain); GERHARD BIENERT (Policeman); ILSE FÜRSTENBERG (Rath's housekeeper); FRIEDRICH HOLLAENDER (Pianist), Weintraub Syncopators (Band).
CREDITS: JOSEF VON STERNBERG (director); ERICH POMMER (producer); ROBERT LIEBMANN, DR. KARL VOLLMÖLLER, CARL ZUCKMAYER (scenarists); GÜNTHER RITTAU, HANS SCHNEEBERGER (photographers); OTTO HUNTE, EMIL HASLER (set decorators); SAM WINSTON (editor and assistant director); FRIEDRICH HOLLAENDER (musical score); RICHARD RILLO, ROBERT LIEBMANN, FRIEDRICH HOLLAENDER (lyrics); FRITZ THIERY, HERBERT KIEHL (sound); VIKTOR EISENBACH (production manager); TIHAMER VARADY, KARL LUDWIG HOLUB (costumers); KARL BAYER, LASZLO WILLINGER (stills photographer); WEINTRAUB SYNCOPATORS (orchestra); based on the novel *Professor Unrath* by HEINRICH MANN.

SONGS: "Nimm Dich in Acht vor blonden Frauen" ("Blonde Women"); Ich bin die fesche Lola" ("I'm Naughty Little Lola"); "Kinder, Heut' Abend such ich mir was aus" ("This Evening, Children"); "Ich bin von Kopf bis Fuss auf Liebe eingestellt" ("Falling in Love Again") by FRIEDRICH HOLLAENDER (music and lyrics), ROBERT LIEBMANN and RICHARD RILLO (lyrics); English lyrics by SAM LERNER.
LENGTH: 2,965 meters, 108 minutes (German version); 2,696 meters, 99 minutes (English version).
PRODUCTION DATES: November 4, 1929, to January 22, 1930, Ufa-Studios Babelsberg.
PREMIERE: April 1, 1930, Gloria-Palast, Berlin.

1930 · MOROCCO

German titles: *Herzen in Flammen, Marokko*

United States, 1930
Paramount Publix Corp.
Released through Paramount Publix Corp.
Black-and-white

CAST:

GARY COOPER (Tom Brown); MARLENE DIETRICH (Amy Jolly); ADOLPHE MENJOU (La Bessière); ULLRICH HAUPT (Adjutant Caesar); EVE SOUTHERN (Madame Caesar); MICHAEL VISAROFF (Barratire); JULIETTE COMPTON (Anna Dolores); ALBERT CONTI (Colonel Quinnovieres); FRANCIS MCDONALD (Corporal Tatoche); PAUL PORCASI (Lo Tinto), ÉMILE CHAUTARD (French general).
CREDITS: JOSEF VON STERNBERG (director); HECTOR TURNBULL (producer); JULES FURTHMAN, VINCENT LAWRENCE (scenarists); LEE GARMES, LUCIEN BALLARD (photographers); SAM WINSTON, BOB LEE, DAN KEEFE (editors); DAN KEEFE, ELEANOR MCGEARY (unit managers); BOB LEE, BOB MARGOLIS (assistant directors); HANS DREIER (art director); TRAVIS BANTON (costumer); HARRY D. MILLS (sound); based on the novel *Amy Jolly, Die Frau aus Marrakesh* by BENNO VIGNY.
SONGS: "Give Me the Man" (not used), "What Am I Bid" by LEO ROBIN and KARL HAJÓS; "Quand l'amour meurt" by OCTAVE CRÉMIEUX and G. MILLANDY.
LENGTH: 2,511 meters.
PRODUCTION DATES: July 15 to August 18, 1930; indoor shooting: Paramount Studios stage 4 and Universal back lot; outdoor

shooting: Chatsworth Ranch and Guadelupe.
PREMIERE: November 14, 1930, Rivoli Theater, New York; November 25, 1930, Grauman's Chinese Theatre, Hollywood.
OSCAR NOMINATIONS, 1930–31 (fourth): actress: Marlene Dietrich; art direction: Hans Dreier; cinematography: Lee Garmes; directing: Josef von Sternberg.

1931 · DISHONORED

German titles: *Entehrt; X-27*

United States, 1931
Paramount Publix Corp.
Released through Paramount Publix Corp.
Black-and-white

CAST:

MARLENE DIETRICH (X-27); VICTOR MCLAGLEN (Colonel Kranau); LEW CODY (Colonel Kovrin); GUSTAV VON SEYFFERTITZ (Head of Austrian Secret Service); WARNER OLAND (Colonel von Hindau); BARRY NORTON (Young lieutenant); DAVISON CLARK (Court officer); WILFRED LUCAS (General Dymov); BILL POWELL (Manager); with George Irving.
CREDITS: JOSEF VON STERNBERG (director); DANIEL H. RUBIN (scenarist); LEE GARMES (photographer); HANS DREIER (art director); KARL HAJOS (musical score, with quotations from Ivanovici's *Donauwellen* and Ludwig van Beethoven's *Moonlight* Sonata and various "themes" by Josef von Sternberg); TRAVIS BANTON (costumer); HARRY D. MILLS (sound recorder); based on a story by JOSEF VON STERNBERG.
LENGTH: 2,469 meters, 91 minutes.
PRODUCTION DATES: October to November 29, 1930, Paramount, Hollywood.
PREMIERE: March 5, 1931, Rialto Theatre, New York.

1932 · SHANGHAI EXPRESS

United States, 1932
Paramount Publix Corp.
Released through Paramount Publix Corp.
Black-and-white

CAST:

MARLENE DIETRICH (Shanghai Lily); CLIVE BROOK (Captain Donald Harvey); ANNA MAY

WONG (Hui Fei); WARNER OLAND (Henry Chang); EUGENE PALLETTE (Sam Salt); LAWRENCE GRANT (Mr. Carmichael); LOUISE CLOSSER HALE (Mrs. Haggerty); GUSTAV VON SEYFFERTITZ (Eric Baum); ÉMILE CHAUTARD (Major Lenard); CLAUDE KING (Albright); NESHEDA MINORU (Chinese spy); with Willie Fung.
CREDITS: JOSEF VON STERNBERG (director); JULES FURTHMAN (scenarist); LEE GARMES (photographer); WARREN LYNCH, ROY CLARK (second cameramen); WARNER CRUIZE, MILTON BRIDENBREKER (assistant cameramen); HANS DREIER (art director); W. FRANKE HARLING (musical score); TRAVIS BANTON (costumer); HARRY D. MILLS (sound recorder); TOM GUBBINS (technical advisor); JUNIUS ESTEP (stills photographer); based on a story by HARRY HERVEY.
LENGTH: 84 minutes
PRODUCTION DATES: August 1931 to end of November 1931.
PREMIERE: February 2, 1932, Rialto Theatre, New York.
OSCAR, 1931–32 (fifth): cinematography: Lee Garmes.
OSCAR NOMINATIONS, 1931–32 (fifth): directing: Josef von Sternberg; outstanding production: Paramount Publix Corp.

1932 · BLONDE VENUS

German title: *Die blonde Venus*

United States, 1932
Paramount Publix Corp.
Released through Paramount Publix Corp.
Black-and-white

CAST:
MARLENE DIETRICH (Helen Faraday/Helen Jones); HERBERT MARSHALL (Edward Faraday); CARY GRANT (Nick Townsend); DICKIE MOORE (Johnny Faraday); GENE MORGAN (Ben Smith); RITA LA ROY ("Taxi Belle" Hooper); ROBERT EMMETT O'CONNOR (Dan O'Connor); SIDNEY TOLER (Detective Wilson); FRANCIS SAYLES (Charlie Blaine); MORGAN WALLACE (Dr. Pierce); EVELYN PREER (Iola); ROBERT GRAVES (La Farge); LLOYD WHITLOCK (Baltimore manager); CECILE CUNNINGHAM (Cabaret owner); ÉMILE CHAUTARD (Chautard); JAMES KILGANNON (Janitor); Students: STERLING HOLLOWAY (Foe), CHARLES MORTON (Bob), FERDINAND SCHUMAN-HEINK (Henry); JERRY TUCKER (Otto); HAROLD BERQUIST (Big fellow); DEWEY ROBINSON (Greek restaurant

proprietor); CLIFFORD DEMPSEY (Night court judge); BESSIE LYLE (Grace); MILDRED WASHINGTON, HATTIE MCDANIEL (Negro girls); GERTRUDE SHORT (Receptionist); BRADY KLINE (New Orleans cop); DAVISON CLARK (Bartender); AL BRIDGE (Bouncer); MARCELLE CORDAY (French maid); MARY GORDON (Landlady); ERIC ALDEN (Guard); PAT SOMERSET (Companion); with Kent Taylor.
CREDITS: JOSEF VON STERNBERG (director); JULES FURTHMAN, S. K. LAUREN (scenarists); BERT GLENNON (photographer); WIARD IHNEN (art director); OSKAR POTOKER (musical score); TRAVIS BANTON (costumer); WILLIAM RAND, BENNY MAYER (camera operators); LUCIEN BALLARD, NEAL BECKNER (assistant cameramen); PAULO IVANO (additional cameraman); HARRY D. ENGLISH (sound); DON ENGLISH (stills photographer); based on a story by JOSEF VON STERNBERG.
MUSIC: "Leise zieht durch mein Gemüt" from *Das Buch der Lieder: Neuer Frühling* by Felix Mendelssohn (music) and Heinrich Heine (lyrics).
SONGS: "Hot Voodoo" by RALPH RAINGER (music) and SAM COSLOW (lyrics); "You Little So-and-So" by LEO ROBIN (music) and SAM COSLOW (lyrics); "I Couldn't Be Annoyed" by LEO ROBIN (music) and DICK WHITING (lyrics).
LENGTH: 2,578 meters, 97 minutes.
PRODUCTION DATES: May 26 to June 11, 1932.
PREMIERE: September 22, 1932.

1933 · SONG OF SONGS

United States, 1933
Paramount Productions Inc.
Released through Paramount Productions Inc.
Black-and-white

CAST:
MARLENE DIETRICH (Lily Czepanek); BRIAN AHERNE (Richard Waldow); LIONEL ATWILL (Baron von Merzbach); ALISON SKIPWORTH (Frau Rasmussen); HARDIE ALBRIGHT (Walter von Prell); HELEN FREEMAN (Fräulein von Schwartzfegger); with James Marcus, Richard Bennett, Morgan Wallace, Wilson Benge, Rita La Roy, Hans Schumm.
CREDITS: ROUBEN MAMOULIAN (director and producer); LEO BIRINSKI, SAMUEL HOFFENSTEIN (scenarists); BENJAMIN GLAZER, EDWIN JUSTUS MAYER (contribution writers);

VICTOR MILNER (photographer); WILLIAM MELLOW (camera operator); GUY ROE, ROBERT RHEA (camera assistants); HANS DREIER (art director); S. CARTAINO SCARPITTA (sculptor of statue of Lily); TRAVIS BANTON (costumer); KARL HAJOS, MILAN RODER (musical score); NATHANIEL W. FINSTON (musical director); HARRY MILLS (sound); FRED GEIGER (chief electrician); KENNETH DELAND (chief grip); JOE YOUNGERMAN (props); DON ENGLISH (stills photographer); based on the novel *Das hohe Lied* by HERMANN SUDERMANN and the play by EDWARD SHELDON.
SONGS: "Heideröslein" by FRANZ SCHUBERT (music) and JOHANN WOLFGANG VON GOETHE (lyrics); "Johnny" by FRIEDRICH HOLLAENDER (music and German lyrics) and EDWARD HEYMAN (English lyrics).
LENGTH: 2,300 meters.
PRODUCTION DATES: February to May 1933, Paramount Studios, Hollywood.
PREMIERE: July 19, 1933, Criterion Theatre, New York.

1934 · THE SCARLET EMPRESS

German titles: *Die scharlachrote Kaiserin; Die grosse Zarin*

United States, 1934
Paramount Productions Inc.
Released through Paramount Productions Inc.
Black-and-white

CAST:
MARLENE DIETRICH (Sophia Frederica, Catherine II); JOHN LODGE (Count Alexei); SAM JAFFE (Grand Duke Peter); LOUISE DRESSER (Empress Elizabeth); MARIA SIEBER (Sophia Frederica as a child); C. AUBREY SMITH (Prince August); RUTHELMA STEVENS (Countess Elizabeth); OLIVE TELL (Princess Johanna); GAVIN GORDON (Gregory Orloff); JAMESON THOMAS (Lieutenant Ovtsyn); HANS HEINRICH VON TWARDOWSKI (Ivan Shuvolov); DAVISON CLARK (Archimandrite [also Archbishop] Simeon Tevedovsky); ERVILLE ALDERSON (Chancellor Bestuchef); MARIE WELLS (Marie); JANE DARWELL (Mademoiselle Cardell); HARRY WOODS (Doctor); EDWARD VAN SLOAN (Mr. Wagner); PHILIP G. SLEEMAN (Count Lestocq); JOHN B. DAVIDSON (Marquis de la Chetardie); GERALD FIELDING (Lieutenant Dmitri); JAMES BURKE (Guard); BELLE STODDARD JOHNSTONE, NADINE BERESFORD,

EUNICE MOORE, PETRA MCALLISTER, BLANCHE ROSE (Aunts); JAMES MARCUS (Landlord); THOMAS C. BLYTHE (First Narcissus); CLYDE DAVID (Second Narcissus); RICHARD ALEXANDER (Count von Breummer); HAL BOYER (Paul, second lackey); BRUCE WARREN (Seventh lackey); GEORGE DAVIS (Jester); ERIC ALDEN (Fifth lackey); AGNES STEELE, BARBARA SABICHI, MAY FOSTER, MINNIE STEELE (Elizabeth's ladies-in-waiting); KATHERINE SABICHI, JULANNE JOHNSTON, ELINOR FAIR, DINA SMIRNOVA, ANNA DUNCAN, PATRICIA PATRICK, ELAINE ST. MAUR (Catherine's ladies-in-waiting).
CREDITS: JOSEF VON STERNBERG (director and producer); SAMUEL COHEN (executive producer); MANUEL KOMROFF (scenarist); ELEANOR MCGEARY (contributor to script); BERT GLENNON (photographer); HANS DREIER (art director); PETER BALLBUSCH (sculpture); RICHARD KOLLORSZ (icons); W. FRANKE HARLING, JOHN M. LEIPOLD, MILAN RODER (music arrangers; music based on themes by TCHAIKOVSKY, MENDELSSOHN, WAGNER); SAM WINSTON (editor); HARRY MILLS (recording engineer); TRAVIS BANTON, ALI HUBERT (costumers); GORDON JENNINGS (special effects); based on the book *Diary of Catherine the Great*; uncredited footage from *The Patriot* (1928) by ERNST LUBITSCH.
LENGTH: 2,797 meters.
PREMIERE: May 19, 1934, Carlton Theatre, London.

1935 · THE DEVIL IS A WOMAN

German title: *Die spanische Tänzerin*

United States, 1935
Paramount Productions Inc.
A Josef von Sternberg Production
Released through Paramount Productions Inc.
Black-and-white

CAST:
MARLENE DIETRICH (Concha Perez); LIONEL ATWILL (Don Pasqual); CESAR ROMERO (Antonio Galvan); EDWARD EVERETT HORTON (Don Paquito); ALISON SKIPWORTH (Señora Perez); DON ALVARADO (Morenito); PACO MORENO (Secretary); MORGAN WALLACE (Dr. Mendez); TEMPE PIGOTT (Tuerta); JILL DENNETT (Maria); LAWRENCE GRANT (Conductor); CHARLES SELLON (Letter writer); LUISA ESPINAL

(Gypsy dancer); HANK MANN (Foreman, snowbound train); EDWIN MAXWELL (Superintendent, tobacco factory); DONALD REED (Miguelito); EDDIE BORDEN (Drunk in carnival café).

CREDITS: JOSEF VON STERNBERG (director and photographer); SAMUEL COHEN (executive producer); JOHN DOS PASSOS (adaptation); S. K. WINSTON (continuity); DAVID HERTZ (contributor to treatment); JOSEF VON STERNBERG, LUCIEN BALLARD (photography); HANS DREIER (art director); TRAVIS BANTON (Miss Dietrich's costumes); SAM WINSTON (editor); A. E. FREUDEMAN (set dresser); HENRY WEST (wardrobe); HARRY D. MILLS (sound); EVELYN EARLE (script clerk); STANLEY WILLIAMS (chief electrician); RICHARD HARLAN, NEIL WHEELER (assistant directors); LLOYD AHEARN, JIMMY KING (assistant photographer); ART CAMP, CARL COLEMAN, WALTER BROADFOOT, GENE LOWRY (propmen); JIMMY HOSTLER (grip); FRED DATIG (casting); GASTON DUVAL (research); JOHN MILES (publicity); ERIC LOCKE (bus manager); ANITA WILSON (stand-in for Marlene Dietrich); JOHN ENGSTEAD (stills photographer); based on the novel *The Woman and the Puppet* by PIERRE LOUYS.

MUSIC: *Capriccio espagnol* by RIMSKI-KORSAKOV, arranged by RALPH RAINGER; other music by ANDREA SETARO.

SONGS: "(If It Isn't Pain) Then It Isn't Love," "Three Sweethearts Have I" by RALPH RAINGER (music) and LEO ROBIN (lyrics).

LENGTH: 2,162 meters, 77 minutes.

PRODUCTION DATES: October 15, 1934, to January 1935.

PREMIERE: May 3, 1935, Paramount Theatre, New York.

1935 · THE FASHION SIDE OF HOLLYWOOD

United States, 1935
A Paramount Picture
Black-and-white

CAST:

KATHLEEN HOWARD, TRAVIS BANTON, MARLENE DIETRICH, JOAN BENNETT, CAROLE LOMBARD, GEORGE RAFT, CLAUDETTE COLBERT, MAE WEST.

CREDITS: JOSEF VON STERNBERG (director); WILLIAM H. PINE (producer); HERBERT

MOULDEN (editor); GRETCHEN MESSER (costumes selection); KATHLEEN HOWARD, TRAVIS BANTON (descriptive narration); MIKHAIL ROMM used the clips with Marlene Dietrich in his documentary film *Obyknovennyj fashizm* (*Ordinary Fascism*).

LENGTH: 10 minutes.

PRODUCTION DATES: February 1935.

PREMIERE: spring 1935.

1936 · DESIRE

German title: *Sehnsucht*

United States 1936
Paramount Productions, Inc.
A Frank Borzage Production
Released through Paramount Productions Inc., April 11, 1936
Black-and-white

CAST:

MARLENE DIETRICH (Madeleine de Beaupré); GARY COOPER (Tom Bradley); JOHN HALLIDAY (Carlos Margoli); WILLIAM FRAWLEY (Mr. Gibson); ERNEST COSSART (Aristide Duvalle); AKIM TAMIROFF (Police official Avilia); ALAN MOWBRAY (Dr. Edouard Pauquet); ZEFFIE TILBURY (Aunt Olga); ENRIQUE ACOSTA (Pedro); ALICE FELIZ (Pepi); STANLEY ANDREWS (Customs inspector); HARRY DEPP (Clerk); MARC LAWRENCE (Valet); HENRY ANTRIM (Chauffeur); ARMAND KALIA, GASTON GLASS (Jewelry clerks); ALBERT POLLET (French policeman); GEORGE DAVIS (Garage man); CONSTANT FRANKE (Border official); ROBERT O'CONNOR (Customs official); RAFAEL BLANCO (Driver of haywagon); ALDEN CHASE (Clerk in hotel); TONY MERLO (Waiter); ANNA DELINSKY (Servant); GEORGE MACQUARRIE (Clerk with gun); ISABEL LA MAL (Nurse); OLIVER ECKHARDT (Husband); BLANCHE CRAIG (Wife); ROLLO LLOYD (Clerk in mayor's office); ALFONSO PEDROSA (Oxcart driver).

CREDITS: FRANK BORZAGE (director); ERNST LUBITSCH (producer, fill-in director); HENRY HERZBRUN (executive producer); LEW BORZAGE (assistant director); ERIC LOCKE (second unit director); EDWIN JUSTUS MAYER, WALDEMAR YOUNG, SAMUEL HOFFENSTEIN (scenarists); CHARLES LANG (photographer); FARCIOT EDOUART, HARRY PERRY (special photographic effects); HANS DREIER, ROBERT USHER (art directors); WILLIAM SHEA (editor); A. E. FREUDEMAN (interior decorations); TRAVIS BANTON (cos-

tumer); HARRY MILLS, DON JOHNSON (sound recording); FREDERICK HOLLANDER (musical score); based on the play *Die schönen Tage von Aranjuez* by HANS SZEKELY and R. A. STEMMLE.

SONG: "Awake in a Dream" by FREDERICK HOLLANDER (music) and LEO ROBIN (lyrics).

LENGTH: 95 minutes/99 minutes

PRODUCTION DATES: September 16 to December 21, 1935; retakes: February 4 to February 5, 1936.

PREMIERE: April 1, Berlin (as *Sehnsucht*); April 11, 1936, Paramount Theatre, New York.

1936 · I LOVED A SOLDIER

A.k.a. *Hotel Imperial; Invitation to Happiness*

United States, 1936 (not completed)
A Paramount Picture
Black-and-white

CAST (IN THE ORDER HIRED):

MARLENE DIETRICH, CHARLES BOYER, AKIM TAMIROFF, WALTER CATLETT, PAUL LUCAS, VICTOR KILLIAN, SAMUEL S. HINDS, TED OLIVER, NESTER ABER, SIEGFRIED RUMANN, LIONEL STANDER, JOHN MILJAN, HARRY CORDING, BRANDON EVANS, BOB KORTMAN, ROBERT MIDDLEMASS, FRED KOHLER, SAM JAFFE, MICHAEL MARK.

CREDITS: HENRY HATHAWAY (director); RAY LISSNER (assistant director); BENJAMIN GLAZER, ERNST LUBITSCH (producers); JOHN VAN DRUTEN (scenarist); CHARLES LANG (photographer); HARRY D. MILLS (sound recorder); GROVER JONES (additional dialogue and rewriter); based on a play by MELCHIOR LENGYELL; translated from the Hungarian by ALICE DE SOOS.

1936 · THE GARDEN OF ALLAH

German title: *Der Garten Allahs*

United States, 1936
Selznick International Pictures Inc.
Released through United Artists Corp.
Technicolor

CAST:

MARLENE DIETRICH (Domini Enfilden); CHARLES BOYER (Boris Androvsky, a.k.a. Brother Antoine); BASIL RATHBONE (Count

Ferdinand Anteoni); C. AUBREY SMITH (Father J. Roubier); JOSEPH SCHILDKRAUT (Batouch); JOHN CARRADINE (Sand diviner); ALAN MARSHALL (Captain de Trevignac); LUCILE WATSON (Mother Superior Josephine); HENRY BRANDON (Hadj); TILLY LOSCH (Irena); HELEN JEROME EDDY (Nun); MARCIA MAE JONES, ANN GILLIS (Children in convent); CHARLES WALDRON (the Abbé); JOHN BRYAN (Brother Gregory); NIGEL DE BRULIER (Lector); PEDRO DE CORDOBA (Gardener); FERDINAND GOTTSCHALK (Hotel clerk); ADRIAN ROSELY (Carriage driver); ROBERT FRAZER (Smain); DAVID SCOTT (Larby); BARRY DOWNING (Little Boris); BONITA GRANVILLE, BETTY JANE GRAHAM (Children in convent); ANDREW MCKENNA (Mueddin); BETTY VAN AUKEN, MARION SAYERS, EDNA MAE HARRIS, FRANCES TURNHAM (Oasis girls); LEONID KINSKY (Voluble Arab); LOUIS ALDEZ (Blind singer); JANE KERR (Ouled Nails's madam); RUSSELL POWELL (Ouled Nails's proprietor); ERIC ALDEN (Anteoni's lieutenant); MICHAEL MARK (Coachman); HARLAN BRIGGS (American tourist); IRENE FRANKLIN (Wife); LOUIS MERCIER, MARCEL DE LA BROSSE, ROBERT STEVENSON (De Trevignac's patrol men); "CORKY" (Bous-Bous); MARIA SIEBER (Girl); with Henry Kleinbach, Frank Puglia.

CREDITS: RICHARD BOLESLAWSKI (director); DAVID O. SELZNICK (producer); ERIC STACEY, CHAUNCEY PYLE (assistant directors); W. P. LIPSCOMB, LYNN RIGGS (scenarists); WILLIS GOLDBECK (contributor to treatment); ROBERT ROSS (unit manager); VIRGIL MILLER (director of photography); W. HOWARD GREENE (photographer); HAROLD ROSSON (photographic advisor); WILFRIED CLINE, ROBERT CARNEY (associate photographers); NELSON CORDES (assistant cameraman); JACK COSGROVE (special effects); NATALIE KALMUS (color supervisor); MAX STEINER (musical score); LANSING C. HOLDEN (designer in color); EDWARD BOYLE (art director); STURGES CARNE, LYLE WHEELER (settings); HAL C. KERN, ANSON STEVENSON (editors); ERNST DRYDEN (costumer); BILL BOWMAN (wardrobe); JEANNETTE COUGET (costume construction); E. SAM KAUFMAN (Makeup); ARL A. WOLCOTT (sound recorder); TOM CARMEN (microphone); JAMIEL HASSON (technical advisor); ORAN MCPHERSON, MORRIS ROSEN (electricians); DON DICKEY, FRANK LEAVITT (grips); WILLIS GOLDBECK (producer's assistant); IRVING SINDLER (props); based on the novel by ROBERT HICHENS.

LENGTH: 80 minutes.

PRODUCTION DATES: April 15 to July 3,

1936, desert near Yuma, Arizona; Chatsworth; Selznick Studios.

PREMIERE: November 19, 1936, Radio City Music Hall, New York.

OSCARS, 1936 (ninth): special award (cinematography): W. Howard Greene, Harold Rosson.

OSCAR NOMINATIONS, 1936 (ninth): assistant director: Eric G. Stacey; music (scoring): Selznick International Pictures Music Department, Max Steiner, head of department.

1937 · KNIGHT WITHOUT ARMOUR

A.k.a. *Knight Without Armor*
German title: *Tatjana*

England, 1937
An Alexander Korda-London Films Presentation
Released through United Artists
Black-and-white

CAST:

MARLENE DIETRICH (Alexandra); ROBERT DONAT (A. J. Fothergill); IRENE VANBURGH (Duchess); HERBERT LOMAS (Vladinoff); AUSTIN TREVOR (Colonel Adraxine); BASIL GILL (Axelstein); DAVID TREE (Maronin); JOHN CLEMENTS (Poushkoff); FREDERICK CULLEY (Stanfield); LAWRENCE HANRAY (Forrester); DORICE FORDRED (Maid); FRANKLIN KELSEY (Tomsky); LAWRENCE BASKCOMB (Commissar); ALLAN JEAYES (White general); HAY PETRIE (Stationmaster); MILES MALESON (Drunken Red commissar); LYN HARDING (Bargee); RAYMOND HUNTLEY (White officer); PETER EVAN THOMAS (General Andreyevitch); Torin Thatcher (Secretary); PETER BULL (Red soldier); MIKLOS ROZSA (Piano player).

CREDITS: JACQUES FEYDER (director); ALEXANDER KORDA (producer); LAJOS BIRO (scenarist); ARTHUR WIMPERIS (dialogue writer, scenarist); FRANCES MARION (adaptation); HARRY STRADLING (photographer); JACK CARDIFF (camera operator); LAZARE MEERSON (settings); GEORGE BENDA (costumer); MIKLOS ROZSA (musical score); MUIR MATHIESON (musical director); NED MANN (special photographic effects); FRANCIS LYON (editor); A. W. WATKINS (recording director); ROMAN GOUL (technical advisor); IMLAY WATTS (assistant director); BERNARD BROWNE (assistant photographer); MAXWELL WRAY (associate director for dia-

logue); HALFDAN WALLER (assistant art director); DAVID B. CUNYNGHAME (production manager); WILLIAM HORNBECK (supervising editor); based on the novel by JAMES HILTON.

LENGTH: 107 minutes.

PRODUCTION DATES: end of July to November 1936, Denham Studios, England.

PREMIERE: September 2, 1937, Cinéma Avenue, Paris.

1937 · ANGEL

German title: *Engel*

United States, 1937
Paramount Pictures Inc.
An Ernst Lubitsch Production
Released through Paramount Pictures Inc.
Black-and-white

CAST:

MARLENE DIETRICH (Maria Barker); HERBERT MARSHALL (Sir Frederick Barker); MELVYN DOUGLAS (Anthony Halton); EDWARD EVERETT HORTON (Graham); DOUGLAS ERNEST COSSART (Walton); LAURA HOPE CREWS (Grand Duchess Anna Dmitrievna); HERBERT MUNDIN (Greenwood); IVAN LEBEDEFF (Prince Vladimir Gregorovitch); DENNIE MOORE (Emma); LIONEL PAPE (Lord Davington); LEONARD CAREY, GERALD HAMER (Footmen); PHILLIS COGHLAN (Maid); ERIC WILTON (English chauffeur); HERBERT EVANS (Butler); MICHAEL S. VISAROFF (Russian butler); DUCI KEREKJARTO (Prima violinist); HERBERT EVANS (Butler); OLAF HYTTEN (Photographer); GWENDOLYN LOGAN (Woman with Maria); JAMES FINLAYSON (Butler); GEORGE DAVIS, ARTHUR HURNI (Taxi drivers); JOSEPH ROMANTINI (Headwaiter); SUZANNE KAAREN (Gambling girl); LOUISE CARTER (Flower woman); GINE CORRADO (Vice hotel director); MAJOR SAM HARRIS (Man in club); with Ivan Lebedeff.

CREDITS: ERNST LUBITSCH (director and producer); JOSEPH LEFERT (assistant director); SAMSON RAPHAELSON (scenarist); GUY BOLTON, RUSSELL MEDCRAFT (adaptation); CHARLES LANG JR. (Photographer); FARCIOT EDOUART (special photographic effects); LLOYD KNECHTEEL, HARRY PERRY (photographic effects); HANS DREIER, ROBERT USHER (art directors); WILLIAM SHEA (editor); HARVEY JOHNSTON (assistant editor); A. E. FREUDEMANN (interior decorations);

TRAVIS BANTON (costumer); BORIS MORROS (musical director); MAURICE LAWRENCE (musical score); HARRY MILLS (sound); LOUIS MESENKOP (sound and dubbing mixer); based on the play *Ankyal* by MENYHÉRT LENGYEL.

SONG: "Angel" by FREDERICK HOLLANDER (music) and LEO ROBIN (Lyrics).

LENGTH: 90 minutes.

PRODUCTION DATES: March 22 to June 14, 1937, Paramount Studios; second unit locations in Europe.

PREMIERE: November 3, 1937, Paramount Theatre, New York.

1939 · DESTRY RIDES AGAIN

German title: *Der grosse Bluff*

United States, 1939
Universal Pictures Corp.
A Joe Pasternak Production
Released through Universal Pictures Corp.
Black-and-white

CAST:

MARLENE DIETRICH (Frenchy); JAMES STEWART (Tom Destry Jr.); MISCHA AUER (Boris Callahan); CHARLES WINNINGER (Washington Dimsdale); BRIAN DONLEVY (Kent); ALLEN JENKINS (Gyp Watson); WARREN HYMER (Bugs Watson); IRENE HERVEY (Janice Tyndall); UNA MERKEL (Lily Belle Callahan); BILLY GILBERT (Loupgerou); SAMUEL S. HINDS (Judge Hiram J. Slade); JACK CARSON (Jack Tyndall); TOM FADDEN (Lem Claggett); VIRGINIA BRISSAC (Sophie "Ma" Claggett); EDMUND MACDONALD (Rockwell); LILLIAN YARBO (Clara); JOE KING (Sheriff Keogh); ANN TODD (Claggett girl); DICKIE JONES (Eli Whitney Claggett); CARMEN D'ANTONIO (Dancer); HARRY CORDING (Rowdy); DICK ALEXANDER, BILL STEELE GETTINGER (Cowboys); MINERVA URECAL (Mrs. DeWitt); BOB MCKENZIE (Doctor); BILLY BLETCHER (Pianist); LLOYD INGRAHAM (Turner, express agent); BILL CODY JR. (Small boy); LOREN BROWN, HAROLD DEGARRO (Jugglers); HARRY TENBROOK (Stage Rider); BUD MCCLURE (Stage driver); ALEX WOLOSHIN (Assistant bartender); CHIEF BIG TREE (Indian); MARY SHANNON (Woman on street); with Dora Clement, Florence Dudley.

CREDITS: GEORGE MARSHALL (director); JOE PASTERNAK (producer); ISLIN AUSTER (associate producer); VERNON KEAYS (assis-

tant director); FELIX JACKSON, HENRY MYERS, GERTRUDE PURCELL (scenarists); HAL MOHR (photographer); JACK OTTERSON (art director); MARTINA OBZINA (associate art director); MILTON CARRUTH (editor); RUSSELL A. GAUSMAN (set decorator); VERA WEST (costumer); CHARLES PREVIN (musical director); FRANK SKINNER (musical score); BERNARD B. BROWN (sound supervisor); ROBERT PRITCHARD (technician); based on an original story by FELIX JACKSON, suggested by the novel by MAX BRAND.

SONGS: "Little Joe, the Wrangler," "You've Got That Look (That Leaves Me Weak)," "The Boys in the Back Room," "Frenchy" (sung by Lillian Yarbo) by FREDERICK HOLLANDER (music) and FRANK LOESSER (lyrics).

LENGTH: 2,609 meters, 94 minutes.

PRODUCTION DATES: September 7 to November 2, 1939, Universal Studios and Kernville, California.

PREMIERE: November 29, 1939, Rivoli Theatre, New York.

1940 · SEVEN SINNERS

German title: *Das Haus der sieben Sünden*

United States, 1940
Universal Pictures Corp.
A Joe Pasternak Production
Released through Universal Pictures Corp.
Black-and-white

CAST:

MARLENE DIETRICH (Bijou); JOHN WAYNE (Lieutenant Dan Brent); ALBERT DEKKER (Dr. Martin); BRODERICK CRAWFORD (Little Ned); ANNA LEE (Dorothy Henderson); MISCHA AUER (Sasha); BILLY GILBERT (Tony); RICHARD CARLE (District officer); SAMUEL S. HINDS (Governor Henderson); OSCAR HOMOLKA (Antro); REGINALD DENNY (Captain Church); VINCE BARNETT (Bartender); HERBERT RAWLINSON (First mate); JAMES CRAIG, WILLIAM BAKEWELL (Ensigns); ANTONIO MORNO (Rubio); RUSSELL HICKS (First governor); WILLIAM B. DAVIDSON (Police chief); HARRY SEYMOUR (Piano player); HARRY PAYNE (Second mate); LARRY LAWSON (Chief officer); CHARLES STAFFORD, PETER SULLIVAN, MICHAEL HARVEY, EDGAR EDWARDS, FRANK SWANN, LESLIE VINCENT (Ensigns); SOLEDAD JIMINEZ (Bijou's maid); FRANK HAGNEY (Hench-

man); WILLIE FUNG (Shopkeeper); HENRY VICTOR (Dutch officer); DANNY BECK (Orchestra leader); NOBLE JOHNSON (Russian); AL HILL, TAY GARNETT, ERIC ALDEN, WARD WING (Sailors); JOHN SHEENAN (Drunk); NANETTE VALLON (First maid); EVELYN SELBIE (Fortune-teller); TOM SEIDEL (Ensign Scott); with Betty Beagle, Claire Mead, Raquel Vierria, Mamo Clark, Virginia Engels, Mary Ann Hyde.
CREDITS: TAY GARNETT (director); JOE PASTERNAK (producer); PHILLIP KARLSTEIN (assistant director); JOHN MEEHAN, HARRY TUGEND (scenarists); RUDOLPH MATÉ (photographer); JACK OTTERSON (art director); MARTIN OBZINA (associate); TED KENT (editor); RUSSELL A. GAUSMAN (set decorator); Miss Dietrich's costumes by IRENE; VERA WEST (costumer); CHARLES PREVIN (musical director); FRANK SKINNER, HANS SALTER (musical score); BERNARD B. BROWN (sound supervisor); ROBERT PRITCHARD (sound technician); I. C. JOHNSON, CAPTAIN USN (technical advisor); ALANSON EDWARDS (unit publicist); based on an original story by LADISLAS FODOR and LASLO VADNAI.
SONGS: "I've Been in Love Before," "I Fell Overboard," "The Man's in the Navy" by FREDERICK HOLLANDER (music) and FRANK LOESSER (lyrics).
LENGTH: 86 minutes.
PRODUCTION DATES: early July to September 14, 1940.
PREMIERE: November 16, 1940, Rivoli Theatre, New York.

1941 · THE FLAME OF NEW ORLEANS

German title: *Die Abenteuerin*

United States, 1941
Universal Pictures Company Inc.
A René Clair Production
Released through Universal Pictures Company Inc.
Black-and-white

CAST:

MARLENE DIETRICH (Countess Claire Ledeux, a.k.a. Lili); BRUCE CABOT (Robert Latour); ROLAND YOUNG (Charles Giraud); MISCHA AUER (Zolotov); ANDY DEVINE (First sailor); FRANK JENKS (Second sailor); EDDIE QUILLAN (Third sailor); LAURA HOPE CREWS (Auntie); FRANKLIN PANGBORN (Bellows); THERESA HARRIS (Clementine); CLARENCE MUSE (Samuel); MELVILLE COOPER (Brother-in-law); ANNE REVERE (Sister); BOB EVANS (William); EMILY FITZROY, VIRGINIA SALE, DOROTHY ADAMS (Cousins); GITTA ALPAR, ANTHONY MARLOWE (Opera singers); SHEMP HOWARD, FRANK SULLY, TONY PATON (Waiters); GUS SCHILLING (Clerk); JO DEVLIN, FRANK MORAN, JACK RAYMOND (Sailors); REX EVANS (Burly); JESS LEE BROOKS, BILLY MITCHELL (Black men); BARBARA BREWSTER, GLORIA BREWSTER, VIRGINIA ENGELS (Girls); JAMES GUILFOYLE (Man on dock); LOIS LINDSAY (Young girl); with Roy Harris, Mary Treen, Herbert Rawlinson, Charlotte Treadway, Jennifer Gray, Lowell Drew, Reed Hadley.
CREDITS: RENÉ CLAIR (director); JOE PASTERNAK (producer); PHILLIP P. KARLSTEIN (assistant director); NORMAN KRASNA (scenarist); RUDOLPH MATÉ (photographer); JACK OTTERSON (art director); MARTIN OBZINA (associate art director); FRANK GROSS (editor); RUSSELL A. GAUSMAN (set decorations); RENÉ HUBERT (costumer); CHARLES PREVIN (musical director); FRANK SKINNER (musical score); BERNARD B. BROWN (sound supervisor); ROBERT PRITCHARD (technician); VINCENT MAHONY (unit publicity writer).
SONGS: "Sweet Is the Blush of May" (sung by Marlene Dietrich), "Salt o' the Sea" (sung by the ship's crew), "Oh, Joyful Day" (sung by chorus during wedding ceremony) by CHARLES PREVIN (music) and SAM LERNER (lyrics).
LENGTH: 2,170 meters, 79 minutes.
PRODUCTION DATES: January 6 to early March 1941.
PREMIERE: April 24, 1941, Orpheum, New Orleans.
OSCAR NOMINATIONS, 1941 (fourteenth): art direction (black-and-white): Martin Obzina, Jack Otterson; interior decoration (black-and-white): Russell A. Gausman.

1941 · MANPOWER

German title: *Herzen in Flammen*

United States, 1941
Warner Bros. Pictures Inc.
A Warner Bros.–First National Picture
Released through Warner Bros. Pictures Inc.
Black-and-white

CAST:
EDWARD G. ROBINSON (Hank McHenry); MARLENE DIETRICH (Fay Duval); GEORGE RAFT (Johnny Marshall); ALAN HALE (Jumbo Wells); FRANK MCHUGH (Omaha); EVE ARDEN (Dolly); BARTON MACLANE (Smiley Quinn); WARD BOND (Eddie Adams); WALTER CATLETT (Sidney Whipple); JOYCE COMPTON (Scarlett); LUCIA CARROLL (Flo); EGON BRECHER (Pop Duval); CLIFF CLARK (Cully); JOSEPH CREHAN (Sweeney); BEN WELDEN (Al Hurst); BARBARA PEPPER (Polly); DOROTHY APPLEBY (Wilma); CARL HARBAUGH (Noisy Nash); BARBARA LAND (Marilyn); RALPH DUNN (Man at phone); HARRY STRANG (Foreman); NAT CARR (Waiter); JOHN KELLY, PAT MCKEE (Bouncers); JOAN WINFIELD, AUDRA LINDLEY, FAYE EMERSON (Nurses); ISABEL WITHERS (Floor nurse); JAMES FLAVIN (Orderly); CHESTER CLUTE, JOHN DILSON (Clerks); DOROTHY VAUGHAN (Mrs. Boyle); BILLY WAYNE (Taxi driver); DICK ELLIOTT, ARTHUR Q. BRYAN (Drunks); HARRY SEYMOUR (Piano player); NELLA WALKER (Floor lady); BRENDA FOWLER (Saleslady); JOYCE BRYANT (Miss Brewster); GAYLE MELLOTT, MURIEL BARR (Models); HARRY HOLMAN (Justice of the peace); VERA LEWIS (Wife); BEAL WONG (Chinese singer); JOE DEVLIN (Bartender); GEORGIA CAINE (Head nurse); JOHN HARMON (Benny); JEAN AMES (Thelma); JANE RANDOLPH (Hatcheck girl); FRANK MAYO (Doorman); EDDY CHANDLER, LEE PHELPS (Detectives); WILLIAM GOULD (Desk sergeant); ROBERT STRANGE (Bondsman); LEAH BAIRD (Matron); HERBERT HEYWOOD (Watchman); DREW RODDY, PETER CALDWELL, HARRY HARVEY JR., BOBBY ROBB (Boys); MURRAY ALPER, CHARLES SULLIVAN, FRED GRAHAM, ELLIOTT SULLIVAN, WILLIAM NEWELL, DICK WESSEL (Linemen); CLIFF SAUM, ROLAND DREW, EDDIE FETHERSTON, CHARLES SHERLOCK, JEFFREY SAYRE, WILLIAM HOPPER (Men); with Al Herman.
CREDITS: RAOUL WALSH (director); HAL B. WALLIS (executive producer); MARK HELLINGER, JACK SAPER (associate producers); HUGH CUMMINGS (dialogue director); ROSS SAUNDERS (assistant director); original screenplay by RICHARD MACAULAY, JERRY WALD; ERNEST HALLER (photographer); BYRON HASKIN, H. F. KOENEKAMP (special effects); MAX PARKER (art director); RALPH DAWSON (editor); MILO ANDERSON (costumer); ADOLPH DEUTSCH (musical score); LEO F. FORBSTEIN (musical director); DOLPH THOMAS (sound); PERC WESTMORE (makeup); VERNE ELLIOTT (technical advisor); FRANK MATTISON (unit manager).

SONGS: "I'm in No Mood for Music Tonight," "He Lied and I Listened," by FREDERICK HOLLANDER (music) and FRANK LOESSER (lyrics).
LENGTH: 2,843 meters, 103 minutes.
PRODUCTION DATES: March 24 to May 12, 1941.
PREMIERE: July 1941, Strand Theatre, New York.

1942 · THE LADY IS WILLING

United States, 1942
Columbia Pictures Corp.
Mitchell Leisen Productions
Released through Columbia Pictures Corp.
Black-and-white

CAST:

MARLENE DIETRICH (Elizabeth Madden); FRED MACMURRAY (Dr. Corey T. McBain); ALINE MACMAHON (Buddy); STANLEY RIDGES (Kenneth Hanline); ARLINE JUDGE (Frances); ROGER CLARK (Victor); MARIETTA CANTY (Mary Lou); DAVID JAMES (Baby Corey); RUTH FORD (Myrtle); HARVEY STEPHENS (Dr. Golding); HARRY SHANNON (Detective Sergeant Barnes); ELIZABETH RISDON (Mrs. Cummings); CHARLES LANE (K. K. Miller); MURRAY ALPER (Joe Quig); KITTY KELLY (Nellie Quig); STERLING HOLLOWAY (Arthur Miggle); CHESTER CLUTE (Income tax man); ROBERT EMMETT KEANE (Hotel manager); EDDIE ACUFF (Murphy); MYRTLE ANDERSON, LORNA DUNN (Maids); EUGENE BORDEN (Wine steward); JUDITH LINDEN (Airline stewardess); NEIL HAMILTON (Charlie); HELEN AINSWORTH (Interior decorator); LOU FULTON (Mop man); BILLY NEWELL (Counterman); JIMMY CONLIN (Bum); CHARLES HALTON (Dr. Jones); ROMAINE CALLENDER (Bald-headed man); RAY WALKER (Reporter), ERNIE ADAMS, ROY CRANE (Doormen); GEORGIA BACKUS, FRANCES MORRIS (Nurses); PAUL OMAN (Violinist); EDWARD MCWADE (Boston doorman).
CREDITS: MITCHELL LEISEN (director and producer); JAMES EDWARD GRANT, ALBERT MCCLEERY (scenarists); TED TETZLAFF (photographer); LIONEL BANKS (art director); RUDOLPH STERNAD (associate art director); EDA WARREN (editor); gowns for Marlene Dietrich by IRENE; hats for Marlene Dietrich by JOHN FREDERICS; jewels for Marlene Dietrich by PAUL FLATO; W. FRANKE HARLING (musical score); MORRIS W. STOLOFF (musical director); DOUGLAS DEAN (dance

director); LODGE CUNNINGHAM (sound recorder); FRANCISCO ALONSO (production assistant); BUD BRILL (assistant to Mitchell Leisen); based on an original story by JAMES EDWARD GRANT.

SONG: "Strange Thing (And I Find You)" by JACK KING (music) and GORDON CLIFFORD (lyrics).

LENGTH: 2,484 meters, 92 minutes.

PRODUCTION DATES: August 11 to October 24, 1941.

PREMIERE: February 12, 1942.

1942 · THE SPOILERS

German titles: *Die Freibeuterin; Stahlharte Fäuste*

United States, 1942
Universal Pictures Company Inc.
Fred Lloyd Productions Inc.
A Charles K. Feldman Group Production
Released through Universal Pictures Company Inc.
Black-and-white

CAST:

MARLENE DIETRICH (Cherry Malotte); RANDOLPH SCOTT (Alexander McNamara); JOHN WAYNE (Roy Glennister); MARGARET LINDSAY (Helen Chester); HARRY CAREY (Al Dextry); RICHARD BARTHELMESS (Bronco Kid Farrell); GEORGE CLEVELAND (Banty); SAMUEL S. HINDS (Judge Horace Stillman); RUSSELL SIMPSON (Flapjack Simms); WILLIAM FARNUM (Wheaton); MARIETTA CANTY (Idabelle); JACK NORTON (Mr. Skinner); RAY BENNETT (Clark); FORREST TAYLOR (Bennett); CHARLES MCMURPHY, ART MILES (Deputies); CHARLES HALTON (Johnathan Struve); BUD OSBORNE (Marshall); DREW DEMOREST (Galloway); CHESTER CLUTE (Clerk); WILLIE FUNG (Chinese man); ROBERT W. SERVICE (himself); WILLI ROBERT "BOB" HOMANS (Sea captain); BILL HAADE (Deputy Joe); AM GOULD (New marshall); HARRY STRANG, HARRY WOODS, MICKEY SIMPSON, PAUL NEWLAN, BOB BARRON, DUKE YORK, HARRY CORDING, EARLE HODGINS (Miners); GLENN STRANGE, DICK CRAMER (Deputies); LLOYD INGRAHAM (Kelly); BEN TAGGART (Banker); DICK RUSH (Court bailiff); IRVING BACON (Hotel owner); with Kitty O'Neil, Frank Austin, Bob McKenzie, Emmett Lynn.

CREDITS: RAY ENRIGHT (director); FRANK LLOYD (producer, second unit director); LEE MARCUS (associate producer); VERNON KEAYS (assistant director); GENE LEWIS (dialogue director); LAWRENCE HAZARD, TOM REED (scenarists); MILTON KRASNER (photographer); JOHN P. FULTON (special photographic effects); JACK OTTERSON (art director); JOHN B. GOODMAN (associate); CLARENCE KOLSTER (editor); RUSSELL A. GAUSMAN, EDWARD R. ROBINSON (set decorators); VERA WEST (costumer); HANS J. SALTER (musical score); CHARLES PREVIN (musical director); BERNARD B. BROWN (sound supervisor); ROBERT PRITCHARD (technician); based on the novel by REX BEACH.

LENGTH: 2,389 meters, 87 minutes.

PRODUCTION DATES: January 12 to late February 1942, Lake Arrowhead and Universal Studios.

PREMIERE: May 8, 1942.

OSCAR NOMINATIONS, 1942 (fifteenth): art direction (black-and-white): Jack Otterson, John B. Goodman; interior decoration (black-and-white): Russell A. Gausman, Edward R. Robinson.

1942 · PITTSBURGH

United States, 1942
Universal Pictures Company Inc.
A Charles K. Feldman Production
Released through Universal Pictures Company Inc.
Black-and-white

CAST:

MARLENE DIETRICH (Josie "Hunky" Winters); RANDOLPH SCOTT (Cash Evans); JOHN WAYNE (Charles "Pittsburgh" Markham, a.k.a. Charles Ellis); FRANK CRAVEN ("Doc" Powers); LOUISE ALLBRITTON (Shannon Prentiss); SHEMP HOWARD (Shorty); THOMAS GOMEZ (Joe Malneck); LUDWIG STÖSSEL (Dr. Grazlich); SAMUEL S. HINDS (Morgan Prentiss); PAUL FIX (Mine operator); WILLIAM HAADE (Johnny); CHARLES COLEMAN (Butler Mike); NESTOR PAIVA (Barney); DOUGLAS FOWLEY (Mort Brawley); SAMMY STEIN (Killer Kane); HARRY SEYMOUR (Theater manager); HOBERT CAVANAUGH (Derelict); PAUL MCVEY (Thornton); ED EMERSON (Reporter); KAY LINAKER, FRANCES MORRIS (Secretaries); RAY WALKER (Sutliffe); VIRGINIA SALE (Mrs. Bercovici); DON BARCLAY (Drunk); WADE BOTELER (Mine superintendent); LORIN RAKER (Milgraine); MIRA MCKINNEY (Tilda); JOHN SHEEHAN (Bill); WILLIAM RUHL (Stretcher bearer); HARRY CORDING, CHARLES SULLIVAN (Miners); BOB BARRON (Foreman); JOHN DILSON (Wilson); EDWARD KEANE (Headwaiter); GUS GLASSMIRE (Chemist); WILLIAM GOULD (Burns); JOHN MARVIN (Jones); PAUL SCOTT (Doctor); ALPHONSE MARTELL (Carlos); TONY WARDE (Attendant); BOB PERRY (Referee); BEN TAGGART (Police sergeant); CHARLES SHERLOCK (Chauffeur); JACK C. SMITH (Officer O'Toole); HAL CRAIG, NOLAN LEARY (Accountants); JACK CHEFE (Barber); BROOKS BENEDICT, PHIL WARREN (Guests); LARRY MCGRATH (Waiter); JACK GARDNER (Clerk); BRODERICK O'FARRELL (Doorman); with Winifred Harris, Lois Austin, Ethan Laidlaw, Grace Cunard, Sandra Morgan, Irving Mitchell, Bess Flowers, Frank Marlowe, Ed Mortimer.

CREDITS: LEWIS SEILER (director) ROBERT FELLOWS (associate producer); CHARLES GOULD (assistant director); PAUL FIX (dialogue director); KENNETH GAMET, TOM REED (scenarists); JOHN TWIST (additional dialogue); WINSTON MILLER, ROBERT FELLOWS (contribution writers); ROBERT DE GRASSE (Photographer); JOHN P. FULTON (special photographic effects); HARRY KAUFMANN (special effects); JOHN B. GOODMAN (art director); PAUL LANDRES (editor); RUSSELL A. GAUSMAN (set decorator); IRA S. WEBB (associate set decorator); VERA WEST (costumer); FRANK SKINNER, HANS J. SALTER (musical score); CHARLES PREVIN (musical director); BERNARD B. BROWN (director of sound); PAUL NEAL (sound technician); LELAND T. DOAN (technical advisor); DAN THOMAS (unit publicity writer); based on an original story by GEORGE OWEN and TOM REED.

LENGTH: 2,497 meters, 92 minutes.

PRODUCTION DATES: August 26 to late October 1942.

PREMIERE: December 11, 1942, Criterion Theatre, New York.

1944 · FOLLOW THE BOYS

United States, 1944
Universal Pictures Company
Black-and-white

CAST:

GEORGE RAFT (Tony West); VERA ZORINA (Gloria Vance West); CHARLEY GRAPEWIN (Nick West); GRACE MCDONALD (Kitty West); CHARLES BUTTERWORTH (Louie Fairweather); GEORGE MACREADY (Walter Bruce); ELIZABETH PATTERSON (Annie); THEODORE VON ELTZ (William Barrett); REGIS TOOMEY (Dr. Jim Henderson); RAMSAY AMES (Laura); SPOOKS (Junior); MACK GRAY (Lieutenant Reynolds); MOLLY LAMONT (Miss Hartford, the secretary); JOHN MEREDITH (Blind soldier in Jeanette MacDonald's number); RALPH GARDNER (Patient in Jeanette MacDonald's number); JOHN ESTES (Patient); DORIS LLOYD (Nurse); CHARLES D. BROWN (Colonel Starrett); NELSON LEIGH (Bull Fiddler); LANE CHANDLER (Ship's officer); CYRIL RING (Laughton, *Life* photographer); EMMETT VOGAN (Harkness, *Life* reporter); ADDISON RICHARDS (McDermott, *Life* editor); FRANK LARUE (Mailman); TONY MARSH (First officer); STANLEY ANDREWS (Australian officer); LESLIE DENISON (Reporter); LEYLAND HODGSON (Australian reporter); BILL HEALY (Ship's officer); JIMMY CARPENTER, BERNARD THOMAS, JOHN WHITNEY, WALTER TETLEY, JOEL ALLAN, CARLYLE BLACKWELL, MICHAEL KIRK, MEL SCHUBERT, STEPHEN WAYNE, CHARLES KING (Soldiers); RALPH DUNN (Loomis); BILLY BENEDICT (Joe, a soldier); GRANDON RHODES (George Grayson); HOWARD HICKMAN (Dr. Wood); EDWIN STANLEY (Film director); ROY DARMOUR (Eddie, assistant director); CARL VERNELL (Terry Dennis, dance director); WALLIS CLARK (Victory committeeman); RICHARD CRANE (Marine officer); FRANK WILCOX (Captain Williams, army doctor); CAREY HARRISON, WILLIAM FORREST (Colonels); GEORGE RILEY (Jimmy); STEVE BRODIE (Australian pilot); JACK WEGMAN (Mayor); CLYDE COOK, BOBBY BARBER (Stooges); DICK NELSON (Sergeant); ANTHONY WARDE (Captain); TOM HANLON (Announcer); DON MCGILL, FRANKLIN PARKER, MARTIN ASHE (Men in the office); DENNIS MOORE (HVC officer); ODESSA LAUREN, NANCY BRINCKMAN, JANET SHAW, JAN WILEY (Telephone operators); BILL DYER (Messenger boy); DUKE YORK (M.P.); LENNIE SMITH, BOB ASHLEY (Jitterbugs); JACKIE LOU HARDING (Girl in montage), GENEVIEVE BELL (Mother in montage); EDWIN STANLEY (Room clerk); DON KRAMER, ALLAN COOKE, LUIS TORRES NICHOLAI, JOHN DUANE, ED BROWNE, CLAIRE FREEMAN, BILL MEADER, EDDIE KOVER (Dancers); TONY HUGHES (Man); BILLY WAYNE (Columnist); LEE BENNETT (Acrobat); DAISY (Fifi); JOHN CASON (Soldier on radio); GEORGE ELDRIDGE (Submarine officer); MARIE OSBORNE (Nurse); NICODEMUS STEWART (Lieutenant Reynolds); GEORGE "SHORTY" CHIRELLO (Welles's assistant); JANICE GAY, JANE SMITH, MARJORIE FECTEAN, DORIS BRENN, ROSE-

MARY BATTLE, LOLITA LEIGHTER, MARY ROW-LAND, ELEANOR COUNTS, LINDA BRENT (Magic maids); BILL WOLF (Zoot suiter); FRANK JENKS (Chic Doyle). Guest stars appearing as themselves: Jeanette Mac-Donald, Orson Welles's Mercury Wonder Show, Marlene Dietrich, Dinah Shore, Donald O'Connor, Peggy Ryan, W. C. Fields, the Andrews Sisters, Artur Rubinstein, Carmen Amaya and Her Company, Sophie Tucker, the Delta Rhythm Boys, Leonard Gautier's dog act "The Bricklayers," Agustín Castellón Sabicas, Ted Lewis and his band, Freddie Slack and his orchestra, Charlie Spivak and his orchestra, Louis Jordan and his orchestra. In the Hollywood Victory Committee sequence: Louise Beavers, Clarence Muse, Maxie Rosenbloom, Maria Montez, Susanna Foster, Louise Allbritton, Robert Paige, Alan Curtis, Lon Chaney Jr., Gloria Jean, Andy Devine, Turhan Bey, Evelyn Ankers, Noah Beery Jr., Gale Sondergaard, Peter Coe, Nigel Bruce, Thomas Gomez, Lois Collier, Samuel S. Hinds, Randolph Scott, Martha O'Driscoll, Elyse Knox, Philo McCullough; stars in film clips: Joan Bennett, Hedy Lamarr, Martha Scott, Irene Dunn.

CREDITS: EDDIE SUTHERLAND (director); CHARLES K. FELDMAN (producer); ALBERT L. ROCKETT (associate producer); JACK RAWLINS (director of additional scenes); LOU BRESLOW (director of Delta Rhythm Boys sequence); HOWARD CHRISTIE, WILLIAM HOLLAND, WILLARD SHELDON (assistant directors); JOE SCHOENFELD (writer of epilogue "Soldiers in greasepaint"); DAVID ABEL (photographer); CHARLES VAN ENGER (photographer of additional scenes); HAL MOHR (photographer of Delta Rhythm Boys sequence); WALLACE CHEWNING (camera operator); M. NATHAN (camera assistant); ROSS SAVON (gaffer); E. ESTERBROOK (stills photographer); JOHN P. FULTON (special photographic effects); CARL LEE (special effects); JOHN B. GOODMAN, HAROLD H. MACARTHUR (art directors); FRED R. FEITSHANS JR. (editor); RUSSELL A. GAUSMAN, IRA S. WEBB (set decorators); DAN FISH (props); VERA WEST (gowns); HOWARD GREER (Miss Zorina's gowns); LACKRITZ (Miss Zorina's jewelry); LEIGH HARLINE (musical director); GEORGE HALE (dance creator and director); GEORGE BALANCHINE (dance director); BERNARD B. BROWN (sound supervisor); ROBERT PRITCHARD (sound technician); FRANK ARTMAN (boom operator); WILLIAM SCHWARTZ (recording operator); HENRY C.

ROGERS (publicity); based on an original screenplay by LOU BRESLOW and GERTRUDE PURCELL.
MUSIC: "Swing Low, Sweet Chariot," traditional, arranged by HENRY THACKER BURLEIGH; "I Feel a Song Coming On" by JIMMY MCHUGH, DOROTHY FIELDS, GEORGE OPPENHEIM; "Furlough Fling" by CHARLES WEINTRAUB and FRANK DAVENPORT; "Besame Mucho" by CONSUELO VELÁZQUEZ; "Liebestraum" by FRANZ LISZT; "Sweet Georgia Brown" by BEN BERNIE and MACEO PINKARD; "Merriment" by AUGUSTÍN CASTELLÓN SABICAS.
SONGS: "Good Night" by LEO WOOD, CON CONRAD and IRVING BIBO; "Tonight" by WALTER DONALDSON (music) and KERMIT GOELL (lyrics); "The Bigger the Army and Navy" by JACK YELLEN; "Kittens with Their Mittens Laced" by INEZ JAMES and SIDNEY MILLER; "Beyond the Blue Horizon" by RICHARD A. WHITING, W. FRANKE HARLING, and LEO RUBIN; "I'll Walk Alone," "A Better Day Is Comin'" by JULE STYNE (music) and SAMMY CAHN (lyrics); "I'll Get By" by FRED E. AHLERT (music) and ROY TURK (lyrics); "Is You Is, or Is You Ain't My Baby" by LEWIS JORDAN and BILLY AUSTIN; "I'll See You in My Dreams" by GUS KAHN and ISHAM JONES; "The House I Live In" by EARL ROBINSON (music) and LEWIS ALLAN (lyrics); "Shoo Shoo, Baby" by PHIL MOORE; "Mad About Him Blues" by LARRY MARKS and DICK CHARLES; "Some of These Days" by SHELTON BROOKS.
LENGTH: 122 minutes.
PRODUCTION DATES: 1943.
PREMIERE: April 1944.
OSCAR NOMINATION, 1944 (seventeenth): music (song): Jule Styne, Sammy Cahn.

1944 · KISMET

United States, 1944
Metro-Goldwyn-Mayer Corp., controlled by Loew's Inc.
Released through Loew's Inc.
Technicolor

CAST:
RONALD COLMAN (Hafiz); MARLENE DIETRICH (Jamilla); JAMES CRAIG (Caliph); EDWARD ARNOLD (Mansur, the Grand Vizier); HUGH HERBERT (Feisal); JOY ANN PAGE (Marsinah); FLORENCE BATES (Karsha); HARRY DAVENPORT (Agha); HOBART CAVANAUGH (Moolah); ROBERT WARWICK

(Alfife); FRANK MORGAN (Narrator); JULIAN OLIVER, VICTOR DUBINSKY, SAUL SILVERMAN, HERMAN HELLER, GABRIEL LEONOFF (Singers); BEATRICE and EVELYNE KRAFT (Court dancers); BARRY MACOLLUM (Amu); VICTOR KILLIAN (Jehan); CHARLES MIDDLETON (the miser); HARRY HUMPHREY (Gardener); NESTOR PAIVA (Captain of police); ROQUE YBARRA (Son of the miser); EVE WHITNEY (Café girl); MINERVA URECAL (Retainer); JOE YULE (Attendant); MORGAN WALLACE; FRANK PENNY, PETE CUSANELLI (Merchants); JOHN MAXWELL (Guard); WALTER DE PALMA (Detective); JIMMY AMES (Majordomo); CY KENDALL (Herald); CHARLES LA TORRE (Alwah); MAREK WINDHEIM (Sapu); NOBLE BLAKE (Nubian slave); ANNA DEMETRIO (Café owner); DAN SEYMOUR (Fat Turk); MITCHELL LEWIS (Sheik); PHIROZ NAZIR, ASIT GHOSH (Nabout fighters); CARMEN D'ANTONIO (Dancer in café); JOYCE GATES, JESSIE TAI SING, ZEDRA CONDE, BARBARA GLENZ, FRANCES RAMSDEN (Café girls); CHARLES JUDELS (Rich merchant); DALE VAN SICKEL (Assassin); HARRY CORDING, SAMMY STEIN, JOSEPH GRANBY (Policemen); GABRIEL GONZALES (Monkey man); BRUNO WEISE (Pole act); ZACK WILLIAMS (Executioner); JOHN MERTON, DICK BOTILLER, JACK "TINY" LIPSON (Mansur aides); EDDIE ABDO (Mansur aide/Arabic prayer voice); BILLY CUMMINGS (Arabic prayer voice); LYNNE ARLEN, LESLIE ANTHONY, ROSALYN LEE, SONIA CARR, CARLA BOEHM, EILEEN HERRIC, SHELBY PAYNE (Queen's retinue); PAUL SINGH (Caliph's valet); PEDRO DE CORDOBA (Muezzin); PAUL BRADLEY (Magician); LOUIS MANLEY (Fireeater); JOHN VERNON SCHALLER, RAMIRO RIVAS, WILLIAM RIVAS (Jugglers).
CREDITS: WILLIAM DIETERLE (director); EVERETT RISKIN (producer); MARVIN STUART (assistant director); JOHN MEEHAN (scenarist); CHARLES ROSHER (photographer); JOHN NICKOLAUS JR. (second cameraman); WARREN NEWCOMBE (special effects); MARK DAVIS (special effects cameraman); A. ARNOLD GILLESPIE (miniatures, special photographic effects, transparency shots); NATALIE KALMUS (Technicolor color director); HENRI JAFFA (associate technical color director); CEDRIC GIBBONS, DANIEL B. CATHCART, PRESTON AMES (art directors); BEN LEWIS (editor); EDWIN B. WILLIS (set decorator); RICHARD PEFFERLE (associate set decorator); costume supervision by IRENE; costume execution by KARINSKA; HERBERT STOTHART (musical score); MURRAY CUTTER (orchestral collaboration); JACK COLE (dance director); JANNETT BATE (assistant

dance director); DOUGLAS SHEARER (sound recorder); JAMES Z. FLASTER (unit mixer); STANDISH J. LAMBERT, FRANK B. MACKENZIE, ROBERT W. SHIERLEY, NEWELL SPARKS, WILLIAM STEINKAMP, MICHAEL STEINORE, JOHN A. WILLIAMS (rerecording and effects mixer); M. J. MCLAUGHLIN, HERBERT STAHLBERG (music mixer); JACK DAWN (makeup); SYDNEY GUILAROFF (hair stylist); VICTOR STOLOFF (technical advisor); DOREEN TRYDEN (singing double for Joy Ann Page); based on the play by EDWARD KNOBLOCH.
SONGS: "Tell Me, Tell Me, Evening Star," "Willow in the Wind" by HAROLD ARLEN (music) and E. Y. HARBURG (lyrics).
LENGTH: 2,740 meters, 101 minutes.
PRODUCTION DATES: October 23 to December 31, 1943.
PREMIERE: August 22, 1944, Astor Theatre, New York.
OSCAR NOMINATIONS, 1944 (seventeenth): art direction (color): Cedric Gibbons, Daniel B. Cathcart; cinematography (color): Charles Rosher; interior decoration (color): Edwin B. Willis, Richard Pefferle; music (music score of a dramatic or comedy picture): Herbert Stothart; sound recording: Metro-Goldwyn-Mayer Studio Sound Department, Douglas Shearer (sound director).

1946 · MARTIN ROUMAGNAC

France, 1946
An Alcina Production
Released in the United States as *The Room Upstairs* through Lopert Films, Inc.
Black-and-white

CAST:
MARLENE DIETRICH (Blanche Ferrand); JEAN GABIN (Martin Roumagnac); MARGO LION (Jeanne, Martin's sister); MARCEL HERRAND (Consul); JEAN D'YD (Blanche's uncle); DANIEL GÉLIN (Lover); JEAN DARCANTE (Lawyer); HENRI POUPON (Gargame); MARCEL ANDRÉ (Judge); MARCEL PÉREZ (Paulot); CAMILLE GUERINI (Postman); CHARLES LEMONTIER (Bonnemain); LUCIEN NAT (Poorhouse superintendent); with Michel Ardan, Paul Faivre, Marcelle Geniat, Rivers Cadet, O. Barencey.
CREDITS: GEORGES LACOMBE (director); MARC LE PELLETIER (producer); RAYMOND LAMY (assistant producer); PIERRE VERY (scenarists); GEORGES LACOMBE (scenarists); PIERRE VERY (dialogue writer); RENÉ RIBAULT (pho-

tographer); A. CHARLET (assistant photographer); LUCIEN PINOTEAU (director of administration); JEAN-MARIE LOUTREL (production manager); FERNAND TRIGNOL (associate manager); HENRI MORIN (associate decorator); RENÉ CALVIERA (assistant decorator); BONA DE FAST (Makeup); HUGUETTE ADAM (hairdresser); JEAN DESSES (costumes for Marlene Dietrich); GERMAINE ARTUS (editor); GEORGES WAKHEVITCH (art director); MARCEL MIROUZE (musical score); MARC LE PELLETIER (production director); based on the novel by PIERRE RENÉ WOLF.

LENGTH: 114 minutes.

PRODUCTION DATES: Summer 1946.

PREMIERE: December 1946.

1947 · GOLDEN EARRINGS

United States, 1947
Paramount Pictures Inc.
A Mitchell Leisen Production
Released through Paramount Pictures Inc.
Black-and-white

CAST:

RAY MILLAND (Colonel Ralph Deniston); MARLENE DIETRICH (Lydia); MURVYN VYE (Zoltan); BRUCE LESTER (Byrd); DENNIS HOEY (Hoff); QUENTIN REYNOLDS (himself); REINHOLD SCHÜNZEL (Professor Otto Krosigk); IVAN TRIESAULT (Major Reimann); HERMINE STERLER (Greta Krosigk); ERIC FELDARY (Zweig); FRED NURNEY, OTTO REICHOW (Agents); GISELA WERBISECK (Dowager); LARRY SIMMS (Page boy); HALDOR DE BECKER (Telegraph boy); GORDON RICHARDS, VERNON DOWNING (Club members); LESLIE DENISON (Miggs); TONY ELLIS (Dispatch rider); GWEN DAVIES (Stewardess); ROBERT CORY (Doorman); HANS VON MORHART (SS trooper); HENRY ROWLAND (Pfeiffer); WILLIAM YETTER SR., HENRY GUTTMAN (Peasants); ROBERTA JONAY (Peasant girl); WILLIAM YETTER JR., LEO SCHLESINGER, JON GILBREATH, JAMES W. HORNE (Soldiers); CARMEN BERETTA (Tourist); FRANK JOHNSON (Waiter); LOUISE COLOMBET (Flower woman); MAYNARD HOLMES (Private); FRED GIERMANN (Sergeant); HARRY ANDERSEN (German farmer); CARYL LINCOLN (his wife); ROBERT VAL, GORDON ARNOLD, PEPITO PÉREZ (Gypsies); GEORGE SOREL, HANS SCHUMM (Policemen); MARTHA BAMATTRE (Wise old woman); ANTONIA MORALES (Gypsy dancer); JACK WILSON (Hitler Youth leader);

CHARLES BATES (Small boy); JOHN DEHNER (SS man); HOWARD MITCHELL (Naval officer); ARNO FREY (Major); JOHN GOOD (SS lieutenant); JACK WORTH, WALTER RODE (Nazi party officials); PETER SEAL (Police chief); JOHN PETERS (Lieutenant colonel); AL WINTERS (Elite Guard colonel); GRETA ULLMANN, CATHERINE SAVITZKY (German wives); BOB STEVENSON, HENRY VROOM (SS guards); ELLEN BAER (Girl); MARGARET FARRELL.

CREDITS: MITCHELL LEISEN (director); HARRY TUGEND (producer); JOHNNY COONAN (assistant director); ABRAHAM POLONSKY, FRANK BUTLER, HELEN DEUTSCH (scenarists); DANIEL L. FAPP (photographer); GORDON JENNINGS (special photographic effects); FARCIOT EDOUART (process photography); HANS DREIER, JOHN MEEHAN (art directors); ALMA MACRORIE (editor); SAM COMER, GRACE GREGORY (set decorators); MARY KAY DODSON (costumer); VICTOR YOUNG (musical score); PHIL BOUTELJE (music associate); dances staged by BILLY DANIELS; DON MCKAY, WALTER OBERST (sound recorders); WALLY WESTMORE (makeup); DR. ERNEST GOLM (advisor); MADAME HILDA GRENIER (technical consultant on Hungarian Gypsy sequence); ED RALPH (production manager); LEO SHUKEN, SIDNEY CUTNER (orchestrations); based on the novel by YOLANDA FOLDES.

SONG: "Golden Earrings" by VICTOR YOUNG (music) and JAY LIVINGSTON, RAY EVANS (lyrics).

LENGTH: 95 minutes/100 minutes.

PRODUCTION DATES: August 6 to October 17, 1946.

PREMIERE: August 27, 1947.

1948 · A FOREIGN AFFAIR

German title: *Eine auswärtige Angelegenheit*

United States, 1948
Paramount Pictures Inc.
Released through Paramount Pictures Inc.
Black-and-white

CAST:

JEAN ARTHUR (Phoebe Frost); MARLENE DIETRICH (Erika von Schlütow); JOHN LUND (Captain John Pringle); MILLARD MITCHELL (Colonel Rufus J. Plummer); PETER VON ZERNECK (Hans Otto Birgel); STANLEY PRAGER (Mike); BILL MURPHY (Joe); GOR-

DON JONES (First M.P.); FREDDIE STEELE (Second M.P.); RAYMOND BOND (Pennecott); BOYD DAVIS (Giffin); ROBERT MALCOLM (Kramer); BOBBY WATSON (Adolf Hitler in film clip); CHARLES MEREDITH (Yandell); MICHAEL RAFFETTO (Salvatore); JAMES LARMORE (Lieutenant Hornby); DAMIEN O'FLYNN (Lieutenant colonel); HARLAND TUCKER (General McAndrew); GEORGE CARLTON (General Finney); FRANK FENTON (Major Mathews); WILLIAM NEFF (Lieutenant Lee Thompson); LEN HENDRY (Staff sergeant); BOB SIMPSON (Major); PAUL LEEFS, WILLIAM SELFS, DON LYNCH, JOHN SHAY, PAT SHADE, KEN LUNDY (GIs); ERIC WYLAND (German waiter); PETER SIMILUK, ZIVKO SIMUNOVICH, CHESTER A. HAYES, NICK ABRAMOFF (Russian soldiers); EDWARD VAN SLOAN, WALTER E. THIELE, LISA GOLM (Germans); HENRY KULKY (Russian sergeant); ILKA GRÜNING (German wife); PAUL PANZER (German husband); JERRY JAMES, HAZARD NEWBERRY (Lieutenants); FAY WALL, CHRISTA WALTON (Fräuleins); RICHARD RYEN (Maier); PHYLLIS KENNEDY (WAC technical sergeant); TED KOTTLE (Gerhardt Maier); OTTO WALDIS (Inspector); GREGORY MERIMS, GEORGE UNANOFF, GEORGE KACHIN, NICHOLAS L. ZANE, SERGEI N. VONESKY, FRANK POPOVICH, LEO GREGORY, GEORGE PARIS (Russian soldiers); FRAN YACONELLI (Accordian player), WILL KAUFMAN, HANS HERBERT, VILMOS GYMES (Waiters); JACK VLASKIN, WILLIAM SABBOT (Russian dancers); ZINA DENNIS (Russian); JIMMIE DUNDEE (American M.P.); OTTO REICHOW (German policeman); NORMAN LEAVITT (Noncommissioned officer); ALBIN ROBELING (Cook); HENRY VROOM (American sergeant); HARRY LAUTER (Corporal); LARRY NUNN (Sergeant); BERT MOORHOUSE (Flight officer); WILLIAM SHEEHAN, HOWARD JOSLIN (M.P.'s); REX LEASE (M.P. lieutenant).

CREDITS: BILLY WILDER (director); CHARLES BRACKETT (producer); CHARLES BRACKETT, BILLY WILDER, RICHARD L. BREEN (scenarists); ROBERT HARARI (adaptation); CHARLES B. LANG JR. (photographer); DEWEY WRIGLEY (second unit cameraman); JAMES HAWLEY (second unit assistant cameraman); KURT SCHULTZ (camera operator in Berlin); HERBERT GEYER (assistant cameraman in Berlin); PAUL FILIPP (stills photographer in Berlin); FARCIOT EDOUART, DEWEY WRIGLEY (process photographers); HANS DREIER, WALTER TYLER (art directors); SAM COMER, ROSS DOWD (set directors); GORDON JENNINGS (special effects); DOANE HARRISON (editor); HUGH BROWN (production

manager); GUY BENNETT (assistant cameraman); C. C. COLEMAN JR., GERD OSWALD (assistant directors); DOUGLAS BRIDGES (extra second assistant director); WILLY HERMANN, WILLY RETHER, WITHOLD GRUNBERG (assistant directors in Berlin); RONNIE LUBIN (dialogue director); FREDERICK HOLLANDER (musical score); HUGO GRENZBACH, WALTER OBERST (sound); EDITH HEAD (costumer); WALLY WESTMORE (makeup); COLONEL C. A. MURPHY (technical advisor); HUGH BROWN (production manager); HARRY HOGAN (script supervisor); ED CROWDER (grip); based on an original story by DAVID SHAW and IRWIN SHAW.

SONGS: "Black Market," "Illusions," "The Ruins of Berlin" by FREDERICK HOLLANDER.

LENGTH: 3,270 meters, 116 minutes.

PRODUCTION DATES: Germany location shooting: August 17 to September 5, 1947; Los Angeles studio shooting: December 1, 1947, to February 10, 1948; retakes and second unit: February 1948.

PREMIERE: July 7, 1948, New York.

OSCAR NOMINATIONS, 1948 (twenty-first): cinematography (black-and-white): Charles B. Lang Jr.; writing (screenplay): Charles Brackett, Billy Wilder, Richard L. Breen.

1949 · JIGSAW

United States, 1949
A Tower Pictures Production
Released through United Artists
Black-and-white

CAST:

FRANCHOT TONE (Howard Malloy); JEAN WALLACE (Barbara Whitfield); MYRON MCCORMICK (Charles Riggs); MARC LAWRENCE (Angelo Agostini); WINIFRED LENIHAN (Mrs. Hartley); BETTY HARPER (Caroline Riggs); HEDLEY RAINNIE (Sigmund Kosterich); WALTER VAUGHN (District Attorney Walker); GEORGE BREEN (Knuckles); ROBERT GIST (Tommy Quigley); HESTER SONDERGAARD (Mrs. Borg); LUELLA GEAR (Pet shop owner); ALEXANDER CAMPBELL (Pemberton); ROBERT NOE (Waldron); ALEXANDER LOCKWOOD (Nichols); KEN SMITH (Wylie); ALAN MACATEER (Museum guard); MANUEL APARICIO (Warehouse guard); BRAINERD DUFFIELD (Butler); with unbilled guest appearances by MARLENE DIETRICH (Nightclub patron); FLETCHER

MARKLE (Nightclub patron); HENRY FONDA (Nightclub waiter); JOHN GARFIELD (Street loiterer); MARSHA HUNT (Secretary-receptionist); LEONARD LYONS (Columnist); BURGESS MEREDITH (Bartender); with Everett Sloane.
CREDITS: FLETCHER MARCLE (director); EDWARD J. DANZIGER, HARRY LEE DANZIGER (producers); FLETCHER MARKLE, VINCENT MCCONNOR (scenarists); DON MALKAMES (photographer); ROBERT W. STRINGER (musical score); ROBERT MATTHEWS (editor); WILLIAM L. NEMETH (unit manager); DAVID M. POLAK (sound recorder); FRED RYLE (makeup); SAL J. SCOPPA JR. (assistant director); WILLIAM N. NEMETH (unit manager); based on an original story by JOHN ROEBURT.
LENGTH: 1,975 meters, 72 minutes.
PRODUCTION DATES: end of 1948.
PREMIERE: March 1949, Mayfair Theatre, New York.

1950 · STAGE FRIGHT

German title: *Die rote Lola*

United States, 1950
Warner Bros. Pictures Inc.
A Warner Bros.–First National Picture
Released through Warner Bros. Pictures Inc.
Black-and-white

CAST:
JANE WYMAN (Eve Gill, a.k.a. Doris); MARLENE DIETRICH (Charlotte Inwood); MICHAEL WILDING (Detective Wilfred Smith); RICHARD TODD (Jonathan Cooper); ALISTAIR SIM (Commodore Gill); SYBIL THORNDIKE (Mrs. Gill); KAY WALSH (Nellie Goode); MILES MALLISON (Mr. Fortesque); HECTOR MACGREGOR (Freddie Williams); JOYCE GRENFELL ("Lovely Ducks"); ANDRE MORELL (Inspector Byard); PATRICIA HITCHCOCK (Chubby Bannister); BALLARD BERKELEY (Sergeant Mellish); with Irene Handel, Arthur Howard, Everley Gregg, Helen Goss, Cyril Chamberlain, and ALFRED HITCHCOCK as a nameless passerby.
CREDITS: ALFRED HITCHCOCK (director and producer); WHITFIELD COOK (scenarist); ALMA REVILLE (adaptation); JAMES BRIDIE (additional dialogue); WILKIE COOPER (photographer); JACK HASTE (camera operator); TERENCE VERITY (art director); EDWARD

B. JARVIS (editor); CHRISTIAN DIOR (Miss Dietrich's wardrobe); MILO ANDERSON (Miss Wyman's wardrobe); LEIGHTON LUCAS (musical score); LOUIS LEVY (musical director); LEIGHTON LEWIS (music conductor); HAROLD KING (sound); COLIN GARDE (makeup); FRED AHERN (production supervisor); based on the novel *Man Running* by SELWYN JEPSON.
SONGS: "La Vie en rose" by MARGUERITE MONOT, LOUIS LOUIGUY (music) and EDITH PIAF (lyrics); "The Laziest Gal in Town" by COLE PORTER.
LENGTH: 112 minutes.
PRODUCTION DATES: May 31 to September 19, 1949, Elstree Studios, London.
PREMIERE: February 23, 1950, Radio City Music Hall, New York.

1951 · NO HIGHWAY

U.S. title: *No Highway in the Sky*
German title: *Die Reise ins Ungewisse*
England 1951
A 20th Century-Fox Picture
Black-and-white

CAST:
JAMES STEWART (Mr. Honey); MARLENE DIETRICH (Monica Teasdale); GLYNIS JOHNS (Marjorie Corder); JACK HAWKINS (Dennis Scott); RONALD SQUIRE (Sir John); JANETTE SCOTT (Elspeth Honey); NIALL MCGINNIS (Captain Samuelson); ELIZABETH ALLAN (Shirley Scott); KENNETH MORE (Dobson); DAVID HUTCHESON (Penworthy); BEN WILLIAMS (Guard); MAURICE DENHAM (Major Pease); WILFRID HYDE WHITE (Fisher); HECTOR MACGREGOR (First engineer); BASIL APPLEBY (Second engineer); MICHAEL KINGSLEY (Navigator); PETER MURRAY (Radio operator); DORA BRYAN (Rosie); JILL CLIFFORD (Peggy Miller).
CREDITS: HENRY KOSTER (director); LOUIS D. LIGHTON (producer); R. C. SHERRIFF, OSCAR MILLARD, ALEC COPPEL (scenarists); GEORGES PERINAL (photographer); MANUEL DEL CAMPO (editor); C. P. NORMAN (art director); BUSTER AMBLER (sound recorder); ROBERT E. DEARLING (production supervisor); CORNEL LUCAS (stills photographer); GEORGE MORRE O'FARRELL (dialogue coach); MARGARETE FURSE (wardrobe supervisor); BLUEY HILL (assistant director); Miss Dietrich's wardrobe by CHRISTIAN DIOR; BEN LYON (casting director); based on the novel by NEVIL SHUTE.
LENGTH: 2,693 meters.

PRODUCTION DATES: October 1950 to January 1951, Elstree Studios, England.
PREMIERE: August 2, 1951, Odeon, London.

1952 · RANCHO NOTORIOUS

German titles: *Engel der Gejagten; Die Gejagten*

United States, 1952
Fidelity Pictures Inc., Hollywood, for RKO Pictures
Released through RKO-Radio Pictures
Technicolor

CAST:
MARLENE DIETRICH (Altar Keane); ARTHUR KENNEDY (Vern Haskell); MEL FERRER (Frenchy Fairmont); LLOYD GOUGH (Kinch); GLORIA HENRY (Beth Forbes); WILLIAM FRAWLEY (Baldy Gunder); LISA FERRADAY (Maxine); JOHN RAVEN (Chuck-a-Luck dealer); JACK ELAM (Geary); GEORGE REEVES (Wilson); FRANK FERGUSON (Preacher); FRANCIS MCDONALD (Harbin); DAN SEYMOUR (Comanche Paul); JOHN KELLOGG (Salesman); RODRIC REDWING (Rio); STUART RANDALL (Starr); ROGER ANDERSON (Red); CHARLES GONZALES (Hevia); FELIPE TURICH (Sanchez); JOSE DOMINGUEZ (Gonzales); STAN JOLLEY (Deputy Warren); JOHN DOUCETTE (Whitney); CHARLITA (Mexican girl in bar); RALPH SANFORD (Intrigant); LANE CHANDLER (Sheriff Hardy); FUZZY KNIGHT (Barber); FRANK GRAHAM (Ace Maguire); DICK WESSEL (Human nag); DICK ELIOT (Storyteller); WILLIAM HAADE (Sheriff Bullock); RUSSELL JOHNSON (Croupier); MABEL SMANEY (Fat woman); with Dick Eliot.
CREDITS: FRITZ LANG (director); HOWARD WELSCH (producer); DANIEL TARADASH (scenarist); HAL MOHR (photographer); SAM LEAVITT (assistant photographer) BEN HERSH (production manager); OTTO LUDWIG (editor); WIARD IHNEN (production designer); ROBERT PRIESTLEY (set decorator); Miss Dietrich's costumes by DON LOPER; JOE KING (wardrobe); EMIL NEWMAN (musical score); RICHARD MUELLER (Technicolor consultant); HUGH MCDOWELL, MAC DALGLEISH (sound recorders); EMMETT EMERSON (assistant director); FRANK WESTMORE (makeup); NELLIE MANLEY (Marlene Dietrich's hairstylist); based on the story "Gunsight Whitman" by SILVIA RICHARDS.
SONGS: "Gypsy Davey," "Get Away, Young

Man" (sung by Marlene Dietrich); "Legend of Chuck-a-Luck" (sung by William Lee) by KEN DARBY.
LENGTH: 89 minutes.
PRODUCTION DATES: March 19 to April 26, 1951; shooting dates for Marlene Dietrich: March 21 to April 25, 1951; makeup and wardrobe tests: March 7, 9, and 15, 1951.
PREMIERE: March 6, 1952, State Lake Theatre, Chicago.

1956 · AROUND THE WORLD IN 80 DAYS

German title: *In 80 Tagen um die Welt*

United States, 1956
A Michael Todd Company, Inc., Production in Todd-AO
Released through United Artists
Color

CAST:
DAVID NIVEN (Phileas Fogg); CANTINFLAS (Passepartout); ROBERT NEWTON (Mr. Fix); SHIRLEY MACLAINE (Aouda); with the following stars in cameo parts: Charles Boyer, Joe E. Brown, Robert Cabal, Martine Carol, John Carradine, Charles Coburn, Ronald Colman, Melville Cooper, Noël Coward, Finlay Currie, Reginald Denny, Andy Devine, Marlene Dietrich, Luis Miguel Dominguin, Fernandel, Ava Gardner, Sir John Gielgud, Hermione Gingold, Jose Greco and troupe, Sir Cedric Hardwicke, Trevor Howard, Glynis Johns, Buster Keaton, Evelyn Keyes, Beatrice Lihie, Peter Lorre, Edmund Lowe, Victor McLaglen, Colonel Tim McCoy, A. E. Matthews, Mike Mazurki, John Mills, Alan Mowbray, Robert Morley, Edward R. Murrow, Jack Oakie, George Raft, Gilbert Roland, Cesar Romero, Frank Sinatra, Red Skeleton, Ronald Squire, Basil Sydney, Richard Wattis, and Harcourt Williams.
CREDITS: MICHAEL ANDERSON (director); MICHAEL TODD (producer); WILLIAM CAMERON MENZIES (associate producer); S. J. PERELMAN, JAMES POE, JOHN FARROW (scenarists); VICTOR YOUNG (musical score); LEO SHUKEN, SID GUTNER (orchestration); MILES WHITE (costumer); LIONEL LINDON (photographer); GENE RUGGIERO, PAUL WEATHERWAX (editors); JAMES W. SULLIVAN, KEN ADAMS (art directors); ROSS DOWD (set decorator); PAUL GODKIN (choreographer); JOSEPH KANE (sound editor); RONNIE RON-

DELL, LEW BORZAGE, FARLEY JAMES, IVAN VOLKMAN, DENNIS BERTERA (first assistant directors); SAUL BASS (titles); on location: KEVIN O'DONOVAN (second unit director and assistant to the producer); EDWARD WILLIAM (technical consultant); KOICHI KAWANA, DR. C. P. BEARD (technical advisors); WILLIAM K. WILLIAMS, STANLEY HORSLEY, ELLIS CARTER (second unit directors of photography); HARRY MIMURA, GRAHAM KELLY (cameramen); based on the novel by JULES VERNE.

PREMIERE: October 17, 1956, Rivoli Theater, New York.

OSCARS, 1956 (twenty-ninth): best motion picture: Michael Todd; cinematography (color): Lionel Lindon; film editing: Gene Ruggiero, Paul Weatherwax; music (music score of a dramatic or comedy picture); Victor Young; writing (screenplay adaptation): James Poe, John Farrow, S. J. Perelman.

OSCAR NOMINATIONS, 1956 (twenty-ninth): art direction (color): James W. Sullivan, Ken Adam; costume design (color): Miles White; directing: Michael Anderson; set decoration (color): Ross J. Dowd.

GOLDEN GLOBE AWARDS, 1957: best motion picture (drama); best performance by an actor in a motion picture—comedy/musical: Cantinflas.

1957 · THE MONTE CARLO STORY

German title: *Die Monte Carlo Story*

United States, 1957
A Titanus Production, produced by Tan Film in Technirama
Released through United Artists
Color

CAST:

MARLENE DIETRICH (Marquise Maria de Crevecoeur); VITTORIO DE SICA (Count Dino della Fiaba) ARTHUR O'CONNELL (Mr. Hinkley); NATALIE TRUNDY (Jane Hinkley); JANE ROSE (Mrs. Freeman); CLELIA MATANIA (Sophia); ALBERTO RABAGLIATI (Albert); MISCHA AUER (Hector); RENATO RASCEL (Duval); CARLO RIZZO (Henri); TRUMAN SMITH (Mr. Freeman); MIMO BILLI (Roland); MARCO TULLI (François); GUIDO MARTUFI (Paul); JEAN COMBAL (Hotel director); VERA GARRETTO (Caroline); YANNICK GEFFROY (Gabriel); BETTY PHILIPPSEN (Zizj); FRANK COLSON (Walter, first American);

SERGE FLIEGERS (Harry, second American); FRANK ELLIOTT (Mr. Ewing); BETTY CARTER (Mrs. Ewing); GERLAINE FOURNIER (German lady); SIMONE MARIE ROSE (Lady in magenta); CLARA BECK (American oil heiress); with MARIO CAROTENUTO.

CREDITS: SAMUEL A. TAYLOR (director); Guilio Macchi (second unit director); MARCELLO GIROSI (producer); SAMUEL A. TAYLOR (scenarist); GIUSEPPE ROTUNNO (photographer); NINO MISIANO (production manager); GASTONE MEDIN (art director); FERDINANDO RUFFO (stage manager); RENZO ROSSELINI (musical score and conductor); LUISA ALESSANDRI, ROBERTO MONTEMURRO, MARIA RUSSO (assistant directors); KURT DOUBRAWSKY (sound recorder); GEORGE WHITE (editor); ELIO COSTANZI (wardrobe); Miss Dietrich's gowns by JEAN LOUIS; HARRIET MEDIN (dialogue teacher); based on an original story by SAMUEL A. TAYLOR, MARCELLO GIROSI, and DINO RISI.

SONGS: "Les Jeux sont faits (Rien ne va plus)" by MICHAEL EMER; "Back Home in Indiana."

PRODUCTION DATES: summer to autumn 1956, Titanus Studios, Rome, and Monte Carlo.

1958 · WITNESS FOR THE PROSECUTION

German title: *Zeugin der Anklage*

United States, 1958
An Edward Small–Arthur Hornblow Production
Released through United Artists
Black-and-white

CAST:

TYRONE POWER (Leonard Vole); MARLENE DIETRICH (Christine Vole); CHARLES LAUGHTON (Sir Wilfrid Robarts); ELSA LANCHESTER (Miss Plimsoll); JOHN WILLIAMS (Brogan-Moore); HENRY DANIELL (Mayhew); IAN WOLFE (Carter); TORIN THATCHER (Mr. Meyers); NORMA VARDEN (Mrs. French); UNA O'CONNOR (Janet MacKenzie); FRANCIS COMPTON (Judge); PHILIP TONGE (Inspector Hearne); RUTA LEE (Diana); MOLLY RODEN (Miss McHugh); OTTOLA NESMITH (Miss Johnson); MARJORIE EATON (Miss O'Brien).

CREDITS: BILLY WILDER (director); ARTHUR HORNBLOW JR. (producer); BILLY WILDER, HARRY KURNITZ (scenarists); LARRY MARCUS (adaptation); RUSSELL HARLAN

(photographer); EMMETT EMERSON (assistant director); EDITH HEAD (Miss Dietrich's costumer); JOSEPH KING (costumer); RAY SEBASTIAN, HARRY RAY, GUSTAF NORIN (makeup); DANIEL MANDELL (editor); HOWARD BRISTOL (set decorator); ALEXANDER TRAUNER (art director); MATTY MALNECK (musical score); LEONID RAAB (music arranger); ERNEST GOLD (music conductor); FRED LAU (sound recorder); HELENE PARRISH, NELLIE MANLEY (hairdressers); STANLEY DETLIE (props); DOANE HARRISON (production associate); JOHN FRANCO (script supervisor); BEN HERSH (production supervisor); based on the play by AGATHA CHRISTIE.

SONG: "I May Never Go Home Anymore" by RALPH ARTHUR ROBERTS (music) and JACK BROOKS (lyrics).

LENGTH: 114 minutes.

PRODUCTION DATES: June to August 1957, Goldwyn Studios, Hollywood.

PREMIERE: January 30, 1958, Leicester Square Theatre, London.

OSCAR NOMINATIONS, 1957 (thirtieth): actor: Charles Laughton; actress in a supporting role: Elsa Lanchester; best motion picture: Arthur Hornblow Jr.; directing: Billy Wilder; film editing: Daniel Mandell; sound recording: Samuel Goldwyn Studio Sound Department, Gordon E. Sawyer (sound director).

GOLDEN GLOBE AWARDS NOMINATIONS, 1958: best movie, best director: Billy Wilder; best actor: Charles Laughton; best actress: Marlene Dietrich; best supporting actress: Elsa Lanchester.

1958 · TOUCH OF EVIL

German title: *Im Zeichen des Bösen*

United States, 1958
A Universal-International Picture
Black-and-white

CAST:

CHARLTON HESTON (Ramon Miguel "Mike" Vargas); JANET LEIGH (Susan Vargas); ORSON WELLES (Hank Quinlan); JOSEPH CALLEIA (Pete Menzies); AKIM TAMIROFF ("Uncle Joe" Grandi); JOANNA MOORE (Marcia Linnekar); MARLENE DIETRICH (Tanya); RAY COLLINS (Adair); DENNIS WEAVER (Motel manager); VICTOR MILLAN (Manolo Sanchez); LALO RIOS (Risto); VALENTIN DE VARGAS (Pancho); MORT MILLS (Schwartz); MERCEDES MCCAMBRIDGE (Leader of the

Gang); WAYNE TAYLOR, KEN MILLER, RAYMOND RODRIGUEZ (Gang members); MICHAEL SARGENT (the boy); ZSA ZSA GABOR (Nightclub owner); JOSEPH COTTON (Police surgeon); PHIL HARVEY (Blaine); JOI LANSING (Blond); HARRY SHANNON (Gould); RUSTY WESCOATT (Casey); ARLENE MCQUADE (Ginnie); DOMENICK DELGARDE (Lackey); JOE BASULTO (Hoodlum); JENNIE DIAS (Jackie); YOLANDA BOJORQUEZ (Bobbie); ELEANOR DORADO (Lia); JOHN DIERKES (Police); KEENAN WYNN (Bit part).

CREDITS: ORSON WELLES (director and scenarist); ALBERT ZUGSMITH (producer); RUSSELL METTY (photographer); VIRGIL W. VOGEL, AARON STELL, EDWARD CURTISS (editors); ALEXANDER GOLITZEN, ROBERT CLATWORTHY (art directors); RUSSELL A. GAUSMAN, JOHN P. AUSTIN (set decorators); BILL THOMAS (gowns); BUD WESTMORE (makeup); HENRY MANCINI (music); PHIL BOWLES, TERRY NELSON (assistant directors); PHILIP H. LATHROP, JOHN RUSSELL (camera operators); JOSEPH GERSHENSON (music supervisor); LESLIE I. CAREY, FRANK WILKINSON (sound); F. D. THOMPSON (production manager); HARRY KELLER (director of additional scenes); based on the novel *Badge of Evil* by WHIT MASTERSON.

LENGTH: 95 minutes/105 minutes/112 minutes (restored version from 1998).

PRODUCTION DATES: February to March 1957, Universal Studios and Venice, California.

PREMIERES: February 1958, United States; October 4, 1996, United States (rerelease); September 11, 1998, United States (restored version).

RESTORED: 1998 by Universal Studios Restoration Services. Reedited and released by October Films.

CAST OF RESTORATION: RICK SCHMIDLIN (Orson Welles's requested editorial changes producer); WALTER MURCH (editor); BILL VARNEY, PETER REALE, WALTER MURCH (rerecording); BOB O'NEIL (picture restoration); JONATHAN ROSENBAUM (consultant); SEAN CULLEN (assistant editor); RICHARD LEGRAND, JR. (supervising sound editor); HARRY SNODGRASS, ROBERT MCNABB, WILLIAM HOOPER (sound effects editors); DEBORAH ROSS (title design); PACIFIC TITLE MIRAGE, RESTORATION DIVISION (digital restoration services); PACIFIC TITLE MIRAGE, OPTICAL DIVISION (titles and optical effects); YCM LABORATORIES (laboratory services); ERIC AIJALA (negative restoration, cutting and timing).

1961 · JUDGMENT AT NUREMBERG

German title: *Urteil von Nürnberg*

United States, 1961
Roxlom Films
Released through United Artists
Black-and-white

CAST:

SPENCER TRACY (Judge Dan Haywood); BURT LANCASTER (Ernst Janning); RICHARD WIDMARK (Colonel Tad Lawson); MARLENE DIETRICH (Madame Bertholt); MAXIMILIAN SCHELL (Hans Rolfe); JUDY GARLAND (Irene Hoffman); MONTGOMERY CLIFT (Rudolf Peterson); WILLIAM SHATNER (Captain Byers); EDWARD BINNS (Senator Burkette); KENNETH MACKENNA (Judge Kenneth Norris); JOSEPH BERNARD (Major Abe Radnitz); WERNER KLEMPERER (Emil Hahn); TORBEN MEYER (Werner Lammpe); ALAN BAXTER (General Merrin); VIRGINIA CHRISTINE (Mrs. Halbestadt); OTTO WALDIS (Pohl); KARL SWENSON (Dr. Geuter); RAY TEAL (Judge Curtiss Ives); BEN WRIGHT (Halbestadt); OLGA FABIAN (Mrs. Lindnow); MARTIN BRANDT (Friedrich Hofstetter); JOHN WENGRAF (Dr. Wieck); HOWARD CAINE (Wallner); PAUL BUSCH (Schmidt); BERNARD KATES (Perkins); SHEILA BROMLEY (Mrs. Ives); JANA TAYLOR (Elsa Scheffler); JOSEPH CREHAN (Spectator); RUDY SOLARI (Interpreter in courtroom).
CREDITS: STANLEY KRAMER (director and producer); PHILIP LANGNER (associate producer); ABBY MANN (scenarist); ERNEST LASZLO (photographer); CHARLES F. WHEELER (camera operator); GEORGE MILO (set decorator); RUDOLPH STERNAD (production designer); PACIFIC TITLE (titles and opticals); FREDERIC KNUDTSON (editor); ERNEST GOLD (musical score); JAMES SPEAK (sound engineer); WALTER ELLIOTT (sound editor); ART DUNHAM (music editor); IVAN VOLKMAN (assistant director); CLEM BEAUCHAMP (production manager); MARSHALL SCHLOM (script supervisor); JEAN LOUIS (Miss Dietrich's gowns); JOSEPH KING (costumes); ROBERT J. SCHIFFER (makeup); MORRIS ROSEN (company grip); MARTIN KASHUK (assistant company grip); ART COLE (property master); DON L. CARSTENSEN (chief gaffer); STALMASTER-LISTER CO., LYNN STALMASTER (casting); German crew: RICHARD RICHTSFELD (special effects), L. OSTERMEIER (administration staff), LYN HANNES

(administration staff), PIA ARNOLD (production manager), ALBRECHT HENNINGS (production design), LACI VON RONAY (assistant director), HUBERT KARL (administration staff), EGON HÄDLER (administration staff), FRANK WINTERSTEIN (unit manager), RICHARD EGLSEDER (property master), HANNELORE WINTERFELD (assistant editor); from the original story by ABBY MANN.
SONGS: "Lili Marleen" by NORBERT SCHULTZE (music) and HANS LEIP (German lyrics), "Liebeslied" by ERNEST GOLD (music) and ALFRED PERRY (lyrics).
LENGTH: 190 minutes.
PRODUCTION DATES: January 22 to May 1961, Revue Studios, Universal City; April 1961, Berlin and Nuremberg.
PREMIERE: December 14th, 1961, Kongresshalle, Berlin.
OSCARS, 1961 (thirty-fourth): actor: Maximilian Schell, Spencer Tracy; writing (screenplay—based on material from another medium): Abby Mann.
OSCAR NOMINATIONS, 1961 (thirty-fourth): actor in a supporting role: Montgomery Clift; actress in a supporting role: Judy Garland; art direction (black-and-white): Rudolph Sternad; best motion picture: Stanley Kramer; cinematography (black-and-white): Ernest Laszlo; costume design (black-and-white): Jean Louis; directing: Stanley Kramer; film editing: Frederic Knudtson; set decoration (black-and-white): George Milo.
GOLDEN GLOBE AWARDS, 1962: best director (motion picture): Stanley Kramer; best performance by an actor in a motion picture—drama: Maximilian Schell.

1962 · BLACK FOX: THE TRUE STORY OF ADOLF HITLER

United States, 1962
An Image Productions
Released through Metro-Goldwyn-Mayer
Black-and-white

CREDITS:

LOUIS CLYDE STOUMEN (director, producer, scenarist); JACK LEVIEN (executive producer); DON DEVLIN (associate producer); AL STAHL (animation supervisor); FRANCIS LEE (animation design associate); KENN COLLINS, MARK WORTREICH (editors); EZRA LADERMAN (musical score); music played by NEW YORK CHAMBER ORCHESTRA, JUILLIARD STRING QUARTET; RICHARD VORISEK (sound); RICHARD KAPLAN (production

supervisor); ANGELA GRIEG STOUMEN (production assistant); LEE KOHNS (director of research and production associate); MARLENE DIETRICH (narrator); based in part on "Reynard the Fox," adapted from a folktale of the twelfth Century by JOHANN WOLFGANG VON GOETHE.
LENGTH: 89 minutes.
PRODUCTION DATES: 1962.
PREMIERE: September 6, 1962, Biennale, Venice, Italy.
OSCAR, 1962 (thirty-fifth): documentary (feature): Louis Clyde Stoumen.

1964 · PARIS WHEN IT SIZZLES

German title: *Zusammen in Paris*

United States, 1964
Richard Quine Productions–Charleston Enterprises
Released through Paramount Pictures
Technicolor

CAST:

WILLIAM HOLDEN (Richard Benson); AUDREY HEPBURN (Gabrielle Simpson); GRÉGOIRE ASLAN (Police inspector); RAYMOND BUSSIÈRES (Gangster); CHRISTIAN DUVALEIX (Maître d'hotel); NOËL COWARD (Alexander Meyerheimer); TONY CURTIS (Policeman); MARLENE DIETRICH (herself); MEL FERRER (himself); with Thomas Michel, Dominique Boshero, Evi Marandi; and the voices of Fred Astaire and Frank Sinatra.
CREDITS: RICHARD QUINE (director); RICHARD QUINE, GEORGE AXELROD (producers); CARTER DE HAVEN, JOHN R. COONAN (associate producers); GEORGE AXELROD (scenarist); CHARLES LANG JR., CLAUDE RENOIR (photographer); JEAN D'EAUBONNE (art director); GABRIEL BECHIR (set decorator); ARCHIE MARSHEK (editor); NELSON RIDDLE (musical score); ARTHUR MORTON (music orchestration); JO DE BRETAGNE, CHARLES GRENZBACH (sound); PAUL FEYDER (assistant director); HUBERT DE GIVENCHY (Miss Hepburn's gowns and perfumes); CHRISTIAN DIOR (Miss Dietrich's gowns); JEAN ZAY (costume coordinator); DEAN COLE (hairdresser); FRANK MCCOY (makeup); PAUL K. LERPAE (special photographic effects); based on the story "La Fête à Henriette" by JULIEN DUVIVIER and HENRI JEANSON.
SONG: "That Face" by ALAN BERGMAN and LEW SPENCE (sung by Fred Astaire).
LENGTH: 110 minutes.

PRODUCTION DATES: autumn 1963.
PREMIERE: April 1964, Trans Lux Theatre, New York.

1973 · I WISH YOU LOVE

England, 1972

A BBC/Bentwood Television Corp. Coproduction
Released through the BBC
(*An Evening with Marlene Dietrich,* a different version, was released through Picture Music International.)

CAST:

MARLENE DIETRICH.
CREDITS: CLARK JONES (director); ALEXANDER H. COHEN (producer); ROY A. SOMLYO (associate producer); JERRY ADLER (production supervisor); BURT BACHARACH (musical arrangements); STAN FREEMAN (orchestra conductor); ROUBEN TER-AROUTUNAN (design); SANDRA SHEPHERD (makeup); JOE DAVIS (lighting advisor); TOMMY THOMAS (lighting); GRAHAM HAINES (sound); IAN DOW (production advisor); JEAN LOUIS (Miss Dietrich's gown); ERNEST MAXIN (producer).
SONGS: "I Get a Kick out of You" by COLE PORTER; "You're the Cream in My Coffee" by BUDDY DE SYLVA, LEW BROWN, RAY HENDERSON (music and lyrics); "My Blue Heaven" by WALTER DONALDSON (music) and G. WHITING (lyrics); "See What the Boys in the Backroom Will Have" by FREDERICK HOLLANDER (music) and FRANK LOESSER (lyrics); "The Laziest Gal in Town" by COLE PORTER; "When the World Was Young" by PHILIPPE GERARD (music) and VANNIER (lyrics); "Johnny" (sung in German; not used in any of the different versions) by FRIEDRICH HOLLAENDER (music and German lyrics); "Go 'Way from My Window" (not used) by JOHN JACOB NILES; "I Wish You Love" by CHARLES TRENET; "White Grass" and "Boomerang Baby" by CHARLES MARAWOOD; "La Vie en rose" by MARGUERITE MONOT, LOUIS LOUIGUY (music) and EDITH PIAF (lyrics); "Allein in einer grossen stadt" (sung in German; not used) by FRANZ WACHSMANN (music) and MAX KOLPE (lyrics); "Lola" (sung in English) by FRIEDRICH HOLLAENDER (music) and ROBERT LIEBMANN (lyrics); "Don't Ask Me Why I Cry" (sung in German; not used) by ROBERT STOLZ (music) and WALTER REISCH, ARMIN ROBINSON (lyrics); "Marie, Marie" (sung in French; not used) by GILBERT

BECAUD (music) and P. DELANOE (lyrics); "Lili Marlene" (sung in English) by NORBERT SCHULTZE (music) and HANS LEIP, TOMMIE CONNOR (lyrics); "Where Have All the Flowers Gone" by PETE SEEGER; "Honeysuckle Rose" by FATS WALLER (music) and ANDY RAZAF (lyrics); "Falling in Love Again" (also taped in German after the show, but not used) by FRIEDRICH HOLLAENDER (music) and SAM WINSTON, ALAN LERNER (English lyrics).

LENGTH: 54 minutes (BBC version); 50 minutes (*An Evening with Marlene Dietrich*).

PRODUCTION DATES: November 23 and 24, 1972, New London Theatre, London.

PREMIERE: January 1, 1973, BBC Television.

1978 · JUST A GIGOLO

German title: *Schoner Gigolo—Armer Gigolo*

Germany, 1978
A Leguan Film Production
Released in the United States via United Artists Classics
Color

CAST:

DAVID BOWIE (Paul von Pryzgodsky); SYDNE ROME (Cilly); KIM NOVAK (Helga); DAVID HEMMINGS (Captain Hermann Kraft); MARIA SCHELL (Mutti); CURT JÜRGENS (Prince); MARLENE DIETRICH (Baroness von Semering); ERIKA PLUHAR (Eva); RUDOLF SCHÜNDLER (Gustav, Paul's father); HILDE WEISSNER (Aunt Hilda); WERNER POCHATH

(Otto); BELA ERNY (von Lipzig); FRIEDHELM LEHMANN (Major Von Müller); RAINER HUNOLD (Lothar); EVELYN KÜNNEKE (Frau Aeckerle); KARIN HARDT (Frau Üxküll); GUDRUN GENEST (Frau von Putzdorf); URSULA HEYER (Greta); CHRISTIANE MAYBACH (Gilda); MARTIN HIRTHE (director); RENE KOLLDEHOFF (Max, Cilly's agent); GÜNTER MEISNER (Drunken worker); PETER SCHLESINGER (First man in bath).

CREDITS: DAVID HEMMINGS (director); ROLF THIELE (producer); JOSHUA SINCLAIR, [ENNIO DE CONCINI] (scenarists); CHARLY STEINBERGER (photographer); GÜNTHER FISCHER (musical score); PETER ROTHE (production designer); MAX MAGO, INGRID ZORE (costumes); ALFRED SRP, SUSAN JAEGER, MAXINE JULIUS (editors); HERBERT F. SCHUBERT (choreographer); GÜNTHER KORTWICH (sound); AXEL BÄR (production manager); EVA MARIA SCHÖNECKER (assistant director); INGRID WINDISCH (production assistant); GERNOT KÖHLER (camera assistant); ANTHONY CLAVET, INGRID THIER, ALFRED RASCHE, KARIN BAUER (makeup); ROLF VON DER HEYDT (stills photographer); MARIO STOCK, WOLFGANG KALLNISCHKIES (props); RUDI HARTL (Lighting); ERWIN LANGE (special effects); CHARLOTTE LÄUFER (business manager).

SONGS: "Revolutionary Song" by DAVID BOWIE and JACK FISHMAN (performed by SYDNE ROME); "Johnny" by FREDERICK HOLLANDER and JACK FISHMAN, "I Kiss Your Hand, Madame" by RALPH ERWIN, FRITZ ROTTER, SAM LEWIS, and JOE YOUNG, "Jealous Eyes" by Mihaly Erdeli and Jack Fishman (all performed by THE MANHATTAN TRANSFER); "Salome" by ROBERT STOLZ and ARTHUR REDNER, "Charmaine" by

ERNO RAPPÉ and LEW POLLACK, "Black Bottom" by RAY HENDERSON, BUDDY DE SYLVA, and NACIO HERB BROWN (all performed by THE PASADENA ROOF ORCHESTRA); "Ragtime Dance" by SCOTT JOPLIN and A. S. MASTERS (arranged by JACK FISHMAN), "Easy Winners" by SCOTT JOPLIN (arranged by JACK FISHMAN; both performed by THE RAGTIMERS); "Just a Gigolo" by LEONELLO CASUCCI and IRVING CAESAR (performed by MARLENE DIETRICH); "Don't Let It Be Too Long" by GÜNTHER FISCHER and DAVID HEMMINGS (performed by SYDNE ROME).

LENGTH: 90 minutes.

PRODUCTION DATES: December 5, 1977, to March 1978, Berlin-Spandau and Paris.

PREMIERE: November 16, 1978, Cinema Paris, Berlin.

1984 · MARLENE

A.k.a. *Marlene: A Feature*

Germany, 1984
An Oko-Filmproduktion/Karel Dirka Film
Released in the United States through Alive Films, 1986
Color and black-and-white

CREDITS:

MAXIMILIAN SCHELL (director); KAREL DIRKA, ZEV BRAUN (producers); PETER GENÉE (production manager); NORBERT BITTMANN (coproducer); MEIR DOHNAL, MAXIMILIAN SCHELL (script); IVAN SLAPETA, PAVEL HISPLER, HENRY HAUCK (photographers); BAVARIA TRICKTEAM, MICHAEL KUNS-

DORFF (special effects); FILMLICHT, MARTIN GERBL (lighting); PAVEL VOSICKY, RUDOLF ROEMMELT (graphics); HEIDI GENÉE, DAGMAR HIRTZ (editors); HEINZ EICKMEIER, ZBYNEK HLOCH (art directors); NICHOLAS EICKMEIER (costumes); REGINE KUSTERER (makeup); NICHOLAS ECONOMOU (musical score); NORBERT LILL, MILAN BOR (sound); DIETRICH LEIDING, NATHAN PEDHORZER (researchers); MARION CRAEMER, SLATA FINDEIS (assistant directors); with KAREL DIRKA, ANNIE ALBERS, BERNHARD HALL, HEIDI GENÉE, DAGMAR HIRTZ, MARTA RAKOSNIK, PATRICIA SCHELL, IVANA SPINNELL, WILLIAM VON STRANZ, and the voices of MARLENE DIETRICH, MAXIMILIAN SCHELL. Film clips: *Tragödie der Liebe* (1923); *Ich küsse Ihre Hand, Madame* (1929); *Der blaue Engel/The Blue Angel* (1930); *Morocco* (1930); *Dishonored* (1931); *Blonde Venus* (1932); *The Scarlet Empress* (1934); *The Devil Is a Woman* (1935); *Desire* (1936); *Destry Rides Again* (1939); *Citizen Kane* (1941); *Stage Fright* (1950); *Witness for the Prosecution* (1957); *Touch of Evil* (1958); *Judgment at Nuremberg* (1961); *Schöner Gigolo—Armer Gigolo/Just a Gigolo* (1979). In subtitled German, French, and English dialogue.

LENGTH: 94 minutes.

PRODUCTION DATES: 1982–83; interviews in Paris: September 1982.

PREMIERE: February 26, 1984, Berlin.

OSCAR NOMINATION, 1984 (fifty-seventh): documentary (feature): Karel Dirka, Zev Braun.

AWARDS: German Film Prize, 1984; Bavarian Film Prize, 1984; New York Film Critics; National Society of Film Critics; National Board of Review.

Theatography and Concertography

DIE BÜCHSE DER PANDORA (*PANDORA'S BOX*)

Play by Frank Wedekind. Directed by Carl Heine.
Marlene Dietrich as Ludmilla Steinherz.
Kammerspiele at Deutsches Theater.
From September 7, 1922.

DER GROSSE BARITON (*THE GREAT BARITONE*)

Play by Leo Ditrichstein and Fred and Fanny Hutton. Directed by Eugen Robert.
Marlene Dietrich as a fan of the great baritone.
Schlossparktheater, Berlin.
From October 7, 1922.

DER WIDERSPENSTIGEN ZÄHMUNG (*THE TAMING OF THE SHREW*)

By William Shakespeare. Directed by Ivan Schmidt.
Marlene Dietrich as the widow.
Grosses Schauspielhaus, Berlin.
From November 18, 1923.

THIMOTEUS IN FLAGRANTI

By Charles-Maurice Hennequin and Pierre Véber. Directed by Ivan Schmidt.

Marlene Dietrich as Suzanne, Anne-Marie, and Miss Simpson (alternating).
Deutsches Theater, Berlin.
From January 11, 1923.

DER KREIS (*THE CIRCLE*)

By W. Somerset Maughan. Directed by Bernhard Reich.
Marlene Dietrich as Mrs. Shenstone.
Kammerspiele, Berlin.
From January 24, 1923.

PENTHESILEA

By Heinrich von Kleist. Directed by Richard Révy.
Marlene Dietrich as Amazon captain.
Deutsches Theater, Berlin.
From February 6, 1923.

ZWISCHEN NEUN UND NEUN (*BETWEEN NINE AND NINE*)

By Hans Sturm. Director known.
Marlene Dietrich as daughter/mother (alternating).
Theater in der Königgrätzer Strasse, Berlin.
Summer 1923.

MEIN VETTER EDUARD (*MY COUSIN EDUARD*)

By Fred Robs (Fritz Friedmann-Friedrich and Ralph Arthur Roberts). Directed by Ralph Arthur Roberts.
Marlene Dietrich as Lilian Berley.
Komödienhaus, Berlin.
From September 12, 1923.

EIN MITTSOMMERNACHTS-TRAUM (*A MIDSUMMER NIGHT'S DREAM*)

By William Shakespeare. Directed by Reinhard Bruck.
Marlene Dietrich as Hyppolyta, Queen of the Amazons.
Theater in der Königgrätzer Strasse, Berlin.
From February 9, 1924.

WENN DER NEUE WEIN WIEDER BLÜHT (*WHEN THE NEW VINE BLOOMS*)

By Bjönstjerne Björnson. Directed by Dr. Reinhard Bruck.
Marlene Dietrich in an unknown role.
Theater in der Königgrätzer Strasse, Berlin.
From March 8, 1924.

DER EINGEBILDETE KRANKE (*THE IMAGINARY INVALID*)

By Molière. Director unknown.
Marlene Dietrich as Toinette, a servant.
Theater in der Königgrätzer Strasse, Berlin.
From April 1924.

ZURÜCK ZU METHUSALEM (*BACK TO METHUSELAH*)

By George Bernhard Shaw. Directed by Victor Barnowsky.
Marlene Dietrich as Eve in Parts III to V, second evening.
Theater in der Königgrätzer Strasse, Berlin.
From November 26, 1925.

ZURÜCK ZU METHUSALEM (*BACK TO METHUSELAH*)

By George Bernhard Shaw. Directed by Victor Martin Kerb.
Marlene Dietrich as Eve in Parts I and II, first evening.
Tribüne, Berlin.
From January 24, 1926.

DUELL AM LIDO (*DUEL ON THE LIDO*)

By Hans J. Rehfisch. Directed by Leopold Jessner.

Marlene Dietrich as Lou Carrère.
Schaupielhaus, Berlin.
From February 20, 1926.

DER RUBICON (THE RUBICON)

By Eugène Bourdet. Directed by Ralph Arthur Roberts.
Marlene Dietrich in an unknown role.
Tribüne, Berlin.
From April 4, 1926.

VON MUND ZU MUND
(FROM MOUTH TO MOUTH)

By Eric Charell. Directed by Eric Charell.
Marlene Dietrich as Erika, mistress of ceremonies.
Grosses Schauspielhaus, Berlin.
Probably from September 10, 1926.

WENN MAN ZU DRITT
(THREE'S COMPANY)

By Max Brod. Directed by Max Brod.
Marlene Dietrich in an unknown role.
Kammerspiele, Vienna.
Summer 1927.

BROADWAY

By George Abbott and Philip Dunning.
Directed by Franz Wenzler.
Marlene Dietrich as Rubie.
Kammerspiele, Vienna.
From September 30, 1927.

DIE SCHULE VON UZNACH
ODER NEUE SACHLICHKEIT
(UZNACH'S SCHOOL OR NEW SOBRIETY)

By Carl Sternheim. Directed by Emil Geyer.
Marlene Dietrich as Thylla Vandenbergh.
Theater in der Josefstadt, Vienna.
From November 28, 1927.

BROADWAY

By George Abbott and Philip Dunning.
Directed by Eugen Robert.
Marlene Dietrich as Rubie.
Komödienhaus, Berlin.
From March 9, 1928.

NACHTKABARETT
(NIGHT CABARET)

A celebration of the fiftieth anniverary of Guido Thielscher's theatrical career.
Directed by Dr. Martin Zickel.
Marlene Dietrich as one of the Thielscher Girls.
Lustspielhaus, Berlin.
March 27, 1928 (one performance only).

ES LIEGT IN DER LUFT
(IT'S IN THE AIR)

By Marcellus Schiffer (book and lyrics) and Mischa Spoliansky (music). Directed by Robert Forster Larrinanga.
Marlene Dietrich in Scene 2: Clearance; Scene 6: Jokes and Gags; Scene 8: Kleptomaniacs; Scene 11: Bridal Wear; Scene 14: Knickknacks; Scene 16: Music Department; Scene 19: Sisters; Scene 22: Athletic Equipment; Scene 24: Exchange Desk.
Komödie, Berlin.
From May 15, 1928.

ELTERN UND KINDER
(MISALLIANCE)

By George Bernhard Shaw. Directed by Heinz Hilpert.
Marlene Dietrich as Hypatia.
Komödie, Berlin.
From September 12, 1928.

DER MARQUIS VON KEITH
(THE MARQUIS OF KEITH)

By Frank Wedekind. Directed by Leopold Jessner.
Marlene Dietrich as a bit player.
Schauspielhais am Gendarmenmarkt, Berlin.
March 28, 1929 (one performance only, for the benefit of the family of actor Albert Steinrück).

ZWEI KRAWATTEN
(TWO BOW TIES)

By Georg Kaiser (book) and Mischa Spoliansky (music). Directed by Robert Forster Larrinaga.
Marlene Dietrich as Mabel.
Berliner Theater, Berlin.
September 5, 1929.

USO TEST SHOW

World War II morale performance. Motion Picture Production Defense Committee.
Fort Ord, California
Kay Kyser and His Orchestra, Lucille Ball, Kay Francis, Judy Carnova, Jerry Adler, Desi Arnaz, Pat O'Brien, Ann Miller.
June 1941.

CALIFORNIA TOUR

World War II morale performance. Motion Picture Production Defense Committee.
Camp McQuaide, California
Kay Kyser and His Orchestra, Lucille Ball, Kay Francis, Judy Carnova, Jerry Adler, Desi Arnaz, Pat O'Brien, Ann Miller.
June 1941.

CALIFORNIA TOUR

World War II morale performance. Motion Picture Production Defense Committee.
Hamilton Field, California
Kay Kyser and His Orchestra, Lucille Ball, Kay Francis, Judy Carnova, Jerry Adler, Desi Arnaz, Pat O'Brien, Ann Miller.
June 1, 1941.

USO TEST SHOW

World War II morale performance. Motion Picture Production Defense Committee.
Fort Hunter Liggett, California
Charles Feldman, Mark Sandrich, Jack Lawrence, William ("Buster") Collier,
William Dover, Max Bercutt, Art Carter.
June 14–16, 1941.

CALIFORNIA TOUR

World War II morale performance. Motion Picture Production Defense Committee.
Camp Callan, California
Kay Kyser and His Orchestra, Lucille Ball, Kay Francis, Judy Carnova, Jerry Adler, Desi Arnaz, Pat O'Brien, Ann, Miller.
June 27, 1941.

CALIFORNIA TOUR

World War II morale performance. Motion Picture Production Defense Committee.
Camp Haan, California
Kay Kyser and His Orchestra, Lucille Ball, Kay Francis, Judy Carnova, Jerry Adler, Desi Arnaz, Pat O'Brien, Ann Miller.
June 28, 1941.

CALIFORNIA TOUR

World War II morale performance. Motion Picture Production Defense Committee.
Camp Roberts, California
Kay Kyser and His Orchestra, Lucille Ball, Kay Francis, Judy Carnova, Jerry Adler, Desi Arnaz, Pat O'Brien, Ann Miller.
June 30, 1941.

KAY KYSER SHOW

Motion Picture Production Defense Committee.
San Francisco Bay, California
Kay Kyser and His Orchestra, Lucille Ball, Kay Francis, Judy Carnova, Jerry Adler, Desi Arnaz, Pat O'Brien, Ann Miller.
July 2, 1941.

CALIFORNIA TOUR

World War II morale performance. Motion Picture Production Defense Committee.
Moffett Field, California
Kay Kyser and His Orchestra, Lucille Ball, Kay Francis, Judy Carnova, Jerry Adler,

Desi Arnaz, Pat O'Brien, Ann Miller.
July 3, 1941.

USO SHOW

USO Tour, European Theatre of Operations.
Europe and Africa.
May to April 1943

USO SHOW

Kilmer Bowl, Camp Kilmer, New Jersey.
August 22, 1944

USO SHOW

St. Vith, Belgium.
December 4–5, 1944

USO SHOW: *STAGE DOOR CANTEEN*

Theatre Marigny, Paris
Maurice Chevalier, Noël Coward.
March 1945.

USO SHOW

St. Avold, France.
March 18, 1945.

USO SHOW

Abensberg, Germany.
May 31, 1945.

ALLIED TROOP STAGE SHOW: *HOLLYWOOD MEDLEY*

Allied Paris Entertainments.
Paris Olympia, Paris
Freddy Wittop, Roger Machardo, Eduardo Raspini.
February 26 to March 3, 1946.

ALLIED TROOP STAGE SHOW

Gala for the RAF. Paris.
March 17, 1946.

ALLIED TROOP STAGE SHOW

Allied Paris Entertainments.
Paris Olympia, Paris.
May 1946.

THE BIG SHOW

Tallulah Bankhead's radio show, RCA Studios, New York.
July 1 to October 21, 1951, and March 23, 1952

PERFORMANCE

Congo Room, Sahara Hotel, Las Vegas.
December 15 to January 4, 1953.

CEREBRAL PALSY BENEFIT: *"THE CIRCUS MASTER"*

Produced by Maria Riva, spokesperson for cerebral palsy.
Ringling Bros., Barnum & Bailey Circus, Madison Square Garden, New York.
March 31, 1954.

PERFORMANCE

Café de Paris, London.
June 21 to July 18, 1954.

PERFORMANCE

Congo Room, Sahara Hotel, Las Vegas.
October 15 to November 4, 1954.

PERFORMANCE

Café de Paris, London.
May 30 to July 11, 1955.

SUNDAY NIGHT AT THE BLACKPOOL OPERA HOUSE

Produced by Harold Fielding. Blackpool Opera House, Blackpool, England
Pat Dodd on piano.
July 17, 1955.

PERFORMANCE

Congo Room, Sahara Hotel, Las Vegas.
October 4–31, 1955.

PERFORMANCE

Blue Room, Tropicana Hotel, Las Vegas.
November 1957.

PERFORMANCE

The Sands, Las Vegas.
February 14 to March 7, 1957.

PERFORMANCE

Congo Room, Sahara Hotel, Las Vegas.
January 28 to February 24, 1958.

PERFORMANCE

Miami Beach, Florida.
February 1958.

PERFORMANCE

Café de Paris, London.
June 9 to July 7, 1958.

PERFORMANCE

Congo Room, Sahara Hotel, Las Vegas.
May 12 to June 8, 1959.

PERFORMANCE

Produced by Chuck Woodword. Golden Room, Copacabana Palace Hotel, Rio de Janeiro.

July 27 to August 2, 1959.

PERFORMANCE

Téatro Central, Santiago de Chile.
August 1959.

PERFORMANCE

Téatro Record, São Paulo, Brazil.
August 4–9, 1959.

PERFORMANCE

Clemento Lococo S.A.
Gran Téatro Opera, Buenos Aires, Argentina.
August 12–15, 1959.

PERFORMANCE

Victoria Plaza Hotel, Montevideo, Uruguay.
August 18, 1959.

PERFORMANCE

Théatre de l'Etoile, Paris.
Burt Bacharach (arrangements), René Leroux (orchestra), Sonia Shaw (choreography).
November 27, 1959.

PERFORMANCE

Congo Room, Sahara Hotel, Las Vegas.
January 3–23, 1960.

PERFORMANCE

Shaw-Hitchcock Productions
Harrah's, Lake Tahoe,
Russ Hall (entertainment director),
Leighton Noble (orchestra).
February 26 to March 13, 1960.

Vienna.
April 27, 1960.

Titania-Palast, Berlin.
May 3–5, 1960.

Hamburg Opera.
May 7, 1960.

Tivoli, Copenhagen.
May 9–11, 1960.

Oslo, Norway.
May 11, 1960.

Park Avenue Theater, Göteborg, Sweden.
May 12, 1960.

Berns Salonger, Stockholm.
May 13–14, 1960.

Schauspielhaus, Düsseldorf.
May 16, 1960.

Ufa Palast, Cologne.
May 19, 1960.

Kurhaus, Bad Kissingen, Germany.
May 20, 1960.

Theater am Aegi, Hannover, Germany.
May 21, 1960.

Rhein-Main-Halle, Wiesbaden, Germany.
May 22, 1960.

Kursaal, Baden-Baden, Germany.
May 23, 1960.

Konzerthalle, Zürich.
May 24, 1960.

Liederhalle, Stuttgart, Germany.
May 25, 1960.

Deutsches Theater, Munich.
May 27, 1960.

Tuschinsky Theater, Amsterdam.
May 30, 1960.

Tel Aviv.
June 17, 1960.

Jerusalem (Binyanei HaUma) and Haifa.
June 17–26, 1960.

Madrid.
July 12–15, 1960.

State Fair Music Hall, Dallas.
August 21 to September 4, 1960.

THE MARLENE DIETRICH SHOW

Geary Theatre, San Francisco.
Burt Bacharach (conductor, orchestration),
Sonia Shaw-Hitchcock (Choreography),
Joe Privitier (lighting).
September 6–12, 1960.

DIETRICH IN PERSON SHOW

Shubert Theatre, Detroit.
Burt Bacharach (musical director, orchestration), Joe Privitier (lighting).
October 15–22, 1960.

O'Keefe Centre, Toronto.
October 25, 1960.

Her Majesty's Theatre, Montreal.
October 1960

Riviera Night Club, Las Vegas.
November 14 to December 4, 1960.

Latin Casino, Merchantville, New Jersey.
Morty Gunty, Moro Landis Dancers.
December 20, 1960, to January 1, 1961.

CHANUKAH FESTIVAL FOR
ISRAEL BENEFIT

State of Israel Bonds. Madison Square
Garden, New York.
Marlene Dietrich, Edward G. Robinson,
Jan Peerce, Rise Stevens, Mike Wallace,
David Bar-Illan, Maurice Levine (conductor), Hyman Brown (producer), Sophie
Maslow (choreography), Sam Leve (stage
design), Ramse Mostoller (costumes).
January 2, 1961.

IN PERSON MARLENE DIETRICH
SHOW

Colonial Theatre, Boston.
Burt Bacharach (musical director, orchestration), Sonia Shaw (choreography), Joe
Privitier (lighting).
January 16–29, 1961.

Club Tropicoro, San Juan, Puerto Rico.
March 1961

Fontainebleau, Miami.
March 10–22, 1961.

Broadmoor International Theatre, Colorado Springs.
August 21–27, 1961.

PERFORMANCE

Allied Arts Corp. Arie Crown Theatre at McCormick Place, Chicago.
Burt Bacharach (musical director).
December 1–2, 1961.

PERFORMANCE

Latin Casino, Merchantville, New Jersey.
Dave Barry.
January 11–18, 1962.

PERFORMANCE

Riviera Night Club, Las Vegas.
Louis Armstrong.
February 19 to March 21, 1962.

PERFORMANCE

Paris Olympia, Paris.
Burt Bacharach (conductor), Joe Layton (choreography), Joe Davis (lighting).
May 11–31, 1962.

PERFORMANCE

Palm-Beach-Casino, Cannes.
August 1962.

DIPLOMATIC CORPS BENEFIT

Washington, D.C.
September 1962.

PERFORMANCE

Institute of International Education. Houston Music Hall, Texas.
September 26, 1962.

MUSIK DER WELT

Unicef Gala. Kongresshalle, Düsseldorf.
Burt Bacharach (conductor), Max Reger (Orchestra).
October 6, 1962.

GRAND GALA DU DISQUE SHOW

The Hague.
October 12, 1962.

PERFORMANCE

Golder's Green Hippodrome, London.
November 1962.

PERFORMANCE

Palace St. Moritz, Switzerland.
December 27, 1962.

BENEFIT

La Société des bains de mer et du cercle des étranges à Monte Carlo.
Monte Carlo, Monaco.
January 19, 1963.

PERFORMANCE

Brussels Music Hall, Belgium.
Burt Bacharach (conductor), Joe Davis (lighting).
January 26–31, 1963.

PERFORMANCE

Parador del Foc, Valencia, Spain.
March 15–16, 1963.

DEUTSCHE
SCHLAGERFESTSPIELE
PERFORMANCE

Kursaal, Baden-Baden, Germany.
June 15, 1963.

PERFORMANCE

Terrazza Casino Club, Mexico City.
July 3–14, 1963.

PERFORMANCE

Port-o-Call Inn and Country Club, Tierra Verde, Florida.
August 27–31, 1963.

PERFORMANCE

Shoreham Hotel, Washington, D.C.
September 6–14, 1963.

PERFORMANCE

Monticello Inn, Framingham, Massachusetts.
September 19–28, 1963.

PERFORMANCE

Berns Salonger, Stockholm.
October 19, 1963.

EL ALAMEIN REUNION

News of the World. Royal Albert Hall, London.
October 25, 1963.

ROYAL VARIETY SHOW

Prince of Wales Theater, London.
November 4, 1963.

PERFORMANCE

Kongress-Saal des Kulturpalastes, Warsaw.
Burt Bacharach (conductor).
January 18–19, 1964.

LA SOIRÉE EXTRAORDINAIRE
MARLENE DIETRICH

Palace de Gstaad, Switzerland.
February 15, 1964.

PERFORMANCE

Akademietheater Puschkin, Leningrad.
May 1964.

PERFORMANCE

Estradentheater, Moscow.
May 21 to June 2, 1964.

PERFORMANCE

Cabaret Hallen, Liseberg, Denmark.
June 1–16, 1964.

PERFORMANCE

Gröna Lunds Tivoli, Stockholm.
Raymond Senechal (conductor), Serge Maleskevitch, Ingvald Heyman (lighting).
June 18–30, 1964.

PERFORMANCE

Lieseberg Cabaret Hallen, Sweden
Daniel Janin (dirigent), Max Lefko (regisseur), Knut Solberg (ausstattung).
June 19, 1964.

PERFORMANCE

Palm-Beach-Casino, Cannes.
July 21, 1964.

PERFORMANCE

Tivoli, Copenhagen.
Eigil Svan (künstlerischer Leiter), Otto Lington (dirigent), Danny Ray (conferencier).
August 1–15, 1964.

PERFORMANCE

Casino Kursaal, Taormina, Italy.
August 19, 1964.

FESTIVAL

Edinburgh Festival Society. Royal Lyceum Theatre, Edinburgh.
Burt Bacharach (conductor), Joe Davis (lighting).
August 31 to September 5, 1964.

AN EVENING WITH MARLENE DIETRICH

Houston Music Hall, Texas.
Burt Bacharach (orchestration), Claire Carter, Paul Sullivan (lighting), Jacques Loussier Trio (orchestra), Joe Harnell (conductor).
September 23, 1964.

AN EVENING WITH MARLENE DIETRICH

John Kornfeld Assoc. Masonic Temple, San Francisco.
Burt Bacharach (orchestration), Claire Carter, Paul Sullivan (lighting), Jacques Loussier Trio (orchestra), Joe Harnell (conductor).
September 25–27, 1964.

AN EVENING WITH MARLENE DIETRICH

Queen Elizabeth Theatre, Vancouver.
Burt Bacharach (orchestration), Claire Carter, Paul Sullivan (lighting), Jacques Loussier Trio (orchestra), Joe Harnell (conductor).
September 29–30, 1964.

AN EVENING WITH MARLENE DIETRICH

Clowes Memorial Hall, Butler University, Indianapolis.

Burt Bacharach (orchestration), Claire Carter, Paul Sullivan (lighting), Jacques Loussier Trio (orchestra), Joe Harnell (conductor).
October 5, 1964.

AN EVENING WITH MARLENE DIETRICH

Pabst Theater, Milwaukee.
Burt Bacharach (orchestration), Claire Carter, Paul Sullivan (lighting), Jacques Loussier Trio (orchestra), Joe Harnell (conductor).
October 7–11, 1964.

PERFORMANCE

Queen's Theatre, London.
Burt Bacharach (arrangements, musical director), Joe Davis (lighting).
November 23 to December 12, 1964.

PERFORMANCE

Civic Theatre, Johannesburg.
April 28, 1965.

THE STARS SHINE FOR JACK

Tribute to Jack Hylton.
Bernhard Delfont,
Drury Lane, Theatre Royal, London.
May 30, 1965.

PERFORMANCE

Tivoli, Copenhagen.
June 28 to July 18, 1965.

PERFORMANCE

Theatre Royal, Brighton, England.
August 2–7, 1965.

PERFORMANCE

Birmingham Theatre (Hippodrome), England

Burt Bacharach (arrangements), William Blezard (musical director), Joe Davis (lighting).
August 9–14, 1965.

PERFORMANCE

Golder's Green Hippodrome, London.
Burt Bacharach (arrangements), William Blezard (musical director), Joe Davis (lighting).
August 16–21, 1965.

FESTIVAL

Edinburgh Festival Society, produced by John Coast and Donald Langdon.
Royal Lyceum Theatre, Edinburgh.
Burt Bacharach (conductor), Joe Davis (lighting).
August 23–28, 1965.

PERFORMANCE

Manchester Opera House, England.
Burt Bacharach (arrangements), William Blezard (musical director), Joe Davis (lighting).
August 30 to September 4, 1965.

PERFORMANCE

Royal Court Theatre, Liverpool.
Burt Bacharach (arrangements), William Blezard (musical director), Joe Davis (lighting).
September 6–11, 1965.

PERFORMANCE

Bristol Hippodrome, England.
Burt Bacharach (arrangements), William Blezard (musical director), Joe Davis (lighting).
September 13–18, 1965.

PERFORMANCE

Carroll Freeholders Proprietrary Ltd.
Princess Theatre, Melbourne.

Burt Bacharach (arrangements), William Blezard (conductor), Joe Davis (lighting).
October 7–23, 1965.

PERFORMANCE

J. C. Williamson Theatres Ltd.
Theatre Royal, Sydney, Australia
Burt Bacharach (arrangements), William Blezard (conductor), Joe Davis (lighting).
October 28 to November 13, 1965.

ISRAEL TOUR

Rural Music Center, Kibbuzim En Gev, Israel.
February 12–24, 1966.

ISRAEL TOUR

Produced by Giora Godik.
Frederik R. Mann Auditorium, Tel Aviv.
William Blezard (piano), I. Graziani (conductor), Andy White (drums), Andy Lovell (guitar), Joe Davis (lighting), Arieh Gelblum (public relations).
February 15, 1966.

ISRAEL TOUR

Jerusalem.
February 18–19, 1966.

ISRAEL TOUR

Haifa, Israel.
February 23, 1966.

PERFORMANCE

Kongress-Saal des Kulturpalastes, Warsaw.
William Blezard (conductor), Richard Serafinowicz and Joe Davis (lighting), Andy White (drums), Chic Lovelle (guitar).
February 26 to March 1 and March 7, 1966.

PERFORMANCE

Allied Arts Corp. Arie Crown Theatre at McCormick Place, Chicago.
Burt Bacharach (musical director).
December 1–2, 1961.

PERFORMANCE

Latin Casino, Merchantville, New Jersey.
Dave Barry.
January 11–18, 1962.

PERFORMANCE

Riviera Night Club, Las Vegas.
Louis Armstrong.
February 19 to March 21, 1962.

PERFORMANCE

Paris Olympia, Paris.
Burt Bacharach (conductor), Joe Layton (choreography), Joe Davis (lighting).
May 11–31, 1962.

PERFORMANCE

Palm-Beach-Casino, Cannes.
August 1962.

DIPLOMATIC CORPS BENEFIT

Washington, D.C.
September 1962.

PERFORMANCE

Institute of International Education. Houston Music Hall, Texas.
September 26, 1962.

MUSIK DER WELT

Unicef Gala. Kongresshalle, Düsseldorf.
Burt Bacharach (conductor), Max Reger (Orchestra).
October 6, 1962.

GRAND GALA DU DISQUE SHOW

The Hague.
October 12, 1962.

PERFORMANCE

Golder's Green Hippodrome, London.
November 1962.

PERFORMANCE

Palace St. Moritz, Switzerland.
December 27, 1962.

BENEFIT

La Société des bains de mer et du cercle des étranges à Monte Carlo.
Monte Carlo, Monaco.
January 19, 1963.

PERFORMANCE

Brussels Music Hall, Belgium.
Burt Bacharach (conductor), Joe Davis (lighting).
January 26–31, 1963.

PERFORMANCE

Parador del Foc, Valencia, Spain.
March 15–16, 1963.

DEUTSCHE
SCHLAGERFESTSPIELE
PERFORMANCE

Kursaal, Baden-Baden, Germany.
June 15, 1963.

PERFORMANCE

Terrazza Casino Club, Mexico City.
July 3–14, 1963.

PERFORMANCE

Port-o-Call Inn and Country Club, Tierra Verde, Florida.
August 27–31, 1963.

PERFORMANCE

Shoreham Hotel, Washington, D.C.
September 6–14, 1963.

PERFORMANCE

Monticello Inn, Framingham, Massachusetts.
September 19–28, 1963.

PERFORMANCE

Berns Salonger, Stockholm.
October 19, 1963.

EL ALAMEIN REUNION

News of the World. Royal Albert Hall, London.
October 25, 1963.

ROYAL VARIETY SHOW

Prince of Wales Theater, London.
November 4, 1963.

PERFORMANCE

Kongress-Saal des Kulturpalastes, Warsaw.
Burt Bacharach (conductor).
January 18–19, 1964.

LA SOIRÉE EXTRAORDINAIRE
MARLENE DIETRICH

Palace de Gstaad, Switzerland.
February 15, 1964.

PERFORMANCE

Akademietheater Puschkin, Leningrad.
May 1964.

PERFORMANCE

Estradentheater, Moscow.
May 21 to June 2, 1964.

PERFORMANCE

Cabaret Hallen, Liseberg, Denmark.
June 1–16, 1964.

PERFORMANCE

Gröna Lunds Tivoli, Stockholm.
Raymond Senechal (conductor), Serge Maleskevitch, Ingvald Heyman (lighting).
June 18–30, 1964.

PERFORMANCE

Lieseberg Cabaret Hallen, Sweden
Daniel Janin (dirigent), Max Lefko (regisseur), Knut Solberg (ausstattung).
June 19, 1964.

PERFORMANCE

Palm-Beach-Casino, Cannes.
July 21, 1964.

PERFORMANCE

Tivoli, Copenhagen.
Eigil Svan (künstlerischer Leiter), Otto Lington (dirigent), Danny Ray (conferencier).
August 1–15, 1964.

PERFORMANCE

Casino Kursaal, Taormina, Italy.
August 19, 1964.

FESTIVAL

Edinburgh Festival Society. Royal Lyceum
Theatre, Edinburgh.
Burt Bacharach (conductor), Joe Davis
(lighting).
August 31 to September 5, 1964.

AN EVENING WITH MARLENE
DIETRICH

Houston Music Hall, Texas.
Burt Bacharach (orchestration), Claire
Carter, Paul Sullivan (lighting), Jacques
Loussier Trio (orchestra), Joe Harnell (con-
ductor).
September 23, 1964.

AN EVENING WITH MARLENE
DIETRICH

John Kornfeld Assoc. Masonic Temple, San
Francisco.
Burt Bacharach (orchestration), Claire
Carter, Paul Sullivan (lighting), Jacques
Loussier Trio (orchestra), Joe Harnell (con-
ductor).
September 25–27, 1964.

AN EVENING WITH MARLENE
DIETRICH

Queen Elizabeth Theatre, Vancouver.
Burt Bacharach (orchestration), Claire
Carter, Paul Sullivan (lighting), Jacques
Loussier Trio (orchestra), Joe Harnell (con-
ductor).
September 29–30, 1964.

AN EVENING WITH MARLENE
DIETRICH

Clowes Memorial Hall, Butler University,
Indianapolis.

Burt Bacharach (orchestration), Claire
Carter, Paul Sullivan (lighting), Jacques
Loussier Trio (orchestra), Joe Harnell (con-
ductor).
October 5, 1964.

AN EVENING WITH MARLENE
DIETRICH

Pabst Theater, Milwaukee.
Burt Bacharach (orchestration), Claire
Carter, Paul Sullivan (lighting), Jacques
Loussier Trio (orchestra), Joe Harnell (con-
ductor).
October 7–11, 1964.

PERFORMANCE

Queen's Theatre, London.
Burt Bacharach (arrangements, musical
director), Joe Davis (lighting).
November 23 to December 12, 1964.

PERFORMANCE

Civic Theatre, Johannesburg.
April 28, 1965.

THE STARS SHINE FOR JACK

Tribute to Jack Hylton.
Bernhard Delfont,
Drury Lane, Theatre Royal, London.
May 30, 1965.

PERFORMANCE

Tivoli, Copenhagen.
June 28 to July 18, 1965.

PERFORMANCE

Theatre Royal, Brighton, England.
August 2–7, 1965.

PERFORMANCE

Birmingham Theatre (Hippodrome),
England

Burt Bacharach (arrangements), William
Blezard (musical director), Joe Davis (light-
ing).
August 9–14, 1965.

PERFORMANCE

Golder's Green Hippodrome, London.
Burt Bacharach (arrangements), William
Blezard (musical director), Joe Davis (light-
ing).
August 16–21, 1965.

FESTIVAL

Edinburgh Festival Society, produced by
John Coast and Donald Langdon.
Royal Lyceum Theatre, Edinburgh.
Burt Bacharach (conductor), Joe Davis
(lighting).
August 23–28, 1965.

PERFORMANCE

Manchester Opera House, England.
Burt Bacharach (arrangements), William
Blezard (musical director), Joe Davis (light-
ing).
August 30 to September 4, 1965.

PERFORMANCE

Royal Court Theatre, Liverpool.
Burt Bacharach (arrangements), William
Blezard (musical director), Joe Davis (light-
ing).
September 6–11, 1965.

PERFORMANCE

Bristol Hippodrome, England.
Burt Bacharach (arrangements), William
Blezard (musical director), Joe Davis (light-
ing).
September 13–18, 1965.

PERFORMANCE

Carroll Freeholders Proprietrary Ltd.
Princess Theatre, Melbourne.

Burt Bacharach (arrangements), William
Blezard (conductor), Joe Davis (lighting).
October 7–23, 1965.

PERFORMANCE

J. C. Williamson Theatres Ltd.
Theatre Royal, Sydney, Australia
Burt Bacharach (arrangements), William
Blezard (conductor), Joe Davis (lighting).
October 28 to November 13, 1965.

ISRAEL TOUR

Rural Music Center, Kibbuzim En Gev,
Israel.
February 12–24, 1966.

ISRAEL TOUR

Produced by Giora Godik.
Frederik R. Mann Auditorium, Tel Aviv.
William Blezard (piano), I. Graziani (con-
ductor), Andy White (drums), Andy Lovell
(guitar), Joe Davis (lighting), Arieh Gel-
blum (public relations).
February 15, 1966.

ISRAEL TOUR

Jerusalem.
February 18–19, 1966.

ISRAEL TOUR

Haifa, Israel.
February 23, 1966.

PERFORMANCE

Kongress-Saal des Kulturpalastes, Warsaw.
William Blezard (conductor), Richard Ser-
afinowicz and Joe Davis (lighting), Andy
White (drums), Chic Lovelle (guitar).
February 26 to March 1 and March 7, 1966.

Gdansk, Poland.
March 2–4, 1966.

Warsaw.
March 6, 1966.

City Hall, Durban, South Africa.
Raymont Le Senechal (musical director),
Burt Bacharach (arrangements), Joe Davis
(lighting).
April 4–9, 1966.

Produced by Toerien & Rubin.
Alhambra Theatre, Cape Town, South
Africa.
Raymont Le Senechal (musical director),
Burt Bacharach (arrangements), Joe Davis
(lighting).
April 11–16, 1966.

Civic Theatre, Johannesburg.
Raymont Le Senechal (musical director),
Burt Bacharach (arrangements), Joe Davis
(lighting).
April 18–23, 1966.

Golder's Green Hippodrome, London.
October 31 to November 5, 1966.

Alhambra Theatre, Glasgow.
Burt Bacharach (arrangements), William
Blezard (musical director), Joe Davis (light-
ing).
November 7–12, 1966.

New Theatre, Oxford, England.
Burt Bacharach (arrangements), William
Blezard (musical director), Joe Davis (light-
ing).
November 14–19, 1966.

Brighton Theatre Royal, England.
Burt Bacharach (arrangements), William
Blezard (musical director), Joe Davis (light-
ing).
November 21–26, 1966.

Adelphi Theatre, Dublin.
Bacharah, Burt (arrangements), William
Blezard (musical director), Joe Davis (light-
ing).
November 28–29, 1966.

Grand Theatre, Wolverhampton, England.
Burt Bacharach (arrangements), William
Blezard (musical director), Joe Davis (light-
ing).
December 13, 1966.

Empire Theatre, Sunderland, England
Burt Bacharah (arrangements), William
Blezard (musical director), Joe Davis (light-
ing).
December 5–6, 1966.

Pavilion Theatre, Bournemouth, England.
Burt Bacharach (arrangements), William
Blezard (musical director), Joe Davis (light-
ing).
December 9–10, 1966.

Congress Theatre, Eastbourne, England.
December 15, 1966.

Expo Theatre, Montreal.
Burt Bacharach (arrangements), Joe Davis
(lighting).
June 12–24, 1967.

Tivoli, Copenhagen.
William Blezard (musical director), Andy
White (drums), Chic Lovelle, (guitar),
Siegfried Ehrenberg (lighting), Balenciaga
and Pierre Balmain (wardrobe).
August 1–31, 1967.

Swedish Theatre, Helsinki, Finland.
September 2–5, 1967.

Nine O'Clock Productions. Lunt-Fontanne
Theatre, New York.
October 9 to November 18, 1967.

Adelaide, Australia.
March 8–21, 1968.

Ahmanson Theatre, Los Angeles.
Burt Bacharach (arrangements and con-
ductor), William Blezard (conductor), Joe
Davis (lighting).
April 25 to May 11, 1968.

John Kornfeld Assoc.
Masonic Auditorium, San Francisco.
Burt Bacharach (arrangements), William
Blezard (music director), Joe Davis (light-
ing).
May 21–25, 1968.

Nine O'Clock Productions—Alexander H.
Cohen (producer).
Mark Hellinger Theatre, New York.
Burt Bacharach (arrangements), Stan Free-
man (conductor), Joe Davis (lighting).
October 3 to November 30, 1968.

Blue Room, Tropicana Hotel, Las Vegas.
Fred Smith (stage Manager).
December 5–21, 1968.

Opera House, National Arts Centre,
Ottawa, Canada.
Burt Bacharach (conductor), Joe Davis and
Paul Sullivan (lighting).
August 4–10, 1969.

Tru-Attractions, Inc.
Broadmoor International Theatre, Col-
orado Springs.
July 1–5, 1969.

Society for the Performing Arts. Jesse H.
Jones Hall, Houston, Texas.
Burt Bacharach (orchestration), Bernhard
Raymond (conductor), Paul Sullivan (light-
ing).
July 29 to August 1, 1969.

Merriweather Post Pavilion, Columbia, Maryland
Burt Bacharach (orchestration), Bernhard Raymond (conductor), Paul Sullivan (lighting).
August 13–16, 1969.

PERFORMANCE

Expo 70. Expo Theatre, Osaka.
September 8–10, 1970.

PERFORMANCE

Playboy Plaza Hotel, Miami.
Stan Freeman (conductor), Chic Lovelle (guitar), Andy White (Drums), Paul Sullivan (lighting).
February 1971.

PERFORMANCE

Expo 70. Tivoli, Copenhagen.
July 16–31, 1971.

PERFORMANCE

Matinee: Benefit for the National Association for Mental Health.
Evening Show: Drury Lane, Theatre Royal, London.
Burt Bacharach (arrangements), William Blezard (musical director), Joe Davis (lighting), Terry Miller (producer).
September 15, 1971.

PERFORMANCE

Viareggio, Itlay. April 2nd, 1972

PERFORMANCE

Produced by Robert Paterson.
Queen's Theatre, London.
Burt Bacharach (arrangements), Stan Free-

man (accompanist), Joe Davis (lighting).
May 29 to June 10, 1972.

PERFORMANCE

Robert S. Garner Attractions, Inc.
Auditorium Theatre, Denver.
Burt Bacharach (arrangements), Stan Freeman (accompanist), Paul Sullivan (lighting).
September 20–23, 1972.

TV SPECIAL

New London Theatre, Drury Lane, London.
Burt Bacharach (arrangements), Stan Freeman (accompanist), Joe Davis (lighting).
November 24–26, 1972.

PERFORMANCE

Dade County Auditorium, Miami.
February 1–3, 1973.

PERFORMANCE

Mill Run Theatre, Niles, Illinois.
March 15–18, 1973.

PERFORMANCE

Circle Star Theatre, San Carlos, California.
March 22–24, 1973.

BRITISH TOUR

Robert Paterson. Alexandra Theatre, Birmingham, England.
Burt Bacharach (arrangements), William Blezard (musical director), Joe Davis (lighting).
May 14–19, 1973.

BRITISH TOUR

Robert Paterson. New Southport Theatre, Southport, England.

Burt Bacharach (arrangements), William Blezard (musical director), Joe Davis (lighting), Terry Miller (executive producer), John D. Collins (stage manager), Dudley Russell (production assistant).
May 23–26, 1973.

BRITISH TOUR

Robert Paterson. Theatre Royal, Brighton, England.
Burt Bacharach (arrangements), William Blezard (musical director), Joe Davis (lighting).
May 28 to June 2, 1973.

BRITISH TOUR

Robert Paterson. New Theatre, Cardiff, Wales.
Burt Bacharach (arrangements), William Blezard (musical director), Joe Davis (lighting).
June 4–9, 1973.

BRITISH TOUR

Robert Paterson.
Wimbledon Theatre, London.
Burt Bacharach (arrangements), William Blezard (musical director), Joe Davis (lighting).
June 11–16, 1973.

GALA PERFORMANCE

Tito's Night Club, Palma de Mallorca, Spain.
June 23, 1973.

PERFORMANCE

L'Espace Pierre Cardin, Paris.
September 19–20 and September 29 to October 10, 1973.

PERFORMANCE

Tivoli, Copenhagen.
October 20, 1973.

PERFORMANCE

Stadsteater, Malmö, Sweden.
October 21, 1973.

PERFORMANCE

Stockholm Concert Hall, Sweden.
October 22, 1973.

PERFORMANCE

Music Fair, Valley Forge, Pennsylvania.
November 6–11, 1973.

PERFORMANCE

Shady Grove Music Fair, Washington, D.C.
November 13–18, 1973.

THE INCOMPARABLE MARLENE DIETRICH SHOW

Place des Artes, Montreal.
Stan Freeman (piano, conductor), Stephen Bell (Guitar).
November 24, 1973.

PERFORMANCE

Royal York Hotel, Toronto.
November 28 to December 1, 1973.

PERFORMANCE

Celebrity Theatre, Phoenix, Arizona.
December 4, 1973.

PERFORMANCE

Fairmont Hotel, San Francisco.
December 6–16, 1973.

PERFORMANCE

Carnegie Hall, New York.
January 3–6, 1974.

Fairmont Hotel, Dallas, Texas.
January 10–23, 1974.

Masonic Temple, Detroit.
February 2–3, 1974.

Roosevelt Hotel, New Orleans.
February 7–20, 1974.

Flamboyan Hotel, San Juan, Puerto Rico.
February 26 to March 3, 1974.

Fairmont Hotel, New Orleans.
April 3–13, 1974.

Dorothy Chandler Pavilion, Los Angeles.
April 15–16, 1974.

John F. Kennedy Center Opera House, Washington, D.C.
April 23–25, 1974.

Symphony Hall, Phoenix, Arizona.
May 17–18, 1974

Masonic Temple, Toledo, Ohio.
May 24, 1974.

O'Shaughnessy Auditorium, St. Paul, Minnesota.
May 26, 1974.

Chicago Auditorium, Illinois.
May 29, 1974.

Music Circus, Sacramento, California.
June 3–9, 1974.

Mexico City.
June 13–26, 1974.

THE INCOMPARABLE MARLENE DIETRICH SHOW

Produced by Ken Gaston and Wally Griffin. Candlewood Theatre, New Fairfield, Connecticut.
Burt Bacharach (arrangements), Stan Freeman (musical director), David Segal, Joe Davis (lighting).
July 15–21, 1974.

Grosvenor House, London.
Burt Bacharach (arrangements), Joe Davis (lighting).
September 9–15, 1974.

National Theatre, Rio de Janeiro.
November 22–24, 1974.

Municipal Theatre, São Paulo, Brazil.
November 29–30, 1974.

Opera House, Porto Alegre, Brazil.
December 2–3, 1974.

Hotel Tamanaco, Caracas, Venezuela.
December 6–7, 1974.

MARLENE DIETRICH IN JAPAN '74

Festival Hall, Osaka.
December 15–16, 1974.

MARLENE DIETRICH IN JAPAN '74

Sun Plaza Hall, Tokyo.
December 17, 1974.

MARLENE DIETRICH IN JAPAN '74

Imperial Hotel, Tokyo.
December 23, 1974.

MARLENE DIETRICH IN JAPAN '74

Hotel Pacific, Tokyo.
December 24–25, 1974.

Forest National, Brussels.
January 25, 1975.

Carre Theatre, Amsterdam.
January 27, 1975.

Queen Elizabeth Theatre, Antwerp, Belgium.
January 30, 1975.

Wimbledon Theatre, London.
Burt Bacharach (arrangements), William Blezard (musical director), Joe Davis (lighting), Mervyn Conn (producer).
February 3–15, 1975.

Civic Hall, Wolverhampton, England.
February 16, 1975.

Royal York Hotel, Toronto.
February 24 to March 1, 1975.

Place des Artes, Montreal.
March 2, 1975.

Fairmont Hotel, Dallas, Texas.
March 5–15, 1975.

Coconut Grove Playhouse, Miami.
John A. Prescott (public relations), Robert S. Fishko (managing producer).
March 17–23, 1975.

Fairmont Hotel, San Francisco.
March 27 to April 6, 1975.

PERFORMANCE

Fairmont Hotel, New Orleans.
April 9–19, 1975.

PERFORMANCE

Memphis, Tennessee.
May 2, 1975.

PERFORMANCE

Front Row Theatre, Cleveland, Ohio.
May 2–4, 1975.

PERFORMANCE

Star Theatre, Nanuet, New York.
May 9–11, 1975.

PERFORMANCE

Fairmont Hotel, Atlanta, Georgia.
May 14–24, 1975.

PERFORMANCE

Playhouse in the Park, Philadelphia.
May 27 to June 1, 1975.

PERFORMANCE

Kenley Players Veterans Memorial Auditorium, Columbus, Ohio.
June 13–15, 1975.

PERFORMANCE

Star Theatre, Flint, Michigan.
July 19–21, 1975.

PERFORMANCE

Northshore Music Theatre, Beverly, Illinois.
June 23–28, 1975.

PERFORMANCE

Her Majesty's Theatre, Melbourne, Australia.
September 1–13, 1975.

PERFORMANCE

Canberra Theatre, Australia.
Burt Bacharach (arrangements), William Blezard (conductor), Joe Davis (lighting).
September 16–18, 1975.

PERFORMANCE

Produced by Danny O'Donnovan and Cyril Smith.
Her Majesty's Theatre, Sydney, Australia.
Burt Bacharach (arrangements), William Blezard (conductor), Joe Davis (lighting).
September 22 to October 4, 1975.

Discography

MARLENE DIETRICH IN LONDON

Recorded Live at Queen's Theatre. Musical arrangements and direction by Burt Bacharach. 1965 PYE Records. 1992 DRG Records Inc. Produced by Franklin Boyd. Recorded 1964.

"I Can't Give You Anything but Love." Jimmy McHugh, Dorothy Fields. 1964.
"The Laziest Gal in Town." Cole Porter. 1964.
"Shir Hatan." Zarav, Sahar. 1964.
"La Vie en Rose." Louiguy (Louis Gugliemi). 1964.
"Jonny." Friedrich Hollaender. 1964.
"Go 'Way from My Window." John Jacob Niles. 1964.
"Allein In Einer Grossen Stadt." Franz Wachsmann, Max Colpet. 1964.
"Lili Marlene." Norbet Schutlze, Hans Leip, Tommie Connor. 1964.
"Das Lied Ist Aus (Frag' Nicht Warum Ich Gehe)." Robert Stolz, Walter Reisch, Armin L. Leo Robinson. 1964.
"Lola." Friedrich Hollaender, Robert Liebmann. 1964.
"I Wish You Love." Charles Trenet, Albert Beach. 1964.
"Marie, Marie." Gilbert Becaud, Pierre Delanoe. 1964.

"Honeysuckle Rose." Fats Waller, Andy Razaf. 1964.
"Falling in Love Again." Friedrich Hollaender, Samuel Lerner. 1964.

THE BEST OF MFARLENE DIETRICH

1973 Sony Entertainment Inc. 1992 SONY-RANDOM HOUSE / COLUMBIA LEGACY.

INTRODUCTION BY NOEL COWARD. 1954.
"The Boys in the Backroom." Friedrich Hollaender, Frank Loesser. 1954.
"The Laziest Gal in Town." Cole Porter. 1954.
"Lola." Friedrich Hollaender. 1954.
"I Wish You Love." Charles Trenet, Albert Beach. 1964.
"Johnny." Friedrich Hollaender. 1954.
"Lili Marlene." Norbet Schutlze, Hans Leip, Tommie Connor. 1964.
"Go 'Way from My Window." John Jacob Niles. 1964.
"La Vie en Rose." Edith Piaf, Louiguy (Louis Gugliemi). 1954.
"Honeysuckle Rose." Fats Waller, Andy Razaf. 1964.
"Falling in Love Again." Friedrich Hollaender. 1964.

MARLENE DIETRICH: MARLENE

1985 ASV Living Era.

"Ich Bin Die Fesche Lola." Friedrich Hollaender, Robert Liebmann. 1930.
"Quand L'Amour Meurt." Leo Robin, Octave Cremieux. 1931.
"Johnny." Friedrich Hollaender. 1931.
"Mein Blondes Baby." Peter Kreuder, Fritz Rotter. 1933.
"Wenn Die Beste Freundin." Mischa Spoliansky, Marcellus Schiffer. 1928.
"Wenn Ich Mir Was Wünschen Dürfte." Friedrich Hollaender. 1930.
"Allein In Einer Grossen Stadt." Franz Wachsmann, Max Colpet. 1933.
"Ich Bin Von Kopf Bis Fuss Auf Liebe Eingestellt." Friedrich Hollaender. 1930.
"Es Liegt In der Luft." Mischa Spoliansky, Marcellus Schiffer. 1928.
"Nimm Dich In Acht Vor Blonden Frauen." Friedrich Hollaender, Richard Rillo. 1930.
"Give Me the Man." Leo Robin, Octave Cremieux. 1931.
"Kinder, Heut' Abend, Da Such Ich Mir Was Aus." Friedrich Hollaender, Robert Liebmann. 1930.
"Leben Ohne Liebe Kabnnst Du Nicht." Mischa Spoliansky, Robert Gilbert. 1931.

"Falling in Love Again." Friedrich Hollaender, Frank Connelly. 1930.

MARLENE DIETRICH: MYTHOS MARLENE DIETRICH

1987 EMI.

"Ich Bin Von Kopf Bis Fuss Auf Liebe Eingestellt." Friedrich Hollaender; arr. Burt Bacharach. 1960.
"Mein Blondes Baby." Peter Kreuder; arr. Burt Bacharach. 1960.
"Peter." Rudolf Nelson, Friedrich Hollaender; arr. Burt Bacharach. 1960.
"Allein." Franz Wachsmann, Max Colpet; arr. Burt Bacharach. 1960.
"Wenn Ich Mir Was Wünschen Dürfte." Friedrich Hollaender; arr. Burt Bacharach. 1960.
"Johnny, Wenn Du Geburtstag Hast." Friedrich Hollaender; arr. Burt Bacharach. 1960.
"Marie—Marie." Gilbert Becaud, Max Colpet; arr. Burt Bacharach. 1960.
"Ich Weiss Nicht, Zu Wem Ich Gehöre." Friedrich Hollaender, Robert Liebmann; arr. Burt Bacharach. 1960.
"Ich Hab' Noch Einen Koffer In Berlin." Ralph M. Siegel, Aldo von Pinelli; arr. Burt Bacharach. 1960.

"Die Welt War Jung." Philippe-Gerarde, Max Colpet; arr. Burt Bacharach. 1962.

"Wenn Die Soldaten." Trad; arr. Jan Pronk. 1964.

"Die Antwort Weiss Ganz Allein Der Wind." Bob Dylan, Hans Bradtke; arr. Burt Bacharach. 1963.

"Sag Mir, Wo Die Blumen Sind." Pete Seeger, Max Colpet; arr. Burt Bacharach. 1962.

"Der Trommelmann." Simeone, Onorati, David, George Buschor; arr. Jan Pronk. 1964.

"Paff, Der Zauberdrachen." Peter Yarrow, Lipton, Oldörp; arr. Burt Bacharach. 1963.

"Sch . . . Kleines Baby." Ralph M. Siegel, Costa, Dietrich; arr: Stott. 1964.

MARLENE DIETRICH: LILI MARLENE

1989 SPA Licensed by Palladium Productions. Remember RMB.

"Falling in Love Again." Friedrich Hollaender. 1939.

"The Boys in the Backroom." Friedrich Hollaender, Frank Loesser. 1939.

"Lili Marlene." Norbet Schutlze, Hans Leip. 1945.

"Ich Bin Die Fesche Lola." Friedrich Hollaender, Robert Liebmann. 1930.

"Give Me the Man." Octave Cremieux, Leo Robin. 1931.

"Nimm Dich In Acht Vor Blonden Frauen." Friedrich Hollaender. 1930.

"You Go to My Head." Fred Coots, Haven Gillespie. 1939.

"You've Got That Look." Friedrich Hollaender, Frank Loesser. 1939.

"If He Swings by the String." John Addison, Julian More. 1964.

"This World of Ours." DeBout, Harrison. 1965.

"Near You." Francis Craig, Kermet Goell. 1957.

"Candles Glowing." Bader Harrison. 1965.

"Kisses Sweeter Than Wine." Joel Newman, Paul Campbell. 1957.

"Such Trying Times." John Addison, Julian More. 1964.

"Illusions." Friedrich Hollaender. 1949.

"Johnny." Rudolf Nelson, Friedrich Hollaender. 1931.

"I've Been in Love Before." Friedrich Hollaender, Frank Loesser. 1939.

"Black Market." Friedrich Hollaender. 1949.

"Lazy Afternoon." Jerome Moross, John Latouche. 1954.

"Another Spring, Another Love." Gloria Shayne, Noel Paris. 1957.

"Symphonie." Alex Alstone, Andre Tabet, Roger Bernstein. 1945.

"You Do Something to Me." Cole Porter. 1939.

DIETRICH IN RIO

(1959.08.17). 1989 CBS Records Inc. CBS Special Products.

"Look Over Me Closely." Terry Gilkyson. 1959.

"You're the Cream in My Coffee." BG DeSylva, Lew Brown, Ray Henderson. 1959.

"My Blue Heaven." George Whiting, Walter Donaldson. 1959.

"The Boys in the Backroom." Friedrich Hollaender, Frank Loesser. 1959.

"Das Lied Ist Aus (Frag'Nicht Warum Ich Gehe)." Robert Stolz, Walter Reisch, Armin L. Leo Robinson. 1959.

"Je Tire Ma Reverence." Bastia. 1959.

"Alright, Okay, You Win." Sid Wyche, Mayme Watts. 1959.

"Makin' Whoopee." Gus Kahn, Walter Donaldson. 1959.

"I've Grown Accustomed to Her Face." Fredrick Loewe, Alan Jay Lerner. 1959.

"One for My Baby (And One More for the Road)." Harold Arlen, Johnny Mercer. 1959.

"Maybe I'll Come Back." Giltinan, Vannah. 1959.

"Luar Do Sertao." Catulo do Paixao Cearense. 1959.

MARLENE DIETRICH. DIE FRÜHEN AUFNAHMEN

1990 Preiserrecords.

"Ich Bin Die Fesche Lola." Friedrich Hollaender, Robert Liebmann. 1930.

"Kinder, Heut' Abend Such Ich Mir Was Aus." Friedrich Hollaender, Robert Liebmann. 1930.

"Ich Bin Von Kopf Bis Fuss Auf Liebe Eingestellt." Friedrich Hollaender. 1930.

"Nimm Dich In Acht Vor Blonden Frauen." Friedrich Hollaender, Richard Rillo. 1930.

"Wenn Ich Mir Was Wünschen Dürfte." Friedrich Hollaender. 1930.

"Leben Ohne Liebe Kannst Du Nicht." Mischa Spoliansky, Robert Gilbert. 1931.

Give Me the Man." Leo Robin, Karl Hajos. 1931.

"Quand l'Amour Meurt." Octave Cremieux. 1931.

"Johnny." Friedrich Hollaender. 1931.

"Peter." Rudolf Nelson, Friedrich Hollaender. 1931.

"Assex." Wal-Berg, Emile Stern, Jean Tranchant. 1933.

"Moi, Je M'Ennui." WAL-BERG, CAMILLE FRANCOIS. 1933.

"Allein In Einer Großen Stadt." Franz Wachsmann, Max Colpet. 1933.

"Wo Ist Der Mann?." Peter Kreuder. 1933.

"Mein Blondes Baby." Peter Kreuder, Fritz Rotter. 1933.

"Wenn Die Beste Freundin." Mischa Spoliansky, Marcellus Schiffer. 1928.

MARLENE DIETRICH: L'ANGE BLEU

1928–1933. Success Et Raretes. 1990 Chansophone.

"Wenn Die Beste Freundin." Mischa Spoliansky, Marcellus Schiffer. 1928.

"Falling in Love Again." Friedrich Hollaender, Frank Connelly. 1930.

"Nimm Dich In Acht Vor Bonden Frauen." Friedrich Hollaender, Richard Rillo. 1930.

"Blonde Women." Friedrich Hollaender. 1930.

"Ich Bin Die Fesche Lola." Friedrich Hollaender, Robert Liebmann. 1930.

"Ich Bin Von Kopf Bis Fuss Auf Liebe Eingestellt." Friedrich Hollaender. 1930.

"Wenn Ich Mir Was Wünschen Dürfte." Friedrich Hollaender. 1930.

"Kinder, Hete Abend, Da Such Ich Mir Was Aus." Friedrich Hollaender, Robert Liebmann. 1930.

"I Am the Naughty Lola." Friedrich Hollaender. 1930.

"This Evening Children." Friedrich Hollaender. 1930.

"Peter." Rudolf Nelson, Friedrich Hollaender. 1931.

"Jonny." Friedrich Hollaender. 1931.

"Jonny." Friedrich Hollaender. 1931.

"Leben Ohne Liebe Kannst Du Nicht." Mischa Spoliansky, Robert Gilbert. 1931.

"Quand l'Amour Meurt. Octave Cremieux. 1931.

"Give Me the Man." Leo Robin, Karl Hajos. 1931.

"Assez." Wal-Berg, Emile Stern, Jean Tranchant. 1933.

"Azzez." Wal-Berg, Emile Stern, Jean Tranchant. 1933.

"Moi, J'M'Ennuie." Wal-Berg, Camille Francois. 1933.

"Ja So Bin Ich." Robert Stolz, Walter Reisch. 1933.

"Allein, In Einer Grossen Stadt." Franz Wachsmann, Max Colpet. 1933.

"Mein Blondes Baby." Peter Kreuder, Fritz Rotter. 1933.

"Wo Ist Der Mann." Peter Kreuder, Max Colpet. 1933.

MARLENE DIETRICH. DIE GROSSEN ERFOLGE

1991 Electrola.

"Sag Mir Wo Die Blumen Sind." Pete Seeger, Max Colpet; arr. Burt Bacharach. 1962.

"Lili Marlene." Norbet Schutlze, Hans Leip; arr. Burt Bacharach. 1960.

"Die Welt War Jung." Phillipe-Gerards, Max Colpet; arr. Burt Bacharach. 1962.

"Die Antwort Weiss Ganz Allein Der Wind." Bob Dylan, Hans Bradtke; arr. Burt Bacharach. 1962.

"Wenn Ich Mir Was Wünschen Dürfte." Friedrich Hollaender; arr. Burt Bacharach. 1963.

"Johnny, Wenn Du Geburtstag Hast." Friedrich Hollaender; arr. Burt Bacharach. 1960.

"Allein." Franz Wachsmann, Max Colpet; arr. Burt Bacharach. 1960.

"Peter." Rudolf Nelson, Friedrich Hollaender; arr. Burt Bacharach. 1960.

"Paff, Der Zauberdrachen." Peter Yarrow, Lipton, Oldörp; ar. Burt Bacharach. 1963.

"Wenn Der Sommer Wieder Einzieht." Cavanaugh, Weldon, Robertson, Metzl; arr: Jan Pronk. 1964.

"Marie—Marie." Gilbert Becaud, Max Colpet; arr. Burt Bacharach. 1960.

"Ich Hab' Noch Einen Koffer In Berlin." Ralph M. Siegel, Also von Pinelli; arr. Burt Bacharach. 1960.

"Cherche La Rose." R. Rouzard, H. Salvador; arr. Burt Bacharach. 1962.

"Ich Werde Dich Lieben." Welch, Dietrich; arr: Stott. 1964.

"Nimm Dich In Acht Vor Blonden Frauen. Friedrich Hollaender, Richard Rillo. 1930.

"Ich Bin Von Kopf Bis Fuss Auf Liebe Eingestellt." Friedrich Hollaender. 1930.

"Ich Bin Die Fesche Lola." Friedrich Hollaender, Robert Liebmann. 1930.

"Kinder, Heut' Abend Such Ich Mir Was Aus." Friedrich Hollaender, Robert Liebmann. 1930.

THE MARLENE DIETRICH ALBUM: LIVE AT THE CAFE DE PARIS, LONDON

(1954.06.21). 1991 Sony Music Entertainment Inc. Sony Masterworks.

Introduction by Noel Coward.
"La Vie en Rose." Louiguy (Louis Gugliemi), Edith Piaf. 1954.

"The Boys in the Backroom." Friedrich Hollaender, BG DeSylva, Lew Brown(?). 1954.

"Lazy Afternoon." Jerome Moross, John Latouche. 1954.

"Lola." Friedrich Hollaender. 1954.

"Look Me Over Closely. Terry Gilkyson. 1954.

"No Love, No Nothin'." Harry Warren, Leo robin. 1954.

"The Laziest Gal in Town." Cole Porter. 1954.

"Jonny." Friedrich Hollaender. 1954.

"Lili (Lilli) Marlene." Norbet Schutlze, Hans Leip, Conner. 1954.

"Falling in Love Again. Friedrich Hollaender, Frank Connelly. 1954.

"Too Old to Cut the Mustard." Bill Carlisle. 1952.

"Baubles, Bangles, and Beads." Robert Wright, George Forrest. 1954.

"A Guy What Takes His Time." Ralph Rainger. 1952.

"Peter." Rudolf Nelson, Friedrich Hollaender. 1954.

"Dot's Nice—Donna Flight." Max Showalter, Ross Bagdasarian. 1953.

"Makin' Whoopee." Walter Donaldson, Gus Kahn. 1959.

"I've Grown Accustomed to Her Face." Fredrick Loewe, Alan Jay Lerner. 1959.

"One for My Baby (And One More for the Road)." Harold Arlen, Johnny Mercer. 1959.

"Das Lied Ist Aus." Robert Stolz, Walter Reisch, Armin L. Leo Robinson. 1959.

MARLENE DIETRICH: THE BLUE ANGEL

1991 Patricia Records.

"Wo Ist Der Mann?" Peter Kreuder, Max Colpet. 1933.

"Je M'Ennuie." Wal-Berg, Camille Francois. 1933.

"Allein In Einer Grossen Stadt." Franz Wachsmann, Max Colpet. 1933.

"Assez." Wal-Berg, Emile Stern, Jean Tranchant. 1933.

"Falling in Love Again." Friedrich Hollaender, Samuel Lerner. 1939.

"You Go to My Head." Fred Coots, Haven Gillespie. 1939.

"The Boys in the Backroom." Friedrich Hollaender, Frank Loesser. 1933.

"Naughty Lola." Friedrich Hollaender. 1930.

"Falling in Love Again." Friedrich Hollaender. 1930.

"Blonde Women." Friedrich Hollaender. 1930.

"I Gotta Get a Man." Friedrich Hollaender. 1930.

"Give Me the Man." Leo Robin, Octave Cremieux. 1931.

"Peter." Rudolf Nelson, Friedrich Hollaender. 1931.

"Johnny." Friedrich Hollaender. 1931.

"Hot Voodoo." Ralph Rainger, Sam Coslow. 1932.

THE ESSENTIAL MARLENE DIETRICH

1991 Emi Records Ltd.

"Ich Bin Von Kopf Bis Fuss Auf Liebe Eingestellt." Friedrich Hollaender. 1930.

"Quand l'Amour Meurt." Octave Cremieux, Leo Robin. 1931.

"Give Me the Man." Leo Robin, Karl Hajos. 1931.

"Leben Ohne Liebe." Mischa Spoliansky, Robert Gilbert. 1931.

"Mein Blondes Baby." Peter Kreuder, Fritz Rotter. 1960.

"Allein In Einer Grossen Stadt." Franz Wachsmann/Max Colpet; arr. Burt Bacharach. 1960.

"Peter." Rudolf Nelson/Friedrich Hollaender; arr. Burt Bacharach. 1960.

"Lola." Friedrich Hollaender/Robert Liebmann; arr. Burt Bacharach. 1960.

"Wer Wird Denn Weinen." Hugo Hirsch/Arthur Rebner; arr. Burt Bacharach. 1960.

"Johnny, Wenn Du Geburtstag Hast." Friedrich Hollaender; arr. Burt Bacharach. 1960.

"Lili Marlene." Norbet Schutlze/Hans Leip; arr. Burt Bacharach. 1960.

"Dejeuner du Matin." Jacques Prevert/Joseph Kosma; arr. Burt Bacharach. 1962.

"Ou Vont les Fleurs." Francis Lemarque/R. Rouzard/Pete Seeger; arr. Burt Bacharach. 1962.

"Wenn Die Soldaten." Trad; arr. Jan Pronk. 1964.

"In Den Kasernen." Gerard/Koch; arr. Rogers. 1964.

"Und Wenn Er Wiederkommt." Gerard/Max Colpet/Maeterlinch; arr. Jan Prink. 1964.

"Wenn Der Sommer Wieder Einzieht." Cavanaugh/Welden/Robertson/Metcl; arr. Jan Pronk. 1964.

"Blowing in the Wind." Bob Dylan; arr. Burt Bacharach. 1965.

"Die Welt War Jung." Philippe-Gerarde/Max Colpet; arr. Burt Bacharach. 1962.

"Where Have All the Flowers Gone." Pete Seeger; arr. Burt Bacharach. 1965.

"Ich Werde Dich Lieben." Welch/Dietrich; arr. Stott. 1964.

"Der Trommelmann." Simsone/Onorati/Davis/George Buschor; arr. Jan Pronk. 1964.

"Auf Der Mundharmonika." Mischa Spoliansky/Robert Gilbert; arr. Stott. 1964.

MARLENE DIETRICH: LIVE

1965 PRT. 1991 Castle Communications PLC. Marble Arch. CMA.

"Identisch Mit CD Marlene Dietrich in London."

MARLENE DIETRICH: I COULDN'T BE SO ANNOYED

1992 Remember RMB.

"Wenn Die Beste Freundin." Mischa Spoliansky, Marcellus Schiffer. 1928.

"Es Liegt In Der Luft (Potpurri)." Mischa Spoliansky, Marcellus Schiffer. 1928.

"Blonde Women." Friedrich Hollaender, Richard Rillo. 1930.

"Kinder, Heut Abend, Da Such Ich Mir Was Aus." Friedrich Hollaender, Robert Liebmann. 1930.

"Ich Bin Von Kopf Bis Fus Auf Liebe Eingestellt." Friedrich Hollaender. 1930.

"Wenn Ich Mir Was Wünschen Dürfte." Friedrich Hollaender. 1930.

"Peter." Rudolf Nelson, Friedrich Hollaender. 1931.

"Leben Ohne Liebe Kannst Du Nicht." Mischa Spoliansky, Robert Gilbert. 1931.

"quand l'Amour Meurt." Octave Cremieux. 1931.

"Hot Voodoo." Ralph Rainger, Sam Coslow. 1932.

"I Couldn't Be So Annoyed." George Whiting, Leo Robin. 1932.

"You Little So-and-So." Ralph Rainger, Sam Coslow. 1932.

"Moi, Je M'Ennuie." Wal-Berg, Camille Francois. 1933.

"Ja So Bin Ich." Robert Stolz, Walter Reisch. 1933.

"Allein In Einer Grossen Stadt." Franz Wachsmann, Max Colpet. 1933.

"Assez." Wal-Berg, Emile Stern, Jean Tranchant. 1933.

"Awake in a Dream." Friedrich Hollaender, Leo Robin. 1935.

"La Vie en Rose." Marguerite Monot, Edith Piaf. 1949.

MARLENE DIETRICH: DAS LIED IST AUS

1992 Remember RMB.

"Quand l'Amour Meurt. Octave Cremieux. 1931.

"Wo Ist Der Mann." Peter Kreuder, Max Colpet. 1933.

"A Touch of Paradise (Illusions)." Friedrich Hollaender. 1948.

"Ruins of Berlin." Friedrich Hollaender. 1948.

"Indiana (Back Home in Indiana)." B. McDonald, JF Hanley. 1948.

"You Go to My Head." Fred Coots, Haven Gillespie. 1949.

"Ich Weiss Nicht Zu Wem Ich Gehöre." Friedrich Hollaender, Robert Liebmann. 1949.

"Symphonie." Alex Alstone, Andre Tabet, Roger Bernstein. 1949.

"Ein Roman." Bronislau Kaper. 1949.

"Let's Call It a Day." BG DeSylva, Lew Brown, Ray Henderson. 1949.

"No Love, No Nothin'." Harry Warren, Leo Robin. 1949.

It Must Have Been Something I Dreamed Last Night." 1959.

"Lieb Zu Mir." Roy Turk, Fred E. Albert. 1950.

"Je Sais Que Vous Etes Jolie." Christine, Nova Flor, Leonie et Vorelli, H. Poupon. 1950.

"Love Me." Don Raye, Gene DePaul. 1951.

"Das Alte Lied." Friedrich Hollaender, Robert Liebmann. 1951.

Marlene Dietrich and Bing Crosby (talk). 1952.

"La Vie en Rose" (with Bing Crosby). Louiguy (Louis Gugliemi), Edith Piaf. 1952.

"I Am the Naughty Lola." Friedrich Hollaender, Robert Liebmann. 1959.

"Lili Marlene." Norbet Schutlze, Hans Leip. 1960.

"Das Lied Ist Aus." Walter Reisch, Armin L. Leo Robinson, Robert Stolz. 1958.

MARLENE DIETRICH: ON SCREEN, STAGE, AND RADIO

1992 Legend Records. 2 CDs.

THE MOVIE YEARS — DISC ONE

"Lola" & "Lola" (German and English version; original soundtrack from the two versions of *Der Blaue Engel/The Blue Angel*) Friedrich Hollaender, Frank Connelly. 1930.

"Kinder, Heut' Abend Such Ich Mir Was Aus" & This Evening Children" (German and English version; original soundtrack from the two versions of *Der Blaue Engel/The Blue Angel). Friedrich Hollaender, Robert Liebmann. 1930.*

"Ich Bin Von Kopf Bis Fuss Auf Liebe Eingestellt" (original soundtrack from Der Blaue Engel). Friedrich Hollaender. 1930.

"Falling in Love Again" (original soundtrack from the English version of *The Blue Angel*). Friedrich Hollaender, Frank Connelly. 1930.

"Nimm Dich In Acht Vor Blonden Frauen" & "Blonde Women" (German and English version; original soundtrack from the two versions of *Der Blaue Engel/The Blue Angel*).

"Quand l'Amour Meurt." Octave Cremieux, Leo Robin. 1930.

"What Am I Bid?" (original soundtrack from *Morocco*). Karl Hajos, Leo Robin. 1930.

"German Lullaby (Leise zieht durch mein Gemüt/Ein Männlein steht im Walde)"

(original soundtrack from *Blonde Venus*). Henrich Heine/Franz Schubert; Trad. 1932.

"Hot Voodoo" (original soundtrack from *Blonde Venus*). Ralph Rainger, Sam Coslow. 1932.

"You Little So-and-So" (original soundtrack from *Blonde Venus*). Ralph Rainger, Sam Coslow. 1932.

"I Couldn't Be Annoyed" (original soundtrack from *Blonde Venus*). George Whiting, Leo Robin. 1932.

"You Are My Song of Songs (Heideröslein)" (original soundtrack from "Song of Songs"). Franz Schubert, Johann Wolfgang von Geothe. 1933.

"Jonny" (English version; original soundtrack from *Song of Songs*). Friedrich Hollaender. 1933.

"Three Sweethearts Have I" (original soundtrack from *The Devil Is a Woman). Ralph Rainger, Leo Robin. 1934.*

"Awake In a Dream" (original soundtrack from Desire). Friedrich Hollaender, Leo Robin. 1935.

"Little Joe the Wrangler" (original soundtrack from *Destry Rides Again*). Friedrich Hollaender, Frank Loesser. 1939.

"You've Got That Look" (original soundtrack from *Destry Rides Again*). Friedrich Hollaender, Frank Loesser. 1939.

"The Boys in the Backroom" (original soundtrack from *Destry Rides Again*). Friedrich Hollaender, Frank Loesser. 1939.

"I Can't Give You Anything but Love" (original soundtrack from *Seven Sinners*). Jimmy McHugh, Dorothy Fields. 1939.

"I've Been in Love Before" (original soundtrack from *Seven Sinners*). Friedrich Hollaender, Frank Loesser. 1939.

"The Man's in the Navy" (original soundtrack from *Seven Sinners*). Friedrich Hollaender, Frank Loesser. 1940.

"Sweet as the Blush of May" (original soundtrack from *The Flame of New Orleans*). Charles Previn, Samuel Lerner. 1941.

"Tell Me, Tell Me, Evening Star" (original soundtrack from *Kismet*). Harold Arlen, E. Y. Harburg. 1944.

"Gypsy Song" (original soundtrack from *Golden Earrings*). 1946.

"Black Market" (original soundtrack from *A Foreign Affair*). Friedrich Hollaender. 1949.

"Illusions" (original soundtrack from *A Foreign Affair*). Friedrich Hollaender. 1949.

"The Ruins of Berlin" (original soundtrack from *A Foreign Affair*). Friedrich Hollaender. 1948.

"The Laziest Gal in Town" (original soundtrack from *StageFright*). Cole Porter. 1949.

"Gypsy Davey" (original soundtrack from *Rancho Notorious*). Ken Darby. 1952.

"Get Away, Young Man" (original soundtrack from *Rancho Notorious*). Ken Darby. 1952.

"Back Home in Indiana" (original soundtrack from *Monte Carlo Story*). B. McDonald, JF Hanley. 1957.

"I May Never Go Home Any More" (original soundtrack from *Witness for the Prosecution*). Ralph Arthur Roberts, Jack Brooks. 1957.

THE CONCERT YEARS — DISC TWO

"Look Me Over Closely." Terry Gilkyson. 1953.

"Time for Love." Alec Wilder, William Engvick. 1953.

"Come Rain or Come Shine." Harold Arlen, Johnny Mercer. 1952.

"Love Me" (studio version). Don Raye, Gene DePaul. 1952.

"Peter." Rudolf Nelson, Friedrich Hollaender. 1954.

"Ich Hab Noch Einen Koffer In Berlin." Ralph M. Siegel, Aldo von Pinelli. 1960.

"Symphonie." Alex Alstone, Andre Tabet, Roger Bernstein. Unknown.

"Ein Roman." Bronislau Kaper. Unknown.

"Let's Call It a Day." BG DeSylva, Lew Brown, Ray Henderson. Unknown.

"No Love, No Nothing." Harry Warren, Leo Robin. Unknown.

"Something I Dreamed Last Night." Unknown.

"Lieb Zu Mir (Mean to Me)." Roy Turk, Fred E. Alhert. Unknown.

"Das Alte Lied." Friedrich Hollaender, Robert Liebmann. Unknown.

"Ich Weiss Nicht Zu Wem Ich Gehöre." Friedrich Hollaender, Robert Liebmann. Unknown.

"Je Sais Que Vou Etes Jolie." Christine, Nova Flor, Leoni et Varelli, H. Poupon. Unknown.

"Frag' Nicht Warum Ich Gehe." Robert Stolz, Walter Reisch, Armin L. Leo Robinson. Unknown.

"Love Me" (live version). Don Raye, Gene DePaul. Unknown.

"I've Been in Love Before." Friedrich Hollaender, Frank Loesser. Unknown.

"La Vie en Rose" (with Joe Venuti and Bing Crosby). Louiguy (Louis Gugliemi), Edith Piaf. 1952.

Conversation with Bing Crosby. 1952.

Conversation with Tallulah Bankhead. 1952.

"Falling in Love Again." Friedrich Hollaender, Frank Connelly. 1951.

A Return Visit with Tallulah. 1952.

"The Boys in the Backroom." Friedrich Hollaender, Frank Loesser. 1952.

ART DECO: THE COSMOPOLITAN MARLENE DIETRICH

1993 Sony Music Entertainment. Columbia/Legacy.

"Lili Marlene." Hans Leip, Norbet Schutlze. 1951.

"Mean to Me." Roy Turk, Fred E. Alhert. 1951.

"Annie Doesn't Live Here Any More." Joe Young, Johnny Burke, Harold Spina. 1951.

"The Surrey with the Fringe on Top." Rogers & Hammerstein II. 1951.

"Time on My Hands." Harold Adamson, Mack Gordon, Vincent Youmans. 1951.

"Taking a Chance on Love." John Latouche, Ted Fetter, Vernon Duke. 1951.

"Miss Otis Regrets." Cole Porter. 1951.

"I Never Slept a Wink Last Night." Harold Adamson, Jimmy McHugh. 1951.

"Peter." Rudolf Nelson, Friedrich Hollaender. 1954.

"Come Rain or Come Shine." Johnny Mercer, Harold Arlen. 1952.

"A Guy What Takes His Time." Ralph Rainger. 1952.

"Good for Nothing." William Engvick, Alec Wilder. 1952.

"Falling in Love Again." Friedrich Hollaender. 1954.

"La Vie en Rose." Edith Piaf, Louiguy (Louis Gugliemi), David. 1952.

"No Love, No Nothin'." Leo Robin, Harry Warren. 1952.

"Let's Call It a Day." Lew Brown, Ray Henderson. 1952.

"Lili Marlene." Hans Leip, Norbet Schutlze. 1954.

MARLENE DIETRICH: MYTHOS UND LEGENDE (MYTH AND LEGEND)

1994 EMI Electrola GmbH. 3 CDs.

DISC ONE

"Es Liegt In Der Luft." Mischa Spoliansky, Marcellus Schiffer. 1928.

"Wenn Die Beste Freundin." Mischa Spoliansky, Marcellus schiffer. 1928.

"Ich Bin Von Kopf Bis Fuss Auf Liebe Eingestellt." Friedrich Hollaender. 1930.

"Ich Bin Von Kopf Bis Fuss Auf Liebe Eingestellt." Friedrich Hollaender. 1930.

"Nimm Dich In Acht Vor Blonden Frauen." Friedrich Hollaender. 1930.

"Ich Bin Die Fesche Lola." Friedrich Hollaender, Robert Liebmann. 1930.

"Kinder, Heut' Abend Da Such Ich Mir Was Aus." Friedrich Hollaender, Robert Liebmann.1930.

"Wenn Ich Mir Was Wünschen Dürte." Friedrich Hollaender. 1930.

"Leben Ohne Liebe Kannst Du Nicht." Mischa Spoliansky, Robert Gilbert. 1931.

"Peter." Rudolf Nelson, Friedrich Hollaender. 1931.

"Jonny." Friedrich Hollaender. 1931.

"Jonny." Friedrich Hollaender. 1931.

"Ja, So Bin Ich." Robert Stolz, Walter Reisch. 1933.

"Mein Blondes Baby." Peter Kreuder, Fritz Rotter. 1933.

"Allein In Einer Grossen Stadt." Franz Wachsmann, Max Colpet. 1933.

"Wo Ist Der Mann?." Peter Kreuder, Max Colpet. 1933.

"Falling in Love Again." Friedrich Hollaender, Frank Connelly. 1930.

"Blonde Women." Friedrich Hollaender, Frank Connelly. 1930.

"Quand l'Amour Meurt." Octave Cremieux, Leo Robin. 1931.

"Give Me the Man." Karl Hajos, Leo Robin. 1931.

DISC TWO

"I Am the Naughty Lola." Friedrich Hollaender, Frank Connelly. 1930.

"Assez." Wal-Berg, Emile Stern, Jean Tranchant. 1933.

"Moi, Je M'Ennuie." Wal-Berg, Camille Francois. 1933.

"Cherche la Rose." R. Rouzaud, H. Salvador; arr. Burt Bacharach. 1962.

"Ou Vont les Fleurs." Pete Seeger, Lemorque, R. Rouzaud; arr. Burt Bacharach. 1962.

"Marie, Marie." Gilbert Becaud, Pierre Delanoe; arr. Burt Bacharach. 1962.

"Dejeuner du Matin." Jacques Prevert, Joseph Kosma; arr. Burt Bacharach. 1962.

"Where Have All the Flowers Gone." Pete Seeger; arr. Burt Bacharach. 1965.

"Blowin' in the Wind." Bob Dylan; arr. Burt Bacharach. 1965.

"Wer Wird Denn Weinen, Wenn Man

Auseinander Geht." Hugo Hirsch, Arthur Rebner; arr. Burt Bacharach. 1960.

"Mein Blones Baby." Peter Kreuder, Fritz Rotter; arr. Burt Bacharach. 1960.

"Peter." Rudolf Nelson, Friedrich Hollaender; arr. Burt Bacharach. 1960.

"Allein In Einer Grossen Stadt." Franz Wachsmann, Max Colpet; arr. Burt Bacharach. 1960.

"Ich Bin Die Fesche Lola." Friedrich Hollaender, Robert Liebmann; arr. Burt Bacharach. 1960.

"Wenn ich Mir Was Wünschen Dürfte." Friedrich Hollaender; arr. Burt Bacharach. 1960.

"Johnny, Wenn Du Geburtstag Hast." Friedrich Hollaender; arr. Burt Bacharach. 1960.

"Marie, Marie." Gilbert Becaud, Max Colpet; arr. Burt Bacharach. 1960.

"Lili Marlene." Norbet Schutlze, Hans Leip; arr. Burt Bacharach. 1960.

DISC THREE

"Ich Weiss Nicht, Zu Wem Ich Gehöre." Friedrich Hollaender, Robert Liebmann; arr. Burt Bacharach. 1960.

"Ich Hab Noch Einen Koffer In Berlin." Ralph M. Siegel, Aldo von Pinelli; arr. Burt Bacharach. 1960.

"Kinder, Heut' Abend, Da Such Ich Mir Was Aus." Friedrich Hollaender; ar. Burt Bacharach. 1960.

"Sag' Mir, Wo Die Blumen Sind." Pete Seeger, Max Colpet; arr. Burt Bacharach. 1962.

"Die Welt War Jung." Philippe-Gerarde, Max Colpet; arr. Burt Bacharach. 1962.

"Die Antwort Weiss Ganz Allein Der Wind." Bob Dylan, Hans Bradtke; arr. Burt Bacharach. 1963.

"Paff, Der Zauberdrachen." Peter Yarrow, Lipton, Oldörp; arr. Burt Bacharach. 1963.

"Wenn Die Soldaten." Trad. arr. Jan Pronk. 1964.

"In Den Kasernen." Gerard, Koch; arr. Rogers. 1964.

"Und Wenn Er Wiederkommt." Gerard, Max Colpet, Maeterlinck; arr: Jan Pronk. 1964.

"Auf Der Mundharmonika." Mischa Spoliansky, Robert Gilbert; arr. Stott. 1964.

"Der Trommelmann." Simsone, Onorati, Davis, George Buschor; arr. Jan Pronk. 1964.

"Wenn Der Sommer Wieder Einzieht." Cavanaugh, Weldon, Robertson, Metzl; arr. Jan Pronk. 1964.

"Ich Werde Dich Lieben." Welch, Dietrich; arr. Stott. 1964.

"Sch . . . , Kleines Baby." Ralph M. Siegel, Coster, Dietrich; arr. Stott. 1964.

"Mutter, Hast Du Mir Vergeben?" C. Niemen, J. Grau, Dietrich; arr. Stott. 1964.

"Ich Bin Von Kopf Bis Fuss Auf Liebe Eingestellt." Friedrich Hollaender; arr. Burt Bacharach. 1960.

MARLENE DIETRICH: COME UP
AND SEE ME SOMETIME!

1994 Hot Club De France.

"Ich Bin Von Kopf Bis Fuss Auf Liebe Eingestellt." Friedrich Hollaender. 1930.

"Blonde Women." Friedrich Hollaender. 1930.

"Wenn Die Beste Freundin." Mischa Spoliansky, Marcellus Schiffer. 1928.

"Falling in Love Again." Friedrich Hollaender. 1930.

"Mein Blondes Baby." Peter Kreuder. 1933.

"Lola." Friedrich Hollaender. 1930.

"Leben Ohne Liebe." Mischa Spoliansky. 1931.

"Allein In Einer Grossen Stadt." Franz Wachsmann, Max Colpet. 1933.

"This Evening Children." Friedrich Hollaender. 1930.

"Give Me the Man." Leo Robin. 1931.

"Quand l'Amour Meurt." Octave Cremieux. 1931.

"Es Liegt In Der Luft—Medley." Mischa Spoliansky, Marcellus schiffer. 1928.

"Lili Marlene" (sung in English)." Norbet Schutlze, Hans Leip. 1945.

MARLENE DIETRICH

1994 Rondo Hitline.

"Ich Bin Von Kopf Bis Fuss Auf Liebe Eingestellt." Friedrich Hollaender. 1930.

"Lili Marlene." Norbet Schutlze, Hans Leip, Conner, Philips. 1945.

"Ich Bin Die Fesche Lola." Friedrich Hollaender, Robert Liebmann. 1930.

"Wenn Die Beste Freundin." Mischa Spoliansky, Marcellus Schiffer. 1928.

"Allein In Einer Grossen Stadt." Franz Wachsmann, Max Colpet. 1933.

"Falling in Love Again." Friedrich Hollaender, Frank Connelly. 1930.

"Jonny." Friedrich Hollaender. 1931.

"The Boys in the Backroom." Friedrich Hollaender. 1939.

"Nimm Dich In Acht Vor Blonden Frauen." Friedrich Hollaender. 1930.

"Kinder, Heut' Abend Da Such Ich Mir Was Aus." Friedrich Hollaender, Robert Liebmann. 1930.

"Leben Ohne Liebe Kannst Du Nicht." Mischa Spoliansky, Robert Gilbert. 1931.

"Ja, So Bin Ich." Robert Stolz, Walter Reisch. 1933.

"Wo Ist Der Mann?" Peter Kreuder, Max Colpet. 1933.

"Blonde Women." Friedrich Hollaender, Frank Connelly. 1930.

"Give Me the Man." Octave Cremieux, Leo Robin. 1931.

"I Am the Naughty Lola." Friedrich Hollaender, Frank Connelly. 1930.

MARLENE DIETRICH: LILI
MARLENE

1997 Brisa UK Ltd.

"Lili Marlene." Norbet Schutlze, Hans Leip. 1945.

"Lola." Friedrich Hollaender, Robert Liebmann. 1930.

"The Boys in the Backroom." Friedrich Hollaender. 1939.

"Quand l'Amour Meurt." Octave Cremieux, Leo Robin. 1931.

"Symphonie." Alex Alstone. 1945.

"Moi, Je M'Ennuie." Wal-Berg, Camille Francois. 1933.

"Illusions." Friedrich Hollaender. 1949.

"Johnny." Friedrich Hollaender. 1931.

"I've Been in Love Before." Friedrich Hollaender, Frank Loesser. 1939.

"Black Market." Friedrich Hollaender. 1949.

"Another Spring, Another Love." Gloria Shayne, Noel Paris. 1957.

"Falling in Love Again." Friedrich Hollaender. 1939.

"Give Me the Man." Octave Cremieux, Leo Robin. 1931.

"You Go to My Head." Fred Coots, Haven Gillespie. 1939.

"You've Got That Look." Friedrich Hollaender. 1939.

"Near You (Pres de Vous)." Francis Craig, Kermet Goell. 1957.

"Such Trying Times." John Addison, Julian More. 1964.

"Mein Blondes Baby." Peter Kreuder, Fritz Rotter. 1960.

MARLENE DIETRICH: AT QUEEN'S THEATRE

(1964.12.12). 1998 Delta Music GmbH. Laser Light Digital.

"Allein." Franz Wachsmann, Max Colpet. 1964.
"Falling in Love Again." Friedrich Hollaender, Samuel Lerner. 1964.
"Go 'Way from My Window." John Jacob Niles. 1964.
"Honeysuckle Rose." Fats Waller, Andy Razaf. 1964.
"I Can't Give You Anything but Love." Jimmy McHugh, Dorothy Fields. 1964.
"I Wish You Love." Charles Trenet, Albert Beach. 1964.
"Johnny." Friedrich Hollaender. 1964.
"La Vie en Rose." Louiguy (Louis Gugliemi). 1964.
"The Laziest Gal in Town." Cole Porter. 1964.
"Lili Marlene." Norbet Schutlze, Hans Leip, Tommie Connor. 1964.
"Lola." Friedrich Hollaender. 1964.
"Marie, Marie." Gilbert Becaud, Pierre Delanoe. 1964.
"Shir Hatan." Sahar, Zarai. 1964.
"Warum." Robert Stolz, Walter Reisch, Armin L. Leo Robinson 1964.

MARLENE DIETRICH/RITA HAYWORTH: DIVAS THE GOLD COLLECTION. 40 CLASSIC PERFORMANCES

1998 Proper/Retro. 2 CDs.

DISC ONE — MARLENE DIETRICH
"Lili Marlene." Norbet Schutlze, Hans Leip. 1945.
"Lola." Friedrich Hollaender, Robert Liebmann. 1930.
"Johnny." Friedrich Hollaender. 1930.
"Falling in Love Again." Friedrich Hollaender, Frank Connelly. 1930.
"You've Got That Look." Friedrich Hollaender, Frank Loesser. 1939.
"The Boys in the Backroom." Friedrich Hollaender, Frank Loesser. 1939.
"I've Been in Love Before." Friedrich Hollaender, Frank Loesser. 1939.
"You Do Something to Me." Cole Porter. 1939.

"You go to My Head." Fred Coots, Haven Gillespie. 1939.
"Illusions." Friedrich Hollaender. 1949.
"Black Market." Friedrich Hollaender. 1949.
"Symphonie." Alex Alstone, Andre Tabet, Roter Bernstein. 1945.
"Look Me Over Closely." Friedrich Hollaender. 1954.
"Lazy Afternoon." Jerome Moross, John Latouche. 1954.
"Such Trying Times." John Addison, Julian More. 1964.
"If He Swings by the String." John Addison, Julian More. 1964.
"La Vie en Rose." Louiguy (Louis gugliemi), Edith Piaf. 1954.
"Another Spring, Another Love." Gloria Shayne, Noel Paris. 1957.
"Near You." Francis Craig, Kermet Goell. 1957.
"Kisses Sweeter Than Wine." Paul Campbell, Joel Newman. 1957.

MARLENE DIETRICH: LEGENDS OF THE 20TH CENTURY

1999 EMI Records Ltd.

"Ich Bin Von Kopf Bis Fuss Auf Liebe Eingestellt." Friedrich Hollaender. 1930.
"Blonde Women." Friedrich Hollaender, Frank Connelly. 1930.
"Quand l'Amour Meurt." Octave Cremieux, Leo Robin. 1931.
"I Am the Naughty Lola." Friedrich Hollaender, Frank Connelly. 1930.02.
"Assez." Wal-Berg, Emile Stern, Jean Tranchant. 1933.07.
"Mein Blondes Baby." Peter Kreuder, Fritz Rotter. 1960.08.
"Peter." Rudolf Nelson, Friedrich Hollaender. 1960.08.
"Allein In Einer Grossen Stadt." Franz Wachsmann, Max Colpet. 1960.08.
"Where Have All the Flowers Gone." Pete Seeger. 1963.11.
"Cherche la Rose." R. Rouzaud, H. Salvador. 1962.
"Mo, Je M'Ennuie." Wal-Berg, Camille Francois. 1933.
"Marie, Marie." Gilbert Becaud, Pierre Delano. 1962.
"Defeuner du Matin." Joseph Kosma, Jacques Prevert. 1962.
"Blowin' in the Wind." Bob Dylan. 1963.
"Wenn Ich Mir Was Wünschen Dürfte." Friedrich Hollaender. 1960.
"Johnny, Wenn Du Geburtstag Hast." Friedrich Hollaender. 1960.

"Ich Weiss Nicht, Zu Wem Ich Gehöre." Friedrich Hollaender, Robert Liebmann. 1960.
"Ich Hab' Noch Einen Koffer In Berlin." Ralph M. Siegel, Aldo von Pinelli. 1960.
"Lili Marleen." Norbet Schutlze, Hans Leip. 1960.
"Die Welt War Jung." Phillipe-Gerard, Max Colpet. 1962.
"In Den Kasernen." Gerard, Koch. 1964.
"Ich Werde Dich Lieben." Welch, Dietrich. 1964.
"Falling in Love Again." Friedrich Hollaender, Frank Connelly. 1930.

MARLENE DIETRICH: ICH BIN DIE FESCHE LOLA

1999 DA Music Sonia.

"Falling in Love Again." Friedrich Hollaender, Frank Connelly. 1930.
"You Do Something to Me." Cole Porter. 1939.
"Ich Bin Die Fesche Lola." Friedrich Hollaender, Robert Liebmann. 1930.
"You Go to My Head." Fred Coots, Haven Gillespie. 1939.
"Blonde Women." Friedrich Hollaender, Frank Connelly. 1930.
"Peter." Rudolf Nelson, Friedrich Hollaender. 1931.
"The Boys in the Backroom." Friedrich Hollaender, Frank Loesser. 1939.
"Hot Voodoo." Ralph Rainger, Sam Coslow. 1932.
"Wo Ist Der Mann." Peter Kreuder, Max Colpet. 1933.
"I've Been in Love Before." Friedrich Hollaender, Frank Loesser. 1939.
"Johnny." Friedrich Hollaender. 1931.
"Give Me the Man." Leo Robin. 1931.
"Moi, Je M'Ennuie." Wal-Berg, Camille Francois. 1933.
"You've Got That Look." Friedrich Hollaender, Frank Loesser. 1939.
"Assez." Wal-Berg, Emile Stern. Jean Tranchant. 1933.
"I Gotta Get a Man." Friedrich Hollaender. 1930.

A PORTRAIT OF MARLENE DIETRICH

1999 Music Collection International. Gallerie Gale. 2 CDs.

"Falling in Love Again." Friedrich Hollaender, Frank Connelly. 1930.
"Es Liegt In Der Luft." Mischa Spoliansky, Marcellus Schiffer. 1928.
"Wenn Dei Beste Freundin." Mischa Spoliansky, Marcellus Schiffer. 1928.
"Ich Bin Von Kopf bis Fuss Auf Liebe Eingestellt." Friedrich Hollaender. 1930.
"Ich Bin Von Kopf Bis Fuss Auf Liebe Eingestellt." Friedrich Hollaender. 1930.
"Nimm Dich In Acht Vor Blonden Frauen." Friedrich Hollaender. 1930.
"Kinder, Heut' Abend, Da Such Ich Mir Was Aus." Friedrich Hollaender, Robert Liebmann. 1930.
"Ich Bin Die Fesche Lola." Friedrich Hollaender, Robert Liebmann. 1930.
"Blonde Women." Friedrich Hollaender, Frank Connelly. 1930.
"This Evening, Children." Friedrich Hollaender. 1930.
"I Am the Naughty Lola." Friedrich Hollaender, Frank Connelly. 1930.
"Wenn Ich Mir Was Wünschen Dürfte." Friedrich Hollaender. 1930.
"Jonny." Friedrich Hollaender. 1931.
"Peter." Rudolf Nelson, Friedrich Hollaender. 1931.
"Jonny." Friedrich Hollaender. 1931.
"Leben Ohne Liebe." Mischa Spoliansky. Robert Gilbert. 1931.
"What Am I Bid? (original soundtrack from *Morocco*)." Leo Robin, Karl Hajos. 1930.
"Quand l'Amour Meurt." Octave Cremieux, Leo Robin. 1930.
"Give Me the Man." Karl Hajos, Leo Robin. 1930.
"Allein, In Einer Grossen Stadt." Franz Wachsmann, Max Colpet. 1933.
"Ja So Bin Ich." Robert Stolz, Walter Reisch. 1933.
"Mein Blondes Baby." Peter Kreuder, Fritz Rotter. 1933.

"Assez." Wal-Berg, Emile Stern, Jean Tranchant. 1933.
"Moi, Je M'Ennuie." Wal-Berg, Camille Francois. 1933.
"Wo Ist Der Mann?" Peter Kreuder, Max Colpet. 1933.
"Hot Voodoo" (original extended soundtrack from *Blinde Venus*). Ralph Rainger, Sam Coslow. 1932.
"You Little So and So? (original extended soundtrack from *Blinde Venus*). Ralph Rainger, Sam Coslow. 1933.
"I Couldn't Be Annoyed" (original extended

soundtrack from *Blinde Venus*). George Whiting, Leo Robin. 1933.

"Awake in a Dream" (original soundtrack from *Desire*). Friedrich Hollaender, Leo Robin. 1935.

"Quand l'Amour Meurt." Octave Cremieux, Leo Robin. 1939.

"The Boys in the Backroom." Friedrich Hollaender, Frank Loesser. 1939.

"You've Got That Look." Friedrich Hollaender, Frank Loesser. 1939.

"I've Been in Love Before." Friedrich Hollaender, Frank Loesser. 1939.

"You Do Something to Me." Cole Porter. 1939.

"You Go to My Head." Fred Coots, Haven Gillespie. 1939.

"The Man's in the Navy" (original soundtrack from *Seven Sinners*). Friedrich Hollaender, Frank Loesser. 1940.

"Falling in Love Again." Friedrich Hollaender, Frank Connelly. 1939.

"Symphonie." Alex Alstone, Andre Tabet, Roger Bernstein. 1946.

"Lili Marlene." Norbet Schutlze, Hans Leip. 1945.

"Black Market" (original soundtrack from *A Foreign Affair*). Friedrich Hollaender. 1948.

"Illusions." Friedrich Hollaender. 1949.

"Black Market." Friedrich Hollaender. 1949.

"The Ruins of Berlin" (original soundtrack from *A Foreign Affair*) Friedrich Hollaender. 1948.

MARLENE DIETRICH: THE BLUE ANGEL

1999 Disconforme. The Soundtrack Factory.

"Ich Bin Von Kopf Bis Fuss Auf Liebe Eingestellt." Friedrich Hollaender. 1930.

"Falling in Love Again." Friedrich Hollaender, Frank Connelly. 1930.

"Ich Bin Die Fesche Lola." Friedrich Hollaender, Robert Liebmann. 1930.

"I Am the Naughty Lola." Friedrich Hollaender, Frank Connelly. 1930.

"Kinder, Heut' Abend Da Such' Ich Mir Was Aus." Friedrich Hollaender, Robert Liebmann. 1930.

"Nimm Dich In Acht Vor Blonden Frauen." Friedrich Hollaender. 1930.

"Blonde Women." Friedrich Hollaender, Frank Connelly. 1930.

"Peter." Rudolf Nelson, Friedrich Hollaender. 1931.

"Jonny." Friedrich Hollaender. 1931.

"Leben Ohne Liebe Kannst Du Nicht." Mischa Spoliansky, Robert Gilbert. 1931.

"Quand l'Amour Meurt." Octave Cremieux, Leo Robin. 1931.

"Give Me the Man." Octave Cremieux, Leo Robin. 1931.

"Assex." Wal-Berg, Emile Stern, Jean Tranchant. 1933.

"Moi, Je M'Ennuie." Wal-Berg, Camille Francois. 1933.

"Wo Ist Der Mann?" Peter Kreuder, Max Colpet. 1933.

"Falling in Love Again." Friedrich Hollaender, Samuel Lerner. 1939.

"I've Been in Love Before." Friedrich Hollaender, Frank Loesser. 1939.

"You've Got That Look (That Leaves Me Weak)." Friedrich Hollaender, Frank Loesser. 1939.

"You Do Something to Me." Cole Porter. 1939.

"You Go to My Head." Fred Coots, Haven Gillespie. 1939.

"See What the Boys in the Backroom Will Have." Friedrich Hollaender, Frank Loesser. 1939.

"Symphonie." Alex Alstone, Andre Tabet, Roger Bernstein. 1945.

"Illusions." Friedrich Hollaender. 1949.

"Black Market." Friedrich Hollaender. 1949.

"Lili Marlene." Norbet Schutlze, Hans Leip, Dietrich. 1945.

MARLENE DIETRICH: THE BLUE ANGEL

1999 A&R Productions. Nostalgia. ZYX Music.

"Lili Marlene." Norbet Schutlze, Hans Leip, Conner, Philips. 1945.

"You Do Something to Me." Cole Porter. 1940.

"Peter." Rudolf Nelson, Friedrich Hollaender. 1933.

"Symphonie." Alex Alstone, Andre Tabet, Bernstin. 1945.

"Falling in Love Again." Friedrich Hollaender, Samuel Lerner. 1940.

"I've Been in Love Before." Friedrich Hollaender, Frank Loesser. 1940.

"Black Market." Friedrich Hollaender. 1949.

"Illusions." Friedrich Hollaender. 1949.

"You Go to My Head." Fred Coots, Haven Gillespie. 1940.

"The Boys in the Backroom." Friedrich Hollaender, Frank Loesser. 1939.

"Look Over Me Closely." Terry Gilkyson. 1948.

"Johnny." Friedrich Hollaender. 1933.

"Mein Blondes Baby." Peter Kreuder, Fritz Rotter. 1933.

"You've Got That Look (That Leaves Me Weak)." Friedrich Hollaender, Frank Loesser. 1940.

"Give Me the Man." Jan Pronk. 1931.

"Quand l'Amour Meurt." Octave Cremieux, Leo Robin. 1930.

"This Evening Children." Friedrich Hollaender. 1939.

"Blonde Women." Friedrich Hollaender. 1933.

"Moi, Je M'Ennuie." Wal-Berg, Camille Francois. 1933.

"Leben Ohne Liebe." Mischa spoliansky, Robert Gilbert. 1933.

GRAND ECRAN 3. MARLENE DIETRICH

1999 Bella Music BMF.

"Lili Marlene (Lili Marleen)" (live at Queens Theatre, sung in English). Norbet Schutlze, Hans Leip, Tommie Connor; arr. Burt Bacharach. 1964.

"La Vie en Rose" (live at Queens Theatre). Louiguy (Louis Gugliemi), Edith Piaf; arr. Burt Bacharach. 1964.

"Lola" (live at Queens Theatre). Friedrich Hollaender, Robert Liebmann; arr. Burt Bacharach. 1964.

"The Boys in the Backroom." Friedrich Hollaender, Frank Loesser. 1959.

"I May Never Go Home Any More." Jack Brooks, Ralph Arthur Roberts. 1957.

"Another Spring, Another Love." Gloria Shayne, Noel Paris. 1957.

"Go 'Way from My Window" (live at Queens Theatre). John Jacob Niles; arr. Burt Bacharach. 1964.

"Honeysuckle Rose" (live at Queens Theatre). Fats Waller, Andy Razaf; arr. Burt Bacharach. 1964.

"Such Trying Times." John Addison, Julian More. 1964.

"Near You." Francis Craig, Kermet Goell. 1957.

"Allein" (live at Queens Theatre). Franz Wachsmann, Max Colpet; arr. Burt Bacharach. 1964.

"Johnny" (live at Queens Theatre). Friedrich Hollaender; arr. Burt Bacharach. 1964.

"I Can't Give You Anything but Love" (live at Queens Theatre). Jimmy McHugh,

Dorothy Fields; arr. Burt Bacharach. 1964.

"Laziest Gal in Town" (live at Queens Theatre). Cole Porter; ar. Burt Bacharach. 1964.

"Frag Nicht, Warum Ich Gehe" (live at Queens Theatre). Robert Stolz, Walter Reisch, Armin L. Leo Robinson; arr. Burt Bacharach. 1964.

"I Wish You Love" (live at Queens Theatre). Charles Trenet, Albert Beach; arr. Burt Bacharach. 1964.

"I Will Come Back Again (Maybe I'll Come Back)" (live in Rio de Janeiro). Jeffrey, Cooke; arr. Burt Bacharach. 1959.

"Illusions." Friedrich Hollaender. 1949.

"Falling in Love Again" (live at Queens Theatre). Friedrich Hollaender, Samuel Lerner; arr. Burt Bacharach. 1964.

"Shir Hatan" (live at Queens Theatre). Sahar; arr. Burt Bacharach. 1964.

You Go to My Head. Fred Coots, Haven Gillespie. 1939.

MARLENE DIETRICH 2000: THE BLUE ANGEL

Edition Pro Arte. Produced by Nichevo Productions, Inc.

"Naughty Lola." Friedrich Hollaender. 1930.

"Falling in Love Again." Friedrich Hollaender. 1930.

"Blonde Women." 1930.

"I Gotta Get a Man (This Evening Children)." Friedrich Hollaender. 1930.

"Give Me the Man." Octave Cremieux, Leo Robin. 1931.

"Peter." Rudolf Nelson, Friedrich Hollaender. 1931.

"Jonny." Friedrich Hollaender. 1931.

"Hot Voodoo." Ralph Rainger, Sam Coslow. 1932.

"Wo Ist Der Mann?" Peter Kreuder, Max Colpet. 1933.

"Je M'Ennuie." Wal-Berg, Camille Francois. 1933.

"Allein In Einer Grossen Stadt." Franz Wachsmann, Max Colpet. 1933.

"Assez." Wal-Berg, Emile Stern, Jean Tranchant. 1933.

"Falling in Love Again." Friedrich Hollaender, Samuel Lerner. 1930.

"You Go to My Head." Fred Coots, Haven Gillespie. 1939.

"The Boys in the Backroom." Friedrich Hollaender, Frank Loesser. 1939.

"The Boys in the Backroom—Parody as a Salute to Mitchell Leisen." Friedrich Hollaender, Frank Loesser, Unknown. 1941.

MARLENE DIETRICH: BERLIN–HOLLYWOOD

2000 Ceraton CT.

"Ich Bin Von Kopf Bis Fuss Auf Liebe Eingestellt." Friedrich Hollaender. 1930.
"Wo Ist Der Mann." Peter Kreuder, Max Colpet. 1933.
"Jonny." Friedrich Hollaender. 1931.
"Leben Ohne Liebe Kannst Du Nicht." Mischa Spoliansky, Robert Gilbert. 1931.
"Wenn Ich Mir Was Wünschen Dürfte." Friedrich Hollaender. 1930.
"Cherche La Rose." R. Rouzaud, H. Salvador. 1939.
"Kinder, Heut Abend, Da Such Ich Mir Was Aus." Friedrich Hollaender, Robert Liebmann. 1930.
"Ich Bin Die Fesche Lola." Friedrich Hollaender, Robert Liebmann. 1930.
"Mein Blondes Baby." Peter Kreuder, Fritz Rotter. 1933.
"Nimm Dich In Acht Vor Blonden Frauen." Friedrich Hollaender, Richard Rillo. 1930.
"Ja So Bin Ich." Robert Stolz, Walter Reisch. 1933.
"Allein In Einer Grossen Stadt." Franz Wachsmann, Max Colpet. 1933.
"Assez." Wal-Berg, Emile Stern, Jean Tranchant. 1933.
"Destry Rides Again—Medley" ("Little Joe, the Wrangler;" "You've Got That Look;" "The Boys in the Backroom"). Friedrich Hollaender, Frank Loesser. 1939.
"Lili Marlene." Hans Leip, Norbet Schutlze. 1945.
"You Go to My Head." Fred Coots, Haven Gillespie. 1939.
"A Foreign Affair—Medley ("Black Market;" "Illusions"; "Ruins of Berlin"). Friedrich Hollaender. 1949.
"Falling in Love Again." Friedrich Hollaender. 1930.

MARLENE DIETRICH: THE GREATEST HITS. (VON KOPF BIS FUSS . . .)

200 Trumpets of Jericho Ltd. 2000 The International Music Company.

"Ich Bin Von Kopf Bis Fuss Auf Liebe Eingestellt." Friedrich Hollaender. 1930.
"Nimm Dich In Acht Vor Blonden Frauen." Friedrich Hollaender. 1930.
"Ich Bin Die Fesche Lola." Friedrich Hollaender, Robert Liebmann. 1930.
"Kinder, Heut' Abend, Da Such Ich Mir Was Aus." Friedrich Hollaender, Robert Liebmann. 1930.
"Wenn Ich Mir Was Wünschen Dürfte." Friedrich Hollaender. 1930.
"Quand l'Amour Meurt." Octave Cremieux, Leo Robin. 1930.
"Give Me the Man." Octave Cremieux, Leo Robin. 1930.
"Leben Ohne Liebe." Mischa Spoliansky, Robert Gilbert. 1931.
"You've Got That Look (That Leaves Me Weak)." Friedrich Hollaender, Frank Loesser. 1939.
"The Boys in the Backroom." Friedrich Hollaender, Frank Loesser. 1939.
"You Do Something to Me." Cole Porter. 1940.
"You Go to My Head." Fred Coots, Haven Gillespie. 1940.
"I've Been in Love Before." Friedrich Hollaender, Frank Loesser. 1940.
"Symphonie." Alex Alstone, Andre Tabet, Roger Bernstein. 1944.
"Lili Marlene." Norbet Schutlze, Hans Leip, Conner, Philips. 1944.
"Illusions." Friedrich Hollaender. j1948.
"Black Market." Friedrich Hollaender. 1948.
"Falling in Love Again." Friedrich Hollaender, Frank Connelly. 1930.

MARLENE DIETRICH: IHRE GROSSEN ERFOLGE

2000 ZYX Music.

"Ich Bin Von Kopf Bis Fuss Auf Liebe Eingestellt." Friedrich Hollaender. 1930.
"Kinder, Heut' Abend, Da Such Ich Mir Was Aus." Friedrich Hollaender. 1930.
"Ich Bin Die Fesche Lola." Friedrich Hollaender, Robert Liebmann. 1930.
"Allein In Einer Grossen Stadt." Franz Wachsmann, Max Colpet. 1933.
"Lili Marlene." Norbet Schutlze, Hans Leip, Tommie Connor, Philips. 1945.
"Frag Nicht, Warum Ich Gehe." Robert Stolz, Walter Reisch. 1964.
"Johnny, Wenn Du Geburtstag Hast." Friedrich Hollaender. 1931.
"Mein Blondes Baby." Peter Kreuder, Fritz Rotter. 1960.

"The Boys in the Backroom." Friedrich Hollaender, Frank Loesser. 1939.
"Quand l'Amour Meurt." Octave Cremieux, Leo Robin. 1931.
"Moi, Je M'Ennuie." Wal-Berg, Camille Francois. 1933.
"Leben Ohne Liebe." Mischa Spoliansky. 1931.
"Peter." Rudolf Nelson, Friedrich Hollaender. 1954.
"Illusions." Friedrich Hollaender. 1949.
"Symphonie." Alex Alstone, Andre Tabet, Roger Bernstein. 1945.
"Wenn Ich Mir Was Wünschen Dürfte." Friedrich Hollaender. 1930.
"You Do Something to Me." Cole Porter. 1939.
"I've Been in Love Before." Friedrich Hollaender, Frank Loesser. 1939.
"You Go to My Head." Fred Coots, Haven Gillespie. 1939.
"Falling in Love Again." Friedrich Hollaender, Samuel Lerner. 1939.
"Blonde Women." Friedrich Hollaender. 1930.

MARLENE DIETRICH: EINFACH DAS BESTE—SIMPLY THE BEST

2000 Sony Music Entertainment. Columbia.

"Wenn Ein Müadel Einen Herrn Hat." Walter Kollo. 1965.
"Es Gibt Im Leben Manchmal Momente." Brommel, Steinberg. 1965.
"Das War In Schöneberg." Walter Kollo, Rudolf Bernauer, Rudolf Schanzer. 1965.
"Ja, Das Haben Die Mädchen So Gerne." Gilbert, Schönfeld, Gilbert, Kren. 1965.
"La Vie en Rose." Edith Piaf, Louiguy (Louis Gugliemi), David. 1965.
"Lieber Leierkastenmann." Walter Kollo. 1965.
"Lili Marleen" (sung in German). Hans Leip, Norbet Schutlze. 1965.
"Wenn Du Einmal Eine Braut Hast." Hugo Hirsch, Heye. 1965.
"Durch Berlin Fliesst Immer Noch Die Spree." Gilbert, Gilbert. 1965.
"Das Ist Berlin Wie's Weint, Das Ist Berlin Wie's Lacht." Walter Kollo. 1965.
"Solang Noch Untern Linden." Walter Kollo. 1965.
"Nach Meine Beene Ist Ja Ganz Berlin Verrückt." Walter Kollo, FW Hardt. 1965.
"Mit Dir, Mit Dir Da Möchte Ich Sonntags Angeln Gehen." Walter Kollo, Rideamus. 1965.

"Du Hast Ja Keine Ahnung Wie Schön Du Bist Berlin." Gilbert, Schönfeld. 1965.

MARLENE DIETRICH: RECORDS 1928–1933

2000 CDM Digital Audio GmbH.

"Ich Bin Die Fesche Lola." Friedrich Hollaender. 1930.
"Kinder, Heut' Abend Da Such Ich Mir Was Aus." Friedrich Hollaender. 1930.
"Nimm Dich In Acht Vor Blonden Frauen." Friedrich Hollaender. 1930.
"Ich Bin Von Kopf Bis Fuss Auf Liebe Eingestellt." Friedrich Hollaender. 1930.
"Allein In Einer Grossen Stadt." Jose D'Alba, Kurt Gerhardt. 1933.
"Leben Ohne Liebe Kannst Du Nicht." Mischa Spoliansky, Robert Gilbert. 1931.
"Jonny." Friedrich Hollaender. 1931.
"Wenn Ich Mir Was Wünschen Dürfte." Friedrich Hollaender. 1931.
"Peter." Friedrich Hollaender. 1931.
"Mein Blondes Baby." Peter Kreuder, Fritz Rotter. 1933.
"Assez." Wal-Berg, Eile Stern, Jean Tranchant. 1933.
"Je M'Ennuie." Wal-Berg, Camille Francois. 1933.
"Wenn Die Beste Freundin." Mischa Spoliansky, Marcellus Schiffer. 1928.

MARLENE DIETRICH: WENN ICH MIR WAS WÜNSCHEN DÜRFTE

2000 Duophon Edition Berliner Musenkinder.

"Es Liegt In Der Luft—Potpourri." Mischa Spoliansky, Marcellus schiffer. 1928.
"Wenn Die Beste Freundin." Mischa Spoliansky, Marcellus Schiffer. 1928.
"Ich Bin Von Kopf Bis Fuss Auf Liebe Eingestellt." Friedrich Hollaender. 1930.
"Falling in Love Again." Friedrich Hollaender, Frank Connelly. 1930.
"Nimm Dich In Acht Vor Blonden Frauen." Friedrich Hollaender, Richard Rillo. 1930.
"Blonde Women." Friedrich Hollaender, Frank Connelly. 1930.
"Ich Bin Die Fesche Lola." Friedrich Hollaender, Robert Liebmann. 1930.
"Lola." Friedrich Hollaender, Frank Connelly. 1930.

"Kinder, Heut' Abend Da Such' Ich Mir Was Aus." Friedrich Hollaender, Robert Liebmann. 1930.

"There's Nothing to It, I've Got to Get a Man." Friedrich Hollaender, Frank Connelly. 1930.

"Ich Bin Von Kopf Bis Fuss Auf Liebe Eingestellt." Friedrich Hollaender, Robert Liebmann. 1930.

"Wenn Ich Mir Was Wünschen Dürfte." Friedrich Hollaender. 1930.

"Wenn Ich Mir Was Wünschen Dürfte." Friedrich Hollaender. 1930.

"Peter." Rudolf Nelson, Friedrich Hollaender. 1931.

"Jonny." Friedrich Hollaender. 1931.

"Jonny." Friedrich Hollaender. 1931.

"Leben Ohne Liebe Kannst Du Nicht." Mischa Spoliansky, Robert Gilbert. 1931.

"Quand l'Amour Meurt." Octave Cremieux, Leo Robin. 1931.

"Give Me the Man." Karl Hajos, Leo Robin. 1931.

MARLENE DIETRICH

2 CD box. 2000 Delta Music GmbH. Laser Light Digital 24 923 (LC 8259)/ Germany.

DISC ONE: *MARLENE DIETRICH: AT QUEEN'S THEATRE*
1998 Delta Music GmbH.
Track list: see above.

DISC TWO: *MARLENE DIETRICH*
2000 Delta Music GmbH. Laser Light Digital.
"Ich Bin Von Kopf Bis Fuss Auf Liebe Eingestellt." Friedrich Hollaender. 1930.
"Nimm Dich In Acht Vor Blonden Frauen." Friedrich Hollaender. 1930.
"Kinder, Heut' Abend, Da Such Ich Mir Was Aus." Friedrich Hollaender, Robert Liebmann. 1930.
"Ich Bin Die Fesche Lola." Friedrich Hollaender, Robert Liebmann. 1930.
"Give Me the Man." Leo Robin, Octave Cremieux. 1931.
"You Do Something to Me." Cole Porter. 1939.
"Quand l'Amour Meurt." Leo Robin, Octave Cremieux. 1931.
"Wenn Ich Mir Was Wünschen Dürfte." Friedrich Hollaender. 1930.
"Mein Blondes Baby." Peter Kreuder, Fritz Rotter. 1933.
"Es Liegt In Der Luft." Mischa Spoliansky, Marcellus Schiffer. 1928.

"Wenn Die Beste Freundin." Mischa Spoliansky, Marcellus Schiffer. 1928.

"Leben Ohne Liebe Kannst Du Nicht." Mischa Spoliansky, Robert Gilbert. 1931.

"You've Got That Look." Friedrich Hollaender, Frank Loesser. 1939.

"I've Been in Love Before." Friedrich Hollaender, Frank Loesser. 1939.

MARLENE DIETRICH . . . DENN DAS IST MEINE WELT, UND SONST GAR NICHTS

2000 Mazur Media GmbH High Definition Classics, High Definition Nostalgia.

"Nimm Dich In Acht Vor Blonden Frauen." Friedrich Hollaender. 1930.
"Kinder, Heut' Abend, Da Such Ich Mir Was Aus." Friedrich Hollaender, Robert Liebmann. 1930.
"Ich Bin Von Kopf Bis Fuss Auf Liebe Eingestellt." Friedrich Hollaender. 1930.
"Ich Bin Die Fesche Lola." Friedrich Hollaender, Robert Liebmann. 1930.
"Es Liegt In Der Luft." Mischa Spoliansky, Marcellus schiffer. 1928.
"Wenn Die Beste Freundin." Mischa Spoliansky, Marcellus Schiffer. 1928.
"Leben Ohne Liebe Kannst Du Nicht." Mischa Spoliansky, Robert Gilbert. 1931.
"Johnny." Friedrich Hollaender. 1931.
"Johnny." Friedrich Hollaender. 1931.
"Ja, So Bin Ich." Robert Stolz, Walter Reisch. 1933.
"Peter." Rudolf Nelson, Friedrich Hollaender. 1931.
"Give Me the Man." Karl Hajos, Leo Robin. 1931.
"Quand l'Amour Meurt." Octave Cremieux, Leo Robin. 1931.
"Assez." Wal-Berg, Emile Stern, Jean Tranchant. 1933.
"Moi, Je M'Ennuie." Wal-Berg, Camille Francois. 1933.
"Mein Blondes Baby." Peter Kreuder, Schott. 1933.
"Wo Ist Der Mann?." Peter Kreuder, Max Colpet. 1933.
"Allein In Einer Grossen Stadt." Franz Wachsmann, Max Colpet. 1933.
"Wenn Ich Mir Was Wünschen Dürfte." Friedrich Hollaender. 1930.
"Falling in Love Again." Friedrich Hollaender, Frank Connelly. 1930.
"Blonde Women." Friedrich Hollaender, Frank Connelly. 1930.

Collection Inventory and Exhibitions

- More than 3,000 textile items from the 1920s to the 1990s, including 50 film and 70 show costumes by Jean Louis, Travis Banton, Edith Head, Eddie Schmidt, and others.

- 1,000 individual items from her private wardrobe, including 50 handbags and 150 pairs of gloves by Elizabeth Arden, Balenciaga, Balmain, Chanel, Courreges, Dior, Givenchy, Guerlain, Irene, Knize, Lee, Levis, Schiaparelli, Ungaro, and others.

- 400 hats.

- 440 pairs of shoes by Agnés, Aprile, Cavanagh, Lilly Daché, Delman, Edouard, John Frederics, Massaro, and others.

- About 15,000 photographs from 1904 to 1992, including 5,000 film stills and behind-the-scenes pictures, 5,000 pictures of show performances, 2,000 pictures of public appearances, 1,000 private and family pictures, and 2,000 original prints by famous photographers such as Cecil Beaton, Mario Bucovich, Irving Chidnoff, Don English, Horst P. Horst, George Hurrell, Armstrong Jones, Ray Jones, Eugene Robert Richee, Edward Steichen, and William Walling.

- About 300,000 leaves of written documents, including letters from Burt Bacharach, Charles Boyer, Yul Brynner, Maurice Chevalier, Noël Coward, Jean Gabin, Douglas Fairbanks Jr., Willi Forst, Ernest Hemingway, Alfred Kerr, Hildegard Knef, Karl Lagerfeld, Lilli Palmer, Alfred Polgar, Nancy and Ronald Reagan, Erich Maria Remarque, Maximilian Schell, Johannes Mario Simmel, Josef von Sternberg, Orson Welles, Billy Wilder, and Carl Zuckmayer.

- 2,500 sound recordings from the 1930s to the 1980s.

- 300 posters, drawings, and paintings, including 50 costume figurines, 30 film posters, 40 lithographs, 180 show posters, and 80 pieces of luggage (trunks, suitcases, hat boxes, vanity cases).

A BRIEF HISTORY OF EXHIBITIONS FEATURING MARLENE DIETRICH

April 7, 1995, to July 8, 1995
*Kino*Movie*Cinema: 100 Jahre Film*
Architect: Hans Dieter Schaal
Berlin: Martin-Gropius-Bau

November 9, 1995, to February 21, 1996
Marlene Dietrich
Director of construction: Michael Haacke
Bonn: Kunst- und Ausstellungshalle der Bundesrepublik Deutschland

May 30, 1996, to September 2, 1996
Il volo dell'angelo
Architect: Hans Dieter Schaal
Rome: Palazzo delle Esposizioni

December 28, 1996, to January 12, 1997
Marlene Dietrich zum 95. Geburtstag
Weimar: Goethe Institut

Since December 1997
Marlene Dietrich: A Legend in Photographs
Touring exhibition organized by the Goethe Institut

February 11, 1998, to May 5, 1998
Marlene Dietrich
Frankfurtam/Main: Deutsches Filmmuseum

September 27, 1998, to January 24, 1999
Marlene Dietrich
Hagen: Historisches Centrum Hagen–Stadtmuseum

A SELECTION OF OTHER EXHIBITIONS PARTLY FEATURING MARLENE DIETRICH

March 29, 1994, to June 30, 1994
Präsentation der Marlene Dietrich Collection Berlin
Bonn: Bundesministerium des Innern

April 10, 1994, to April 17, 1994
SIME '94: Salon International des Musées et des Expositions
Paris: Internationale Museumsmesse

May 5, 1994, to June 30, 1994
Swatch si gira: Cinema, cento anni di meraviglia
Rome: Spazio Acea Viale Ostiense

May 26, 1994, to June 1, 1994
Hommage an Josef von Sternberg
Berlin: Akademie der Künste

June 1, 1994, to September 4, 1994
Packende Koffer: Von Maria de Medici bis Marlene Dietrich
Zurich: Museum Bellerive

September 9, 1994 to November 11, 1994
Marlene Dietrich in der Kunst. Gem älde-Zeichnunger-Plastiken. Collection Fred Ostrowski
Berlin: Friedrichstadt palast

February 11, 1995, to June 5, 1995
Schätze aus Berliner Museen: Erwerbungen aus Lottomitteln, 1975–1995
Kostbarkeiten aus Sammlungen und Nachlässen
Berlin: Kunstforum in der Grundkreditbank

November 1, 1995, to March 27, 1996
Tanten, Tunten, kesse Väter
Berlin: Schwules Museum

November 9, 1995 to February 25, 1996
Illusion—Emotion—Realität: 100 Jahre Kino
Zurich: Kunsthaus

March 24, 1996, to August 25, 1996
*Mein Kopf und die Beine von Marlene
Dietrich: Heinrich Manns Professor Unrat
und der blaue Engel*
Lübeck: Buddenbrookhaus

August 23, 1996, to January 10, 1997
*Hommage an Hubsi (Hubert von
Meyerinck)*
Berlin: Schwules Museum

August 30, 1996, to November 17, 1996
Illusion—Emotion—Realität
Wien: Kunsthalle Wien und Semper Depot

September 11, 1996, to December 9, 1996
[*Zinkausstellung*]
Stollberg: Industriemuseum Zinkhütter
Hof

October 18, 1996, to November 15, 1996
*Von Kopf bis Fuss: Zum 100. Geburtstag von
Friedrich Holländer*
Berlin: Kulturhaus Karlshorst

October 1996 to January 12, 1997
Friedrich Hollaender
Berlin: Akademie der Künste

December 9, 1996, to March 23, 1997
Christian Dior
New York: Metropolitan Museum of Art

May 16, 1997, to June 7, 1997
Marlene—Reminiszenzen. Collection Fred
Ostrowski
Dresden: Kulturpalast

June 22, 1997, to October 19, 1997
La Femme mise en scène
Granville: Musée et Jardin Christian Dior

February 12, 1998, to May 21, 1998
EXPO 1998
*A Walk Through the Century: One Hundred
Days' Festival*
Lisbon: Centro Cultural de Belém

May 27, 1998, to October 20, 1998
Schnewittchen im Eis

Wattens (Austria): Swarovski Kristallwelten

June 3, 1998, to September 30, 1998
Vis-à-Vis: Deutschland—Frankreich
Bonn: Haus der Geschichte der Bundesrepublik Deutschland

December 15, 1998, to May 31, 1999
Vis-à-Vis: Deutschland—Frankreich
Paris: Maison de Radio France

November 20, 1999, to April 11, 1999
*Nobody Is Perfect: Filmidole von Lesben und
Schwulen*
Berlin: Schwules Museum

April 16, 1999, to October 31, 1999
*Einigkeit und Recht und Freiheit: 50 Jahre
Bundesrepublik Deutschland*
Berlin: Martin-Gropius-Bau

April 16, 2000, to November 30, 2000
*Zwischen Steckrüben und Himbeereis:
Nachkriegselend und Wohlstandsglück im*

Oldenburger Land
Cloppenburg: Museumsdorf Cloppenburg

June 1, 2000, to October 31, 2000
EXPO 2000
Hannover: *Technologiezentrum Fagus-Werk
Abenteuer Spurensuche: Auswanderung
nach Amerika*
Bremerhaven: Am Alten Hafen

October 9, 2000 to January 7, 2001-03-20
*Cristobal Balenciaga: Haute Couture Paris.
Retrospektive, 1937–1968*
Munich: Modemuseum im Münchner
Stadtmuseum

November 23, 2000, to February 25, 2001
*Mensch Telefon: Aspekte telefonischer
Kommunikation*
Frankfurtam/Main: Museum für Kommunikation

September 26, 2000
Opening of Filmmuseum Berlin, permanent exhibition, with about three hundred
square meters devoted to Marlene Dietrich

Acknowledgments

This book was made possible by the dedication and support of Peter and Sandra Riva, Senator Ulrich Roloff-Momin (Ret.), Victoria Wilson, Christine Cheney, Paul Riva, Freider Roth, Dr. Gerd Wiedemann, and Dr. Nikolaus Reber, as well as the staff of the Marlene Dietrich Collection Berlin: Wolfgang Theis (photography), Peter Mänz (prints, 3D objects, and recordings), Barbara Schröter (textile objects), Hans Peter Reichmann and Nicole Ueltzhöffer (correspondence, paper material), Silke Ronneburg (correspondence and management), Martin Koerber (film research), and Kristina Jaspers (exhibits coordinator), with special thanks to Bernd Eichhorn and Tobias Mielke, and very special thanks to Gerlinde Waz; and also the staff of the FilmMuseum Berlin: Director Hans Helmut Prinzler, Monika Brändl (management), Senior Curator Gero Gandert, Film Archivist Eva Orbanz, Wolfgang Jacobsen (publications), Librarian Ute Orluc, and, not least, Head of Collections Werner Sudendorf.

Color photographs by Michael Lüder

Web sites: www.filmmuseum-berlin.de and www.marlene.com

Index

Illustration Credits

Photograph by Lucien Aigner, courtesy of Lucien Aigner Trust: page 99

Photograph by Peter Basch, courtesy of Peter Basch: page 212

Cecil Beaton photograph, courtesy of Sotheby's London: pages xxix, 20

Photograph by William Claxton, courtesy of Demont Photo Management: page 201

Photograph by Louise Dahl-Wolfe © 1989 Center for Creative Photography, Arizona Board of Regents. Collection Center for Creative Photography, the University of Arizona: page 21

Photograph by Human Fink, courtesy of MOMA/Film Still Archive: pages 70, 83, 87, 88, 90, 100, 101

Dietrich image © 2001 Milton H. Greene Archives, Inc., www.archivemhg.com: page 37

Photograph by Tatiana Liebermann, courtesy of Library, Getty Research Institute: page 135

Photograph by Alex Liebermann, courtesy of Library, Getty Research Institute: page 39

Photograph by Bengt H. Malmquist, courtesy of Bengt H. Malmquist: page 213

Photograph by Roddy McDowall, courtesy of the late Roddy McDowall: page 215

Photograph by Paris Match, courtesy of Paris Match: page 208

Photograph by Edward Steichen, courtesy of Condé Nast Publications: page 24

Josef von Sternberg, courtesy of Meri and Nicholas von Sternberg: pages 10, 12, 13, 16, 17, 18, 19, 20, 29, 64, 67, 68, 79, 162, 163, 167, 178

Horst P. Horst, reproduced with permission of Condé Nast Publications: page 134

A NOTE ON THE TYPE

This book was set in Fairfield, the first typeface from the hand of the distinguished American artist and engraver Rudolph Ruzicka (1883–1978). In its structure Fairfield displays the sober and sane qualities of the master craftsman whose talent has long been dedicated to clarity. It is this trait that accounts for the trim grace and vigor, the spirited design and sensitive balance, of this original typeface.

Rudolph Ruzicka was born in Bohemia and came to America in 1894. He set up his own shop, devoted to wood engraving and printing, in New York in 1913 after a varied career working as a wood engraver, in photoengraving and banknote printing plants, and as an art director and freelance artist. He designed and illustrated many books, and was the creator of a considerable list of individual prints—wood engravings, line engravings on copper, and aquatints.

Composition and color separations by
North Market Street Graphics, Lancaster, Pennsylvania

Printed and bound by Quebecor Cayfosa, Barcelona

Designed by Iris Weinstein